# ALL THINGS VAIN
*Religious Satirists and Their Art*

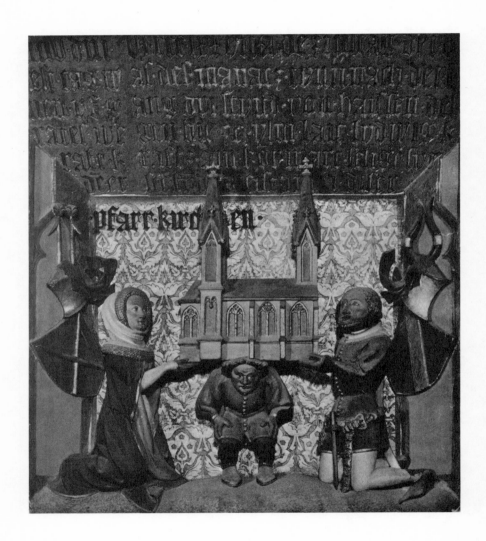

# ALL THINGS VAIN

## Religious Satirists and Their Art

Robert A. Kantra

The Pennsylvania State University Press
University Park and London

*In Memoriam*

Andrew E. Kantra
1905–1963

Leo H. Salvati, M.D.
1897–1958

Library of Congress Cataloging in Publication Data

Kantra, Robert A.
All things vain.

Includes bibliographical references and index.
1. Religious satire, English—History and criticism.
2. Religious satire—History and criticism.   3. Arts and
religion.   I. Title.
PR931.K3   1984      809.7′9382      83-43029
ISBN 0-271-00358-8

# Contents

# List of Illustrations

Of all things transitory and vain, when Sin
With vanity had fill'd the works of men:
Both all things vain, and all who in vain things
Built thir fond hopes of Glory or lasting fame,
Or happiness in this or th' other life. . . .

——John Milton, *Paradise Lost* (III, 446–50)

# Preface

Religion and satire can be incompatible, even opposed, but they can also join to produce great art. Even when it is not great art, religious satire always has a grand theme: man's encroachment on the divine—his effort to play God, in whole or in part—under the banner of religion or of humanity. Heroic art has the same subject, but its attitude and its size are different: it celebrates man's pretensions to divinity, whereas religious satire mocks them, with an intensity that is sometimes but not always reinforced by epic or narrative scope. The mockery may be harsh or gentle, quick or prolonged, but it is essential. If heroic art is ennobling, satiric art is humbling. Comedy sometimes may be found in satiric works, tragedy never, and tragicomedy always. Thus, even if it is not cathartic, satire may be comforting, especially if it is religious satire. Comforting or not, religious satire challenges the critical reader; it confronts him with problems in the domains of taxonomy (genre study), history, and theory.

In an effort to avoid the hazards—taxonomical, historical, theoretical—threatening the critic of religious satire, I have drawn concurrently on my professional and "real life" interests, adapting to this literary study my navigational experience as an amateur airplane pilot. They both span three decades of my life. I know that to fly—or to understand Milton—it is necessary to grasp much of what Newton knew. For one thing, my overview is more optical than hermeneutic; I employ theoretical learning, but I prefer to identify what I see as the natural significances in what I do. For another, just as an aeronaut thinks about terrain and space while consulting his charts and instruments, I shift my mode of perception between fictitious and real

worlds. Thirdly, my optical focus like my literary interest is this-worldly rather than transcendental, which does not mean atheoretical. Critics can no more disregard literary theory than an aeronaut can ignore the theory of flight.

Sir Philip Sidney argued in his *Defence of Poesie* that "as the fertilest ground must be manured, so must the highest-flying wit have a Daedalus to guide him. That Daedalus, they say, both in this and in other, hath three wings to bear itself up into the air of due commendation: that is, Art, Imitation, Exercise." Extraterrestrial effort and mundane experience seem to have a natural satiric connection. Sidney's ancient simile, about rhetoricians and poets, recurs as a modern metaphor about persistent theoretical dilemmas in literary study. Thus, J. Dover Wilson argues that "the English spirit has ever needed two wings for its flight, Order as well as Liberty," and that "the balance . . . between the bliss of freedom and the claims of the common weal has been disturbed by modern literary critics through a failure to preserve a similar balance in themselves." Wilson's aeronautical model is not identical with Sidney's, not any more than Falstaff is Daedalus; but they do equally represent equilibrium in the effort and experience of literary criticism.

In the 1643 edition of Sir Thomas Browne's *Religio Medici,* Will Marshall's engraved frontispiece depicts a man falling Icarus-like into the sea, but also being saved by the miraculous hand of God as it reaches down through low stratus clouds. Browne's literary and extraterrestrial idioms, "wingy mysteries in Divinity and ayery subtilties in Religion," are at once ancient and modern, and survive on into the twentieth century as persistent dualities of existence and as polarities of doubt and certitude. Browne's celebration of the books of Nature and of God was quickly put on the *Index Librorum Prohibitorum.* Although the *Index* is now long defunct, choosing between Nature and God, among other alternatives, continues to be man's predilection, much like the impetus toward censorship itself. Such predilection and impetus are satire's perennial subject matter. Like Browne, George Santayana suggests that every man's passion, like all facts and objects in nature, has an "amphibious moral quality" that can take on opposite moral tints. They are the dominant quality and tints in the wonderful world of satire, just as passion can be said to be a fact or an object in nature. Within the modest scope of my book, I suppose I will be seen to share the self-acknowledged "heresy" of F. W. Bateson, which, "put as bluntly as possible, is not that the serious novel is dead but that, with the exception of the satiric novel, it *ought* to be." I argue, as Bateson does, that for the readers of novels and newspapers "the two worlds become coterminous," that "unlike a mere 'story' (Yes—oh, dear, yes—

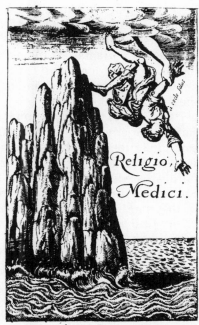

the novel tells a story), the satiric novel points to a verifiable external world." Satiric worlds can be at once fictitious and factual, coterminous and verifiable, in both their visual and verbal depictions.

It seems to me that in literary criticism no less than in literature itself there are objective correlatives. Still, it is true that tensions and disparities in literature—and the traditions and affinities in literary criticism—continue subjective distortion. They continue to spawn the kinds of theoretical contests that Pope describes as mock-heroic and that Martinus Scriblerus unsuccessfully avoids. In this book I do not try to obliterate unique differences between individual authors, titles, genres, and epochs; but in describing one healthy literary genre through more than four centuries of its life, I do argue for numerous connections rather than contrasts, for ambivalences rather than antitheses.

Taxonomically, religious satire is a genre. I use the term *genre* in Friedrich Schiller's sense of a "mode of perception." Schiller repeatedly refers to satire, elegy, and idyll as "modes of perception," as the only three "possible species" of sentimental poetry. Genres or "possible species" are not airtight compartments fixed for all time, as Schil-

ler knew. John Reichert, following Schiller's literary tack, writes that
"it is misleading to speak at all of *the* genre to which a work belongs."
Of course, religious satire can also be an epic poem, a novel or a
novella, or a drama—or indeed a painting, or drawing, or sculpture—
just as an elegy or an idyll can assume such forms. The temptation here
comes easy, merely to abandon the idea of genre because it seems so
messy.

Historically, the temptation to be avoided is the equation of religious
satire with any satire by or about clerical persons having vested inter-
ests in churches. Bishops or parsons, rabbis, or mullahs, the men and
women who administer organized religions, the congregations of any
faith: all are fit objects for social or political satire. Or they may write it.
Religious satire, however, concerns man's encroachment on the divine,
be that man saint or sinner, tinker or tailor, soldier or statesman, poet or
critic. And so an adverse temptation is to imagine that *all* satire might
be religious.

Theoretically, the critic of religious satire—like the religious satirist
himself—might best attempt to sail over rather than through the Scylla
of contempt and the Charybdis of reverence. He can too easily condemn
the religious satirist for his malice or revere him for his wit. In fact, the
accomplished artist who satirizes man's pretensions to divinity is mali-
cious or witty only insofar as he must be so in his effort to pull down
vanity, his own included. Indeed, the practice of religious satire can
sometimes be said to have the hidden location and moral equanimity of
rocky shoals. The common humanity of today's literary critics is no
doubt partly definable through the centuries of their emotional factions
and internecine morality. There are many more arguments in literary
theory than in the theory of flight.

Beyond history, such literary theory is no period piece. Beyond
words, it is no literary illusion either. Thus, connecting the poetic
prose of Buckminster Fuller with "the airplane's principles," Hugh
Kenner's worlds are at once finite and fanciful. He does not argue that
computers help grammar nor that the literary imagination thrives on
cybernetics. But he does describe the American modernist's
"homemade world" at once as American as the Wright brothers and
their first flight, as mythic as the flights of Daedalus and Icarus, and as
mundane as the predilections of Pasiphae and the Minotaur. Kenner re-
employs these winged and labyrinthine metaphors in describing James
Joyce's voices. Similarly, though Walter J. Ong is wary of *spatial*
analogies in literary theory over against the *oral* nature of literature,
like Kenner he employs aeronautical perceptions far-ranging in time
and space:

"Soun ys nought but eyr ybroken," says the loquacious and pedantic

eagle who soars through Chaucer's dream in *The House of Fame.* The frightened, airborne Chaucer had not only his heart in his mouth as he heard this, but his tongue in his cheek as he reported it. He senses that this simple reduction of sound to "broken" air and thus to spatial components was psychologically unreal, much too facile. Today we have the same awareness as Chaucer, set in a more complex context.

Father Ong emphasizes numerous affinities between literature and technology as that context more complex than Chaucer's. "The plight of the spaceman becomes symbolic" *of* technology and *in* literature's intricate themes of isolation and alienation. Ong's strictures concern modern theories less complex than Chaucer's, the self-simplifications of "militant secularism . . . , asserting that nothing exists, or at least nothing matters, except the purely secular, that is to say, actuality to the exclusion of the divine." Ong argues that the real world at the present time "is streaked with the vapor trails of planes in which and between which human consciousness has established incredible complex controls and information patterns." My own argument is that satire is as much technological as religious and is less likely than other genres to simplify things by halving them. Human consciousness intrudes itself on the world, and vice versa.

Religious satire is surely as much visual as verbal, not only metaphoric but also time-bound and spatial. Murray Krieger argues for "the language of space" in his sustained "discussion of earthly birds turned legendary, of poems concerning birds that are at once temporal and supernal." He admonishes critics for their too ethereal and failing Spirit of Gravity. He suggests that the fear of flying is an aesthetic metaphor for self-justifying exclusion from mundane learning, "flight from the world itself as other, disdaining all that impedes the airy leap." The encompassing emblem and epigraph for Krieger's aesthetic that balances poetic presence with poetic illusion is a kind of bird that is the mirror image of itself. Krieger's colophon derives from a miniature sculpture. Balance between painting and poetry, and in literary theory and practice, similarly occurs in Paul Hernadi's "new, dual mode of vision." That is, in literary classification as well as in literature itself, Hernadi prescribes both authorial and figurative perspectives as his theoretical "compass points." Like Krieger, he is prepared to resolve, certainly not ignore, some of the perennial disparities in literary theory:

> Frye's treatment of tragedy and comedy connects aspects of similarity and difference in an especially stimulating manner. Commenting on God's words about man in *Paradise Lost*—"Sufficient to have stood, though free to fall" (III, 99)—Frye points out that Adam loses freedom by his very use of freedom "just as, for a man who deliberately jumps off a

precipice, the law of gravitation acts as fate for the brief remainder of his life."

Hernadi favors Northrop Frye's "genre concepts" and shares his sense of "generic tradition and affinities as interdependent forces." Genre concepts reveal themselves similarly as vector forces in Doré's engraving of that vaster and more winged scene in *Paradise Lost*—"Hell at last/ Yawning receiv'd them whole" (VI, 874–75)—in which mighty Satan and his horrid crew are reduced to an absurdity. Tumbling down and out from the extraterrestrial empyrean, they are as vulnerable as Icarus to heat and the law of gravitation. It is not only for the sons of Adam that gravity acts as fate. Milton's high-flying Satan is, as W. B. Carnochan says, ludicrously earthbound. And of course Montgolfier's balloon and Johnson's "Dissertation on the Art of Flying" are takeoffs in the same satiric century; but my point, similar to Carnochan's on Montgolfier and Johnson, is that the way up and the way down are the same, literally and figuratively, "adjustments" between down-to-earthness and luxuriant imagination. Icarus, Satan, and Rasselas are personae for all seasons.

# Acknowledgments

My first indebtedness is to my guides through the doctoral rite of passage at Ohio State University two decades ago: Morton W. Bloomfield, Robert C. Elliott, Roy Harvey Pearce, and John Harold Wilson. Elliott directed my dissertation, "Satire on the Socialization of Religion," and his recent and posthumous *Literary Persona* briefly discusses humanistic implications of "complementarity" derived from molecular physics, a crucial topic in this book of mine. My sadness that I cannot have his appraisal now is professional as well as personal.

I am grateful to Villanova University for European sabbaticals: at the Österreichische Nationalbibliothek in 1969, when I knew I had this book in mind and, at the British Museum in 1977, when I completed the first draft. Small bits and larger pieces of it were published en route in *Centennial Review, CLIO, Journal of Modern Literature, Journal of Popular Culture, Kansas Quarterly, Modern Drama, The Papin Festschrift: Wisdom and Knowledge, Proceedings of the PMR Conference* (Augustinian Historical Institute), *Renascence*, and the three symposia published in *Satire Newsletter*. During the past six years, Villanova has been generous in granting me reduced teaching chores, and encouraging me to stay out of committees; Joseph P. McGowan has done everything a department chairman can do, arranging my class schedules for time to write. The campus staff in Falvey Memorial Library have been helpful and courteous, always, beyond their duty.

Very special thanks are due James R. Kincaid, who read through five of these chapters in rough draft. Early on, I was guided by Kincaid's mastery of laughter's rhetoric and his clear sense of persistent antagonism between the serious and the funny in literary criticism. Then,

Marcel Gutwirth made subtle suggestions, especially in the third and eighth chapters, when I landed on him with the entire manuscript, heavy in its newness. I cannot say enough for the editorial strength of John M. Pickering of The Pennsylvania State University Press, for his patience in helping get this book cleaned up and off the ground.

My wife Phyllis has been my copilot for many years, literally and figuratively. Like our many other flights in fact and fancy, this book is an act of love.

# Introduction

Satirists and their art are problematic for experts and confusing to amateurs. Satire and criticism of satire are exceedingly various in both words and pictures, which themselves can be satiric criticism of satire, verbal and visual manifestations reflecting upon themselves. The literary problems of religious satire might seem to be a limited and focused part of this difficulty; the specific connections between religion and satire were debatable long before John Dryden's offhand reference to Donne and metaphysics in his *Discourse Concerning Satire*. Their disparities are insufficiently defined as *discordia concors* in Samuel Johnson's "Life of Cowley." And today it seems, as incontrovertible as it is demonstrable, that "criticism of literature is going off in as many directions as literature itself."[1] Students of literature no less than pilots can lose their sense of direction and suffer disorientation. Satiric art of all kinds is scattered everywhere, as is commentary on it. Thus, to ask, What is religious satire? is first of all to ask, Is it necessarily literary? Or even verbal?

Satire concerns real life, being more topical and less "imaginary" than other literary genres. Satire also attacks metaphysical esoterica, often being high-minded even as it takes the low road. So, this book is a literary study but not only about literature, about religion, too, and necessarily concerned with both literary and religious quarrels. Satirists' spirituality plants flags in literary as well as religious wars; partisan secularity as well as denominational fervor ignites literary theory and criticism. Antithetical charges of "dogmatic orthodoxy" and of "blasphemy" have both been shot at religious satirists, sometimes at one and the same satirist. This book tries to describe the shooting without getting much involved in it.

A priori poetics aside—apostate or orthodox, secular or religious—I have had to inquire *why* satirists who have divergent religious convic-

tions write religious satires across-the-board and *how* they write religious satire, with shared sanctions for their kind (or genre) of intellectual and moral debunking. I regard their religious opinions as pertinent in all their many particulars, even where they are not compelling or even clearly defined. My immediate literary concern is to determine, first of all, how satire is a kind of ecclesiastic levity, not all of it verbal. Secondly, I examine satire's similarity with sectarian apologetics, not really "imaginary" or always intended as Great Art. I think the task of describing religious satire in literature and in visual art best begins in its perceived subject matter. Hence I make the following nine arguments in their respectively numbered chapters:

1. Literary theory is more often than not unavailing when it comes to the practice of satire, partly because satire is not always literary and partly because theory is. Literary theory often takes itself seriously, more seriously than satire seems to. Even when satire is literary it has had to live on the lower slopes of Parnassus. Not wanting to think of satire as a literary genre is part of its history. Literary critics are aesthetic balloonists, always seeking more rarefied heights. But satire is weighted down, containing its own low theories.

2. When theory is split from practice in religious satire, some antithetical and artificial dilemmas result. Jerome and Erasmus, for example, are equally and unquestionably religious and satiric; still, their religious orthodoxy and satiric art are quite differently perceived and appraised. Jerome and Erasmus are not the first religious satirists, but their portraiture through centuries of Renaissance art visually defines the aesthetic quandaries built into the appraisals of their verbal art: Jerome the devotional apologist in contrast to Erasmus the secular humanist, the canonized saint as opposed to the nominal heretic. Their divergent holy and secular reputations seem a relentless and persistent inevitability. Considering the clear divergences depicted in visual art generally and in their literary biographies in particular, a common generic description of their shared verbal efforts is certainly complicated and difficult. But it is not impossible. Though their subject matter forces some generic hedging, their emphases are unmistakable. An explication of Erasmus' *Enchiridion*, *Colloquies*, and *Praise of Folly* shows the intricate connections between devotional, polemic, and satiric efforts.

3. The continuing confusion of satire with other genres may have had a beginning but seems likely to have no end. Like tragedy and comedy, before and after the Renaissance, satire has certainly had religious themes, and still does. One might argue that in this sense its subject matter is constant even though its forms can be said to mesh or meld. As tragisatire, so to call it, it has roots in experience and the real

*a "genre" with blurry boundaries*

world which are no less profound for also being primitive, which combine high seriousness with ordinary levity, and which are not now—any more than they have ever been—discrete. Types, kinds, and species in scientific classification are always amenable to redefinition. There is no special reason why artistic genres have to be thought of as different. The idea of tragisatire is a function of perception *and* cf what is perceived; it is a means of transcending or at least not perpetuating the busyness of literary criticism, which seems not to know what to make of religious satire, or even how to acknowledge its existence.

4. Utopian literature sometimes looks like satire. Like tragedy and comedy, the two are virtual mirror images, but there is a world of difference between them. Milton defined them, emphasized their differences, and expressed his preferences, in theory and practice. The reputation of Milton's religious satire among many literary humanists has clearly dropped, along with Milton's literary theory and the long-lived tradition of Christian humanism he represents. Risen up instead, in the estimation of the literary humanists, is the prolific and quantitatively impressive genre of utopian nonfiction. It is in a couple of senses a kind of unintentional satire, often laughable though not always intentionally funny. Miltonic and utopian literary critics quarrel because they see themselves living in different worlds, though their modes of perception look alike.

5. Religion as "subject matter" is controversial in both art and science, in satire and sociology. Sociologists when they write about religion aim for its real and social "content" and, as scientists, do not concern themselves with its mystical or theological "form." Even the "structure" of religion is in this sense substantive. Focusing on religion as subject matter, social scientists write like satirists, in ways that ridicule, ways that can be called unintentional satire. Religious satire is not intended to be science, no more than the sociology of religion is intended to be funny. Nonetheless, sociologists often are funny, no doubt with effects and results that are mixed, but also definitive. The uses of ridicule seem not so much planned as required.

6. Such binary and binomial oppositions as are identified throughout these chapters are not to be construed as "structuralism," that is, they are not peculiar to literature alone *as* an art form nor are they to be found in exclusively verbal contexts. They are "built into" the satirists themselves, the world they create, and the way they and their world can be appraised. Shaw's notion of "Chesterbelloc," for example, is as much a satire as anything in the work of the writers it identifies. Chesterton and Belloc are as inseparable *and* as different as magic and religion. Chesterton's identification of his satiric personae as "two lobes of the same brain" is not just literary or figurative but also as real,

or nonfictional, as the bicameral mind. Satire enjoys a questionable viability and appeal either way.

7. Even when satire in literature is unmistakably intentional, and religion is its obvious target, what religious satire does and is remains duplicitous, equivocal. Belles-lettres and theology, satire and piety, have no necessary claims on each other. Even when satirists have insistent beliefs and write competent theology, they can seem irreligious. Allowing that imaginative literature and Christian apologetics are discrete and contiguous, satire can be shown to reveal religious responsibilities in its authors. Benson and Knox are equally practitioners of an art that does not identically combine antithetical talents. As theologians and as satirists, they can be said to have matching intentions, pastoral and artistic; even though they are not alike, they are not dissimilar either.

*[margin note: Satire's "results" ambiguous]*

8. The literary circumstances and the "real life" occasions of religious satire are its subject matter. They are quite various. And the literary talents that give religious satire its formal configurations are more obvious than definable. Certainly, the art of satire is not contingent on dogmatic belief, nor on mystical faith. In drama, for example, the personal spirituality of Beckett and Eliot is nowhere revealed as clearly as their artistic orthodoxy, their satiric configurations. Beckett's and Eliot's plays certainly cannot be compared on the basis of their authors' religious commitments. Still, Eliot's are no doubt orthodox, just as Beckett's can be called apostate, which may account more for their audiences' contrasting enthusiasms. However, generic comparisons between their plays are more pronounced than contrasts, because of shared subject matter.

*[margin note: the satirist's "stance" may not effect the formal shape of their work]*

9. Differences significant to theologians lose their force in satire, to the extent that satire is fiction: theological precision is elusive in literary contexts. But it is not a constant in "real life" either, not any more than enactment of canon law guarantees obedience to it. Apostasy and orthodoxy have no one prescribed shape or size, in literature or anywhere else. Likewise, no one particular shape or size defines satire; nor does satire prescribe any dogma or heresy. Allegiance to religious creeds does not spell success or failure for satire, apostate or orthodox. Religious satire is a recognition of, not an allegiance to, the variety of sizes and shapes religion may take.

Some of Schiller's sustained contrasting of the naive and sentimental human types as hedonistic and real versus didactic and ideal may be a reinforcement of his own personal idealism. Who else defines naive and sentimental in these terms? Schiller's translator rightly concludes that "there are caricatures of both types," and "that the types are commixed in practice."[2]

Still, regarding the three hazardous problems mentioned in my pre-
face, especially the first in the domain of genre study, Schiller's con-
trasts of naive and sentimental poetry, with its emphasis on poets,
seems to me a useful starting point:

> The sentimental poet is thus always involved with two conflicting repre-
> sentations and perceptions—with actuality as a limit and with his idea
> as infinitude; and the mixed feelings that he excites will always testify to
> this dual source. . . . His presentation will be either *satirical* or it will be
> . . . *elegiac;* every sentimental poet will adhere to one of these two modes
> of perception.

Schiller seems here to gloss over the unwieldy "mixed feelings" in the
readers of satiric poets, and of elegists too, but he neatly focuses on the
satiric poets' "conflicts." He spells out several other Kantian aesthetic
contrasts "built into" art and artists: plastic or visual art over against
poetry and prose; simple-sensual-corporeal forms versus the rich-
ineffable-spiritual; ancient poets and moderns. Further, he makes a
careful distinction between the "pathetic satirist," who depends on his
subject matter for concrete manifestations of his perceived ideal, and
the "playful satirist," who depends on his own person to preserve his
theme from frivolity. In short, the distinction is between representation
and perception. Then, Schiller makes the persuasive suggestion that
satire is closer to tragedy than to comedy in treating of a more sublime
subject matter, but that the satirist himself saves comedy from collaps-
ing into triviality. Similarly, I think, Schiller's distinction between
"punitive" and "playful" satires is not hidebound either. In numerous
instances, satire is executed both "seriously and with passion" and
"jokingly and with good humor." I am not then sure that, as Schiller
parenthetically puts it, "the poet is satirical if he takes as his subject
alienation from nature and the contradiction between actuality and the
ideal (in their effect upon the mind both amount to the same thing)." I
concur, first, that satire is contingent on its subject matter; second, that
the contradiction between actuality and the ideal is satire's "mode of
perception"; and third, that the genre of satire is neatly, if not com-
pletely, thereby defined.

Satire's definition no doubt can be pressed too far in the direction
Schiller wants to take it. Whether visual or verbal, sophisticated or
mundane, large or small, high art forms, even when they soar, are not
devoid of their terrestrial, or low, subject matter. In this regard, the
etymology of *satire* is long and indeterminate. The problem of the
meaning of *cartoon* is similar. Thus, *cartoon* since only the nineteenth
century signifies a humorous drawing. For a much longer time it has
meant a design for larger and more complete painting, often very reli-

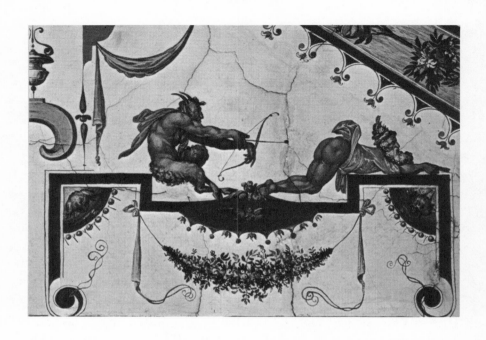

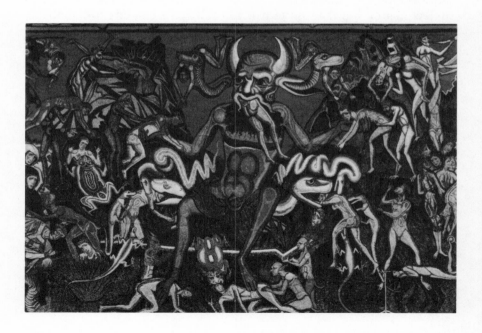

gious and not particularly funny, such as Leonardo da Vinci's *Virgin and Child with St. Anne and St. John the Baptist*, in London's National Gallery, and *The Raphael Cartoons*, in the Victoria and Albert Museum. During a competition for designs for frescoes in the then-new Houses of Parliament, *Punch* parodied these solemn nineteenth-century designs, and *cartoon* acquired its modern meaning.[3] It is a meaning that imbues subtlety and complexity with simplicity and plainness, and vice versa. No doubt, the *Plumpes Denken* of newspaper cartoons is worlds removed from the finesse of the Raphael cartoons. Surely, as Robert C. Elliott's *Power of Satire* has shown conclusively, a developed art form and its primitive origins are two different things. Matthew Hodgart's *Satire* also suggests this extreme range of satire's art in cataloging the primeval elements of satire in lampoon, invective, curse, travesty, and obscenity. Still, I would say, even as small things can be sublime, so satire can be religious.

Consider, for example, Conrad Ferdinand Meyer's novella, *The Monk's Marriage*, which though a small work has high praise bestowed on it,

> . . . for intertwining two equally strong and justifiable realities with one another: That of man's inner forces and that of any given social order. The actual theme of the story is life's eternal, tragic juxtaposition of reason and feeling, of mind and heart, of body and spirit. The particular form in which this duality of life appears in this story is that of justice and mercy. . . . This cannot be complete unity but an organic and creative polarity which is actually anchored in the basic impulses of man himself.[4]

Such "duality of life" is not just an editor's literary partiality. Such theme and form, polarity and impulses, are not only the relentless commonplaces of literature and of literary criticism, but even of all life itself, world without end. They occur in all objective and imaginative perspectives, scientific and artistic. Such polarities are not avoidable— cannot be avoided—in literature any more than in life. They are, as it were, constants by which the protean shapes of literature and life can be perceived.

*The Monk's Marriage* is literature, not life. Yet, it can be valued for the same perceived realities that are intended in Arnold Toynbee's *Study of History*, which is certainly not a novella. Toynbee's visions and versions of history have differed in the several points of time he has attempted to overview. He has continually argued in the *History's* successive revisions that the very geneses of civilizations are to be found in "the two alternating forces or phases in the rhythm of the Universe which Empedocles calls 'love' and 'hate' [and which] have also been detected—quite independently of the movement of Hellenic

thought—by observers in the Sinic world, who have named them Yin and Yang."[5] Toynbee sees their occurrence in Aeschylus' Promethean Trilogy, the Book of Job, and Goethe's *Faust*; they are the perennial and immemorial forces of Zeus enthroned over against Prometheus unbound, traveling through the spheres between Heaven and Earth to bring fire to Man:

> On the plane of mythology Zeus and Prometheus are presented as two separate human personalities, but in a psychological analysis they can be seen as being two impulses in a single human soul which interpenetrate each other, however vehement their conflict, because it is the same soul that feels them both. We can apply this psychological interpretation to the action of human souls in social situations.

Toynbee sees alternating forces everywhere in the universe. Students of literature cannot escape them in the very geneses of verbal contexts either.

Janus-like qualities "on the plane of mythology" extend from classical antiquity and early Christian culture into the cosmos of literary criticism; these alternating forces infiltrate conventional predisposition and textual evidence. Thus, for example, in Milton studies, one does not only read that Milton may have necessarily combined tragedy and comedy in the creation of *Paradise Lost*, that, "by convention, epics are in a comic genre, not a tragic, but the line is sometimes difficult to draw." One also sees phenomenological correspondences drawn between the uroboros (the circular snake devouring its own tail and signifying the union of opposites in the unconscious), Adam and Eve in *Paradise Lost*, and Rangi and Papa, who, one is told, are the Yang and Yin respectively of Polynesian mythology; a structural analysis of *Samson Agonistes* argues that the Samson-Delila encounter is the keystone of the work's bipartite framework and represents its fusion of comic and tragic forms. Consecutive essays in *PMLA* declare that the simple and sophisticated techniques in the *Second Shepherd's Play* minimize the distance between secular and sacred experience, and that the main character in Moliere's *Dom Juan* must be perceived as the comic inverse of a tragic hero, in the improbable light of his relationship to the Deity. Renaissance contrariety, derived from Castiglione, Paracelsus, Bruno, and Montaigne, is said to have provided Shakespeare with a philosophic solution to a baffling dilemma to be found not only in his plays but in himself. Blake's Contraries and Fearful Symmetry are respective epigraphs for "literary criticism, the most ingenious form storytelling can take," and for the revolution in molecular biology that has occurred since my undergraduate years.[6] Thus, bifocal perspectives bend to the requirements of literature and life.

Schiller's polarities occur not only in the humanities but also in the

social sciences, and there too have an affinity with satire. This is to say that satire's subject matter is not *only* to be found in visual and verbal art forms. Harold D. Lasswell, for instance, is celebrated (though, as I show later, he is not rare among his peers) for having "a delicious sense of satire, . . . rarely malicious and never petty," for being "a very kind man, exceptionally generous in his professional judgments." Even so, as a teacher, he "could become testy, clipping the wings of fledgling theorists with sardonic rejoinders."[7] This is of course one of the oldest personifications of the satirist's self as poet, dating before Sidney back at least to Horace. As much to this point, however, is Lasswell's apparently modern notion of "emergent evolution," repeated often in his writings. One of Lasswell's key doctrines, this is a crossbreed of Darwin and Hegel, existential and functional, intended to overcome many old dualisms in political theory most frequently depicted as notions opposed to each other: individual versus society, pluralism versus monism, determinism versus free will, materialism versus idealism, logic versus fantasy. In short, "actualities and potentialities are the two poles of nature that the process of emergence seeks to link and unify."

It should come as no surprise that Schiller's polarities occur not only in the humanities and social sciences but in the physical sciences as well. English literature from the seventeenth century to the present day can scarcely be understood apart from science. Still, Francis Bacon, in the first book of his *Advancement of Learning*, describes an incompatibility of literature and science that is unflagging; even though he himself was an accomplished prose stylist, he expressed his own disdain for the prevailing literary emphasis on "manner" rather than "matter." It is even today not uncommon for Swift's *Battle of the Books* to be read, not as a great satire, but merely as a literary quarrel, in which all humanists are designated as ancients, and all scientists of whatever stripe or competence as moderns. Even so, some scientists reveal themselves as men of letters, as writers with a symbiotic understanding of "new science" in the modern world.

Gerard Manley Hopkins' little poem with a big title, "That Nature is a Heraclitean Fire and of the Comfort of the Resurrection," is replete with antitheses, the yoking of classical mythology with Christian history, nature and God, cosmic range and miraculous focus. Father Hopkins' literary and Victorian avocation in no immediate sense corresponds with that of Erwin Chargaff, who is a world-class scientist and satirist. Yet, this is the poem that provides Chargaff with the title and epigraph for his autobiography and with its controlling mode of perception. Chargaff's *Heraclitean Fire*, at once mundane and esoteric, describes the forever unknowable yet precisely biological mysteries of life, minutiae that are awe-inspiring. No less than Hopkins, Chargaff per-

ceives and imagines. He believes in "the *corpus mysticum* of the world" and, despite its ceaseless irritations and aggravations, in the collegiality of intellect. He describes the "curious antinomy" in the biochemistry of bloodclotting as the very "dialectical character of the life processes"; it is a "delicate equilibrium," which though crucial is merely *one* among numerously revealed and "predetermined oscillations, the condition of life itself." He laments the split worlds represented in the glorious axioms of chemistry ingloriously written, the grotesque flights of fancy published by "the owls of Minerva," that is, those who think they know about the literal subtleties of life but write about it with a literary heavy hand. Regretful of the professional incompatibility of verbal elegance and molecular biology, he nonetheless demonstrates their compatibility. What Chargaff calls "The Miracle of Complementarity" is the basis not only of his sublimity but of his satire. The most sustained satiric passage in this biography is captioned "Gullible's Troubles," his account of the discovery of the DNA molecule; his recollections differ from J. D. Watson's in *The Double Helix,* except perhaps that they are equally irreconcilable.[8] With Chargaff, certainly, as with all satirists, the manifest literary intention of form, style, and tone is not easily distinguished from mere temperamental inclination that seems to be latent despondency or melancholy. Swift and Chargaff both have an elusive identity as participants in the stories they tell. Other biologists, including David Ehrenfeld and Loren Eiseley, are consistently interdisciplinary, and not only on the scientific side. Their books are larded through with literary epigraphs and quotations. These authors maintain that intellectual and cultural dichotomies of all kinds are "mischievous," that these dichotomies are the basis of dangerous fallacies which themselves constitute an absolute faith to control our own destiny. Beyond that, Eiseley celebrates "science and a sense of the holy" and deplores "that bipolar division between the humanities and the sciences, which C.P. Snow has popularized under the title of *The Two Cultures.*" This division is an illusion centuries old, as Eiseley says; it is also what Ehrenfeld calls "the dominant religion of our time."[9] It has always been a favorite subject matter for satire. Many physicists, similar to biologists and in contrast to many humanists—not all of them religious, of course— deplore divisive shoptalk, and look for objective correlatives. Thus, when Freeman Dyson tries to show how "the human situation looks to a scientist" in *Disturbing the Universe,* he takes his title from T.S. Eliot and his concluding chapter blends science with fantasies of flight.[10] And Donald A. Cowan, lamenting the high-brow as well as low-brow ignorance of science, suggests how this-worldly learning is compatible with religion:

> To most people, no doubt, a fact of non-observation would seem to be the stuff of which satire, not science, is made. . . . Satire of course has many edges, and may at any moment slice through to a basic truth. . . . All ages have invisible agencies which they accept on non-empirical evidence. Angels are as much historical entities as are elementary particles, and the historian has the duty to treat them in a manner free of cynical enlightenment.[11]

At least since Browne's *Religio Medici*, I have remarked, every man's passion, like all facts and objects in nature, can be seen to take on opposite moral tints. Angels and satire aside, literature and religion and science nonetheless continue to be antagonistic within as well as outside humanistic scholarship. Otherwise, how can the valediction of a president of the Modern Language Association claim, with the approbation of thousands of humanists, that the humanities (especially literary studies) are not only different from but superior to the sciences on all of three counts? Only the humanities, she says, involve in a professional and scholarly sense "all the perceptive and responsive faculties of each individual," cultivate a sense of values, and provide enjoyment in professional commitment to pleasure seeking. It is very difficult for me to accept the proposition, however delicately veiled or frequently suggested, that literature only, quite apart from religion and science, carries the difficult weight of civilization on its aesthetic shoulders. Happily, there is an alternative if also, perhaps, minority opinion. Expressed similarly in another MLA presidential valediction, it argues the case that "the history of literary genres is tied to technological development," and even that "most of the genres we know and teach are the products of writing and print technologies, now intermixed with electronics."[12]

Gerald R. Bruns argues that "the rhetorical world" of satire is verbal over against real, is suspicious of "simultaneities of meaning," but is open to "such ideas as philosophy is made of, constructions of what lies just out of view: 'views' which are less of things seen than of what to look for, and sometimes what to say." Edward A. and Lillian D. Bloom make a similar though more subtle argument. Allowing that satire can be as duplicitous as Mercury and the tradition of hermeneutics, the Blooms employ numerous antitheses to delineate "the many possibilities of a genre or a set of attitudes: satire can be either or both": personal, vindictive, opportunistic and didactic, hopeful, best-intended; destructive, humiliating and ethical, reformist; literal and conceptual. Their most persistent antithesis is "popular dogma and theory as bona fide commitment to realizable ideals," what they call "antihumanitas" over against "*humanitas*." Satire can be almost anything, in their view; but they also argue that satire at its best celebrates

*humanitas,* in the Restoration and eighteenth century, for example, when satire opposed the standards of both church and state, antagonistic to both the religious world that preceded the enlightened Age of Reason and the technological world that followed it.[13] Hilary Putnam argues quite a different case; the value of literature, he says, is not that it describes "the human predicament," but rather that there is no one such thing, and that "for *many* reasons it seems increasingly difficult to imagine *any* way of life which is both at all ideal and feasible." I concur with Putnam, and with Loren Eiseley, who says that "all talk of the two cultures is an illusion"; it is from both "the artistic and the practical," he argues, that we derive "those humane insights and understandings which alone can lighten our burden and enable us to shape ourselves."[14]

Perennial and immemorial ambivalences reveal themselves in religious satire. Their numerous emergent occasions and their relentless and inevitable occurrence are not an aesthetic crudity. In literature, I play down theory where it disembodies itself from practice, and in religion too; I question those instances when satire is denied the legitimacy of a genre and, more numerously, where religion's fame seems to be that it is the bogey of professional humanists. Religious satirists of course play up the connections of satire with religion, which I do not think is a merely obvious redundancy. I am also saying that religious satirists themselves are their own best theorists, as well as mere practitioners of their art. Of course, just as there are good and bad critics, there are good and bad satirists. This book necessarily concerns them both. If early in my sequence of chapters I seem to give critics first consideration, it is not because criticism is more important than satire, but rather because criticism is "built into" satire and satirists are themselves critics.

Because satire's generic qualities include inversion and variety, criticism of it has been topsy-turvy and diffuse. Satirists themselves, *as* satirists and *as* critics, display a range of competence; what they write defines itself more by subject matter than by structure, in content more than form. Their variety reveals itself in family resemblances that are sometimes uncongenial and antagonistic. Satire and literary criticism, like Siamese twins or even sibling rivals, can be said to have an unintentional coexistence and a natural affinity. Yet, there remain numerous arguments about religious satire, to the extent that its subject matter is certainly not circumscribed by artistic rendering, its content is not limited to aesthetic appraisal, and its structure defies formal—or even perhaps liturgical—definition.

In religious satire and in criticism of it, apparent oppositions and real divisiveness are interdependent forces, numerous and various in their

symbolic identity no doubt, but finite and real too in their referents. Their literary definition can be made in Newtonian analogies. Though there are many possible directions, for each one there is an equal and opposite and reciprocal redirection. Just as one can say in thermody-namics that heat is work and work is heat, religion and satire are best understood together and not as separate entities. Literary theory, like the theory of flight, can be expressed as vector forces even though birds and angels can fly, and satirists can write, without their knowing how. There seems to be no special reason why the literary imagination can-not feel at home in the real world beyond and outside words.

# 1

## The Varieties of Satiric Experience: Theory and Practice

Schiller agrees with Kant that knowledge has "built into" it two kinds of uniformity: external objects as given in appearance, and the human mind itself. He says further that these uniformities reveal themselves with respective and differing clarity in the visual and verbal arts—that is, in their contrasting finitude and abstraction, corporeal and ineffable representation, in antiquity and modern times. Schiller also uses the Kantian expressions "theoretical" and "practical" to distinguish his types of human nature, which, as his modern editor says, constitute Schiller's major contribution to aesthetic history; these are directly in the line of Jung's descriptions of introvert and extrovert, Coleridge's famous Platonist-Aristotelian dictum, William James's division of tender- and tough-minded, Nietzsche's Apollonian and Dionysian types, and numerous other pairs.[1] It almost seems as though these contrarieties are frozen into theories about all artists and their art. Surely, the varieties of satiric experience seem to impinge upon an understanding of the varieties of satire. In this chapter I examine more or less religious instances when the theory and practice of satire are not exclusive of one another, and consider how religious satire is related to thought and feeling, and why its "simple" subject matter, rather than its "complex" sizes and shapes, determines its nature as a "mode of perception."

According to Schiller, though satirists' feelings are sentimental, they are also filtered by intellect, subject to theoretical scrutiny and practical validity, measurable against some purpose extrinsic to their work. Satirists are characterized by their emotional control as well as by their

feelings. Thus, despite Schiller's antithesis of sentimental and naive poetry, I think it is possible that satirists can be naive, as well as sentimental, in the technical sense of modern art history that "naive" or "primitive" visual art is said to be impacted with unschooled sophistication, with untrained awareness of what is going on in the art centers of the world. For example, modern Yugoslavian peasants are naive in the sense that their songs are aesthetically effective insofar as they are illiterate, and that their painting and sculpture reveal crude talent for tackling weighty subject matter.[2]

Schiller's valuable aesthetic categories are perhaps not mutually exclusive, at least not in religious satire. It is certainly true that much naive art, even when its subject matter is religious, is not exactly High Church. Its plastic and poetic intentions—as when they are anticlerical, perhaps, but nondenominational too—can be so weak as to defy generic description, in the direction of religion or of satire. Literature as low art is not to be confused with low art as literature, that is, those verbal and mutant shapes that define mere literacy, or defy it.[3] Even so, generic description is possible on the basis of subject matter; and divergent appraisals of what is being described are perhaps unavoidable. I would argue that among the varieties of religious satire there are especially and frequently strong similarities in verbal and visual art.

Satire as subject matter "built into" art and artifacts is perhaps less comprehensible and more arguable when the satire is religious. Questions immediately come to mind: Do religion and satire have natural juxtapositions, or connections? Are they continuous, or contiguous? Do their shapes merge, or contrast? Are they even verbal? Such questions, so briefly put, are not so easily answered. But neither aesthetic experience nor religious experience need be defined as otherworldly, to the extent that they are not extrasensory or extraterrestrial. That this is apparent in satire is Schiller's major point about it, and about satirists too. Furthermore, *religious* satire, though it may be aesthetically highminded, may also be this-worldly, even in a crude or unrefined sense. For diametrically elusive reasons, religious satire can best be understood as a mode of perceiving its subject matter, as real rather than either mystical or imagined. That religious satire can occur in contexts that are not much poetic, or even verbal, seems obvious enough. What I am suggesting here is that religious satire is not contingent upon either religious belief or aesthetic aspiration. For example, William James in *The Varieties of Religious Experience* and Ronald Knox in his *Essays on Satire* can be said to be worlds apart, though in Schiller's precise sense and by Schiller's standards they have very much in common. A brief discussion of these two texts here—a kind of transatlantic and

nondenominational comparison—can illustrate my main thesis in this chapter: at least in religious satire, the presumptive differences between art and theories about it are negligible.

The main thesis of William James's *Varieties of Religious Experience* is the antithesis of somber and sanguine temperaments psychologically speaking, and thereby the contrast between the Religion of Healthy-mindedness and the Religion of Official Moralists.[4] The book is as much sociological as psychological in its typology of human nature, and is collective as well as individual in its cultural implications. James does not claim that religion is merely neurological in its origins or its definition, nor is he denominational in his emphases. James's book is a virtual anthology of unintentionally funny passages of religious literature, and his lectures contain sardonic commentary on it, like these: he thinks it impossible to overpraise the Quaker religion, though its founder George Fox was "a psychopath or *détraqué* of the deepest dye"; even if "Saint Theresa might have had the nervous system of the placidest cow," her theology must be measured by other criteria and tests. James's judicious selection of numerous quotations itself suggests his sensitivity to "Mind-cure religion"—he terms it foolish, influential, therapeutic, crude, extravagant—and he warns his sophisticated "clerico-academic-scientific" Gifford Lectures audience that it may "play a part almost as great in the evolution of the popular religion of the future as did the [Lutheran and Wesleyan] movements in their day." Furthermore, "nothing can be more stupid than to bar out [these] phenomena from our notice, merely because we are incapable of taking part in anything like them ourselves." He constantly refers to the then-new scientific idiom of "threshold" as a symbolic, or metaphoric, designation in psychology for the point at which one "state of mind" passes into another; especially in "Lectures IV and V" and in "Lectures VI and VII," the implied antithesis of Healthy Mind and Sick Soul ultimately reads like a simultaneous equation, or Theophrastan characters. *Anhedonia*—mere passive joylessness and dreariness, or "psychological neuralgia"—leads to "querulous temper," which in turn is indistinguishable from the most austere and profound mystical tranquility; it is not an "intellectual insanity" but rather the mastered perception of the vanity of mortal things, a sense of sin, a fear of the universe, and the destruction of the vapid or ingenuous "original optimism" and self-satisfaction of the healthy mind. There is ultimately an identifiable sameness in this dialectic of religious experience, the sick soul with the organic weight on the side of cheer. James's intention, like that of many bona fide twentieth-century satirists, is to indicate that though the socialization of religion may seem primitive or uncivilized, it is objectively modern. James is himself often, if uninten-

tionally, concerned to make a fictive identification of the concurrence of social and religious acts, all the while making an actual insistence that these are different. Yet, undoubtedly such an indication and insistence fly in the teeth of some of the most influential pronouncements of social science, and have not saved James from persistent misreading.

Ronald Knox's attempt at a careful definition of satire as art is also replete with dualities, similar to those James finds in religion as experience in human nature. For example, Knox's short essay "On Humour and Satire" grapples with far-ranging implications, yoking Christian prehistory with literary genres as well as with modern morality and popular culture. The implications here are far-ranging in the sense of naive and sentimental, in the sense that not only the practice of humor but the vogue for humor theory is a relentless fact in popular culture.

In a sustained comparison and contrast, Knox questions "whether there could have been humour even in human fortunes but for the Fall of Adam" and "whether humour is in its origins indecent." He stakes literary claims that are temporally precise: "the humorous in literature is for the most part a modern phenomenon"; "with the nineteenth century humour, as an attitude towards life, begins." Such questions and claims however are not always discrete but seem rather to merge: "humour and satire are, before the nineteenth century, almost interchangeable terms." Knox is rather more precise, or less imprecise, in point of time rather than place: "We have concluded that the humorous in literature is the preserve of that period which succeeds the French Revolution, and of those peoples which speak the English language under its several denominations; unless by the word humour you understand 'satire.'" Monsignor Knox is of course best known as Bible translator and Christian apologist, not as literary theorist or satiric practitioner. The point is not that his definitions in theory are diffuse in practice; it is rather that his own theory (and practice) of satire is as religious as James's style on religious subjects is satiric, that Knox's salvational vocation (doesn't a clergyman affirm the goodness and worth of Everyman?) does not keep him from satire. "In satire," he says, "the writer always leaves it to be assumed that he himself is immune from all the follies and the foibles which he pillories"; he adds that "the laughter which satire provokes has malice in it always," and "purifies the spiritual system of man as nothing else can do."

Knox no doubt had a dim view of what he calls mere humour without satire, as cause and effect, "the hearty guffaws which are dismally and eternally provoked by Mutt, Jeff, Felix, and other kindred abominations." He specifically had in mind American culture, but, like James, he was himself transatlantic; he concluded his essay with a prophetic question and awareness: "And have we, on this side of the Atlantic, any

organ in which pure satire could find a natural home?" He believed, more than fifty years ago, that there was a world-wide danger that "we have lost, or are losing, the power to take ridicule seriously." Knox's question signals some still unfinished business in literary theory.[5]

Ordinary juvenile fantasy and traditional satire—what Knox distinguishes as humour and satire—have many shared pictorial qualities, though not the same artistic intentions or pretensions. There is a range of possibilities "built into" humour and satire, from simple to intricate, which affect the reading and writing of and about satire. There are equivalent "possible species" in its theory and practice. This is not to say that the style is the man, merely, but that style is at least in part determined by subject matter. I think this is one implication of Hugh Kenner's assertion that "for the satirist, for the technician, and for the counterfeiter, fact tends to behave this way: retaining its contours, altering its nature."[6] Religious satirists, for example, are not "innocent" even where they may be perceived as ingenuous, not deceitful even when their fictions are obviously an act.

By Schiller's definition, Chaucer and Swift as satirists are sentimental human types; conversely, Chaucer and Swift indeed depict themselves in their satire as naive. It is as though each is wearing two hats, as satirists in theory and in practice. Whether the ingénu is also the poseur, sometimes unwittingly, becomes itself a subject matter, one which is not exclusively literary and which presents problems that cannot be solved simply by explication de texte. Surely, "innocence" lends itself to definitions that are as much religious as literary, and reveals satirists themselves as persons no less than personae. That there is a persistent industry or at least an unending busyness in Chaucerian biography everyone knows. The identification of the "real" Chaucer is continuously up for grabs. It certainly can be said that "we may grasp something of the Chaucerian humor, which hates human meanness and cruelty and which at the same time pities human weakness and affectation and even at times sin." Whether Chaucer, as person or persona, is a satirist is argued variously from one scholarly generation to the next: is Chaucer a humorous jester lacking high seriousness, or a moralistic writer prophesying doom? Similarly, numerous definitions of a "new Jonathan Swift," as Robert C. Elliott says, emerge "from a mistaken way of dealing with issues arising when an author writes in the first person under an assumed character."[7] The problem is complicated further when Gulliver undergoes a sea change. His travels are translated into English for young readers, and many other foreign languages; his antiquarian topicality and "obscenities" are deleted in sometimes ephemeral editions that might seem exotic, even to sophisticates.[8]

That Chaucer and Swift can be read for their "simple" content—over

against their "complex" artistic intentions—does not constitute a mere English literary problem but rather an international cultural phenomenon. It seems to me that Knox alludes to this antithesis as a part of the melding of humor and satire he perceives in point of time after the French Revolution. J. J. Grandville draws apparently simple caricatures, simple in comparison with Daumier's; but even Grandville's "childlike" drawings of animals in human dress combine "two nudging elements" in their subject matter: the fatuousness of French society and the pretensions of all mankind.[9] Grandville's *Les Animaux* is no more a collection of simple line drawings than Orwell's *Animal Farm* is merely a child's fantasy. This melding connection between simplicity and complexity, humor and satire, is not a matter of qualitative indifference. However, intellectual provocation is one affective claim that can be made for international anthologies, some of them multivolume, like *The Limerick, Heiterkeit braucht keine Wort*, and *Die Umwelt des Kindes im Spiegel seiner "verbotenen" Lieder, Reime, Verse und Rätsel*. The point here is not that little things can be made to loom large by mere accumulation. It is that whole volumes by individual artists and authors—Wilhelm Busch's *Max und Moritz, Plisch und Plum, Schein und Sein*, Lewis Carroll's *Alice in Wonderland*, Edward Lear's *Nonsense*, Belloc's *Cautionary Verses*, Eliot's *Practical Cats*, Mervyn Peake's *A Book of Nonsense*—are all threaded with ingenuousness even as they are full of universal and timeless complexities.

Serious literary biography and mere printed gossip can have a shared focus. "Simple" content and "complex" intention also present themselves as sophisticated merchandise, in anthologies with titles like *The Naked Emperor* and *A Treasury of Ribaldry*. From outside the literary world looking in, such shared focus and ignored exclusivity come to seem quite similar. Thus, Kornei Chukovsky's career is a cultural rapprochement on such a double count; he has translated Shakespeare, Swift, and Chesterton into Russian, and, as a child psychologist, he has defined "topsy-turvies" and "doodles" (*pereviortyshi* and *zakaliaka*) as equally relevant to childish humanity and to international literary traditions, including Nonsense Verse.[10] Chukovsky's own children's verse was first entitled *Krokodil* in 1916. One aesthetic inclination is to disesteem children's literature as such—and perhaps satire too—insofar as its scenarios are not so much verbal as visual. Still, some of the entertainments of childish humanity, even in their "cleaned up" versions, go far beyond the mere uses of enchantment and have a continuing fascination even for sophisticates, just as "Jesus jokes" lend themselves to intricate and interdisciplinary study.[11] Friedrich Dürrenmatt tackles abstruse theological premises with irreverent simplicity, employs a "dialectic approach to ideas and art," describes his dramas as

*verschlüsselt,* and implies that his personae are merely "constructs," small riddles easily solved.[12]

It is often on this pejorative basis that satire can be described as no literary genre at all. Satiric personae are frequently and accurately called "two-dimensional" or merely "flat," with the implication that they are inferior inhabitants of at best a disreputable or mixed genre.

There are, however, shared significant generic qualities in visual and verbal art alike, whatever their historical and national origins, whatever their "size" or length or presumed esteem. These qualities are easily if not entirely perceived as character traits in satire's personae, ambivalences that may sometimes be merely apparent and fantastic but also sometimes real and sophisticated. Such personae include, for example, not only Busch's and Dürrenmatt's matched pairs but also Tom Stoppard's—Boots and Moon, Rosencranz and Guildenstern, and, in *Jumpers* especially, Archie Jumper and George Moore. They are satiric personae in children's books and adult dramas, in ancient culture and modern novels. Flann O'Brien's *At Swim-two-birds* puts this case insistently, signaled in its title and explicit in its Greek epigraph, perhaps from Euripides, that everything is understood reciprocally (in two ways). *At-Swim-two-birds,* the story of the lives of two Irish orphans at the turn of the century, is written in the first person by a student/narrator, a sort of spoof Daedalus, and concerns one Trellis, who is himself a novelist. It is a novel about the metamorphosis of a man into a bird, a woman into a kangaroo, and so on; it is also a satire, a profuse demonstration of the joys of Joycean trivia and the Daedalean solemnity of mythology.

Satiric personae can be said to transcend—not to say exclude—clearly apparent simplicity that Knox, as we have seen, identifies as merely humorous, rather than satiric, "hearty guffaws which are dismally and eternally provoked." Just as anthropologists see in primitive tribes the unveneered complications of civilized societies—Bronislaw Malinowski says something like this—it is possible that a definition of literary satires is made clearer by a close look at their simpler shapes. This is partly to say that the value of satire has little to do with its topicality, which everyone knows. It seems an additional and crucial fact that the value of satire is not in the first instance literary.

The flotsam and jetsam of satire provide little religious sense or even oceanic feeling.[13] In those hours when I have been a beachcomber rather than an aeronaut, I have gathered some water-logged satire rather than the high-flying kind. Bits and pieces wash up on the reduced-price tables in the bookstores of several continents. The world is no doubt a better place for the disappearance of most of it from the face of the earth, forever lost but neither missed nor mourned. Dryden refers

briefly to "*ex tempore* doggrel" among even the first Roman satirical poets, and I suspect it has always been around. Much of it is pictorial rather than verbal, intercontinentally collected and re-collected from *The New Yorker*, *Punch*, *Canard enchaîné*, *Pardon*, and *Krokodil*. Some anthologies have a relentlessly religious bent: *Children's Letters to God*, *The Church Bizarre*, *Der klericale Witz* (not the same collection as *The Wit of the Church*), *The Official Religious/Not So Religious Joke Book* (parading itself as "2 Books in One"), *Reiseführer in den Himmel*, *The Reverend Mr. Punch*, and *Witze unter der Kanzel*. If such things are not art, they are surely an industry. Jestbooks "beginning with Caxton and extending almost to the Regency" have modern rebirths deserving of some, if not very much, critical acclaim; and what Ellen Douglas Leyburn has called "superficial modes of writing" and "surface mockery" no doubt seem at least primarily outside the range of literary study.[14] Still, such modes and mockery have had a persistent endurance, if also a life that can be called superficial and unliterary.

Satiric qualities merge like sea and sky, though sometimes the mind's eye sees only a generic mirage. This can happen even when satires bear the mark of single authorship and literary intention. *Satire and Salvation*, for example, makes a double generic promise implicit in its title and explicit in the jacket blurb; it is alleged to be "a rare balance between the satirical and a true compassion," but the poems disappoint on both counts and they do not communicate the author's expressed indebtedness to Walter de la Mare.[15] It remains nonetheless a fact that some small things are unmistakably good, ranging from technocratic to theological, embodying a literary tradition larger than their size, whimsical shape, or national origin. Piet Hein's "grooks," short, modern aphoristic verses in the tradition of Old Nordic Hávamál poetry, were first published in this country by the MIT Press. Theologians write polished collections of conventional prose and goliardic verses.[16] Some religious satire wants to define itself by virtue of its *large* size, long life, and international metamorphosis. Sebastian Brant's *Das Narrenschiff* spans centuries and oceans to become Katherine Anne Porter's *Ship of Fools*; these are comparable rather than contrasting things precisely for their subject matter. Goethe's renowned satires—to say nothing of his epic—have their origins in puppetshows and other folk traditions.[17] Pushkin's Annunciation mock-epic, *The Gabriliad*, finds its transatlantic, translated, and illustrated reception in *Playboy* magazine.[18] Mark Twain's satires are given the full regalia of university publication and solemn criticism in this country, but are published also in tatters, here and elsewhere, dressed down in the quaintly leafed and cartooned persons of Adam and Eve, and made to look like children's books.[19] Satire can be visual or verbal, even minimally art or minimally

literary, in its form. Nonetheless, satire's content can also draw important liturgical and secular connections. High Church and low art are not always exclusive of each other, in either their aspirations or their achievements.

Of course, the content analysis of satire is no simple thing, even when it avoids particularities of chronology and nationality. Even the explanation of standard English parodies and the selection of the simplest English jokes, for foreign consumption, require painstaking effort.[20] J. B. Priestley in *English Humour* is, as he says, "sternly nationalistic" about specifically English *writers*, in fifteen chapters. Then, in a concluding chapter on contrasting blue-tinted paper, he relegates English *artists*—mostly Hogarth, Gillray, Rowlandson, and their tradition—to what looks like a discrete appendix. Thus, unlike Knox, Priestley identifies national differences in humor and traces humor's verbal and visual delineations.[21] Still, such differences in practice seem more asserted than demonstrated in theory, even when nationality is played down, and are even made to seem of little importance, like the nature of satire itself. R. H. Blyth, the renowned English translator of Far Eastern poetry, in *Oriental Humour* pretty much divorces theory from practice. His working definition of satire is a one-liner: "Satire is one half of humour, the cruel half." He does not say what the other half is. His running commentaries are description rather than explanation. He concludes with a half-page "Epilogue" that stands in stark contrast to his 582 pages of verbal translation of reproduced calligraphy with accompanying oriental paintings; this epilogue seems merely affixed, like a postage stamp on a carload of freight.[22] Still, Blyth's aesthetic perception of world views is as vast and detailed as Toynbee's. In his earlier and smaller anthology, *Senryu: Japanese Satirical Verses*, Blyth made seventeen careful distinctions, describing senryu as a subspecies of haiku, and, again like Toynbee, suggested numerous Yin-Yang contrasts in relation to occidental internal-external emphases.[23]

If it is true that "satire knows not whether it prefers a substantival or adjectival existence,"[24] there may be some rustic theoretical sense in calling anything that is satiric a satire, apart from nice rhetorical distinctions about audience appeal or the uses of literacy, or apart from poetic considerations about the quality of artistic performance. Certainly, literary traditions, like political boundaries, are always changing, and there is a continuous rather than a contiguous sense of history repeating itself in religious satire. This is to say that—independent of the limits of time and place, independent of considerations of academic respectability—satire often bridges the distance between high art and low amusement in ways that are easier to perceive than to define.

Whether or not tentative or spurious, satire clearly can be seen to travel outside the geographically cultural boundaries of history and aesthetics.

This violation of spatial and temporal limits may be more true of satire than of any other genre. The cultural dualities identified by Schiller precede him. For example, in *The Curious Perspective: Literature and Pictorial Wit*, Ernest B. Gilman takes his concluding idioms from Sir Thomas Browne. Gilman remarks on the significance of "spatial ambiguities" and "duplicitous images," and on the talent of Browne as a "witty artist" who is able "to approximate the unity of the divine mind." Gilman seems not only to describe but to admire that perspective, whose "effect was to parody, question, and even undermine the central cognitive assumption behind perspective representation"; in other words, Renaissance literature *combined* the dual—literary and pictorial, verbal and visual—perspectives in art.[25] These dualities in wit, parody, and divinity are certainly a characteristic function of religious satire in the Renaissance and neoclassic traditions. As Rosalie L. Colie has shown, the literary problems of genre study have had a long life: "a rigid system of genres . . . never existed in practice and barely even in theory."[26] The basis of mixed *kinds* is more representative of the Renaissance than is the single genre. More than two hundred years ago, certainly, in English satire's Augustan heyday, critical opinions about it were multiform and an overview is bound to make those opinions seem haphazard. For example, P. K. Elkin begins and ends *The Augustan Defence of Satire* with the observation that though there was a considerable body of theoretical opinion on the nature and function of satire in the eighteenth century, it is a fact that criticism of the genre was rarely conducted at a high theoretical level, too much being claimed for satire, or too little; it was "too anxious to prescribe limits, whether of form, style, or subject matter, and to push satire into one or another of a set of exclusive and opposed categories—Roman and Greek, Horatian and Juvenalian, 'smiling' and 'savage.' "[27]

It is precisely such sets of exclusive and opposed categories that Robert Bernard Martin traces in his study of Victorian comic theory: superiority and incongruity as the sources of comedy; the opposition of wit and humor; comparison and contrast as opposing explanations of wit; the conflicting claims of imagination and fancy. Martin's stated intention is not to discuss the connections between criticism and creation, theory and practice, in Victorian literature, yet what he calls the contrast between "amiable, sentimental humour" in comic theory of the early nineteenth century and the later "intellectual, paradoxical wit" in the art of Shaw and Samuel Butler is perhaps itself a function of a split way of perceiving it. For example, Martin's "wit and humor"

regarding Victorian literature in point of time are precisely the terms
Paul Barolsky employs in his overview of Italian Renaissance paint-
ing.[28] Such theoretical dualities may perhaps be seen to occur in tan-
dem rather than as opposites, in the sense that Gilman approximates
the juncture of wit and parody in divine mind. They do not comprise
what Colie would call a rigid system, since they are not precisely verbal
as opposed to visual, nor contained within national boundaries nor
chronological eras.

Even with explicit and delimited emphasis on subject matter, on
*religious* satire, what can result is not necessarily greater precision but
rather the mere awareness of ever greater circumferences and impene-
trable passages. Criticism of religious satire, or even the mere
identification of it, can become lost somewhere in the peripheries of
literary history and the borderlands of theology. Well-known rubrics
sometimes suggest that prehistory and infinitude are uncertain guides
that are perilous to ignore. René Wellek and Austin Warren theorize
that "religious myth is the large-scale authorization of [all] poetic
metaphor."[29] William K. Wimsatt, Jr. and Cleanth Brooks conclude their
history of literary criticism with an ambivalence they trace in it, main-
taining on the one hand that "though they have not been concerned to
implicate literary theory with any kind of religious doctrine," they do
nonetheless "confess an opinion that the kind of literary theory which
seems to us to emerge the most plausibly from the long history of the
debates is . . . precisely within the vision of suffering, the optimism, the
mystery which are embraced in the religious dogma of the Incarna-
tion."[30] J.A.K. Thomson represents the more restrictive but no less com-
monplace view that it is drama specifically among the traditional
genres which "begins in religion"; that it is uniquely four Roman poets
who write "the kind of satire which has influenced the history of litera-
ture"; and that "prose satire was hardly a distinct genre" either in Greek
or Latin.[31] Matthew Hodgart—not indefinite either, but with a farther
ranging eye—perceives that "the perennial topic of satire is the human
condition itself,"[32] which may not be so much inaccurate as implicit in
other genres, and explicit in the novels of Balzac and Malraux.

Schiller's antitheses discussed in my introduction are "built into"
religious satirists and their art. They are visible manifestations of invis-
ible perceptions at once finite and abstract, corporeal and ineffable,
from antiquity to modern times, as Schiller says. However, contrary to
Schiller, generic meaning is "built into" the content of satire in the
visual and verbal way that satiric intention reveals itself in the architec-
ture of some English cathedrals: the angels climbing up and down
ladders on Bath's facade; the roof bosses of Gluttony, Lying, and the
Devil swallowing Judas Iscariot in Southwark; the Bishop's Jester, and

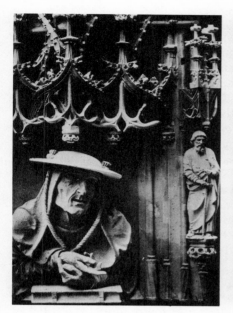

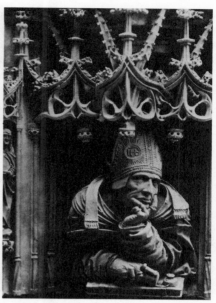

the
gargoyle
as satire

the toothache and thorn-in-foot capitals in Wells; the famous Imp of Lincoln; in more recent times, Epstein's *Ecce Homo* standing in the Coventry ruins; the *reductio* of individual esteem conveyed by the heaping juxtaposition of tombs and memorials in Westminister Abbey; the hyperbolic but nonetheless muted aggrandizement of imperial reputations in St. Paul's statuary. Church art or artifacts in central Europe no less suggest these long-lived values: the diarrhetic Wasser-speier, and the ragtag cherubim celebrating the Marienkrönung in Freiburg; the great cathedral at Cologne, since World War II discovered to be on the site of a Dionysian mosaic rampant with satyrs, thousands of years old; Prague's Týn Church, with its whimsically proportioned spires rising from the periphery of the Old Town Square, late Gothic and Baroque no doubt, but looking also like some supernal fantasy. The bust reliefs of Jerome and Augustine carved into the pulpit of St. Stephen's Cathedral in Vienna surely are whimsical. The whole "hidden world of misericords," and such other cathedral artworks, continually if not insistently suggest the disparities of high purpose and mundane existence.[33] Similar examples of that antithetical tradition, in artworks too numerous to count, would include Mantegna's *San Zeno Triptych*; Pieter Bruegel's *Battle between Fasching and Lent* and his *Fall of the Rebel Angels*; Cranach the Elder's *Crucifixion*; Ensor's small etchings and huge oil of *The Entry of Christ into Brussels*; Egger-Lienz's *Christi Auferstehung*; all the paintings of *Christ Mocked by the Soldiers*, over the centuries, from Bosch to Rouault; Picasso's *Crucifixion* painting, and his numerous, smaller India ink sketches for a *Crucifixion, after Grünewald*. The way satire is "built into" such visual art has an ambivalent bearing in specifically verbal contexts.

No doubt the notion of subject matter "built into" satiric art is elusive for both geographic and historical reasons. To a foreign visitor, in space and time, serious things must sometimes seem funny, even when they are not, and vice versa. Thus, for example, the Magdalenklause at Nymphenburg and Mad Ludwig's Throne Hall at Neuschwanstein (which, like the Magdalenklause, Max Emmanuel's artificial hermitage, also has a fake grotto) are surely architectural exercises in reduction and hyperbole, and can be taken for the contrasting styles of much religious satire, though they are just as surely not intended to be religious jokes. Similarly, Sir John Soane's Museum in London, which holds Hogarth's *The Rake's Progress* and *The Election*, is also famous for its Monk's Yard and Parlour: "It is difficult to be sure whether this macabre part of the house was intended by some to be taken altogether seriously—in his *Description* the architect seems to have his tongue somewhere in his cheek. . . . Nevertheless, it is of serious interest spatially." It is not always easy to determine whether the constructs of religious satire are

serious or tongue in cheek or both, in the same way that cemetery art
elicits nervous amusement, sometimes, over monumental expressions
of unquestionable grief, too heavy for graveyard images "sliding into
theater and, below theater, to the *tableau vivant* or the charade."[34]

Claes Oldenberg's sculptures—*Soft Typewriter, Drainpipe/Crucifix,*
and *Bedroom Ensemble*—are complexly antithetical in theory even
while they look simplistic in practice. Just as Piet Hein's little "grooks"
seem not to suffer by being translated, Oldenberg's *Proposals for Monu-
ments and Buildings* situates massive civic sculptures in transatlantic
locations. They both have values that are extraterritorial and extraliter-
ary. Thus, Oldenberg's art too is international rather than Scandina-
vian, commonplace in its diachronic intention: "All my thought
circulates about opposites; satirical-mystical (worldly-unworldly)," he
notes. "People I disapprove of are those who, whoever they are, are not
innocent, intense, in it. Who have had their intensity or innocence
educated out of them and so reduced all to some hand-label *in their
minds*."[35] Oldenberg has created an art based on polarities that "con-
stantly evoke and equate with each other": hard and soft, erect and
relaxed, formal and informal, organic and geometric, timeless and con-
temporary. They are "dual and seemingly contradictory metaphors for
both the human body and the natural landscape." Oldenberg's biog-
rapher says that satire is the single category that can be said to encom-
pass the vast territory of his imagination, in the sense that "although
satire is primarily a literary genre, there is also a long tradition of satire
in the visual arts." Theory and practice in literary satire are similar to
satire in the visual arts precisely in the "mixture of satirical content and
advanced formal means." It is not just the changes in scale of form but
of content too that, as Oldenberg says, "occur in children's tales and the
literature of satire," and thus provide unique glimpses of "reality
through the haze." Oldenberg's sculptures are not juvenile humor, in
Knox's sense, nor are they created as period pieces. He defines satire in
a poetic as well as a plastic art form, especially in its content rendered
in apparently and perceivably "simple" configurations. He complicates
one's awareness of satire's categorical dualities *as* indiscrete, and
sometimes indiscreet.

This ambivalence in the visual arts and in art criticism is unabated,
of course, just as it is in literature and in literary criticism, especially in
the context of religious satire. The Ensor exhibition of over one hun-
dred pieces in Chicago and New York, especially Ensor's keen rework-
ings of grotesqueries in earlier Belgian painters—Bosch, the Bruegels,
and Rops—becomes for some critics a puzzlement over "the twin im-
pulses toward beauty and, for him, stronger inclination toward night-
mare visions," becomes reason to worry not over Ensor's art but his

"personal demons" and obsessive themes, or his mere anticipation of or sharing in a collective "Expressionist attitude," or his artistic and intellectual motives: "But when trying to impart lessons, what a poseur Ensor was! Every Christ he painted is trivialized by his narcissistic equation of the suffering God and the rejected artist." Ensor's appeal for numerous lovers of art has no more to do with painting than the even greater appeal of Scythian gold treasures and King Tut's tomb can be explained as a popular fascination with archeology. Yet, of course, in visual art as in literature, art's creation is also a challenging act of criticism, as with Francis Bacon, the modern painter, who "like Pound and Eliot seems to have an almost clairvoyant sense of his own situation as an artist in relation to surrounding art"; who perceives modern man as "both damned and heroic"; who "combines eloquent courtesy with the capacity to be deeply scathing"; for whom "the creative and the critical become a single act"; and whose art overall can incorporate traditional myths without their being believed: "Bacon rejects altogether the idea that a religious interpretation can be placed on his pictures of the Crucifixion or of the Pope. . . . He paints a world without religion or God."[36] It is not exclusively in *literary* satire that the relation of art and neurosis, of artist as unintentional poseur rather than deliberate craftsman, of intentional and affective fallacies, is debated.

Unending disputation extends beyond—even as it combines—literature and visual art and has its own monuments. Its architecture would have to include Piet Hein's "poem in reinforced concrete," the modern and imposing city-center in Stockholm. Its design, described as a "super-ellipse," is intended to mediate between two conflicting tendencies of structural forms, rectangular and round, in the architecture of modern civilization. Similarly, among Hein's aphoristic lyrics, the whimsical "grooks" that delight technocrats and humanists alike, this one particularly represents his prolific—and I would say satiric—attempt at aesthetic duality:

> THE ETERNAL TWINS
> Taking fun
>   as simply fun
> and earnestness
>   in earnest
> shows how thoroughly
>   thou none
> of the two
>   discernest.[37]

The simple illustration on the same page is the frontispiece for the entire volume as well as the colophon gracing the endpapers, and consists of Greek tragic and comic masks whose features are rendered in

anthropological and mathematical lines. Ordinarily—and even in *Satire Newsletter*'s amusing colophon through the decade of its publication—Greek masks for comedy and tragedy are stylized and discrete, highly contrasting expressions of grief and joy. Hein's twins, however, are Siamese, conjoined elliptic faces whose smile-frown is a single and continuous parabolic curve. The abstractive yet almond-shaped eyes of the eternal twins's left or tragic face sag downward, like its mouth, at the corners. The middle eye (there are only three) is shared by both faces, mollifying their contiguity. The eyes on the right, or comic, face then appear to pinch down at the bridge, suggesting not so much an oriental and happy expression as an ambivalent Yin-Yang one.

Such content analysis of satire as this visual rather than verbal instance, especially since it seems to avoid the literary difficulties of chronology and nationality, does have its uses and attractions. Even so, one must acknowledge that numerous difficulties remain and cannot be skirted.

There is a five-column "tabular statement" in Fowler's *Modern English Usage* that enjoys perpetuity through most of this century on both sides of the Atlantic. One reads "humor" for "humour" in Nicholson's *American-English Usage* based on Fowler, but the chart is unchanged.[38]

| | MOTIVE or AIM | PROVINCE | METHOD or MEANS | AUDIENCE |
|---|---|---|---|---|
| humour | Discovery | Human nature | Observation | The sympathetic |
| wit | Throwing light | Words & ideas | Surprise | The intelligent |
| satire | Amendment | Morals & manners | Accentuation | The self-satisfied |
| sarcasm | Inflicting pain | Faults & foibles | Inversion | Victim & bystander |
| invective | Discredit | Misconduct | Direct statement | The public |
| irony | Exclusiveness | Statement of facts | Mystification | An inner circle |
| cynicism | Self-justification | Morals | Exposure of nakedness | The respectable |
| The sardonic | Self-relief | Adversity | Pessimism | Self |

This has the appearance of scientific, theoretical validity, the vertical or *y* axis and the horizontal or *x* axis suggesting both differentiation and scaled relationships of Lasswellian analysis. However, insofar as all the categories are demonstrably interchangeable, they have no apparent order, or use. It might be argued that satire has as its MOTIVE, say, Self-relief rather than Amendment, Faults & foibles as its PROVINCE, Observation as its METHOD, and The public as its AUDIENCE, and so on. This would mean, according to the terms of Fowler's table, that satire is partly and at once sardonic, sarcastic, humorous, and invective. Further, it is conceivable that the columnar terms are misplaced as given: might not surprise and mystification be motives, or conversely,

amendment and exclusiveness be methods? There would seem to be thus no reason or obligation to accept as predetermined the selections from columns A, B, C, and D. Since almost any term can be moved to any column with no impairment or improvement in definition, one surely must question the use of this particular chart as "Indispensable Information on How to Use the Right Word in the Right Way," which the blurb on the paperback edition of Nicholson promises. It may be that the problem of generic definition is like the even more universal problem of pain, one which suggests, C. S. Lewis says, a "Doctrine of Total Depravity," a function of that human weakness which reveals itself in the illusion that all is well, that what we have, whether good or bad in itself, is our own and is enough for us, and that our inclinations correspond exactly with our duties.[39] It is a fact that scholarly choirs do not offer up a working definition of satire—to say nothing of religion—and there can be said to be neither one voice nor harmony.

The varieties of theory of satire and the varieties of kinds of satire result from the indeterminate focus on five variables. Satirists, their subject matter, their genre, and their own motives and readers' reactions, provide multiple focuses. It is a fact that literary scholarship provides no single clear vision in the misty and opaque landscape of literary theory. Satire in this respect may be precisely like all the other kinds in genre study. Thus, for example, Christian Dietrich Grabbe's *Jest, Satire, Irony and Deeper Significance: A Comedy in Three Acts* (beginning even with its title page) is a cogent example of unwieldly scholarly problems, as satire and in commentary on it. Maurice Edwards, who translated Grabbe's play, perpetuates etymological confusion and anachronistic literary impressions that not only derive from this play but are also endemic to the study of literary genres. A further question of intention (but not far removed from the question of definition) is whether Grabbe was, as a satirist, a formal artist or a nihilistic iconoclast, or neither, or both. *Does* a reading of the play reveal that "obviously nothing was sacred to Grabbe"? Edwards says that "this rough gem of a comedy" is more explicitly a satyr-play, one of the oldest kinds of drama; that it at once "skillfully satirized" Grabbe's own Leipzig and Berlin; that it is "modern in feeling, so brilliant a forerunner of the avant-garde theater of our time"; and that "*Jest*, for all its originality, had features in common with the literary satire of the period." Grabbe's Satan, like Milton's persona, is variously perceived and described but also variously explained and appreciated. *Jest* might not seem to have, even for an attentive reader, any consistent rationale. It has, Edwards argues, impressive affinities with tragedy and yet simple similarities to ridicule also, and can be described as a "charming soufflé" albeit with "deeper significance." Thus: "We see why it was

necessary to bring the Devil, a creature from another world, into the play—simply to lend credence to our 'bifocal' view of the world." Edwards says that "it is the extraordinary fusion of the puppet/grotesque with the realistic/representational that gives *Jest* its great individuality."[40] I maintain that such "bifocal fusion" is characteristic of the genre as a whole.

In this first chapter I am trying to render some semblance of order, attempting to draw connections between theory and practice without too much simplification, to yoke without too much violence some divergencies in them both. I conclude here with what seems to me the graphic disagreement of Arthur Calder-Marshall with George Orwell, regarding the captioned cartoons of Donald McGill, whom they both acknowledge to be the twentieth-century "King of Postcards." Some simple facts about McGill's humble seaside humor are undisputed by them. Calder-Marshall allows that "Orwell's essay was historically important because it was the first recognition that in popular art were hidden attitudes of social and psychological significance."[41] It is the attitudes and not the art that Calder-Marshall focuses on; the attitudes and the art *both* are to him quantitatively rather than qualitatively important. He observes that the comic picture postcard industry flourished before McGill's participation in it; he perceives McGill's significance to be that his cards were printed across the Channel and the Atlantic, and not that the postcard was sometimes "recognized as an art-form." Calder-Marshall argues for "simpler truths" than Orwell is able to perceive, but for Orwell such simplicity does not make the truths less important. Orwell's essay is itself not very complicated or lengthy. He defines the genre "very 'low' humor" simply as that kind which has no artistic pretensions, giving the immediate impressions of vulgarity and an "indefinable familiarity" that derive from the perception of "something as traditional as Greek tragedy, a sort of sub-world of smacked bottoms and scrawny mothers-in-law which is a part of Western consciousness." What Orwell sees is the genre's relentless, unrepressible, and immemorial existence.[42] What is most apparent to Calder-Marshall is the flourishing contemporaneous volume of McGill's art. Orwell may seem to make overly neat distinctions between what is stale and smutty in McGill's art, over against what is witty and humorous, what is obscene or immoral. No doubt Orwell can make hyperbolic generalities too, which seem too much to transcend time and place. My point is that for Orwell as practitioner, as the writer of *Animal Farm* and *1984*, such theoretical apartheid is negligible:

> The Don Quixote-Sancho Panza combination, which of course is simply the ancient dualism of body and soul in fiction form, recurs more frequently in the literature of the last hundred years than can be explained

by mere imitation. It comes up again and again, in endless variations, Bouvard and Pécuchet, Jeeves and Wooster, Bloom and Dedalus, Holmes and Watson. . . . The two principles, noble folly and base wisdom, exist side by side in nearly every human being, . . . the voice of the belly protesting against the soul.

*Orwell?*

Theoretical perspectives here would seem to violate usual aesthetic practice—namely, customary artistic differentiations that Calder-Marshall employs. I understand Orwell to be saying something important to an understanding of satire in particular. Just the above excerpt from Orwell's essay yields the following theoretical principles: 1) There is something like a combination-dualism in literature and life that is real as well as imaginary. 2) Its representations occur often in modern literature, but they are immemorial, apart from or prior to verbal expression. 3) The essential and verbal forms of antithesis and oxymoron have their equivalent in existential and corporeal substance. 4) These can be perceived as complementary *or* antagonistic in whatever culture they occur and in whatever literary personae represent them. 5) Literature may be definable as an alternative to reality—art *as* fantasy, or escape, or enchantment, *as* fiction over against nonfiction— but even in its least considerable shapes it is never *only* that. 6) To the extent that "two principles" do exist in and for nearly everybody, the clash between the two cultures of fiction and nonfiction is unnecessary or avoidable.

All of these theories explicated from Orwell are relevant to my twofold argument about satire. It is these *kinds* of Orwellian ambivalence—real-imaginary, ancient-modern, verbal-corporeal, simple-complex, particular-universal, comparative-contrasting—which account for satire's generic nature as hodgepodge; and they inevitably lead to satire's mixed esteem. They are also less tidy than Schiller's pairings. This is also to say that the scope of religious satire is apparently or at least visually random; its varieties are an unnumbered "possible species"; its subject matter is surely multiform, definable as a "mode of perception" in human minds relentlessly and minutely different from one another. *Hodgepodge* (*satura lanx* in antiquity) is a prolific variety, hardy and commonplace, and is best understood as having nonauthorial and nonliterary, or perhaps preliterary, origins. *Tragisatire* is a long-lived genre, too, historically and prolifically eminent, and I give it its own moniker. *Orthodox* satire can be said to preclude religious vocation, being more a specific manifestation of literary talent than an occupationally vested interest. *Apostate* satire has nothing to do, exactly, with heresy, but rather it suggests that revolution and reformation are the concern even of satirists who are clearly "nonbelievers." *Unintentional* satire derives from a large number of emergent occasions

from both external objects and human minds that seem to have sketched out silhouettes, sometimes, rather than complete works of art. Either way, it is identifiable as a verbal performance unconnected with an author's public motive or mystical predisposition.

# 2

# Jerome and Erasmus
# in Renaissance Art

In a religious simile, perhaps even a satiric one, Saint Paul suggests that the mind's eye is always at work: Now we see as through a glass darkly (1 Cor. 13:12). One recurring metaphor for satire throughout its long history suggests that it is a house of mirrors, insofar as distortions or even grotesque reflections are built into it. They appear long before Chaucer and Langland in Britain, for example, and in goliardic verses and in the Carmina Burana on the continent. Gerald of Wales's *De invectionibus*, *Speculum duorum*, and *Speculum ecclesiae* bear titles explicitly identifying his satiric tone and mirrored intention. Gerald quotes and imitates Jerome extensively, even as clearly as he records his failure to become bishop or to achieve from Canterbury independence for St. David's. Satire's mirrors include not only Gerald's but many others' as well: Gascoigne's steel glass; Shakespeare's satirical rogue's mirror, held as 'twere up to nature; Swift's sort of glass, wherein beholders do generally discover everybody's face but their own; and Pope's impartial glass.[1] No doubt distortions were bound to occur and appear in both religion and satire from the very beginning. Satire has always been a mirror for reprobates as well as for magistrates.

Questions and answers about satire are catechetical in the way ecclesiastic preferment seems not to require literary skill. They are mere contrapuntal, discursive reflections of one another, and the images of satire necessarily recur in statements about it. Despite Schiller's aesthetic sense of how artists and their art reflect and reflect on one another, and James's connections between the psychology and sociology of religious experience, many questions do not yet have answers in the literary history and theory of religious satire.

Is there, or can there be, a psychology concurrent with holy orders and literary talent? It is neither necessary nor sufficient that a priest, in the performance of his sacramental and liturgical duties, be a secular humanist. Even ordinary observation from daily life reveals that men of the cloth are seldom also men of letters. Religious vocation does not require literary talent or even correct grammar. The New Testament gives a lot of evidence that great learning is not a prerequisite for the disciples or the apostles of Christ, and there are numerous nontheological and modern "proofs" supporting this viewpoint. Priestly vocation aside, in Jerome and Erasmus—men so different in time and place, temperament, and thought—how is it possible they can regard religion as a subject for ridicule? One reason is that both of them are part of a tradition in which the affinity between religion and ironic humor appears in many artistic shapes, not only in literature but in painting and sculpture since the Renaissance.

Do not all religious authors have an identity in their secular society, in its ecclesiastic patterns of culture and the manner in which its worldly powers are distributed and exercised? Are not their literary statements a verbal manner in which they explore their religious beliefs? To persist in looking at the abuses of religion rather than the beauty in it and, more particularly, to risk the provocation of further abuses by calling attention to them, are counted among the characteristic acts of saints and martyrs. No doubt such authors can be regarded as heretical, unreligious, or antireligious. However, is it not too easy to say that their readers are innocent of the burdens of literary sensitivity, as well as of sainthood and martyrdom? In whatever century, the problem of distinguishing between religion and its abuses is never easy, and the sense of importance attached to doing so is not new. Just to tackle the problem, not necessarily to find its solution, requires talent and presumption. Both the reading and writing of religious texts—devotional or apologetic or satiric—require first of all not the accident of revelation, nor the aegis of ecclesiastic sanction, but raw verbal skill and an inclination to exercise it, in a cause at once theological and literary in its definition.

Such questions as these concern the talent and temperament of satirists, of religious satirists and their art. Many biographies and portraits of Jerome and Erasmus suggest a perennial and immemorial literary quandary: a satirist cannot be explicitly religious and implicitly aesthetic at the same time. Thus, even after four and a half centuries of explication, Erasmus' *Praise of Folly* continues to be defended against the relentless "feeling that the two sides of the work, the medieval satire of estates and the Renaissance paradox, have not quite coa-

lesced." Erasmus is seen to have had a dual purpose, his annotating theological passages at odds with his humanistic interest. Coinciding with these quasi-antagonisms, there are two generally acknowledged traditions of Erasmus interpretation; one has made Erasmus into the seeming pioneer of modern religion, and the other into a not very theological antiquarian. Erasmus' life and works are found to have "derogatory aspects," "moral ambiguity," and a "kind of Hegelian pattern." One may even still read that, though "many historians have heaped praise and saintliness upon Erasmus, the 'Prince of Humanism,'" his antisemitism, illegitimacy, total abstinence from physical contact with women, latent homosexuality—all of these things— provoked a "far-out, if not far-fetched theology."[2]

Craig R. Thompson has had to reaffirm over the years that today's readers of the *Colloquies* must be wary of the ways in which Erasmus did write a simple and learned book; that easy contrasts between Christian and humanist intentions, between Renaissance and Reformation, are more conventional than useful in reading him; that many of the colloquies "show us both sides of the picture—his feelings about religion as contrasted with superstition and the plain talk his critics mistook for 'Lutheranism'." And other scholars too have stressed Erasmus' traditional scholarship and scriptural, not to say conventional, piety.[3]

There have always been good priests who have small Latin and less Greek, as well as good satirists who have little theology. Of course, there can be no doubt at all that "for those thousand years between the fall of Rome in the fifth century and the early Renaissance in the 15th, our spiritual strength and survival was a matter of cowls and cloisters," and that "from today's vantage point, it seems that the entire life of the monastery—especially as seen in the Plan of St. Gall—conspired to serve the mind." More particularly, however, there can be little doubt that *The Rule of Saint Benedict* weighed heavily against the aesthetics of humor and satire, with frequent admonitions: to suffer patiently, not to speak ill but to speak well of everyone, to guard one's lips from uttering evil or wicked words. "But as to coarse, idle words, or such as move to laughter, we utterly condemn and ban them in all places. We do not allow any disciple to give mouth to them."[4] Still, it is possible to say that one of Saint Augustine's greatest services to the church was his effective theological defense of sacramental and liturgical duties against articulate Arians, Manicheans, Donatists, and Pelagians. Saint Benedict's alarm is no doubt beneficent, but it does have its obverse side. Church history from the very beginning has been accompanied by a succession of heresies, definable as sects, sins, or crimes. Certainly by the fourth and fifth centuries the opportunity or necessity for ridicule

was very widespread indeed. In the history of intellectual as well as spiritual battle, the forces of light were always numerically small, and the forces of darkness misidentify themselves.

This "original" binary opposition in Christian apologetics is always with us, with numerous analogues in recent religious literary theory, or literary religious theory. Thus, Jean Leclercq, O.S.B., in *The Love of Learning and the Desire for God*, attempts to describe historically "the reconciliation of two elements which seem opposed, but which are to be found in almost all monastic culture. . . . They are, on the one hand, the 'literary' character of monastic writings, on the other, their mystical orientation." Cassiodorus, a contemporary of Saint Benedict, stressed textual accuracy in "secular" as well as "divine" letters; but Dom Leclercq's own sympathies have a representative and understandable clerical emphasis: "St. Benedict's monastery is a school for the service of the Lord, and it is nothing else. . . . No judgment either favorable or unfavorable as to the worth of learning or of the study of letters is to be found in the *Rule* of St. Benedict. The only values stressed are those of eternal life, the only reality upon which unfavorable judgment is passed is sin." Dom Leclercq's main intention, implicit in his title, is to show the modern value of an ancient "twofold treasure," "two tendencies and two attitudes seemingly contradictory, but which were reconciled: the use of the classics and a distrust for them." In a subsection titled *Monastic Humor*, he argues that "a psychological trait for which the monks seem indebted to classical literature is a certain sense of humor," even that "humor is characteristic of the spiritual man." But his concluding *Epilogue: Literature and the Mystical Life* certainly suggests that reconciliation between priesthood and literary art does not come easy:

> The corrective for literature is the experience of God. . . . Self-interest and interest in God or in what one has written about God are mutually exclusive. No one can go off in two directions at the same time. As someone humorously put it, "if one absolutely insists on looking at himself in the mirror, it is altogether useless to kneel at a prie-Dieu." . . . Amid genres and literary conventions, the mystic can be recognized by the extreme simplicity of the means he uses. His style becomes as limpid as his soul is pure. And the more elevated his thought, the less contrived is his expression. . . . Literature, he knows, with all its formalities and necessary laws, is an example of the impotence of our condition, its limitations and of the inadequacy of what we say to represent what gives us our life.[5]

As we have seen, one of the mirrors of humorous reflection is satire, and the mystic's impotence is surely no small part of the human condition Hodgart says is the perennial topic of satire.

What is the intellectual connection between literary genres and the varieties of religious experience? Whether there is such a connection seems never to be settled. The question is part of a relentlessly commonplace chiasma in Renaissance literary study that is variously described as cross-currents or dissociations or oscillations between humanism and Puritanism, which are themselves variously defined. No discussion of Renaissance religious satire can avoid them. H.J.C. Grierson, following Ernst Troeltsch, writes about the conflict between the needs and impulses of nature and Christian *ascesis*, between "religion and the love of amusement." However, the incompatibilities of flesh and spirit in this world are surely not the exclusive character of the Renaissance, or perhaps of any chronological period. Frank Kermode has also grappled with the perennial literary significance of "Carnal and Spiritual Senses." He distinguishes between the verbal institutions of "outsiders" and "insiders" that may or may not have to do with religion. That is, Kermode distinguishes between the "carnal sense" of Gospel readers, to whom simple, literal, comprehensible understanding comes easy, and the "spiritual sense" of institutional interpreters, to whom complex, mystical, latent meanings are known, or at least claimed. Kermode emphasizes that these divergent "senses" apply not only in the New Testament but *also* in pretty simple twentieth-century novels. He argues that the oracular or "psychopomp" preference for spiritual over carnal reading has existed for millennia and still survives in institutions both secular and sacred, among both poets and priests. Walter J. Ong makes much the same argument from the obverse side. Identifying what he calls "both an old theme and a preoccupation and symbol of our time," Father Ong says that all Christians, not just humanists, are outsiders inside of society, that today there is a "new interior-exterior frontier," an "outsider-insider dialectic." He observes that this frontier dialectic is not entirely new, however, but rather is "endemic to the West's understanding of its own culture." Adrien van Kaam, C.S.Sp., argues that "the split between secular and religious learning has its roots deep within the psychological history of the schizoid Western world."[6]

The questions raised in this chapter therefore do not concern religion as against literature in the Renaissance, but rather concern the comparison of visual and verbal artists and art. Thus, Erwin Panofsky, concerned with the *caritas* and *cupiditas* in Renaissance art, writes about the ambivalence of actual and figurative nudity, respectively, as iconographic motifs, and the ways in which "the characters of the Saturnian and the Jovial bear an unmistakable resemblance with what modern psychologists call the 'introvert' and the 'extrovert' type." On the subject of an allegedly and specifically medieval laughter, Otis H.

Green examines the "conflicting forces dating from Heraclitus" in which religion in its "doctrinal parts" is subordinate to the "over-all spirit of fun-making," and the "preacher's art and duty" is much less than his impulse "to realize himself as an artist." This is to say that the preacher's art is not identical with artistic realization, no more than fun-making and duty are the same. "Whoever writes about religion and art comes into contact with two sorts of people: Christians of the most varied stamp, and connoisseurs of art," Gerardus van der Leeuw argues. "Both are rather difficult to get along with." He concludes that the complete unity of religion and art cannot be conceived, that both need to be absolutes, that "religion and art are parallel lines, which intersect at infinity and meet in God."[7] Heraclitean fire in art is at odds with the religious comfort of the Resurrection.

In the National Gallery in London hang some twenty-three oil portraits of Jerome. The Gallery Catalogue lists thirty-three, most of them Italian Renaissance paintings, dating from the fifteenth to the seventeenth century.[8] The Gallery holds no portraits of Erasmus. Sometimes, as in Benozzo Gozzoli's *Virgin and Child*, the saintly portraits of Jerome and Francis merely flank the central figures, each of them subsumed to a religious rather than to an aesthetic purpose. In other instances, as in Catena's or Antonelli da Messina's *St. Jerome in His Study*, the figure of Jerome seems less tended to than the secular and architectural details (there are two of these by Catena, one in London, another in Frankfurt). But always, of course, the implicitly religious depiction suggests reverence and respect. In Parmigianino's *Altarpiece*, for example, the presence of Jerome asleep in the background has led to the erroneous designation, a *Vision of St. Jerome*, despite the prominent theatricality in the foreground of John the Baptist, the large prominence of the Madonna, with a child clearly no longer an infant in her arms, and the lack of historical evidence that Jerome ever had such a vision. Other oil paintings in London, by Cima, Sodoma, and Crespi, spanning centuries of Renaissance art, are representative of numerous other portraits of Jerome worldwide: Cranach's in Berlin, Tiepolo's in Chicago, Van Dyck's in Rotterdam, Veronese's in Washington, D.C., Vienna, and Zurich. They are as excellent as they are various, and yet are uniform in constantly suggesting an uncompromising high purpose, at once aesthetic and religious. Jerome is ubiquitous that way in virtually all the art museums of the Western world. In short, Renaissance art clearly buttresses, if indeed it has not brought about, Jerome's popular literary reputation as the author of the Vulgate, the translator of the Pentateuch, and the early Christian apologist. The great and delicate variety of these portraits of Jerome notwithstanding, one can say that none of them suggests religious parody or humor of any kind. Few

works of visual art—one clear exception is Hieronymus Bosch's *St. Jerome* in Ghent—suggest anything like whimsy or reflect the specific fact that Jerome's satirical *Letters*, with Augustine's *Confessions*, counted among the literary works most appreciated in the Middle Ages and Renaissance.

Erasmus is entirely unrepresented in London's National Gallery, or even next door in the Portrait Gallery, where one may see many less famous temporary residents of England memorialized. Of course, there are and have been national commemorations of Erasmus, like "Erasmus and His English Friends" at the Bodleian and the "Erasmus Exhibition" in the British Museum Library, which marked the quincentenary of his birth in 1469. In addition, there are some eighty *prints* of Erasmus' countenance shelved in the British Museum, Department of Prints and Drawings, in their own portfolio. This is unusual insofar as portfolio collections in the British Museum are arranged not by subject matter but according to artists' name, nationality, and historical period. There is, for example, no collection of prints and drawings of Jerome. Some of the Erasmus prints are exceedingly small, even postage-stamp size, and some show imperfect or indefinite workmanship.[9] Many others, however, are very finely done and preserved, chiefly engravings or woodcuts by Dürer and Holbein the Younger, and copies after these.

In 1514, the year Erasmus completed his edition of Jerome's *Letters*, published in nine volumes two years later, Dürer did an engraving, *St. Jerome in His Study*,. much different from the oil portraitures.[10] The holiness of Jerome is explicit if also uninsistent, his halo being the engraving's focal point, framing Jerome's bald pate, off-center; he is seated ostensibly in a monastery room, which is no bare cubicle, but rather a spacious room, extravagantly cushioned and comfortable. A lion and a little dog in the foreground share with Jerome a conspicuously self-satisfied contentment, as he enjoys himself at his writing desk. "A typically Erasmian room" Kenneth Clark calls it; and it is this unmonastic quality that distinguishes this engraving from the two earlier well-known Dürers, *St. Jerome in the Wilderness* and *St. Jerome by the Pollard Willow*.[11] In these latter, the environmental circumstances are typically austere, and Dürer sketches in no halos to insist on Jerome's sanctity. Flagellation and prayer are, no doubt, more apparently religious than the act of writing. So, in the *Wilderness* Jerome is disheveled, barechested, and is beating himself with the stone in his right hand; the lion at his side is grimacing in constrained ferocity. In the *Willow*, Jerome, seated on a stone ledge at a makeshift reading table, the lion at his feet in uneasy repose, clasps his hands in prayer; and his eyes, though neither closed nor lifted to heaven, strongly suggest the effort of spiritual concentration. *St. Jerome in His Study* particularly

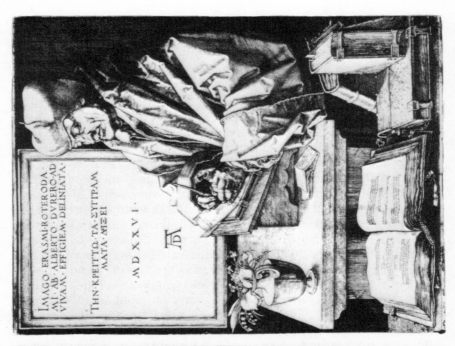

captures the quality of scholarly whimsy, which is not to say, of course, that it contradicts an implicit holiness.

Dürer's *Imago Erasmi Roterdami* is as famous as any of these Jeromes, though not as insightful in its depiction of this kind of dual temperament. Panofsky writes that Dürer "was bound to fail when confronted with the small, quiet, supremely ironical face of Erasmus of Rotterdam," and that "with all his efforts Dürer produced merely an excellent portrait of a cultured, learned and god-fearing humanist; he failed to capture that elusive blend of charm, serenity, ironic wit, complacency and formidable strength that was Erasmus of Rotterdam." The same hesitant appreciation, insofar as Erasmus is shown as merely "cultured" and not ironic, might be made of other portraits of saints and humanists alike, though not without some difficulty.[12]

The most effective and numerous portraits of Erasmus in one location are the three oils in Basle done by Holbein the Younger, and Holbein's famous "Terminus" woodcut portraits and his pen-and-ink drawing of "Erasmus' Device," also in Basle.[13] In the woodcuts, Erasmus' face is the very image of a decorous if also tired civility—wise, tolerant, pacific. The "Terminus" in front of him, however, is the half-body of a satyr, whose face exudes hostile energy and snide rancor; framing them both is an aedicula with decorative figures, whose postures of exhausted ennui compromise the strength of its classic architectural lines. In Holbein's drawing the "Terminus" stands alone—somewhat differently but with comparable ironic effect—under a plain and desolate arch; the head of Erasmus, encircled by a "halo" of anxiety, is looking up to the impending fall of a very heavy timber.

I might suggest, despite arguments to the contrary, that what appears most clearly in the Dürer and Holbein portraits as a temperamental affinity and an intellectual disposition is a cultural commonplace. Jerome's literary purposes have provoked much controversy, from his own lifetime and into the present century, though very little attention, visual or verbal, has been shown to his interplay of devotion and irony.[14] For some readers, an estimate of Jerome's literary talent and religious stature has seemed not so much cognitive as temperamental. Some qualified admiration for Erasmus has similar roots, insofar as the learned intention of ridicule and reform was not, and is not, always appreciated. Father Ong, for example, suggests that the expressed indignation of both Jerome and Erasmus is not a formal, generic intention but rather an occupational hazard for bookish men.[15]

The depictions of Jerome in the National Gallery and Erasmus in the British Museum are as contrasting, of course, as the media of oils and prints themselves, their emphases as different as the two visual genres, even when they are numerously reproduced. Jerome's antiquity, sanc-

titude, and propriety are the more securely preserved on wood or canvas in spectacular colors, in contrast to Erasmus' contemporaneity, secular learning, and academic influence, on fragile and fading paper, in tenuous and fading monochrome. Even so, the similarities in the portraits of Jerome and Erasmus are more important than the apparent contrasts, and in all of Renaissance art they appear most clearly in Dürer and Holbein. No doubt, binary opposition in the reputations of Jerome and Erasmus is older than it is in modern literary theory; their similarities are not pervasive in Renaissance art. One might nonetheless argue that structural dualities are more customary than useful in reading the satires of Jerome and Erasmus, that temperamental and cognitive perspectives are not necessarily exclusive of each other, and that the religious satires of Jerome and Erasmus are generically and not emotively ambivalent.

The incontrovertible meaning of such name-tags as classic, humanist, Renaissance, and Reformation is precisely generic: textual fidelity and formal discrimination for the purpose of intellectual enlightenment. Literary biographies of great clerical men of letters—Jerome, Origen, Erasmus, Luther, Swift—despite the explicitly Christian commitment of these men, or their personal differences and predispositions, are replete with suggestions that their subjects are humanistic harbingers and, therefore, are "dangerous" to the faithful but imperfectly literate multitudes. This is an historical fate shared by such religious laymen as Lucian, Dante, Chaucer, Langland, More, and Pope. Yet, in whatever century, religious writers, clerical and lay, have not only an allegiance to their faith but also a commitment to literary values.

The abuses of religion have been clear to very few; their verbal descriptions have never been appreciated by very many. This would seem to be true not only of church history but of literary history as well. If at this distance in time specific abuses are perforce imperfectly perceived, so too is the ridicule of them. The second-century satirist Lucian is castigated by one of his earliest known biographers, Suidas, a tenth-century Greek encyclopedist, for making fun not only of religious abuses but of religion itself:

> Lucian of Samosata, otherwise known as Lucian the Blasphemer, or the Slanderer, or more accurately, the Atheist, . . . is said to have been torn to pieces by mad dogs, because he had been so rabid against the truth—for in his *Death of Peregrinus* the filthy brute attacks Christianity and blasphemes Christ Himself. So he was adequately punished in this world, and in the next he will inherit eternal fire with Satan.[16]

The religious ridicule in *Peregrinus* seems gentle enough though am-

biguous, and is shown here, for example, in Lucian's reference to Christian belief in immortality, brotherhood, and the value of abstinence:

> The poor wretches have convinced themselves, first and foremost, that they are going to be immortal and live for all time, in consequence of which they despise death and even willingly give themselves into custody, most of them. Furthermore, their first lawgiver persuaded them that they are all brothers of one another after they have transgressed once for all by denying the Greek gods and by worshipping that crucified sophist himself and living under his laws. Therefore they despise all things indiscriminately and consider them common property . . . but then, after Peregrinus had transgressed in some way even against them— he was seen, I think, eating some of the food that is forbidden them— they no longer accepted him.[17]

Of course, this long-lived and important fact of ambiguous gentleness has secular as well as spiritual implications. It is a literary as well as a religious fact that Paul's Letters to the Corinthians suggest numerous connections between ridicule and reform. Paul's pastoral apologetics contain many metaphors of admonition. Then, in the early centuries of the church, when the heathen were enrolled as catechumens during the Mass in the third week in Lent, the Epistle (Exod. 20:12–24) and Gospel (Matt. 15:1–20) were evidently selected to recall the prescriptions of the Ten Commandments and to emphasize those dispositions of loyalty and sincerity with which God's commandments should be observed. According to church history, and entirely believable, the Pharisees had added to the commandments some human traditions, entirely exterior practices, to which they attached greater importance. Jesus Christ himself had to condemn them, and it was evidently necessary for the church to continue guarding against merely outward practice, whether of worship or fasting.

It was the judgment of an eighteenth-century editor that Dryden—at long last—had confuted the charge of Lucian's atheism, and that Lucian's ridicule in the genre of satire would appeal to all "that are Friends to our Constitution in Church and State." Of Lucian's allegedly "rabid" tone, Dryden demurred that "for the most part, he rather laughs like *Horace*, than bites like *Juvenal*. Indeed his Genius was of kin to both; but more nearly related to the former."[18] Still, church authorities of the sixteenth century had placed the *Peregrinus* on the *Index Librorum Prohibitorum*, notwithstanding Lucian's influence on a long and eminent line of clerical men of letters, including Erasmus, who translated him as well as Jerome. But then, Jerome suffered the fate of Lucian in this regard.[19] Satirists and their art—even the church's very own—have always had tenuous ecclesiastic approbation. It is clear that the difficulties involved in perceiving religious truth, and the nature of

its literary defenses, do not lessen with time. If Lucian seems to a modern reader to make no attempt to distinguish the blatant imposter from the true representative of Christian principles; if Lucian was, as he claimed to be, the apostle of free speech and the interpreter of common sense to the rational minority of his day; if he seems to be carried away by personal enmity regarding a vast range of subjects—nonetheless, he cannot on account of these seeming distortions be called antireligious.

Individual temperaments and social influences are no doubt as various in literary history as genres are. Nevertheless, classical learning, the Renaissance, and neoclassicism are definable not only according to literary causes and effects but also in their literary genres, especially satire. Nothing so much as the translations and imitations of Horace, Persius, and Juvenal, Lucian and Jerome, are testimony of this. Jerome no doubt owes his place in literary history to his exegetical studies and revisions of the Bible, and to his staunch defense of the church in theological controversies; yet, as an astoundingly prolific writer and as a defender of the faith, he was devotional, controversial, *and* satiric. He was not much of a poet, so far as is known, and therefore is not identifiable with the tradition of formal Roman verse satire. Still, Jerome does speak specifically of himself, at least twice (in Letters 22.23 and 50.5), as a successor of Horace and Juvenal, and on numerous other occasions refers to charges made against him as a satirist. Jean Steinmann's biography, even though published with the nihil obstat and imprimatur advertising the Catholic church's approval, nonetheless is typical of secular biographies of men of letters; it emphasizes the literary rather than the religious influences on Jerome's character: his great teacher Donatus' massive familiarity with pre-Christian authors and his aesthetic preferences for "the end of stylus that erases to the end that writes"; the "entire education" and formation of "so many great characters in the Church of the Fathers" because they were taught "exclusively profane authors"; "thus Jerome remained faithful [even] in the Chalcis desert to his vocation of man of letters and scholar dedicated to intellectual work." David S. Wiesen's biography demonstrated, perhaps for the first time, how thoroughly and incontrovertibly many of Jerome's quips and images originate in Persius or Horace or Juvenal.[20]

Erasmus himself precisely states the problem of being at once a churchman and a satirist, in his well-known letter to Alfonso Valdes:

> What is this but some fatal malady, consisting in misrepresenting everything? Momus [the Greek god of ridicule] is ridiculed for criticizing Venus's slipper; but these men outdo Momus himself, finding something to carp at in a ring [i.e. the "Terminus" seal]. I would have called them Momuses, but Momus carps at nothing but what he has first carefully

inspected. These fault-finders, or rather false accusers, criticize with their eyes shut what they neither see nor understand: so violent is the disease. And meanwhile they think themselves pillars of the Church, whereas all they do is to expose their stupidity combined with a malice no less extreme, when they are already more notorious than they should be.[21]

The continuing homage paid Erasmus stems more from his academic than from his religious reputation. In the English-speaking world at least, the colleges of Oxford and Cambridge, and not the monastery, were his natural habitat. On the other hand, his notoriety is certainly religious, not academic. The church was the dominant economic and spiritual, if not necessarily the intellectual, force in all of Europe; it was surely Erasmus' more prolonged and perhaps more important vocation. However, Holbein's famous "Terminus" woodcut and his drawing of Erasmus satirically suggest the nature of Erasmus' intellectual intention. Affective, ambivalent responses to that intention are not an antagonism to his massive contribution to the rebirth of secular learning. Rather, they stem from implications of religious reform among those he called "the pillars of the Church." His is the spirit of Momus. Erasmus—the Augustinian canon whose humanism has come to be associated with his deep-seated aversion to monastic life and dislike of scholasticism—was a life-long friend of a saint, a layman and martyr who himself had to wait until the twentieth century for his canonization. His repudiation and approbation of Luther, another Augustinian, is probably no more discreditable to him than, say, in the next century, Dryden's shifting religious allegiances. John Aubrey catches verbally what Holbein depicts visually:

> They were wont to say that Erasmus was Interdependent between Heaven and Hell, till, about the year 1655, the Conclave at Rome damned him for a Heretique, after he had been dead 120 years.
> His deepest divinity is where a man would least expect it: viz. in his *Colloquies* in a Dialogue between a Butcher and a Fishmonger.[22]

Though Erasmus wrote everything in Latin, and his prayers had a long vogue, his ecclesiastic appeal has usually been slight or suspect. Therefore, this greatest Augustinian's claim to fame is basically secular; the first intellectual to take full advantage of the printing press, widely influential through continuous, international translation, he was probably the single person most responsible for that intellectual revolution called the Renaissance, that literary rebirth of the "classic spirit," Huizinga calls it, "in so far as it could be reflected in the soul of a sixteenth-century Christian."[23]

One of Erasmus' most celebrated and influential works, the *Enchirid-*

*ion Militis Christiani,* is an instance of religious literature in a clearly
devotional sense: in generic terms, it is a manual for an illiterate soldier
to attain an attitude of mind worthy of a Christian; in its subject matter,
it is a theologically based program of action, wherein every Christian,
whatever his degree of ingenuousness or ignorance, is to understand
Holy Scripture in its purity and original meaning. There was surely
nothing new in this verbal intention, which is also identifiable in
Jerome's various genres, as it is in Lucian's.[24] The prologue to the *En-
chiridion* reviews "the corruptions of this world, and how far it is out of
frame":

> Yea, of so corrupt and perverse judgments are some, that they count it,
> even in priests, to be but a small vice, which is most abominable; and
> also esteem it to be an high virtue which hath but only the visor and
> appearance of godliness; thinking themselves better for the ceremonies,
> rules, and trifles of men's invention, and yet having no conscience at all
> to slander other men. Neither need men to fear, that the reproving of
> such abuses doth either subvert religion, or hinder true obedience.[25]

This argument chiefly aims at subverting, with the guidance of the great
fathers of the church, the conception of religion as a continual observ-
ance of ceremonies, which, if they do not renew the soul, are valueless
and hurtful. "The eternal law, which God hath created in the right
reason of man, teacheth him to abhor all corrupt affections, and not to
live after them, which thing even the heathen philosophers do also
confess."[26] Under the heading of "Opinions Meet for a Christian Man,"
Erasmus laments the extremes of pride of class, national hostility, pro-
fessional envy, and rivalry between religious orders. He is concerned
with religious abuses from the point of view of their social implica-
tions. "It is not merely religious feeling, it is equally social feeling that
inspired him," Huizinga says.[27] Still, the *Enchiridion* is devotional,
despite its practical and argumentative concern with the social impli-
cations of religion in its faulty operations; its intention is to foster an
attitude of mind and spirit according to ancient or "original" Christian
standards, with whatever benefit to be achieved in another world. In its
expression of reformatory temperament, it is not the harbinger of a
merely secular, humanistic spirit, but the explicit voice of an austere
monastic temperament.

  Erasmus' *Colloquies* deserves its reputation as controversial religious
literature. As Craig R. Thompson has shown, it is not so easy to argue
Erasmus off the hook of adverse criticism. The 1680 translation by Sir
Roger L'Estrange, "Pleasantly Representing Several Superstitious
Levities that were crept into the Church of Rome," clearly could serve
to channel the scorn and irony of Erasmus to the contemporary pur-

poses of exonerating the reader as an opponent of Papists and of testifying to the publisher's allegiance to Titus Oates.[28] It is no wonder that the Colloquies hold an important place in polemic history, especially because of their severe criticism of religious orders.

"A Pilgrimage for Religion's Sake," "The Religious Retreat," "The Souldier and the Carthusian," "The Franciscan's Vision," and "The Gospel Carrier" would delight anyone who could believe, who would *want* to believe, that every fire in London, even the Great Fire itself, could be ascribed to the Pope's direct and personal malice, or that Milton was a frequenter of a popish club, or that Cromwell was in cahoots with the Jesuits. Nevertheless, curiously, L'Estrange deems it necessary to clear himself of complicity in a note "To the Reader":

> The Fanatiques will have him [the translator himself] to be a Favourer of the Plot, or (as all Episcopal men are accounted nowadays) a Papist in Masquerade. The Author of the Compendium of the late Tryals, takes him for a Fanatique: so that with Erasmus himself, he is crush'd betweixt the Two Extremes. Upon the sense of these Unkindnesses, he has now made English of These Colloquies, as an Apology on the One hand, and a Revenge, on the Other.

It is certainly true that Erasmus in "A Pilgrimage for Religion's Sake" describes his very own Austin Canons as "amphibians, such as the beaver. Yes, and the crocodile."[29] In Erasmus' satiric view—the *Colloquies* is unquestionably satiric—the apostolate of the order he joined is neither wholly active nor wholly contemplative, not given over entirely to this world or to the next. The question here is not whether Erasmus was factually accurate or merely descriptive, but whether he was intentionally and merely derogatory. He was an "insider" as well as an "outsider" as far as both the Papist and the English churches were concerned. It can only be guessed whether Erasmus realized how much he was shaking the foundations of the church, considering the institutional charges against him from either side, and the variant readings given his texts. It is certainly a fact that he was a literary ridiculer and an intellectual revolutionary at the same time that, like Thomas More, he remained all his life a believing Roman Catholic.[30]

The literary point at issue is whether Erasmus' express indignation was merely temperamental, or whether it was generically intellectual—that is, whether Erasmus deliberately cultivated the literary talent of Horace, Juvenal, and Persius, who define the purpose, or "classic spirit," of deliberate ridicule. In this regard *The Praise of Folly* is the most literary of his works, having a complexity beyond anything in the *Enchiridion* and the *Colloquies*. It is what Northrop Frye calls Menippean satire, "the favorite form of Erasmus," rather more deliberately stylized than colloquial, dealing less with specific people than with

their attitudes.³¹ More than the *Enchiridion* or the *Colloquies*, it is a literary vision of two worlds according to a single imaginative pattern. Whether it is Erasmus' intention to praise churchmen rather than bury them is not consistently clear, as when Folly herself directly censures rather than praises what Erasmus would wish to censure. So the difference between religion and the abuses of religion here is never as obvious or clear as in the devotional *Enchiridion;* still, they are both consistently brought to mind in a way not typical of the abusive *Colloquies* either. More than half of *The Praise of Folly* is given over to a generalized castigation of all mankind in this world: "In short, if a man like Menippus of old could look down from the moon and behold those innumerable rufflings of mankind, he would think he saw a swarm of flies and gnats quarreling among themselves, fighting, laying traps for one another, snatching, playing, wantoning, growing up, falling, dying."³² Through the eyes of Folly, Erasmus "looks down" on this world. The satire then becomes more particularly directed against "them that carry the reputation of wise men and hunt after that golden bough." Folly closes with a consideration of great authors since antiquity, who have made Folly famous among men. Those with such reputations— clergymen of all ranks easily outnumber any and all other classifications—include, in order, grammarians, scholars, philosophers, divines, the religious and monks "most false in both titles, when both a great part of them are farthest from religion," preachers, begging friars, princes and courts, popes, cardinals, bishops, and lastly "the common herd of priests." While much of the satire is biting, none of it surprises.

If for Erasmus' contemporaries the importance of *Folly* was to a great extent topical or controversial, its lasting literary value has been something at once more profound and more obscure. Consider, for example, the end of Folly's oration given over to "some testimonies of Holy Writ" in behalf of herself. Folly (or Erasmus?) calls attention to Paul, who himself in his epistles to the Corinthians spoke "like a fool":

> And so at last I [Folly] return to Paul. "Ye willingly," says he, "suffer my foolishness," and again, "Take me as a fool," and further, "I speak it not after the Lord, but as it were foolishly," and in another place, "We are fools for Christ's sake." You have heard from how great an author how great praises of folly; and to what other end, but that without doubt he looked upon it as that one thing both necessary and profitable. "If anyone among ye," says he, "seem to be wise, let him be a fool that he may be wise." And in Luke, Jesus called those two disciples with whom he joined himself upon the way, "fools." Nor can I give you any reason why it should seem so strange when Saint Paul imputes a kind of folly even to God himself. "The foolishness of God," says he, "is wiser than men. . . ."
>
> And again, when Christ gives Him thanks that He had concealed the

mystery of salvation from the wise, but revealed it to babes and suck-
lings, that is to say, fools. For the Greek word for babes is fools, which he
opposes to the word wise men. To this appertains that throughout the
Gospel you find him . . . diligently defending the ignorant multitude . . .
but seems chiefly delighted in little children, women, and fishers. . . .
And what does all this drive at, but that all mankind are fools—nay even
the very best.[33]

When Holy Scripture itself seems to side with Folly, the connection—
or perhaps even the identification—of literary genre and religious pur-
pose could scarcely be stronger. Still, the religious implications *as*
satire are more confounding than they are in the devotional *Enchirid-
ion*, for all its audacious criticism of rites and observances, or its final
affirmation that life under religious vows does not necessarily sanctify,
and the possibilities for controversy are more complex than in the
*Colloquies* because they are inclusive and impersonal. Where the *En-
chiridion* focuses primarily on the religious other world of Christian
faith, and the *Colloquies* on the social this world of classical antiquity,
*Folly* manages to do both. Thus, if Erasmus-as-fool is a kind of Paul-as-
fool, the correspondence is not to be explained away in objective who-
represents-whom terms. The correspondence is intellectual and
religious, the institutions of satire and church in society existing in two
worlds at the same time. The praise of folly is its literary deliverance by
both Erasmus and Paul; it is what Huizinga perhaps would refer to as
the "mixture of social and religious feeling" in the praise of folly.

It is possible that all religious men of letters, as such, live in an age of
reformation, and that for them, if not for all of their readers, a notion of
*the* Reformation tends to lose its particularity. Every society, from a
satirist's viewpoint, needs reformation. Huizinga's delineation of Eras-
mus' character in its literary response remarkably matches the picture
of The Satirist and Society, the persona who emerges from classical
antiquity:[34] a very complicated moral character—in comparison with
the professed pietism required of the Brethren of the Common Life—in
a man taking himself to be one of the simplest in the world, he has a
need of purity "driving him" to a consideration of what he finds to be
scatologically and theologically revolting; he reveals a passionate de-
sire for cleanliness and brightness, which, willingly or unwillingly,
becomes a description of stuffy air, smelly substances, and verbal flatu-
lence; he is a "delicate soul in all his fibres," having an indelicate need
of affection, friendship, and concord, unable to be less concerned with
or about public opinion; he has in him a dangerous fusion of inclina-
tion and conviction, an undeniable correlation between personal
idiosyncrasies and universal precepts; he ascribes weakness to himself,
dissatisfaction with his work, possessing as he does a paradoxically

self-centered modesty; he is a man who has "so many friends" yet who is solitary at heart; he nourishes the unhappy feeling of being charged by unlucky stars with Herculean responsibility and labor, without pleasure or profit to himself; and he is restless and precipitate, attracted to truth but compulsively horrified by numerous lies.

If Erasmus' conception of the church was no longer, like Jerome's, "purely" Catholic, if his picture of it could no longer be that which Jerome and Augustine, or Aquinas and Dante, or Chaucer and Langland, had lent their talents to create, such perhaps is the nature of all institutions in this world. Institutions, after all, can have bi-part, ambivalent, literary and social definition. As René Wellek and Austin Warren theorize, "The literary kind is an 'institution'—as Church, University, or State is an institution. It exists not as an animal exists or even as a building, chapel, library, or capitol, but as an institution exists. One can work through, express himself through, existing institutions, create new ones, or get on, so far as possible, without sharing in polities or rituals; one can also join, but then reshape, institutions."[35] In this sense—though Wellek and Warren do not say so, being sensitive to intentional and affective literary fallacies, having little to say about satire, specifically—one can say that a satirist as such works through and exists in both his society and literature, with a special sensitivity to what he reads and writes, in ridicule and reform.

From an orthodox Christian viewpoint, "revealed truth by the very fact of its divine origin, cannot but confront reason with shadows which it will be unable to penetrate," and thus "not everything about heresy is false; it always contains a legitimate intuition, but will be warped by the intrusion of a philosophic system contrary to faith, or by an explicit or implicit denial of the mystery of faith."[36] A churchman's difficulties and problems, when as a satirist he describes them, are not unreligious or antireligious.

It is possible of course to be abusive regarding the abuses of religion, and even if unintentional this would be self-defeating. Ridicule holds a man up to scorn for some evil or defect in him, and may be rooted in a contemptuous pride.[37] Ridicule apart from love is a form of murder, which like other sins and crimes involves the retribution of guilt and punishment:

> You have heard that it was said to the ancients, "Thou shalt not kill"; and that whoever shall kill shall be liable to punishment. But I say to you that everyone who is angry with his brother shall be liable to judgment; and whoever says to his brother, "Raca," shall be liable to the Sanhedrin; and whoever says, "Thou fool!" shall be liable to the fire of Gehenna. (Matt. 5:21–22)

Religious satire necessarily provokes conflicting opinion because of, first, some inevitable obscurities, and, second, the very nature of the genre. No doubt the difficulties in trying to understand a past time in history involve an effort to suspend the changes that have occurred. Still, it can be said that for Erasmus, as for Jerome, there existed one church; Erasmus, like churchmen before him, because they have been called heretical or worse, indicates that the difference between literary talent and clerical responsibility, between ridicule and reform, is not easily understood. Perhaps, however, it can also be said that such men constitute something like a spiritual brotherhood, despite their individual differences and separation in historical time. In their literary imagination they transcend those differences and that separation. If the genre of satire is a mirror or a sort of glass, we necessarily see through it, darkly, but then face to face.

# 3

## "Tragisatire": Legitimacy for an Unchristened Genre

Earlier in this book I suggest that for the modern reader of religious satire, the long history of theory and criticism can be "seen" as well as "heard" to be a massive challenge, partly because of its discursive bulk of course, but also because of the verbal and visual counterpoint "built into" it.[1] In this chapter I want to sharpen up that suggestion, using a "modern" way to confront rather than to battle "ancient" literary problems, which go back much further than Jerome and Erasmus and continue to the present day.

Religious satire is explicitly both otherworldly and this-worldly, characteristically binomial and ambivalent. It has always been so. Literary theory and criticism are ongoing activities, always changing, like art and science. Modern scientific analogies (for example, in physics, form and substance as energy and matter) can be useful in the definition of literary genres (tragedy and comedy as religious and satiric). Strictly literary explanations persist regarding tragedy and comedy as discrete dramatic genres, regarding satire as rhetoric or poetry, Horatian or Juvenalian. Still, visual and verbal "overlapping" is not at all unusual in tragedy and satire, even in seventeenth- and eighteenth-century English literature, when those two genres had their clearest and most notable individual existences. One result is that much genre criticism of tragedy and comedy and satire consists of a grab bag of viewpoints. However, art, which can be as complicated and coherent as science, can also be reinforcing and dependable in its modes of perception. Certainly some literary theory and criticism since Dryden seem to suggest that satire is not only a bifocal function of perception but also an indication of the polar nature of reality. Such

perception of reality in art does sometimes reveal itself in theory and criticism of it. The idea of "tragisatire" is a function both of perception and of what is perceived; it is a means of transcending or at least not perpetuating the wide-ranging busyness of literary theory and criticism.

There are no special reasons to insist that artistic genres are different from scientific types, kinds, and species: they are rarely discrete, they are related to each other, they are always amenable to redefinition, and there is no denying that they exist. The languages of art and science are perhaps not interchangeable, but they are not mutually inviolable either, as when Schiller talks about literary genres as "possible species." Nothing is clearer in literary theory, however, than that it is colored by numerous predispositions, or that literary genres as "possible species" are said not to exist. Theoretical ambivalences are far-ranging and unabated, and the problem of the definition of satire is just a small part of them. Surely literary theorists grasp the metaphoric sense built into the physical sciences; astronomers say we are made of "starstuff," conversely name binary stars "Red Giants and White Dwarfs," and locate "Mutt and Jeff" orbiting pairs in the furthest seen expanse of the cosmos. If complementarity is indeed a concept important to the humanities, then, just as surely, the world of science is not a world apart, and literary genres can be understood in terms that are not peculiarly their own.

In a profound effort to simplify by halves, Morton W. Bloomfield describes dichotomous approaches to literature as "scientific" and "phenomenological," arguing further that the humanities themselves, apart from the sciences, are a "double path of knowing"; he even seems to suggest specifically that religion and satire are at odds, saying, "Much classic Greek art, if it was not parodic or satiric, was religious in nature, both in subject matter and in making possible the re-experience of divine or heroic events." Bloomfield maintains that a "double pull of the humanities puts us at times into a dilemma," and that "the dichotomous nature of the humanities is a given that is desirable to overcome only at times."[2] He is surely not defending here the disposition of humanists to feel different from scientists, nor superior to the man in the street. He seems to allow that modern sciences *can* be complementary, if not chiasmatic, in literary study. A converse implication, it seems to me, is that just as scientists describe "the language of life" in the simplest arithmetic of binary digits, so too can humanists avoid literary theory as intricate as integral calculus. John M. Ellis asks the simple question, "What distinguishes the satire that has survived its original context from the satire that continually appears from time to time in newspapers and journals and is soon forgotten?" and begins to

provide his own answer: "The difference must lie in the fact that the former has something to say to people outside the original situation." Ellis's theoretical starting points are not Bloomfield's, but he does conclude that the "ancient" and "traditional" dispute "between art existing for its own sake, on one hand, and having some useful relation to life on the other, is evidently misconceived: there is no necessary opposition between these views." Writing in commemoration of the centenary of Nietzsche's *Birth of Tragedy*, Roy Fuller reflects equally on the dualities in Nietzsche's long essay and on "the old ambivalent feelings about its author." No doubt, he allows, that Apollonian and Dionysian principles in art have become a commonplace of criticism, particularly in America. He seems to suggest that one result has been a confusion of Nietzsche's subtle poetic duality with its infinite rhetorical effects. He quotes Nietzsche on "the intricate relation of the Apollonian and Dionysian in Tragedy," but also in their relation "to poetry in general, possibly all art."[3] Fuller's essay focuses on the facts that these dual principles have become frayed symbols and that others have been invented to suggest similar opposition: the paleface and the redskin, the savant and the layman, the professor and the god. His list of divided or opposing forces can actually be much extended; a complete catalogue of theoretical pairs, arranged alphabetically, would comprise a library of literary criticism: Apollo and Dionysus, Christ and Apollo, few and many, the garden and the map, language and silence, lion and honeycomb, mirror and lamp, myth and powerhouse, raven and whale, romantic and classic, sceptre and torch, sincerity and authenticity, tower and abyss, Zen and motorcycle maintenance, to name a few. Many such literary pairs are engaging, even when they are not metaphoric, and useful, even when they are far fetched.

In the process of describing the perennial and immemorial "crosscurrents" between otherworldly spirit and this-worldly secularity of mind, "the opposition latent in the dual origin of our European world," Grierson also sees their increasingly clear oscillation, rather than separation. Grierson connects them with what he regards as one of the clearest facts in the history and literature of the years after 1660, namely, that then satire acquired "new force and savageness." Similarly, Douglas Bush emphasizes the compatibility of Christian and humanist values, as when he describes Milton, for example, as their "great exponent" at the very time that Milton and the dual tradition of classical reason and Christian faith was becoming "a noble anachronism in an increasingly modern and mundane world." Such religious connections with literature are frequently argued, though quite unresolved either way. Still, the fascination of generic simplification reveals itself in attempts to equate Christian, or otherworldly, experience with allegory and

tragedy, and humanistic, or "pagan," realities with satire and the other fictive modes that presumably are capable of saying something about this world. So, for example, C. S. Lewis insists that the *bellum intestinum* of Christian conscience was born in the age of Augustine, after Greek antiquity; reveals itself most extensively in allegory; and has its "obvious parallel" in modern psychoanalysis. Karl Stern argues the psychoanalytic and historical point that the "apparently total cleavage between the carnal and the spiritual in the image of woman" in literature since Bacon, Descartes, and Jansen is a symptom of a dreadful illness that might be cured only when the conflict between the two modes of scientific and poetic knowledge is reconciled. Conflicting values were probably born in the first link of the great chain of being, and are certainly inseparable from the scholarly industry of literary history attached to it.[4]

What literary genres are, where they originate, and how they survive are, like nations and political boundaries in the terrestrial world, difficult to determine. The practical problem of generic definition does not disappear when theoretical attempts to solve it are circumscribed in point of time or place. I am concerned with piety as a literary motive and with the kinds of literature that can be seen as a religious enterprise. All readers, unerringly, regard a holy sonnet as religious, even when it might be erotic, but one commonplace and inaccurate view of satire is that it is necessarily irreverent. Describing the subtle and intricate tendency of definition in Metaphysical poetry to become dialectic, Earl Miner likewise identifies the antagonistic reciprocity of those modern critics whom he calls "the Tuves" and "the Empsons"—that is, those who stress rhetorical intention versus those who are champions of poetic effect, regarding Metaphysical poetry. Miner himself is ambivalent in his identification of "lyric affirmation" in that poetry over against its "very nearly contrary element of dialectic wit, of satiric antagonism, of a multiple and ironic consciousness"; he argues that "satiric denial functions with lyric affirmation as a polar charge in Metaphysical poetry," not as disparities but rather as a kind of "double energy: of lyric affirmation and satiric denial."[5]

Scholar-critics who are unquestioned masters of eighteenth-century English literary history agree in general but wrangle over particulars. Focusing on the eighteenth-century heyday of satire in English literature, Sheldon Sacks defines prior categories of Satire, Apologue, and Action (or Novel) as absolutely discrete "organizing principles," even though he also admits they "may seem terribly rigid" and "uncomfortable." Similarly, Edward A. and Lillian D. Bloom argue that religion, politics, and manners constitute a persistent, seemingly arbitrary, but clearly distinguishable "tripartite division" of satire's topics; they

define religious satire especially in the Restoration and eighteenth century as dominant aesthetically yet, despite its decency and restraint, alienating all around, on a long "trail from Lucian to Joyce." W.B. Carnochan goes beyond the generally accepted fact of "the gradual decline of ridicule in the eighteenth century, both in esteem and practice," to discuss "some curious corollaries of that decline" in the psychology of literary taste, corollaries which might explain the eventual drift away from Horace and toward a muddled appreciation of Juvenal. William Kupersmith congratulates Carnochan "for venturing into the terra incognita of mid- and late eighteenth-century English satire," while admonishing him (rightly, I think) for seeming to disallow that "it is our opinion of Juvenal, and not the eighteenth century's that requires explanation."[6] Similarly, it has been argued that "what is essential to satire, and certainly to eighteenth-century satire, is rhetorical in nature."[7] However, any such discussion of satire as a period piece seems to beg the question of whether it is at all possible, anywhere or anyplace, that satire is an entirely rhetorical and single *kind* of art, produced by a single kind of collective verbal skill, revealing itself throughout one point in time, however small or large.

Paul Fussell has shown that ambivalence is the method of Renaissance ethics and that duality permeates the rhetorical world of Augustan humanism. He also has persuasively argued that "the modern *versus* habit: one thing opposed to another" is part and parcel of *Satire of Circumstance*, which originated in the trenches and air battles of World War I. Satire is the premium genre of that method, that world, and that circumstance. Thus, Fussell writes, "Those who actually fought the war tended to leave the inviting analogy to Greek or any other kind of tragedy to the journalists. On the spot, it looked less like a tragedy than like a melodrama, a farce, or a music-hall turn."[8] It is reasonable that literary theory, too, must be counted among the satires of circumstance. After coupling literary presence and illusion, uniting the reader's sense of both reality and literature's reality, Murray Krieger's resolution of antitheses is, as he says, "a kind of *deus ex machina*." He notes, quite accurately, that "the principle of doubling inherent in the game . . . creates the mirrors and their multiplied images which only the arts can project." Krieger's "Playful postscript to the Postscript" on Prisoner-Dilemma games in literary theory is itself one of a kind, a satiric mirror.[9]

From a modern point of view it is possible to see that "form" in literary genres approximates "substance" in a light spectrum. All light is colored, and the colors of light exist even when the human eye seldom notices them or picks them out in particular. Light is often described as a form of *energy*, made up of waves that combine or inter-

fere with one another. At the same time it is also commonly understood
that light is a form of *matter*. This apparent physical paradox is no more
(or less) complicated than the metaphysical (or neoclassic) problem of
the connection between shape and substance in literary art. In this
analogy, light is not a matter of history or geography, and the accuracy
of its definition is not dependent on the possible astigmatism of an
observer. Similarly, literary genres are not a matter of time or place or
personal "interpretation," or of random distinctions between form and
content. In the manner of Newton, photographers know that any color
can be simulated by mixing light waves of red, green and blue of vary-
ing intensity. In like manner, where tragedy and comedy "overlap"
with varying intensity, a variety of satire is produced. This is to say that
more often than not when tragedy and comedy are being talked about
today, what is discussed is the wrong color or the wrong combination
of colors, or that some color blindness may be involved in the percep-
tion of genres. There is a kind of spectroscopy in taxonomy.

Theory of mutually exclusive genres is both long-lived and more
shared than challenged. The huge problem of the interrelated origins of
tragedy, comedy, and satyr plays is one of the playgrounds of classical
studies, and of modern literature as well. Discrete genres are perceived
as products of incompatible talents; equivalent "modes" of *discordia
concors* sustain their unchanging somnolence and vigor through mil-
lennia. Critical disagreement regarding tragedy and satire suggests that
these two genres have in common not only what they are, but also how
they can be "seen." The form and spirit of literature would seem to be
contingent upon writer and reader alike; however, perhaps one can
pick and choose. What a literary work *is* can be (perhaps inevitably
must be) confused with what one thinks it *should* be; categorical im-
peratives tend to be obtrusive and contradictory in these matters, much
the way Heisenberg's principle of indeterminacy applies in the natural
sciences and not just in subatomic physics. If it is impossible to deter-
mine at once both the position and the velocity of an electron, then
perhaps the same may be said about the dualities in literary texts. The
laws governing them probably should be stated in terms of their observ-
able properties, but even then their descriptions will be uncertain.

It is possible that tragedy and satire can be themselves particles of a
genre, describable in their own terms precisely because, as I have previ-
ously suggested, they are never the same. One might hazard a generali-
zation: though a religious act in this world may be a "pious crime" and
serve as a subject for tragedy, as Maritain says of *Antigone*, the *abuses*
of religion—heresies, say, which can at least be defined if not "be-
lieved"—serve as a subject for religious satire. Though the formal or
structural intention of all satire (to say nothing here of its spirit) may be

in important ways different from that of tragedy, the causes and effects
of the genres may still be similar.

Thus, at the end of the *Symposium* Socrates tried to convince Aris-
tophanes and Agathon that tragedy and comedy required identical tal-
ent, but, as everyone knows, drunkenness was as close as the three of
them could get to theoretical agreement. In his famous letter to the
Prince of Verona, Dante wrote that tragedy and comedy move in pre-
cisely contrary directions. Who can succeed where Socrates and Dante
failed? I am trying to define in modern terms what Father Ong would
perhaps call the "closed field of satire" as the "desperation" that be-
longs to its "texture," insofar as it yields "knowledge and experience of
the tragicomedy of the human situation." He argues that Swift is "more
strategic than scientific" and that Swift is not so serious about poetry as
Pope; and he seems to me to denigrate what he calls Swift's concep-
tions of "psychological operations . . . in a mechanistic or geometric
fashion," Swift's ambiguous use of diagrammatic images, and Swift's
"inescapable dependence upon that which he is satirizing."[10] I am sug-
gesting that the limitations—aesthetic and taxonomic—built into satire
are what define it, and that Swift's mastery of them identifies his artis-
tic stature.

From a medieval tradition in English literature, derived from Boccac-
cio's *De Casibus Virorum Illustrium*, tragedy is defined as it is in Chau-
cer's Prologue to the Monk's Tale, according to subject matter rather
than as a dramatic genre. It is a "certeyn storie" rather than an artistic
shape. The neoclassic turn of English literary theory in Sidney's *De-
fence of Poesie* insists that tragic and comic plays are "gross ab-
surdities" when they "thrust in clowns by head and shoulders, to play a
part in majestical matters" and "match hornpipes and funerals." He
specifically condemns "mongrel tragicomedy." Yet, quoting from Ju-
venal's *Satires*, Sidney seems to press the related point about the di-
dactic uses of laughter, namely, that "all the end of the comical part be
not upon such matters as stirreth laughter only, but, mixed with it, that
delightful teaching is the end of poesy."[11] Sidney is himself satiric. His
entire peroration is a rhetorical masterpiece of scorn and delight, a
tribute to Momus, the god of mockery and censure.

John Fletcher had defined "tragicomedy," with approbation, for the
Stuart readers of *The Faithful Shepherdess*. Shakespeare's generic cate-
gories may have always been less than clear to his posthumous audi-
ence, despite the fact that his dramatis personae are frequently
mouthpieces for his literary theories. Hamlet, the satirical slave and
rogue, talks more about theater than drama, more about acting than
literature; Polonius matches his random pieces of advice to Laertes
with his kaleidoscopic praise for Hamlet's actors, "either for tragedy,

comedy, history, pastoral, pastoral-comical, historical-pastoral, trag-
ical-historical, tragical-comical-historical-pastoral, scene individable,
or poem unlimited." Quince and Bottom make comedy out of "lament-
able tragedy," and Shakespeare has Theseus say, of the Pyramus and
Thisbe play within a play, that it is "Merry and tragical! Tedious and
brief!" Like Shakespeare on the nature of dramatic genres, Ben Jonson
seems as problematic on the nature of religion, insofar as Sir Politic
Would-be's counsel to Peregrine is similar to Polonius' to his son: "You
shall have tricks, else, passed upon you hourly. And then, for your
religion, profess none, but wonder at the diversity of all."

Samuel Johnson does not actually refer to the separate and distinct
genre of "tragicomedy" in his *Preface to Shakespeare,* nor is he at all
Platonic, as Sidney is, in his insistence on the factual truth and sober
instructional value of literary art. "History," Johnson says, "is not al-
ways very nicely distinguished from tragedy"; his *Vanity of Human
Wishes,* a loose imitation of Juvenal's Tenth Satire, nonetheless carries
the clear Juvenalian sense that all genius and aspirations are defeated,
at least in this world.[12] Johnson in the *Preface* recalls no Greeks or
Romans who attempted *both* of the dramatic genres, which are, he says,
"intended to promote different ends by contrary means"; he infers that
Shakespeare in almost all his plays "has united the powers of exciting
laughter and sorrow not only in one mind, but in one composition."
Still, he seems to concur that the plays are, rather simply, colloidal
mixtures of comic and tragic scenes, and that Shakespeare's personae,
generically distinct and divided in their worlds, "sometimes produce
seriousness and sorrow, and sometimes levity and laughter." What I am
emphasizing is that connections between these generic polarities are
seldom perceived, over the years. Horace Walpole wrote in his Letter to
Sir Horace Mann that "the world is a comedy to those that think, a
tragedy to those that feel." Of course, neither in literature nor in life are
people separable into such disparate camps, any more than thinking
can be disembodied from feeling. To think of two-dimensional per-
sonae as completely different from three-dimensional persons, or to
refer to separate and contrasting genres, is no doubt a convenient
simplification rather than a theoretical necessity. Still, when Johnson
says that history is not always very nicely distinguished from tragedy, I
take him to mean that there are not only close but also overlapping
resemblances between real life and life as it can be represented on a
printed page, in all its colors, and as fiction or as nonfiction.

Modern scholars continue to ponder the vagaries of love as generic
elements in Shakespeare's plays, as comedy or tragedy in relation to
satiric intent. Thus, C. L. Barber remarks on Touchstone and Jaques's
"counterstatements" as mockery of pastoral contentment in *As You*

*Like It.* Having allowed that Jaques "talks a good deal about satire," Barber maintains that neither Jaques nor Touchstone, as "amateur" and "professional" fool respectively, "ever really gets around to do the satirist's work of ridiculing life," and he concludes that "such humor is very different from modern satire" anyway. Regarding one of Shakespeare's most famous comic heroines, Barber argues this point: "Romantic participation in love and humorous detachment from its follies, the two polar attitudes which are balanced against each other in the action as a whole, meet and are reconciled in Rosalind's personality." But it seems to me that he plays down the alliance of these polar attitudes. Douglas Bush, comparing Marlowe's *Hero and Leander* with Shakespeare's *Romeo and Juliet*, says that, "in general, instead of the ever present consciousness of tragic destiny that Shakespeare gives us, or Chaucer in *Troilus,* we have the mingled conceits and satire of the tale of Cupid, and briefer but not less trivial allusions to the part played by the gods." It is not much questioned that "the mingling of comic and tragic spirits which we know on the Elizabethan stage has behind it most definitely a dramatic tradition." Modern criticism accurately puts it that "the juxtaposition of vulgar comedy and serious religious commemoration in the earlier medieval drama seems to have been made in the most natural manner," and that, in a contemporary view of English literature at least since Chaucer, there exists "a mixture of the superficially tragic and the slightly comic which does not lie easy with us."[13] That tragedy and comedy coincide, though they are no more identical than any other two things, is a rather modern and supraliterary idea; where they coincide I would say they are satire, satire of a tragic variety.

Even in a brief chronological overview of the genre of satire within English literature, the sheer number of satirists makes it impossible to shake hands with everybody. Satire was even in the sixteenth century what Dryden called "a mixed kind of animal," too; and the problem of generic identification is not only logistic and aesthetic. The nature of religious experience is similarly troublesome in literary history. The proliferation of devotional sects, the sustained controversies regarding the nature and definition of crimes and sins, suggest an unavoidable opportunity—or necessity—for satire. Religious and social implications particularly figure into John Peter's *Complaint and Satire in Early English Literature;* William P. Holden's *Anti-Puritan Satire 1572–1642* mainly relates "popular material" to the religious controversies; Albert M. Lyles's *Methodism Mocked* salvages a parcel of satires from literary obscurity in order to show the deep-rooted, multiform prejudices and proprieties of eighteenth-century England. There is no doubt a direct correlation here; but attendant generalizations, James Sutherland's for example, that "by the middle of the eighteenth century satire

had become a literary habit," or that "it is, indeed, a problem of some nicety to decide how far the satirical element in some eighteenth-century poets . . . is natural to them, and how far it is the outcome of their literary environment,"[14] continue to be academic frontiers. None of the provocative puzzles regarding the conventional genres, the influence of environment, or the nature of personal experience will ever be discarded by critics or unexamined by theorists. The point is that from the beginning, the intentional and affective nature of tragedy and satire, at least, of all the genres, is no mere fallacy but rather a real subject matter in verbal as well as visual art. Writers and readers are, like the genres which engage their literary interests, perpetually regenerative, continually engaged in acts of construction and destruction, not to say deconstruction; their acts are physical as well as imaginative.

In *The Cankered Muse*, Alvin B. Kernan has explored the affinity that tragedy and satire have to magic; I certainly concur with Kernan on that affinity, on the fact that there is a "resemblance of the satiric and tragic scenes—and both satiric and tragic here suffer an agonized compulsion to appraise the ills of the world and cure them by naming them." Kernan regards Hamlet as the greatest instance of the combination of the two roles of tragic hero and satirist. W. G. Babbington even argues that the satirical rogue's "To be or not to be" soliloquy is specifically a parody. However, much that is indisputably great literary satire, and not just subliterary ridicule, has been written in mere everyday language too. Conversely, magic is not very clearly an aesthetic and high-class thing. Tragedy can claim its place high on Parnassus, and perhaps magic too, but satire is lowborn and lowbred. Wellek and Warren distinguish among the literary, the everyday, and the scientific uses of language; but the presumptive distance between literary and scientific language also disappears in dominant modern genres. Utopian and dystopian fantasy, for example, are saturated with scientific signs and referents, diction and syntax, speculations and realities. Perhaps it is true, as Wellek and Warren say, that "the center of literary art is obviously to be found in the traditional genres of the lyric, the epic, the drama."[15] Their "center of literary art" idiom, however, begs the question of how the highly complex and stratified organization of literary works can be discovered by an "intrinsic" study, especially in an attempt to define a genre with a dubious tradition.

Perhaps, just as Latin grammar became English prescription, that pattern of religious and philosophic thought in the seventeenth century has been adapted to—or imposed upon—antithetical descriptions of Metaphysical and Neoclassic genres. In any case, such efforts as Frank Kermode's, to show that the Dissociation of Sensibility formula is useless historically or that "powerful aesthetic interests demanded a

catastrophic start to the modern world shortly after the death of Donne, and before *Paradise Lost*," are only recently and incompletely received. This confusion or difficulty, call it what you will, is perhaps not only unresolved but ultimately unresolvable among literary men. Thus, for example, Grierson, acknowledging the view that "the very foundations of tragedy rest on religion," nonetheless argues that, whatever such foundations among Jacobean and Caroline dramatists generally, Shakespeare preeminently was a "humanist"; that is, his plays do not close on a note of moral or religious commitment; he refrained from investing his drama with any explicit ethical or religious significance; and he seemed unconcerned with evil as sin. In sum, "it was neither from Medieval Mystery and Morality, nor from Greek Tragedy, that Elizabethan dramatists derived the *formula* for tragedy nor the *spirit* which inspired it." Willard Farnham, guided by the conception that tragic expression is a special artistic and critical approach to the mystery of human suffering, asserts that "Gothic tragedy had its origin in a clash of otherworldliness and worldliness that came with the Renaissance." It is curious that many among the legions of Chaucer's modern enthusiasts find it difficult to reconcile the last book of *Troilus*, the Parson's Tale, or other palinodes with humanistic ribaldry. Farnham, for one, does *not* see an incongruity in the fact that the creator of the Wife of Bath wrote the Monk's Tale, and he would hold that Chaucer's "most judicious critics" see no disparity between a temperamental light-heartedness and the honesty of a retraction. James Sutherland, writing about Marvell's *Rehearsal Transprosed* in generic terms applicable to a wide chronological range of English literature, says that "even by the standards of political and ecclesiastical controversy it is something of a hybrid. You can either ridicule your opponent, in which case you can afford to be brief, or you can take him seriously, in which case you will have to answer his arguments fully. What you cannot do is to mix argument with ridicule at such lengths as Marvell does, without destroying the seriousness of the argument and losing the effect of the ridicule." That a man as satirist shows an interest at once serious and ridiculing, that he argues fully and according to standards both political and ecclesiastical, and that he employs a mode of literary expression which is not self-contradictory, all seem difficult possibilities to accept, or presuppose, and are frequently regarded as mutually exclusive if not contradictory. "Roughly speaking," Ronald Paulson notes, "if tragedy explores the upper range of man's potential in relation to the limitations of society, custom, or his own nature, satire explores his lower potentials."[16]

My purpose is not for one moment to ignore or pretend to demolish the generic distinction between tragedy and satire; however, I speculate

that the two literary kinds are alike in some characteristic intention and effect—purgative, for example—and that there are other ways of distinguishing between them. Though one may build on Dryden's careful judgments concerning satire, it is hard to argue against them. Not only does Dryden differentiate and value "tragical satire" apart from "the comical"; his concluding definition specifies, first of all, that "the end or scope of satire is to purge the passions." Gilbert Highet maintains, and I agree, that satire can be mistaken for other literary forms unless its emotional and moral effects are clearly defined and understood. Highet also argues that "in the same way as it is difficult for a devout Christian to write a tragedy, so it is almost impossible for a devout Christian to compose a Christian satire dealing with death and judgment and the next world." The analogy here seems sound. Who can say that art is ever easy? There are many Christian satirists, however; that such satire is "almost impossible" would seem to depend on both the writers and readers of it. In what still seems to me the best appraisal of Thomas More, C.S. Lewis says that *Historia Ricardi Tertii*, "if read in the right spirit," can communicate both "a sense of tragedy, and a sense of humour," and that *Utopia*, despite "its serious, even its tragic, elements," is nonetheless "a holiday work." Hugh Trevor-Roper argues that More was Grecian even more than he was Christian; that More was no more Catholic than Erasmus was Protestant; that More, like Erasmus, is Platonic in his comic raillery and irony; that the *Utopia in* literary history was essentially antihistorical and antitheological. It qualified him not for the community of saints, among whom the church now officially numbers him, but "rather to join Erasmus, his lifelong friend, in more interesting or at least more exciting company, on the Index of Forbidden Books." Richard Gerber makes multiple claims for modern utopias linked to older ones: that the role of religion in them is by and large unimportant; that as far back as More's *Utopia*, religion in utopian literature was "important but by no means dominant"; that modern English "religious utopias" have mostly been written by converts to Catholicism, but in any case, modern religious utopias are rare and a religious utopia is a *contradictio in adjecto* anyway; that only Dante's *Divine Comedy* might possibly be called a "truly religious utopia"; that a "truly religious utopia . . . should not depict this world, but the next"; and that the most significant theme for the modern utopian is scientific organization and the reaction against it.[17]

Can tragedy and satire be said to constitute discrete genres? Do they connect with religion in any one time or place? Or with any one religion? Is there anything like the concurrence of literary forms and cultural spirit? Many agree that the seventeenth and eighteenth centuries

mark the high points of English tragedy and satire respectively and consecutively, for sustained quality if not proliferation. But the social and religious developments through these centuries are as complex and fragmented as literature; one may wish to beg off generic theorizing, and legitimately so, since obscurity no less than clarity derives from the presumed advantage point of historical distance here. There are logistic and actuarial difficulties as well. Douglas Bush describes a vast body of "Popular Literature" in the first half of the seventeenth century; largely concentrated in London, it "did mirror the everyday world of the lower and middle classes," and consisted of hornbooks, satires, broadside ballads, almanacs, jestbooks, social tracts, books of characters, romances, and imaginary voyages. Even so, Bush says that the Bible was the most popular book, and that "more than two-fifths of the books printed in England from 1480 to 1640 were religious, and for the years 1600–40 the percentage is still higher." He speculates that religion was more important for greater multitudes of people at that time "than in any other before or since, and in many ways it profoundly affected the lives of those who were not especially devout." It is a matter of continuing conjecture precisely how such discrepancy of popular taste and religious thought can be reconciled within just the British segment of the twentieth-century English speaking world.[18] One might know where and when such genres as satire and tragedy mirror their culture; but can one know how and why?

Such questions posed here involve literary theory more than history, literary criticism more than *explication de texte*. They are, in the language of Wellek and Warren, "extrinsic" rather than "formal"; and of course they are also unwieldy.

In his famous essay on satiric personae, Maynard Mack says they are dramatic fictions, not caricatures of real persons but rather elements of satire as an imaginative genre. One of his main arguments is that literary theory's purpose is the identification of genre (poem as artifice and artifact), which saves readers from merely describing their impressions (poem as effect), or reconstructing the emotional metamorphosis of the poet in the poem (poem as autobiography or origins). "Tragedy and satire, I suspect, are two ends of a literary spectrum," Mack says; if this Newtonian idiom can be taken in a modern sense, he seems to suggest that these two genres provide a literary spectroscope for secular reality, as when he acknowledges the apparent colorations reflected in "a slant of glass, a fictional perspective on the real world—which, as we know, does not wholly correspond either with the tragic outlook or the satiric one." The Blooms seem similarly Newtonian when they say not only that the "vehicle" of a religious satirist ranges "from laughter to rage,

from comedy to tragedy," but also that "within this spectrum, further, his intention may vary from the simple and clamorous to the multiple and deliberately obscure."[19]

All the world's a stage, even more than its genres are spectral; but either way, in Shakespeare's idiom or Newton's, both that stage and its genres are real. Both idioms occur quite outside merely formal descriptions of literature. Peter L. Berger says, "The declaration that the social drama is a comedy may well raise eyebrows and elicit the comment that one can only say this by being inhumanly blind to the tragic aspects of social existence. We would not accept this objection. The tragic and the comic perspectives are not mutually incompatible."[20] It might be accurate to say that satire is identifiable, just as tragedy and comedy always have been, with religious themes and realities rather than according to rhetorical forms and styles. No doubt, one must be attentive to Ian Jack's cautions in *Augustan Satire:* that many modern critics are undisciplined in their historical understanding; that the learned generic intention and idiom of Renaissance poetics is crucial to an understanding of satiric varieties; that, from the Restoration to mid-eighteenth century, "poetry and oratory were sister arts." Of course, writing satire is not simply like speaking, a point that modern deconstruction theory would insist on. Still, Jack does argue that at least in the eighteenth century a poem, like a speech, was and had to be written with attention to the effect it would have on its audience.

Ian Jack is particularly careful to show the relation of satire to other forms: at one end, the "low satire" of *Hudibras,* for example, something like but artistically superior to "light verse" (and what today goes by the name of graffiti), is in complete contrast to form and style at the other end, the genuinely epic qualities of *Absalom and Achitophel* or *The Rape of the Lock.* However, as Jack himself notes, Butler in *Hudibras* can be said to make grand literary arguments and he scores religious points among his "strokes of general satire that have a very wide application."[21] Butler suggests generic as well as religious confusion in purgatorial mediocrities and hypocritical compromises:

> . . . Most men carry things so even
> Between this World, and Hell and Heaven,
> Without the least offence to either,
> They freely deal in all together.

Conversely, as in such lines as Pope's on Sporus, it is possible to say that the imagery suggests more than Ian Jack puts his finger on: that the "mean" imagery is more than a "sign of strong feeling," or connotation. "Mean" here is as much a mathematical as a temperamental denotation:

His Wit all see-saw between *that* and *this*,
Now High, now low, now Master up, now Miss,
And he himself one vile Antithesis.

Similar to the opposition of high and low forms, the connotative feeling
and denotative thought in them, the contrasting contiguity of Horatian
"comical" style over against Juvenal's "tragical manner" is also one of
the relentless generic commonplaces of the Age of Satire. Milton said
satire was "borne out of" tragedy and "ought to resemble his par-
entage." Dryden translated Juvenal as saying that satire "Struts in the
Buskins" of tragedy. John Dennis, however, intensified a critical agree-
ment with Dryden that continues to enjoy a healthy life on into the
twentieth century, namely, that tragedy and comedy, like Horatian and
Juvenalian satire, are essentially incompatible.

Here as elsewhere Dryden is the father of modern literary criticism.
Alvin Kernan rightly asserts that Dryden's *Discourse Concerning Satire*
is the last serious attempt to understand the genre before this century,
but also that, unlike Aristotle's *Poetics* with its working definition of
tragedy, this work does not have a subtle or complete generic descrip-
tion, nor is it a generator of further descriptions.[22] Still, Kernan particu-
larly prizes Dryden's notion of satire as an historically evolving genre
whose distinguishing marks as polished art are the dual qualities of wit
and morality, even as he points out that Dryden's history is fragmentary
and that Dryden "leaves us with a picture of two unrelated halves."
Kernan's own Two Poles of Satire are Dryden's; and it is between them
that, theoretically, Dulness is hanged, drawn, and quartered (the chap-
ters of *The Plot of Satire* being separated into four parts). Kernan cites
two other contemporary critics similarly indebted: Elliott in *The Power
of Satire* "begins, as Dryden does," by connecting the sophisticated
Roman genre with primitive antecedents, showing how the flower of
art, so to say, grows out of a magical and ritualistic humus which
provides it with nutrients while decomposing, itself an object of aes-
thetic delight though perhaps giving off offensive odors; in *Anatomy of
Criticism*, "the scheme Frye sets up is essentially Dryden's," regarding
both the interplay of fantasy and morality in satire and the proximity of
satire to tragedy, genres as similar to one another (in Frye's idiom) as
winter is to autumn. "Satire" and "Tragedy" are the titles of the con-
cluding subsections of the last chapter of *The Plot of Satire*. (*Both* are
identified as the fourth subsection, no doubt a misprint, after the third
one on "Comedy.") Kernan's "crucial point about the nature and rela-
tionship of literary genres" in his "Tragedy" seems to me elusive. I am
not sure of the meaning of his suggestion that every great literary effort
"has a tendency to become" all genres precisely to the extent that they
are great: thus, much of *Don Juan* contains "all the elements of tragedy

in little," or, conversely, "*Lear,* for example, moves toward satire," and "Swift's terrifying vision of human dullness always threatens to conquer his satiric perspective, and becomes so intense and agonizing at times that it topples his writing into tragedy." Precision is lost somewhere between "all" and "in little," between "always" and "at times." If, as Kernan persuasively argues, "the satirist's first occupation is the revelation of the opposition between what seems to be and what is, . . . of the gap between appearance and reality," we still wonder how the satirist is necessarily different from other kinds of artists.

In his last section on tragedy, the question remains how all the quoted lines from Byron's *Don Juan*—or even whole stanzas—are satire, in "the central action of life which the poem imitates," or how they are even satiric, in those crucial fictions, or "two master symbols of the poem, fire and ocean":

> Whene'er I have expressed
> Opinions two, which at first sight may look
> Twin opposites, the second is best                  (XV, 87)

> Between two worlds Life hovers like a star,
> 'Twixt Night and Morn, upon the horizon's verge.    (XV, 99)

These particular lines that both Ian Jack and Alvin Kernan write about here are crucial and useful in the range and variety of satire they represent. What I am saying is that *Hudibras, Epistle to Dr. Arbuthnot,* and *Don Juan* are definable according to the subject matter they identify *in* the genre and *about* real life. The perspective and the perceived are inseparable. Literary criticism of satire is necessarily its own theory as that perspective, and it is a kind of criticism that necessarily goes beyond literature for its subject matter.

The problem of the relation of tragedy to comedy, or of either of them to satire, has existed for a long time in widespread contexts far beyond poetics. Opinions are not always literary, but even those that are have a disconcerting range. Richard B. Sewall's *Vision of Tragedy* is representative of criticism that has come to be called "commentary," both expansive and diffuse; Martin Grotjahn, within a scope more particular if not clearer, says that "psychodynamics of the comedy can be understood as a kind of reversed Oedipus situation," wherein "the clown is the comic figure representing the impotent and ridiculed father. He also represents the sadness of things and finally comes to stand for death in the person of the tragic truly great clown. This is the point where tragedy and comedy finally meet and symbolize human life." Frye theorizes about tragedy as "incomplete comedy," and about comedy as containing "potential tragedy within itself." Similarly, George Steiner says that like all Christian tragedy, "a notion itself paradoxical," Mil-

ton's *Samson Agonistes* is "in part" a *commedia*, that "Christianity is an anti-tragic vision of the world." It is a "glaring fact," Steiner continues, that "Elizabethans mixed tragedy and comedy whereas the Greeks kept the two modes severely distinct." Though "partial tragedy" and "anti-tragedy," and "satiric bias and unruly wit" and "comic sadness" survive today, he concludes with a threefold possibility: "that tragedy is, indeed, dead; that it carries on its essential tradition despite changes in technical form; or, lastly, that tragic drama might come back to life." For R.D. Laing domestic life is a "fantasy structure," a generic sequence of familial scenarios, with a finite cast but otherwise indeterminate, on the stage of life: "These different dramas are performed simultaneously in the one theatre, farce and tragedy at once." H.D. Duncan, defining action in society as "sociodrama," interchanges dramatic genres as descriptive in life as well as in art, but in contexts that are as much elusive as numerous. He says: "Two great dramatic forms are struggling for audiences in our world. Communism is essentially a tragic drama. . . . Democracy is more a comic drama." Also, "Parents (fortunately) are comic as well as tragic"; "Rites are comic as well as tragic"; and "Art is *both* tragedy *and* comedy."[23]

Norman O. Brown forgoes the ordinary conventions of expository prose in *Closing Time* in favor of a verbal collage. It may be said that the pattern of *Finnegans Wake* derives loosely from Giambattista Vico, and that not only history but thought also can be conceived as a circular process of recurrences. But Brown's three-way conversation (himself, Vico, and Joyce, with abbreviated marginalia) does not, as in "An Interlude of Farce,"[24] have the discursive coherence of Dryden's personae in the *Essay on Dramatic Poesy*, but rather the naive visual appearance of quilt patches:

Farce makes a farce out of tragedy.
   *Have you evew thought, wepowtew,*
*that sheew gweatness was his twadgedy?*            FW, 61

        Tomfoolery
Enter Lear, with Cordelia dead in his arms
          My poor fool is hang'd!       *Lear*, V, iii
Beyond tragedy and farce
is the fusion of these opposites.

Beyond tragedy and farce
to the fusion of these opposites
back is
back to the original goat-song out of which both
tragedy and satyr-play, those *siamixed* twins,     FW, 66
by separation arose.

Frank Kermode briefly discusses the human face as a "dominant trait" in "ordinary life," the precise counterpart of Dilthey's artists' "impression point" that unifies disparate impressions of reality in life or art, a kind of dramatic mask "which gives articulation to the whole." Konrad Lorenz makes this aesthetic correlation too, as just one of many detailed analogies "in human beings and in birds." Combining its implications for both visual and verbal art, Lorenz develops it in an explicitly satiric direction: "Just as in the human face, it is in the neighborhood of the eyes that in geese bears the permanent marks of deep grief"—in geese no less than "in the ancient Greek mask of tragedy." Following Lorenz's lead, Kernan takes these kinds of generic illustrations and stresses their interconnection; he argues not only that "aggression lies at the heart of satire," but also that satire, though stylized, is true about what it attacks, with a responsibility moral and zealous.[25]

Is what Lorenz calls "the critical reaction" so different in body- and in word-languages? He is a behavioral scientist who writes Aristophanic beast fables that draw "behavioral analogies to morality." The beasts are sometimes fish, sometimes men, but the author seems to reinforce most of his love-hate, aggression-submission, greeting-threatening, "militant enthusiasm"-"triumph ceremony" antinomies with anecdotes about his beloved greylags, Ada, Martina, Max, Kopfschlitz. Their moral is always clear, frequently explicit: "What do you expect? After all, geese are only human!" or, "That goose must have been through a lot!" Much of his prose reads like Menippean satire, which, Frye says as a matter of definition, deals less with people than with mental attitudes. And at least twice, though written in an obviously scientific context about human beings, Lorenz gives his data a literary, generic identification: "the tragic side of this tragicomedy" of permissive childrearing, and the "fictitious comedy" in "the old tragicomic story" of the frontier preacher who buys a drunkard's horse. Ernst Kris may argue that modern psychoanalysis has come to recognize that ultimately tragedy and comedy, "the great twin dioscuri of art," can be regarded as alternative strategies employed by the ego for the relief of its burdens.[26] Lorenz as a behaviorist, however, is interested not in refuting but in reconciling Freudian theories. Employing an imaginative worldview he calls his "gestalt perception," Lorenz describes the "fairy-tale scenery" and sea life of a Key West coral reef as analogous to human society, "the under surface of the air, more familiar to us in its Janus face as the upper surface of the water." He employs the same metaphor for the human condition: "the Janus head of man" signifies a curious but ascertainable fact—namely, that "the very highest moral and ethical values" directly require a phylogenetic "mecha-

nism" which threatens their very existence; he also argues that aggression is an essential component of friendship, not its obverse. The Janus imagery is one of the recurring definitions of Renaissance literary studies, too, as subject matter, and as perspective.[27]

In his fifth chapter, "Habit, Ritual, and Magic," Lorenz replicates some of Elliott's subtitled interest in "Magic, Ritual, Art." Lorenz's thirteenth chapter is the verbal equivalent of Epstein's Coventry sculpture, *Ecce Homo*. Their titles are the same biblical allusion. Lorenz's concluding chapter has things both ways, both melancholy and celebrative. It is an avowal of optimism, despite the solemn leitmotif, earlier and repeated, that the chimpanzee "appears as something horrible, a diabolical caricature of ourselves, . . . as vulgar as no other animal but a debased human being can be." Lorenz's chimpanzee is Swift's Yahoo; yet he regards it as a humorous animal, too. He affirms the "faculty as specifically human as speech or moral responsibility: humor." He singles out Chesterton's "altogether novel opinion that the religion of the future will be based, to a considerable extent, on a more highly developed and differentiated, subtle form of humor," though, he says, ordinary human laughter does resemble the militant enthusiasm of geese. Either way, man is like a barnyard fowl. "Satire," Lorenz says, "is the right sort of sermon for today."

For Lorenz, satire is humanizing; for Ian Jack, a poem like *MacFlecknoe* is "not only a satire: it is also a comedy," insofar as it communicates ironic sympathy, and "Shadwell takes his place as a member of the same company as Sir John Falstaff." Lorenz deplores the "religious wars" originating in aggressive instincts; Jack singles out "the prominence of the element of attack" in *Absalom and Achitophel* and *The Vanity of Human Wishes* (his archetype of what Dryden calls "tragical satire") as the "specific sense" and the "English sense," respectively, in which these two poems *are* satires. Lorenz's theme is aggression; Jack describes the homiletic affinity of Juvenal's Stoicism with those aspects of Christianity that accomplish a virtuous life.[28] Contemporary scientific hypothesis coincides with diachronic, eighteenth-century explication on important points.

Formalist criticism—or any other kind that follows after the New Criticism—may have an austere attraction, especially for students whose academic and disciplinary attention presupposes the value of literature itself. Yet, in their fear of author psychology or in search of a vogue for audience reaction or other bona fide reality, the practitioners of any criticism can be put at too cool a distance, while others are even banished. Thus, Roy Harvey Pearce says Wellek and Warren "distribute most forms of historical study among the various levels of that Hell they call 'The Extrinsic Approach.'" Kenneth Burke—who is no for-

malist—allows that "the focus of critical analysis must be upon the structure of the given work itself." However, he also contends that "observation about structure is more relevant when you approach the work as the functioning of a structure," when you see it as a "strategy for encompassing a situation," even as he defines poetry to include any work of "critical or imaginative cast" and literature, for readers and writers alike, as "equipment for living."[29]

The burden for many satirists is the theoretical principle "built into" the complicated structure of their unburdening, that is to say, in the practice of their art. Their conversions at least as much as their satires are what Burke calls "symbolic action," the real conversions of the satirists analogous to the conversions of their satiric personae. Their *kinds* of fiction, Northrop Frye says, are confessional anatomies. Benson, Chesterton, Firbank, and Waugh quite literally converted to Catholicism; Eliot and C.S. Lewis to the High Church; Aldous Huxley to the Perennial Philosophy; and Butler and Shaw to kinds of modern religion. If Bertrand Russell was not a true believer, he was nonetheless a fervent preacher; and his kind of commitments no less than those of Christian satirists have frequently been adversely criticized for blurring the truth, his Best Silhouettes literally and not generically described as octogenarian Nightmares of Eminent Persons. Russell's apostate satire is the subject of a later chapter.

Literary historians and critics—often one and the same persons—can perhaps avoid making univocal or astigmatic claims. Is not the ancient origin of tragedy from comedy much like the modern development of literary nightmare from utopia? *Sub specie aeternitatis* and within the vastness of the cosmos, comedy and tragedy and utopia and literary nightmare are not much separated in time and place. Perhaps such origin and development of literary genres can be described as one and the same "strategy" but for encompassing a different "situation." We should not be surprised that such genres have recurrent themes, or that they have a "biblical ring," or that their writers seem to have a "prophetic role," or "that man is incurably religious."[30] Aristotle says that tragedy has as its prime function the provision of experience that is serious, complete, of a certain magnitude, embellished with each kind of artistic ornament, and purgative in its effects. Satire too can be and often has been such an experience.

# 4

# Miltonic and Other Utopians

Milton was one of the greatest religious satirists in theory and practice, and a subtle utopian too. His theoretical statements were quite brief, though nonetheless crucial to an understanding of both religious satirists and other utopians. Satiric and utopian genres are, like tragedy and comedy, or even satirists and utopians themselves, evolving and living relatives, symbiotic and matching pairs, enough alike to invite comparison *and* different enough to provoke contrasting dispositions; Milton had the opinion that they can be either admirable or ineffectual. On the one hand, Milton thought that utopian books are admirable, that they constitute one of the very greatest genres of the Western world, a "grave and noble invention" of some of "the sublimest wits in sundry ages," from Plato to More and Bacon, "teaching this our world better and exacter things, then were yet known, or us'd." He had a high regard for satire, too, which he said *"was borne out of a Tragedy, so ought to resemble his parentage, to strike high, and adventure dangerously at the most eminent vices among the greatest persons."* On the other hand, Milton's high regard for both kinds of literary art was hedgy. He was cautionary about "what it is to *turn the sinnes of Christendome into a mimicall mockery, to rip up the saddest vices with a laughing countenance,* especially where neither reproofs nor better teaching is adjoynd." He also had little respect for *"new models of a commonwealth"* found in utopias, arguing that "to sequester out of the world into *Atlantick* and *Eutopian* polities, which never can be drawn into use, will not mend our condition; but to ordain wisely as in this world of evil, in the midd'st whereof God hath plac'd us unavoidably."[1]

Milton praised satire for its high-minded disposition bordering on

tragedy and not on mockery; in theory and practice, he denigrated mere jesting about the abuses of religion. Conversely, he lauded utopias for their "better and exacter things" and not for their idealizing conceptions. He clearly disesteemed nonfiction parading itself as religious or political panacea, even as he gave his careful approval to utopias as an expressly satiric genre. These Miltonic definitions—literary and satiric fictions set against literal and serious blueprints for social reform—are nowadays often lost, and this loss constitutes or at least permits one relentless impetus in literary studies.[2] Like Thomas More, Milton was a utopian *and* a religious satirist; his art, like More's, has been discredited by some humanists who may or may not be Christians. Milton precisely defined the value of utopian genres insofar as they are also satiric fictions, and he represented qualities of Christian humanism that have gone down with his reputation. It is possible that these facts are connected, even if not causally. Milton's cautions about utopias and satires go unheeded. However, utopias, like religious satires, have a proliferating and unabated existence. One result is a genre I am calling unintentional satire, but the common moniker for this proliferating nonfiction is futurology; it is an amalgam of non-Miltonic peculiarities and value judgments.

In other chapters of this book, I am often concerned with utopian literature insofar as it is satire. This chapter, however, deals with utopian literature as *unintentional* satire. Miltonic utopians are intentionally satiric; futurologists are not, but what they write looks like satire anyhow. I suggest there is a direct connection between some literary neglect of Milton and the quantitatively impressive genre of modern utopian nonfiction, represented in this chapter by a mélange of utopians. In their apparent neglect of the Miltonic distinction between kinds of utopia and satire, they attempt seriousness without formal or generic precision. Milton's distinction between "grave and noble invention" and "this world of evill" blurs and is lost in their kind of expository artistry. Therefore, some unintentional satire—utopias that look like satires—gets written.

Milton and his art have suffered much neglect, not always benign. Neither his achievements nor his intentions have saved him from aesthetic mutilation. Since the late eighteenth century his literary heritage has been described as "negative" more than "positive."[3] The latitudinarian reduction of Milton's stature has sometimes been flagrant; consider, for example, the desecration of his tomb in St. Giles' Cripplegate. More frequently the reduction or desecration has been verbal, more subtle if not less direct, as when Samuel Johnson alleviates literary guilt which comes from not reading Milton: "*Paradise Lost* is one of the books which the reader admires and lays down, and forgets to take up

again. None ever wished it longer than it is. Its perusal is a duty rather than a pleasure. We read Milton for instruction, retire harassed and overburdened, and look elsewhere for recreation; we desert our master and seek for companions." Thomas Gray had honored the possibility of some anonymous and mute inglorious Milton among the unlettered deceased, in the elegy sometimes called the best-known poem in the English language. Johnson went the extra mile, "rejoicing to concur" with the unrecorded preferences of universal literacy, "for by the common sense of readers uncorrupted with literary prejudices, after all the refinements of subtilty and the dogmatism of learning, must be finally decided all claim to poetical honours."[4] Johnson no doubt was attempting an appeal to a *consensus gentium*, but he was a Tory in politics more than in literary theory. His conception of "the common reader"— like the *Elegy*'s intimation of limitless possibility in common writers— has enjoyed a continuous familiarity, up to Virginia Woolf and beyond. Both eighteenth-century texts are venerations of simple literacy that provide the opportunity for a large and, perhaps, intimidated readership to "identify with" or "relate to" voluble critics whose own esteem, though not quite so grand as Milton's, can be shared by verbal osmosis. Still, it is not at all clear that Milton enjoyed an aesthetic or intellectual place in the minds of the English common readers, from 1800 on, at any rate. And, in America, from the inception of its literary culture, "the older poets, including even Milton, were not much read."[5] This curious neglect had begun in Milton's lifetime, not close to the publication of his first poem on Shakespeare in the prestigious Second Folio, but certainly before the posthumous version of *Paradise Lost*. Not the origins of this neglect, however, but its modern consequence is one point of this chapter.

Samuel Simmons' contract with Milton, to publish his epic *and* the apparently solicited pony-or-trot Arguments, is one among many well-known curiosities of Milton's sometimes infirm reputation. The vagaries of Milton's reputation represent an anxiety over an author who was at once a pamphleteer revolutionary and, in his old age, a relative unknown writing a massive poem of questionable market value. The fruits of his mind, as Emile Saillens says, have never ceased to arouse both admiration and hostility.[6] In the modern literary marketplace, it may be that these responses do not so much fluctuate as cancel each other. Contemporary critics often remark on Milton's lack of esteem not only among common readers, but also among themselves, professionally. Randall Jarrell has appraised the implications, beyond the casual misfortunes of literary culture: "*Paradise Lost* is what it was; but the ordinary reader no longer makes the mistake of trying to read it— instead he glances at it, weighs it in his hand, shudders, and his eyes

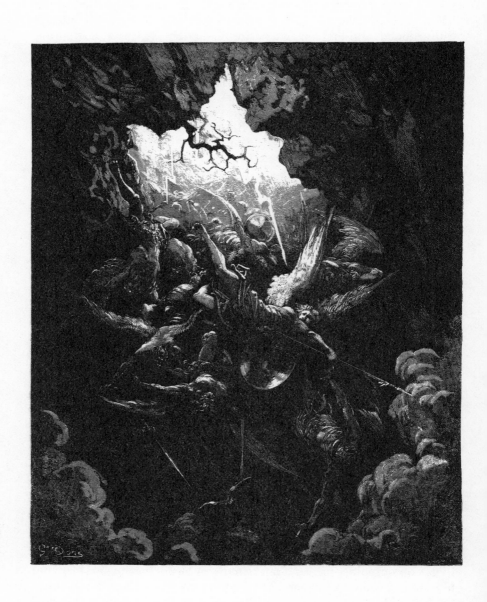

shining, puts it on his list of the ten dullest books he has ever read." Jarrell's own particular poetic despondency, however, concerned "not the Public, nodding over its lunch pail, but the educated reader, the reader the universities have trained." It is precisely the educated reader's unfamiliarity with great literature of the past that is a prior condition of both "obscurity" in modern poetry and ignorance of "a world entirely different from this."[7] Jarrell's implied quandary was not only that, if Milton is unread and unloved, then a mere modern lyricist like himself cannot possibly hope to avoid the same fate. Rather, he seems to suggest that literary ignorance is an inescapable fact of life, implicating a man of letters as well as a man in the street.

In *Paradise Lost* Satan laments that he can experience nothing but unhappiness in this world—"Oh Earth, . . . I feel/ Torment within me, as from the hateful siege/ Of contraries" (IX, 99–122)—that is, as Merritt Y. Hughes notes, Satan feels his mind to be full of logical opposites, mutually exclusive conceptions. Notwithstanding such literary critics as T.S. Eliot, William Empson, and Isaac Asimov, whose readings of Milton are as extensive as they are joyless, it is possible to see in Satan a laughable and entertaining dramatis persona. It may also be possible to extend W.K. Wimsatt's notion of "hateful contraries," derived from *Paradise Lost*, beyond Wimsatt's defensive concern for cognitive criticism, insofar as there *is* in great literature, tragic or comic, what Wimsatt calls "a Manichean, a Dionysian, a Nietzschean note." He seems to suggest a kind of Unfortunate Fall in literary criticism, the paradoxical fact that great literature, to assert good, seems to celebrate evil equally. Knowledge of Good and Evil in literature—and in literary criticism as well—seems based upon a confounding division and opposition.[8]

George Steiner makes the penultimate statement on what one might call the prolonged ceasefire between the Ancients and the Moderns, with neither standing on vantage ground: "The language of Shakespeare and Milton belongs to a stage of history. . . . The writer of today tends to use far fewer and simpler words, both because mass culture has watered down the concept of literacy and because the sum of realities of which words can give a necessary and sufficient account has sharply diminished." Reynolds Price's essay on *Samson Agonistes*, as an appreciative analysis of a classic genre by a contemporary novelist,[9] is very rare, not only in its admiration for Milton but also in its allegiance to a theocratic worldview that regards cumulative literary tradition as a means to achieve what is true and good. On both counts Price opposes the commonplace critical standards of Susan Sontag's *Against Interpretation* and Karl Shapiro's *In Defense of Ignorance*; it is not Price but Sontag and Shapiro who wave the literary banners that

multitudes rally round. Richard Hoggart observes, in a tone at once
sardonic and sympathetic, that the social uses of literacy and not aes-
thetic aspiration determine poetic matter and intention, that "the
democratic lust for widespread and fragmentary opinion unites with a
slight residual awe for knowledgeable people and also with a slight
resentment of them." Hoggart published some forty essays in *Literature
and Society,* in two volumes, mentioning Milton once by name, but
briefly, and in passing, when reporting Eliot on Milton.[10] Such cur-
siveness does little to suggest Milton's possible relevance to the topic of
literature and society; it does suggest an entente cordiale between the
literary establishmentarian and the common reader. The rejection of
Milton or any other author—Pope, Shaw, Orwell—precisely on this
point, the disrepair of language as a cause of social decay, is not so
much severe as offhand, and it makes for curious turns in utopian
contexts that I describe in this chapter.

These "other utopian" views on literature and society, on politics
and literature, are far-removed from those Milton expressed, regarding
especially his unflagging sense of their mutual dependence. Milton
himself did not invent the idea that the fall of a civilization or its "low
and obscure condition were consequent on the general vitiation of its
usage in the matter of speech," or, conversely, that it would "flourish
moderately at least as long as liking and care for its language lasted."[11]
But in contemporary journalism, anxious about the quality of its own
verbiage, not a month of Sundays goes by without a newspaper or
magazine article on "Popspeak," "Fedgush," "Strictly Speaking," "A
Civil Tongue," "After Babel," or "The Fate of Reading." In popular
culture, this anxiety of influence concerning speech and writing carries
far beyond what I have called some still unfinished business in literary
theory. Since Milton, the quality of language in relation to social or
political achievement is one of the museum pieces of literary study.[12]

Optimism regarding utopian change frequently accompanies the pro-
fessional, if also unintentional, rejection of Milton as a man of letters.
However much reason there is to defend such coupled optimism and
rejection, it is sometimes a "self-parody" that is unintentional rather
than deliberate; it is a modern genre, complex far beyond its definition
by Richard Poirier, and influential in ways not necessarily celebrated
within literary culture. Literary utopias *as* a genre are often a form of
unintentional parody. There is a double intricacy here, in theory and
practice. Thus, Northrop Frye, remarking on social analysis among va-
rieties of literary utopias, says that it "passes fiction off as a fact," even
as *the* utopia, as a literary genre, of course "belongs primarily to
fiction." Frye is concerned "with utopian literature, not with social
attitudes," but he nonetheless allows that "literature is rooted in the

social attitudes of its time." His generic derogation of *Walden Two* is that "its Philistine vulgarity makes it a caricature of the pedantry of social science," and of the fourteenth-century poem, *The Land of Cockayne*, that its "line of descent to the schmoos of 'Li'l Abner' is clear enough."[13]

What I am particularly emphasizing here is that satire and utopia "overlap" in ways that are "built into" their subject matter. The forms of utopia are imperfectly signaled by dictionary entries capitalized and lower-cased, and they have no very specific referents, literary or real. Whether utopia is a literary genre or a subject matter, many books that are utopian have nothing to do with Milton or with satire, for example, Karl Mannheim's monumental *Ideology and Utopia* or Gabriel Vahanian's *God and Utopia*. Even some literary studies—Gerber's *Utopian Fantasy* and Hillegas's *The Future as Nightmare*, to name two—have nothing to do with Milton. In some works, such as John Vernon's *The Garden and the Map*, Milton and satire are briefly mentioned, though one might not be certain why. I am emphasizing the ways Milton figures briefly but significantly, as in Elliott's *The Shape of Utopia*, and in Eric S. Rabkin's *The Fantastic in Literature*. Considering fantasy as a "super-genre" in science fiction, utopias, and satire, Rabkin draws a three-ring paradigm similar to that employed in my definition of tragisatire in the preceding chapter. Rabkin argues that every genre—including his three—involves fantasy in varying measures and that "satire is inherently fantastic"; he ventures further to say that a fantastic world appears different from and superior to a real one. He concludes: "Fantasy represents a basic mode of human knowing; its polar opposite is Reality. . . . The glory of man is that he is not bounded by reality. Man travels in fantastic worlds."[14] Surely, however, as many Miltonic scholars have so abundantly shown, *Paradise Lost* is not an argument against the beauty and complexity of reality but rather is a Christian vision of it. Thus, Roland Mushat Frye has considered how Milton's visual—not visionary—imagination is the particular consternation of even sophisticated critics of Milton, and how, "if we are to read Milton aright, we must look at *things* as well as at words and ideas."[15]

In *The English Utopia*, A.L. Morton purports to tell a story limited to literature in English, "the history of Cokaygne," and "the peculiarly English genre of the satirical utopia."[16] He makes this national and geographic limitation even though he recognizes the roots of the genre in the common wants and desires of all corners of Europe. Lower-class or peasant enthusiasms—for food, safety, comfort, and other mundane joys—have perhaps always been, as Morton claims, the butt of those other classes who, since the Renaissance, read and write books. There-

fore, he identifies this genre in extraliterary terms: according to its insular authorship, characteristically middle-class Puritan through four centuries, in its disdain for the perennial Doasyoulikes, and Readymades, and Rock Candy Mountains celebrated in unprepossessing folklore, even in modern America. In fact, he includes all people and places immemorially celebrated in the Earthly Paradises of folk art, in shameful disregard of the Gospel of Work. Continuously reading the literature not as imaginary fantasies but as apologetic tracts for the times, he maintains, on the one hand, an unqualified optimism concerning "the capacity and the splendid future of mankind," and, on the other hand, a reluctant appreciation of Renaissance writers. Readers and writers of utopian literature—"degraded books"—suffer from an eddying humanism whose sole value, Christian or secular, he regards as a precursor to "the philosophy of the bourgeois revolution." Though Bellamy and Morris receive his selective praise, Wells, Shaw, Chesterton, Huxley, and Orwell, despite all their individual political and aesthetic differences, are equally culpable in humanism's "Last Phase," having sunk to "the lowest depths to which the new genre of anti-utopias could fall."

Morton praises More's *Utopia* as "a landmark along the road towards scientific socialism," and More himself "as a pioneer of socialism rather than as a saint or philosopher." Bishop Hall's claim to literary fame is that *Mundus Alter et Idem* is "the first of the negative or satirical utopias," though Morton faults Hall himself for the fact that "a part of his attention was to portray a sort of anti-Cokaygne, to express the disgust felt by the cultivated mind of the comfortable churchman at the grossness of popular delusions." He applauds More's humanism, but argues that Bacon's "had run cold." Milton in his turn is praised, hesitantly, for what would seem to be his incidental advocacy, and not for his literary achievement. So, Morton writes, "We might almost say that the Eden of *Paradise Lost* was Milton's Utopia"; he quotes, and shares, Blake's qualified appreciation that, "because he was a true Poet and of the Devil's party without knowing it," Milton depicted "the distant past and the distant future" of Christian history in ways which were and are unfortunate: "The paradise which Milton lost, then, was the early promise of the revolution," not only Cromwell's revolution but "the bourgeois revolution itself." Morton gives himself over not to a textual reading of *Paradise Lost*, or even a line from it, but rather to guess-making about the inner workings of Milton's mind: "If Milton was the supreme religious Utopian of the English Revolution, his Utopia was so concealed that he was probably unaware of it as such." Morton's guess that Eden is Milton's Utopia does have a theoretical interest—though

his accuracy must of course be questioned—insofar as Morton's elaboration of that Utopia presents some literary problems.

In Morton's generic terms, one might say that Pandaemonium was Milton's anti-Utopia, identifiable with its modern equivalents as a fictional "retreat into fantasy, into an unscientific exploitation of 'science', into gloom for the sake of gloom." It is not only in Pandaemonium, of course, but throughout *Paradise Lost*, as John Steadman has shown, that Milton's concept of Just and Unjust Discourse is useful in understanding Satan, especially, among Milton's epic personae. Steadman's further implication is that it is applicable also to some of Milton's readers, "A. J. A. Waldock among most other spokesmen for 'the Devil's party,'" who write epistemologically and morally, but unfamiliarly, on Milton's mind and art, for "Milton held a somewhat broader view of the rhetorical art than either our contemporaries or their immediate precursors." D.M. Rosenberg says that "style is a central thematic problem in his polemics," that Milton parodies the various techniques of rhetoric, and that his plain speaking "is a satirical technique rising from his conviction that rhetoric is a vehicle for social morality."[17] This is to say that Milton's style itself is important to an understanding of its cultural demise, having incorporated into it what must be understood for what it parodies *as* various techniques. After all, parody is a technique for Miltonic as well as for other utopians. In addition, then, one can identify numerous instances of unaware mimicry of Milton's style, a kind of unintentional parody of parody.

Comparison here seems more appropriate than contrast, insofar as politics and literature, *as* rhetorical discourse, grapple with real problems in this world which cannot be solved, perhaps, are at best "lived with," or at most endured. Both politics and literature contain humanistic and rhetorical genres *as* techniques, or, in Kenneth Burke's sense, "work" of critical or imaginative cast adopting "various strategies for the encompassing of situations." Even when such "verbal action" is "perverse," Burke argues, when "the themes of evil sought for its own sake, of anything as evil when sought without reference to God," are explored unconsciously or unawares, they still constitute "imitation" in the sense of "parody." Thus, in *The Rhetoric of Religion*, Burke's concluding "Epilogue: Prologue in Heaven" is a satiric "Parable of Purpose," a dialogue between The Lord and Satan. This functional hodgepodge, a generic epilogue-prologue-parable-dialogue, is a demonstration of the very resources of language that solve some problems in "the talking animals' way of life in a civilization," but also "the vexing fact that each 'solution' raises further problems."[18] In an explicitly and insistently generic way, Burke maintains his sense of both

politics *and* literature and calls clear if also complex attention to the difference between facts and their interpretation. Morton is nowhere nearly so successful as Burke. In his brief "Introduction," Morton says that his book is "a story of two islands—the Island of Utopia and the Island of Britain"; he concludes it with "a note on the word Utopia," or rather, on three words: *Utopia,* the book by Thomas More; Utopia, referring to an imaginary country; and *a* utopia, a book about such a country. The theoretical distinction between the second and third uses, he allows, is more convenient than easy in practice. The expository flaw of such a book as *The English Utopia* is not that its argument is political, but rather that it is unable to maintain and even seems to ignore its own nicely punctuated distinctions.

The literary curiosity of these generic ambivalences is that a past tense is yoked to a future perfect viewpoint, not only in an imagination of Utopia but also in "real" forecast or anticipation of its "actual" existence. Religious fantasies of social prophecy are intermingled with an ironic hyperbole that confounds, more unintentional than effective as a rhetorical technique. For example, Morris L. Ernst, in an early and celebrative American Bicentennial volume entitled *Utopia 1976,* takes a transatlantic tack similar to Morton's, generically indistinguishable from Morton's. Ernst gives short shrift to antecedents in the utopian literary tradition, though he seems to adopt some of their verbal stratagems. His derision of antiutopians as "glandular pessimists" penning "tomes of despair" seems more ill-informed than ill-natured; his sense of "Religion 1976," like his satisfaction with secular fundamentalists who "spell God with a double o," seems as beneficent as it is unrealistic. However, the millennium is, as it was, elusive. His concluding chapter starts with an understandable awareness that "many think my utopia is insipid, while others deem it brash and far too hopeful." He is pleased to see that in America's religious history since 1776, "as our devotion to the dogma and forms of organized religion declined, our many sects 'tolerated' each other with more outward grace," and that "as we prospered . . . the prestige of the clergy diminished." He expresses the hope that "the churches will by 1976 attain greater prestige than ever before by leading us to forgive, and hence convert, the Communists, the Fascists. . . ." In due time, if not now, "the Ten Commandments will be brought up to date," and he does not have anything like Arthur Clough's Latest Decalogue in mind. His last paragraph is almost ingratiating for its good-natured ingenuousness: "Men and women follow only those with hope. We all seek direction markers of optimism. Our spiritual road may well carry the direction pointers: 1976—This Way—Energy, Leisure, Full Rich Life."

In an earlier collection of essays—seventy-eight titles in random se-

quence within forty-seven chapters, a virtual hodgepodge—Ernst generically describes his effort as "thousands of words of notes" which his publishers at first said "was no book." He gave this "kind of freewheeling series of pieces" a series of random titles, *It's Been Fun, So Far So Good*, settling finally on *The Best is Yet . . .* (a literary allusion to Browning's "Rabbi Ben Ezra"). Most of the essays are as negligible as they are brief, though their topics are important: war, censorship, obscenity, sex, blacklisting, libel, education, divorce, government, and religion, randomly ordered. Though the shape of the book is amorphous and unperceivable, its style is utopian and ingenuous. Ernst writes: "One of my favorite tough and very rich friends . . . discovered that possessions can be a nuisance as well as a joy, and that instead of possessions as a means of showing off they could find a substitute in devotion to the community." "Living a self-contained economic life brings the feeling and power of self-sufficiency." "We can learn much from women's slacks and the International Ladies' Garment Workers Union." "We had fun educating juries and judges." "Back to the old primitive, initial sense. . . . And as for feeling, . . . finger tips are far more important than words, on truly important occasions of life."[19] Whether this ingenuousness is also a reasonable optimism, I am not concerned with here, but rather with the fact that this is a generic garble, not Miltonic in form or content, neither intentionally satiric nor fictional.

It is also true of the vast library of futurology that it is as self-conscious as it is indeterminate: Andrew M. Greeley's *Religion in the Year 2000* and Herbert J. Muller's *Uses of the Future*, for example. Father Greeley's little volume, unlike his better known novels, is "an attempt, within the [single and nonfictional] framework of sociological discipline, to write responsibly about the future of religion," and explicitly separates itself from both the genre of More's *Utopia* and the "fascinating genera which may be called social science fiction." Muller too lauds "The End of Utopia" and with Father Greeley shares a muted enthusiasm for the year 2000. In *A Lively Corpse*, Miriam Strauss Weiss celebrates the ongoing Utopian dream from a viewpoint of religion, attempting to show that God, like Frodo perhaps, lives. I think that Weiss's several references to Milton are as much amusing as oblique.[20]

More widely read than any of these futurologies is Alvin Toffler's *Future Shock*, which has in common with Burton's great *Anatomy of Melancholy* its paradigmatic structure and bulk, as well as the fame of successive editions, if not also the same humor and weight of learning. It is written in dead earnest, in more than 500 printed pages, including a general introduction, six parts with introductions, two to five chapters each, each of these with two to eleven subtitled essays, plus ac-

knowledgments, notes, bibliography, and index. There is a tonal scale
built into Toffler's style, a kind of crescendo of hyperbole, in the begin-
ning a melancholy and dystopian amplitude on the "Death of Perma-
nence and Transience," but concluding with a utopian and optimistic
"Strategy of Social Futurism." A kind of fictionality is also built in,
though Toffler is no Democritus Junior; his topic, "the acceleration of
change in our time," should be, he says, perceived "not merely from the
grand perspective of history"—that is, not only from a diachronic or
even a synchronic viewpoint, "the vantage point of the living, breath-
ing individuals who experience it"—but in an imaginary way, too:
"previously, men studied the past to shed light on the present. I have
turned the time-mirror around, convinced that a coherent image of the
future can also shower us with valuable insights into today."[21] But a
time-mirror is, generically speaking, a curious sort of glass.

The more than 350 titles in his bibliography are arranged according
to several generic "groupings," curiously arbitrary, "not intended to
indicate the subject matter of the work, but the context in which I found
it of interest"; for example, Borges's *Labyrinths*, in BUSINESS/
ECONOMICS/CONSUMER PATTERNS; Ernst's *Utopia 1976* in FUTURE
STUDIES; Barth's *Floating Opera* and Pynchon's *Crying of Lot 49* in
LIFE STYLES/SUBCULTURES/INTERPERSONAL RELATIONS; Kaf-
ka's *The Trial* in ORGANIZATION THEORY; Čapek's *War with the
Newts* and Vercors's *You Shall Know Them* in SCIENCE/TECHNOLOGY;
Huxley's *Brave New World*, Orwell's *1984*, and Skinner's *Walden Two*
in SOCIAL INDICATORS/PLANNING/TECHNOLOGICAL ASSESS-
MENT. Such a morass of multiple "groupings" is obviously not generic,
since they concern socio-political "subject matter" and, despite the
numerous literary titles, eschew any suggestion of imaginary intent.

The importance and scope of Toffler's task are provoked by his
awareness that "today the whole world is a fast-breaking story." The
very obsolescence of his data, he says, verifies not only the book's
thesis about the rapidity of change and the experience of chaos, but also
the book's shape insofar as any writer today does not because he *cannot*
"conceive, research, write, and publish in 'real time'." The importance
of his message requires that he take "the liberty of speaking firmly,
without hesitation, trusting that the intelligent reader will understand
the stylistic problem." He never hesitates to use the verb "will" to
identify speculations as inevitabilities, nor is he troubled by reserva-
tions about other grammatical subtlety. Nonetheless, he claims for him-
self a voice distinct from the babel emanating from the legions of
"television oracles and newspaper astrologers" whom he admonishes.
He makes no invocational apologia for what he himself calls his "ina-

bility to speak with precision and certainty about the future," or for what he acknowledges to be his "impressionistic and anecdotal data."

Toffler makes numerous references throughout his book to religion as a secular institution, his purpose being not to justify the ways of God to man but rather to extol the virtues of "The Coming Ad-hocracy." This beneficent pattern of social organization, he maintains, will fortunately follow *now* "The Collapse of Hierarchy." He welcomes the dawn of neopagan celebration, hailing "perhaps even new religious sects or mystical cults to celebrate the seas," and replacing "The Fractured Family," whose "goals may be social, religious, political, even recreational." Religion as a secular institution is continuously discussed, but the name of God appears for the first time after 300 pages, as one element in a series of topics, distressing to Toffler insofar as they all provoke "value vertigo": "America is tortured by uncertainty with respect to money, property, law and order, race, religion, God, family and self." "Ad-hocracy" or "assemblies" or "utopia factories" would temporarily assuage everyone's sense of collective pain and social impotence, eternally provoke a specific and imaginative hope, high uplifted beyond hope. "Every society faces not merely a succession of *probable* futures, but an array of *possible* futures, and a conflict over *preferable* futures."

*Ars longa, vita brevis. Future Shock* avoids the "time-bias" of real and imaginary history, and cannot be identified as either. It is compendious but not selective, repetitious rather than coherent, detailed instead of complicated, and ingenuous without being ironic. Insistently optimistic, it presses the suggestion to "the reader" that his lifetime of change is even more heroic and perilous than it is accelerated and relentless. However the idea of "future shock" is conceived—the awareness that life is short or prolonged, or that living is more painful for its psychological jolts than for its succession of physical debilities— most readers would probaby concur that "The Death of Permanence" happened a long time ago, and not, as Toffler would have it, just the other day. That "the present moment represents a crucial turning point in human history," not to say *the* turning point, is a general theme and cultural cliché, the repetition of which is not self-validating, but rather self-parodying; the "value vertigo" it decries is represented by its own rhetoric.

B.F. Skinner's *Walden Two* is perhaps less widely read than *Future Shock* and certainly more intricate in its claim for worldly salvation by way of "behavioral engineering," but as utopian volumes they suffer similar shortcomings. While *Walden Two* is argumentative as factual matter, it is confounding as fictional matter. Not just substantively, but

also for its generic confusions, it has been described as the devil's handbook. Thus, many of Skinner's most sympathetic readers are unnerved, for instance, by his *reductio* of Satan's temptation of Christ in the wilderness, as a lollipop hung around the neck of a child, or when in the conversations of his personae, Jesus is spoken of as a "behavioral engineer," and transcendent Love is defined as a "positive reinforcement." Skinner often toys with a Christian worldview with inconsistent results, and this may be the main *literary* explanation for critical attacks on him.[22]

Frazier, the messianic director of Walden Two and the main interlocutor, is the main bafflement. In the earliest chapters he is described as something like a shepherd tending his flocks, or a cathedral guide, or a magician talking in a "figure of speech" about sheep and goats.[23] Then, as at the performance of Bach's B Minor Mass, he becomes scowling and impatient, brazen toward his guests, who attempt unsuccessfully to chasten him for his "godlike" manner. It is Frazier who argues that though "the world isn't ready for simple pacifism or Christian humility," and despite the fact that "Walden Two isn't a religious community," the emotional problems there can be solved by "behavioral engineering" and the employment of the "techniques of religion." Jesus is an "early colleague" of his, whom he resembles. Yet Frazier also trails odors of brimstone, and he acknowledges that his own behavior must seem "conceited, aggressive, tactless, selfish," insensitive in its "effect upon others, except when the effect is calculated." Having motives "ulterior and devious," and emotion "warped," he seems surely to be "one, at least, who couldn't possibly be a genuine member of any community." He is "a modern, mechanized, managerial Machiavelli." "Since we are dealing in 'M's, why not sum it all up and say 'Mephistophelian'?" Frazier *is* and *is not* either Christ or the Devil; his audience at once denies his veracity and regards him as an improbable hero, who may or may not think that he is God. "The principle of 'Get thee behind me, Satan,' . . . is a special case of self-control by altering the environment."

A larger if less baffling duality than Frazier's character is the nature of Walden Two itself. Though it obviously bears a place-name for Utopia, it both *is* and *is not* the Garden of Eden. In a fictional present time, it surely represents a chaotic idea of order in this world, just as it represents an organization of chaotic inclinations present not only now but also in some future world. Walden Two is indeterminately both a kind of Paradise Regained and a vestigial Pandaemonium. The last sentences in the novel are at once apocalyptic and millennial: "Frazier was not in his heaven. All was right with the world."

Skinner is more Mephistophelian than Miltonic.[24] Nonetheless, when

Frazier insists that he has only one important characteristic, his stubbornness, and has "only one idea in my life—a true idée fixe"—namely, "the idea of having my own way," of being reluctant to "yield to God in point of seniority," then the adjective "Miltonic" is curiously applicable to him. Like Milton's Satan, he states the limit and scope of his own character, that fixt mind and high disdain, from sense of injur'd merit, and descends from his "Throne" atop a "Stone Hill" to engage in "a pitched battle with the rest of mankind." Augustine Castle, Frazier's chief protagonist, admonishes him for "The revolt of the angels!" Nowhere in *Walden Two* does Skinner cite Milton; he suggests nonetheless his literary indebtedness, along with explicit allusions to numerous others: Plato, Aristotle, the New Testament, Dante, More, Bacon, Chesterfield, Rousseau, Mill, Bellamy, Freud. These allusions are, though specific, contiguous and oblique; there can be little doubt that Skinner's main intention is hortatory exposition, to justify the ways of science to the widest possible readership. Skinner suggests, if he does not always demonstrate, that he knows he wears two hats, expository and satiric, even though he seems to have them on at the same time, and he risks his readers' amusement regarding a comic effect which is not always intended.

In *God and Utopia* Gabriel Vahanian takes aim at what he terms "the apocalyptic delirium of a Skinner or the beatific enthusiasm of a Toffler," and what he calls the religiosity of "some of our contemporaries, like Harvey Cox, who seem to advocate it under the pretext of playing the Good Samaritan."[25] He is also critical of utopians Berdyaev and Huxley, whom I would call Miltonic for specifically generic reasons. It is true that Vahanian nowhere mentions Milton; in his two or three references to Adam, it is clear that his Adam is not Milton's, any more than his God is Milton's or even William Empson's. His book is not Miltonic but otherwise utopian, not just because he never mentions Milton but rather because of the *kind* of utopia this book is, a kind that has its own formal and textual character, in fact like Toffler's and Skinner's.

Vahanian's book might seem quite unlike Toffler's, not only for what it says but also for what it is. It has no bibliography or index and is in fact not very extensive, whereas Toffler's essay is bulky and weighted down with conspicuous scholarly trappings. Nonetheless, Vahanian is much given over, like Toffler, to neologisms and his own private uses of vocabulary in the public domain, and like Toffler he repeats himself. The two-page glossary, of not precisely denotative and theological terms, is preceded by a four-page note on them hoping that "the reader will indulge the author's habit, acquired in the course of this work, of defining some categories en route, while their meaning is unfolding or

as the argument is drawing to a conclusion." Like Skinner, Vahanian is often laudatory about creators of some "antiquated notions" and "traditional thought"—Augustine, Thomas Aquinas, Copernicus, Luther, Calvin, Marx, Nietzsche, Freud, Einstein—he himself seems anxious to abandon. However, name-dropping is much more frequent than quotations, or even textual references and allusions, and many of his few footnotes have no page references.

At the very least, what Vahanian calls "technological utopianism" looks funny to someone at home with machinery and the laws of gravity. View these brief quotations, for example, which read like jokes, or at least word-games:

> There is no real difference between a hammer and a spaceship, no real difference either between the invention of fire and that of the steam engine. On the other hand, in standing upright, man makes a greater leap toward the human than when he steps onto the moon.

> As a utopianism of the real, nature comes into play only from the moment that it is transformed into a vector of human nature. In the same way, history as a utopianism of the real comes into play only to the extent that it is transformed into a vector of man's freedom.

Machinery has always had uses in utopia that border on hilarity, in the sense that physics and metaphysics have contradictory referents and different languages. Attempts to obliterate those contradictions and differences force the idea that both Hythloday and Gulliver are Everyman, alive and well. The vector forces by which Vahanian means to adjust an imaginary Utopia are real, though he seems to suggest that these forces are imaginary and his utopia is real. Vahanian is a man of letters, not a man of science, so it does not matter that for him a vector is an indeterminate metaphor, an indefinite referent, or both. On the other hand, a physicist, if not a metaphysician, cannot ignore vector forces; and an aeronaut who disabuses vector forces—lift, weight, thrust, drag—at best will not get off the ground, and worse than that can happen to him.

Despite Vahanian's disesteem of "antiquated notions," some very old literary strategies occur in his text anyhow—Metonymy: "Attracted as much by one as by the other of these motifs [God as man, the "otherness" of God], Christianity oscillates between the two"; Synecdoche: "As soon as Adam yields to the serpent's prompting he confuses paradise with nature and loses both." Continuously, Vahanian tries to show "how technological utopianism is in this respect the heir of that dialectic"; but in "that dialectic," precision of form and thought seems to me lost, somewhere between "the polarities of incarnation and redemption," between the frequently repeated "fundamental twin no-

tions of *eschaton* and *novum*," in the forced (purely verbal?) effort expended "in aligning the dialectic of the *eschaton* and the *novum* on a *coincidentia oppositorum* in which transcendence and immanence are the actors (actants)." The definite article appearing before the Greek and Latin nomenclature, and the Latin parenthesis explaining the theatrical commonplace, do little to define and clarify. I think that one result of this divorce of the form of language from the substance of thought can be called unintentional satire.

In "The Cunning Resemblance," a profound essay on the function of parody in Milton's poetry, B. Rajan argues that "language and even the interplay between the structures of myth and the structures of language, do not wholly account for the difference between the path of literature and the highway of the cliché."[26] Undoubtedly, literature is not merely cliché, nor is a path a highway. Rajan suggests that though a highway is paved and graded, it can be crowded and slow-moving, too; a path is prettier, perhaps less taken, yet the better way. Still, are not literature and cliché "extended oppositions" that comprise "more than a poetic technique or literary strategy"? Like Wimsatt in his "hateful contraries," Rajan goes a long way toward identifying the multifariously "dialectical engagement of opposites" throughout the structure of Milton's poems, massed contraries, contending principles, both in life and in art.[27] "Parody refined into the cunning resemblance is the *modus operandi* of temptation," he says. "When evil is thought of as the ultimate perversion of the good, it follows that the perverting energy will seek to declare itself in parodic utterance. . . . In a poem such as *Paradise Lost*, parodic structures are a continuing and powerful reminder of how lasting hell is to be apprehended as the maximum possible distortion of lost happiness." In this sense, Christ and Satan are not only dramatic protagonists but parodic figures as well. Rajan's main point is that parody is not merely a literary device, strategy, or architecture, but rather "part of an education in the nature of vision." Cunning is not only adjectival but substantive, not only verbal but real.

Two questions thus occur: What happens when the *nature* of vision is lost, the path no longer trod, and the highways become crowded? Doesn't parody continue to function anyway? Many years have passed since C.S. Lewis defined the function of parody in allegory, itself a generic function of Christian conscience.[28] He argued that "the antagonism of the two ideals" in religious awareness, the pitched battle, the "root" of medieval allegory, has its modern and secular equivalents in felt conflicts between duty and inclination and that, as I remarked earlier, its personifications have their "obvious parallel" in modern psychoanalysis. If Lewis is correct, there are kinds of parody that are not Miltonic in the visionary sense which Rajan sketches, but rather

mere functions of the libidinous and egoistic personae inhabiting everyone's unconscious.

What *is* the distinction we can make between Christian allegory and literary parody? Will everyone agree that allegory has real referents or that parody is cunningly real? Or, is parody as much imaginary as it can be un-Christian? Is literary parody identical with the travesty of real life? Richard Poirier, in "The Politics of Self-Parody," says that "parody constitutes criticism of the truest, often the best kind," and he gives a special prize to "a literature of self-parody that makes fun of itself *as it goes along.*" According to Poirier, "the difference between older kinds of parody and this newer one is . . . the distinction between . . . criticism that trusts in *a priori* standards of life, reality, and history, and a criticism that finds only provisional support in these terms." In the same essay he asks whether "anyone sufficiently honest about his own experience of 'great' books" would admit to having read all of "*Paradise Lost* or other monsters of that kind, if it weren't for school assignments, the academic equivalent of being asked to write a review?" He argues that the traditional literary genres are the disposable baggage of Western culture, a cumulative pollution that can be stopped by sophisticated ridicule, parody, and deliberate verbal disorder. Though he acknowledges "the risks inherent in self-parody," being itself cumulative, his claim is that today's literary giants are precisely those who refuse to take themselves, or anyone else, seriously. He concludes: "Nothing we have created, in politics or literature, is necessary—that is what humanly matters, by way of liberation, in the writings of self-parody." Rather differently, Matthew Hodgart argues that "there are strong elements of travesty and anarchistic parody in *all* good satire," that "the framework for satire is often a travesty or parody of the most serious forms of literature." Hodgart observes, however, that travesty is "one fairly constant element" of obscenity and scatology also. Karl Mannheim defines the literature of both utopias and chiliasms, with no mention of Milton, as a function of "Wish-Fulfilment and Utopian Mentality": "Myths, fairy tales, other-worldly promises of religion, humanistic fantasies, travel romances, have been continually changing expressions of that which was lacking in actual life."[29] One thing certain is that generic definitions are always elusive. Perhaps there is a sense in which parody is not necessarily witty or comic, but simply *is,* like allegory or travesty, not easily distinguishable from them and not necessarily an art form either.

# 5

# "Neare twins" in Religious Sociology

In both art and science—for the purpose of this chapter on satire and sociology—religion is controversial. Why? Because one shared inclination of satire and sociology is to perceive religion as a social rather than as a spiritual body. In *The Origins of Attic Comedy*, F.M. Cornford wrote that "there may be movements of spiritual life which the most complete sociology will never describe in general terms," that the "movements of spiritual life" have their "rude beginnings" within "comic drama which no individual genius could have invented." He argued that comedy and tragedy have origins and sources that "lay so close together" however much they have drifted apart in the fullness of time. There is a protosociology in the ancient metaphor of his generic definitions: Comedy is "the mirror of society," whereas "Tragedy, on the other hand, is anything but the mirror of contemporary society. . . . Tragedy, as conceived by Aeschylus, will not move towards holding a mirror up to ordinary life." Comedy and Tragedy (his caps) are "two species of dramatic art." Cornford argued for "the supposition of a conscious rescue of Tragedy from its 'satyric' phase—a deliberate expulsion of those elements which distinguish the satyric drama from the tragic plays to which it was so closely linked."[1] Of course, the secular dilemmas of church and state, unlike those esoteric "movements of spiritual life" Cornford alludes to, are amenable to physical description in the body politic if not the mystical body of Christ, in satire and sociology farther back than Lucian and Jerome, and continuing to the present day.

In *Satyre III* John Donne metaphorically identifies a persistent curiosity of religion, insofar as "our Mistresse faire Religion" is in appearance

"Neare twins" to strumpets, wenches, and whores. The social face of
religion, to say nothing of its bottom, is not always distinguishable from
its abuses. Its contours are neither unattractive nor unfortunate, but
anatomical description can be misconstrued. No doubt, too, the per-
sonal motives of literary theory, like the private intention of marital
acts, defy easy simplification or even summary. The search for religious
truth, Donne suggests, is like more mundane courtship and foreplay,
requiring virtually ethereal as well as surely physical choices. Reli-
gious satire itself suffers the generic or genealogical inference that it is a
bastard off-spring, being not entirely fictional. Though sired by writers
with presumably divergent intentions and emphases, satire and sociol-
ogy are born from the same object of attention. Perhaps their family
resemblances can be ascertained insofar as satire and sociology can be
characterized as both fictional and reportorial, imaginative and objec-
tive, symbolic and representational.

My concern is with textual similarities in literature and sociology,
not in literature and theology. I accept several widely expressed view-
points: that sociology is "one of the intellectual disciplines to which
literature would appear to be most obviously connected"; that "sociol-
ogy and literary study are both well-established disciplines with dis-
tinct conceptual frameworks, but they do have certain elements in
common"; even that, in the text and context of satire, "since very little
of our literature is 'religious literature,' there is a limited need for
'religious' or theological critics." There remain, of course, large prob-
lems concerning the precise connection between literary study and the
sociology of literature, represented by such pioneers as Levin
Schücking and H.D. Duncan, and more recently by Malcolm Bradbury,
Diana T. Laurenson and Alan Swingewood, and Joseph P. Strelka.
Their problems are beyond the scope of this chapter to the extent that
they are not specifically generic or formal. But Laurenson and Swinge-
wood do address themselves to widespread and antinomious predis-
positions, very much to my purpose, "both to those who believe that
social science is simply the study of *facts*, and to those for whom
literature is a unique subjective experience which defies scientific
analysis."[2]

Imbalance of humors and the straddling of opposites are the basis
both of uncomplicated jests and of the constructs of knowledge.[3] Like
the "missionary position," they involve some awkwardness of posture
in both body and verbal languages. That utopian fantasy and science
fiction, the best of it anyway, *is* satiric, most everyone knows. Their
tradition in English literature since the Renaissance—from More and
Swift to Butler, Wells, Huxley, and Orwell—is especially effective
when it imitates scientific objectivity, despite all the revealed varieties

of belief and unbelief, from orthodox to apostate. On the other hand, empirical scientists often seem unsuccessful in ignoring—or sometimes just avoiding—ridicule in their descriptions of religion even as they strive for strict objectivity.[4] Satire, poetic or sociological, can be unintentional on two counts: to fail to distinguish the "spirit" of religion from its real abuses is to be ridiculing—or ridiculous—and, more insidiously, to describe those real abuses can be to infer a disesteem of "our Mistresse" herself. One result of this failure is the kind of unintentional satire described in the preceding chapter. Both satire and sociology, like satires and utopias, have equivocal reputations in theory and practice, not only because of what they are and do, but because of what they look like.

Earlier I discussed how William James defended his empirical objectivity, despite the challenge he felt regarding his apparently limitless topic and the subjective nuances of style he knew it provokes.[5] His awareness and Cornford's are entirely similar in this regard: empirical though vast objectivity *and* subjective yet focused style. James sees in the psychology of religion the inevitability, or appropriateness, of one kind of literature; he argues that a "large acquaintance with particulars" and concrete examples of religious temperament may seem to offer an unscientific "caricature" of his subject; and he suggests that "convulsions of piety are not sane." With sardonic but also apparent good humor, he expresses the hope that his seeming caricatures of pious convulsions would give his readers an unfavorable impression only until the middle of his book. *Variety* is a generic word for a sometimes satiric world, not only the name of a trade paper in entertainment but also a synonym for bagatelle, farrago, and hodgepodge. James may have felt that varieties are more fundamental than unities, which is the kind of message to be derived from numerous theatrical and cinematic entertainments in every decade of popular culture. James's *Varieties of Religious Experience* is shot through with *je m'en fichisme*, "the systematic determination not to take anything in life too solemnly"; he sympathetically quotes Voltaire to the effect that "I can look upon the world as a farce even when it becomes as tragic as it sometimes does," and Renan's statement on the world as "fairy pantomime." But there seems to me to be an important curiosity in the fact that though James's topical notion of religion includes its secular hostility to "light irony" as well as to "heavy grumbling and complaint," his book is itself larded with both. He offers numerous apologies throughout, to the effect that a study of human nature's "exaggerations and perversions" has a positive value, and he makes numerous quotations from biblical as well as scientific literature not only to illustrate them, I would think, but to justify them as well. It seems to me that James's literary viewpoint is

Miltonic in the sense that he depicts every man—including himself—as
L'Allegro and Il Penseroso, or indeterminately, as either one. In the
second half of *Varieties* James writes that "were I to parody Kant, I
should say that a 'Critique of Pure Saintliness' must be our theme." He
does then shift his focus away from "religion as an individual personal
function" and toward "religion as an institutional, corporate, or tribal
product," or the "spirit of corporate dominion." He continues to quote
examples of the "*abgeschmeckt* and silly" in the lives of excessively
devout, pure, and chaste persons, all the while showing how "the Uto-
pian dreams of justice [of] contemporary socialists and anarchists . . .
are . . . analogous to the saint's belief in an existent kingdom of
heaven." He constantly employs rhetorical strategies of hyperbole
when attacking his subject, and of understatement about the nature of
that attack; he is *not* objective about his subject, nor toward his audi-
ence.

Ten years after James delivered his lectures on natural religion at
Edinburgh, Freud wrote his major contribution to the psychology of
religion. Insofar as it also extends the analysis of the individual psyche
to include society and culture at large, *Totem and Taboo* qualifies as
unintentional satire, though not for the same reasons that *Varieties*
does. Freud, following James Frazer, says that "totemism is a religious
as well as a social system"; he is willing to forgo the question of
"whether the two sides—the religious and the social—have coexisted
or are essentially independent." For him, both religion and society
originate from the remote past in the psyche of the mass and are a result
of collective neuroses. We can see in this hypothesis some uninten-
tional humor, or perhaps some unconscious wit; Maritain's rejection of
it, a representative one, reads like literary explication:

> Without a smile, in *Totem and Taboo*, Freud explains that one day
> "expelled brothers came together and killed and ate the father, thus
> putting an end to the existence of the paternal horde," and this cannibal-
> istic act is not only the origin of totemic sacrifice and exogamy, but it
> gives the key to all religions. Freud concludes, "I can therefore terminate
> and summarize this brief investigation by stating that in the Oedipus
> complex one finds the beginnings of religion, morality, society, and art at
> the same time." This, on the part of the father of the Oedipus complex, is
> pushing paternal pride a little too far.[6]

Attempting to explain away the difference between religious and social
values by identifying them "without a smile," Freud draws a picture of
mankind in a conflict that probably cannot arouse laughter. His pro-
nouncement is questionably scientific or factual; his intention was cer-
tainly not satiric.

Still, the social sciences vie with satire for the same subject. Emile Durkheim thought "the religious" is identical with "the social." For, "in a general way . . . a society has all that is necessary to arouse the sensation of the Divine in minds, merely by the power that it has over them; for to its members it is what a God is to its worshippers." If this generalization is valid for the past, it may not make clear sense to speak of a society *becoming* its own religion now and in the future. Closer to the sociological viewpoint of Bronislaw Malinowski, it ought to be possible to see "the character of the domain of the *Sacred* and mark it off from that of the *Profane*," without regarding religion, as Freud did, as a matter of explaining or projecting one's dreams, or as Durkheim did, of developing social conventions.[7] The crucial and perennial distinction between God and Caesar reveals itself as an unreconciled sociological perspective: religion is regarded as a means to individual immortal salvation, or to mortal achievement of psychological and political varieties. Some social scientists resolve the perennial dilemmas by ignoring them, and become vulnerable to fellow social scientists and subject to satirists.

Werner Stark's massive quarrel with Rudolph Sohm and Max Weber is a case in point. Stark insists on the identification of priests as saints, some of them at least, from the beginning of Christianity and even before, constantly reiterating the argument: "Perhaps it is natural for men like Sohm and Weber to think of the clergy in essentially bureaucratic terms; it is certainly unnatural for believing Christians to see them in this light." The *intention* of the sociology of religion is to be impartial. Whereas one practitioner, Joachim Wach, describes it as nonevaluative and descriptive in its intention, an objective study of the interrelation of religion and society, satire always has had built into it evaluation and prescription. The social sciences attempt to define religious and social values, in Maritain's phrase, "without a smile"; satire attempts with a smile to provoke a laughing response. Thomas F. O'Dea has posited this fundamental dilemma of the sociology of religion: that it does not—or cannot—concern itself with the truth or worth of the supraempirical beliefs upon which religion rests, that is, the ultimate meaning of and man's place in the overall scheme of things, the sacral mode of consciousness, and the existence of God. His concluding words are a validating quotation from the greatest English satiric poet: "Know thyself, presume not God to scan;/ The proper study of mankind is man." Stark's single reference to the *Essay on Man* is equally brief, but unappreciative: "Alexander Pope's word that 'discord' is 'harmony not understood' and 'partial evil, universal good' is too glib to be acceptable in an honest view of what in fact happened during the Church's pain-punctured millennial march through time." Apologists

on all sides can probably agree that though religion makes laudable contributions to the preservation of society, it has always caused disruption and destruction as well. Nonetheless, sociologists strive for value-free objectivity, which is a professional aspiration: "Sociology as a science is concerned neither with endorsement nor its opposite, but with accurate description and analysis. The thinking individual must take responsibility for his own course of action."[8] One might suggest that the satirist is in some degree both a sociologist and a thinking individual; he deliberately assumes the responsibility for seeing the difference between religion and the abuses of religion in society; his concern to make an "endorsement or its opposite" is implicit in his willingness to assume the burden of this responsibility.

In terms of what David Riesman calls "social character" and "characterological struggle," changes in audiences' attitudes toward religion might be regarded as "adjustment" in what is becoming, from a satirist's literary viewpoint, an increasingly "other-directed" society.[9] Whatever their private social and religious convictions, satirists are neither "adjusted" nor "other-directed," otherwise they probably would not bother to write satire. Rather, they are "anomic" or "autonomous"—malcontented or impervious—as all satirists have always been, or at least have claimed to be. They are primarily religious in their societal notions, "tradition-directed" priests or converts like Knox or Chesterton, or they are "inner-directed," carrying on feuds with organized religion, like Bernard Shaw. Riesman's terms are sometimes regarded as subjective rather than scientific. They are, in any case, comparative and often reinforced with literary illustrations; and some of his explanations for character "direction"—his compass-gyroscope-radar metaphors, for example—are as poetic as they are technological. Considered for their intentional implications and professedly historical derivation, they are in a strict sense diachronic rather than synchronic, and extend beyond the subject of American sociology. To the extent that it illuminates the connection between literature and life in many ways, The Lonely Crowd might be regarded as literary theory as much as scientific scholarship. Riesman's tendency toward categories that have satiric tones, buttressed with literary quotations, is one explanation why his book, though much admired and widely read, raises eyebrows among some professional sociologists.

The fact that the social scientist vies with the satirist for the same subject helps explain the misreadings of sociology and satire alike. Religious fundamentalists, for example, find it possible to imagine sociology as a challenge to sanity or faith, insofar as "the Christian feels almost schizophrenic because he knows he should see society in relation to God, but for the purposes of his studies he has to look at society

in an entirely man-centered way," and to the extent that "the sociology of religion has a very threatening appearance to the Christian."[10] It is not only satire that describes religion in its social rather than its spiritual configurations, looks like ridicule, and, apparently for this reason, inspires or provokes counterattack. The inevitability of controversy as ridicule may be not only psychological but sociological too, like James's antithesis of somber and sanguine temperaments. Surely, what I am calling unintentional satire, as a mode of perception, is to be found in sociological profusion. Satire and sociology are "Neare twins" in the sense that they are perceivably "Siamese," like Piet Hein's tragic and comic masks, and can be said to join from their earliest origins and sources.

The library of verbal configurations that can illustrate this proximal equivalence is a vast one; a few random selections may suffice. Thorstein Veblen, identified as a "sociological Swift," often breaks the tone of scientific objectivity; another reason for the Swiftian label may be that Veblen avoids any apparent theological or metaphysical intention.[11] Describing the socialization of religion economically (in both senses of that word) as the "pecuniary stratification of devoutness," Veblen ridicules the "proneness to devout observances" manifest in all classes.[12] However, the observances (church services, weddings, funerals) tend to be more social than religious among the upper class. The middle or "doubtful leisure" class, in their socially precarious position, are unable to correct or abandon the "devout habit of mind" of their social inferiors (who may also be relatives or even members of their immediate families), or to simulate the "great stress on ceremonial . . . accessories of worship" expended by the upper or "leisure" class to which they aspire. Veblen thoroughly identifies the amalgam of social sensitivity and religious "accessories." We may question the total validity of his economic stratification, or the exclusivity of the middle-class quandary; but literary satirists employ terms similar to his, this socio-economic twist of religious values occurring repeatedly as they pursue their subject beyond economic limits.

The constantly international, literary satiric view suggests a scope beyond and including most political boundaries as well as geographic locations. Will Herberg's *Protestant—Catholic—Jew*, is a study of America's faith compounded of its three religious traditions and its national heritage; modestly subtitled "An Essay in American Religious Sociology," it is certainly comprehensive: "The American Way of Life is, at bottom, a spiritual structure . . . of beliefs and standards; it synthesizes all that commends itself to the American as the right, the good, and the true in actual life. . . . It is a faith that has its symbols and its rituals, its holidays and its liturgy, its saints and its sancta." Though

Herberg's study is not strictly economic, it is geographically limited; yet its implications transcend national facts. Similarly, Louis Schneider and Sanford M. Dornbusch in *Popular Religion* draw the intergeneric connection between inspirational books and American life, suggesting that the trends giving rise to such literature extend well beyond special cultist movements; their study, however, is restricted in its view of the genre as "part and parcel" of American culture specifically. "One can hardly doubt," they say, "that it is distinctively 'American' and reflects American values. . . ."[13] They do frequently emphasize the apparently unintentional humor and irony in inspirational books, though they do not concern themselves with the genre outside of the United States.

Peter L. Berger, in an appendix to *The Social Reality of Religion*, discusses the impossibility, for theoretical reasons, of "dialogue" between sociologists and theologians; he argues the case that empirical inquiry into religious matters must necessarily be based on a "*methodological* atheism." But even the titles of some of his half-dozen books on the sociology of religion seem to violate the intellectual secularity he advocates. In the preface to *The Sacred Canopy*, Berger insists that "this book is not 'a sociology of religion'" even as he states its purpose, "to push to the final sociological consequence an understanding of religion as an historical product." In *The Noise of Solemn Assemblies* and *A Rumor of Angels*, he shows how North American societies, independent of national and geographic particularities, are integrated by organized religions, which infuse political institutions with religious symbolism and provide machinery for social and psychic "adjustment." A recurring subject matter in these books is the rediscovery of the supernatural in modern society, as a mere defense against anomy, and he writes pungently about it. Berger is expansive in the scope of his sociological intention, biblically allusive rather than scientifically objective, and consequently satiric. The vast library of antiutopian or dystopian satire presses Berger's main argument, that in present time society does function without religion as it has existed in the past.

The relation between playing and praying, comedy and Christianity, fantasy and festivity in the modern world, is the subject of Harvey Cox's *Feast of Fools*. Like his earlier bestseller, *The Secular City*, it is primarily theological, perhaps even evangelical, rather than scientific; still, his depictions of "Festivity and the Death of God," "Fantasy and Utopia," "Mystics and Militants," and "Christ as Harlequin," carry conceptual ironies which themselves define the psychological and sociological urgencies of contemporary religious phenomena. Some unintentional satire is more tenuously definable, insofar as it tends to

be neither ridicule nor sociology. Cox himself, for *The Seduction of the Spirit*, receives adverse criticism on literary grounds. Bryan Wilson's *Religious Sects* can be described as neither satire nor as sociology but rather, like Ronald Knox's *Enthusiasm*, as a mere religious entertainment and a catalogue of world-wide foibles of belief. G.W. Target in *Evangelism Inc.* is "amazed, amused and saddened" by the international industry of Billy Graham, but his study is less urbane scholarship than heated polemic. Alan Bestic's *Praise the Lord and Pass the Contribution* investigates how the evangelistic entrepreneurs attempt to justify the ways of God to Mammon, in the holy affluence of America; the author, a Protestant Irishman, can scarcely do it straight-faced, much less with restraint or decorum. Representative of the latter tenuous strain, John M. Allegro's *Sacred Mushroom and the Cross* in evident seriousness depicts Moses and Jesus as a couple of mushrooms and God as "the mighty penis in the skies, ejaculating semen in the violence of the storm." This book has provoked enjoiners equally serious, perhaps equally silly, like John C. King's *Christian View of the Mushroom Myth* and John H. Jacques's *Mushroom and the Bride: A Believer's Examination and Refutation of J.M. Allegro's Book The Sacred Mushroom and the Cross*.[14] Perhaps such exegeses as these last might more accurately be defined as unintentional parody.

The history of sociology records how social theory, at once serious and strange, reads like whimsy, neither art nor science. Louis Schneider observes: "It is perhaps hardly needful to say that to 'make fun' of the literature in any way would be inept, if for no other reason than for the reason that it shows signs of aspiration beyond its own limitations and it would be sheer inaccuracy to miss this. But the literature is *sometimes* so extreme in its assertions that a description can easily give the quite unintended impression of caricature." Alan Swingewood identifies the perception of the social world as largely the work of man, not of divine providence, as the "common postulate of eighteenth-century writers." On this basis he makes the generic identification of Mandeville's *Fable of the Bees* and Montesquieu's *Spirit of the Laws* as "early examples of proto-sociology."[15]

Literary historians Leslie Stephen and Basil Willey account for the flourish of satire in eighteenth-century England precisely in social conditions, and in social thought of several kinds. Thus, Stephen implies that Adam Smith, Jeremy Bentham, and William Paley were as curious as they were popularly received: Bentham's "view of philosophy in the lump was that there was no such thing"; Smith, though one of the century's "great thinkers," has "equally characteristic" limitations; and Paley "is as empirical in his theology as in his ethics, and makes the truth of religion essentially a question of historical and scientific evi-

dence." That science, not just social science, was the primary means of seeming to resolve the century's religious problems is a predisposition that often provokes irony from those who describe it. Satire, even in unintentional forms, is identifiable much further back than sociology is, strictly speaking. The family tree of these "Neare twins," satire and sociology, is difficult to trace even though it does not go back much before the eighteenth century. Basil Willey notes that "the Utopian method of satirizing or criticizing one's own civilization was of course a well-established convention" even before the eighteenth century. He seems repeatedly startled that much of the period's thought violates that convention, not only in Defoe, if not in Swift and Mandeville, but also in those more solidly on the genealogical side of the sciences: John Ray, "usually accounted the founder of modern botany and zoology," whose *Wisdom of God in the Creation* (1691), though not exactly satiric, "became something of a classic" in the century; William Derham, "in no way remarkable either as a scientist or theologian," whose *Physico-Theology* (1713) nonetheless reached twelve editions and three other languages; David Hartley, who in his *Observations on Man* (1749) "evolves his religion . . . from a study of human psychology"; and Paul Henri Holbach, who "began writing Encyclopedia articles on minerals and kindred subjects, and ended as a moralist and sociologist."[16] These and others who were more or less luminaries in the literary firmament establish what Willey sardonically calls "cosmic Toryism" and "Socinian moonlight." Such Tory moonlight is, by his definition, an ingenuous metaphysical optimism about the universe in relation to the possible perfectability of man and his social order. This order is good because God made it, and evil only in the sense that vulgar and unenlightened masses of people are actually content in their inferior unhappiness. In short, though Stephen and Willey are concerned with the thought "content" of the period, they also point out an unintentional "form" as well, an ingenuous one that invites adverse appraisal.

By the turn of the eighteenth century the parenthood of the near twins of satire and sociology of religion can sometimes be both assigned and clearly legitimated. Pope, for example, was not only the greatest English satiric poet, he was also something of a sociologist; in his Notes to the Reader in the *Essay on Man*, he reveals his interest in "the Nature and State of MAN, . . . as an Individual, and as a Member of Society," and his intention to deliver from the "science of Human Nature" its *"few clear points."* His contemporary Montesquieu has been called a forefather of social science, too, for the *Persian Letters* is at once a social documentary on Persia as well as an epistolary satire on eighteenth-century French institutions. Certainly Pope and Montes-

quieu started out with different viewpoints and intentions. Pope was an orthodox Catholic layman, whereas Montesquieu, though he never openly disavowed traditional Christianity, frequently took the stand that civil morality is the true basis of all religions and accounts for their value and their equality. "In truth," he has Uzbek say in the *Letters*, "should not the first object of a religious man be to please the divinity who established the religion he professes? The best means of succeeding in this is doubtless to observe the rules of society and the duties of humanity." "Moreover," Uzbek says later, "since every religion contains some precepts useful to society, it is right that each should be observed with devotion." Pope's religious orthodoxy, like Swift's, has never saved him from being misread; and the poetic problem of identifying him among his personae has been notoriously long-lived. Nor is this kind of problem alleviated in verse or prose; if it is true that Montesquieu's delightful and instructive exposition developed into scientific discipline only in the next century, it is also true that the genre remains a literary puzzle.[17] The similitude of Montesquieu's ideas and those of his persona Uzbek, as with Swift and his Gulliver, is an intricate literary problem. The passages on the Troglodytes may be, as one recent editor claims, the very heart of Montesquieu's thinking on government as a social institution; but Montesquieu on the Troglodytes is as vexing as Swift on the Houyhnhnms. There is an "identity crisis" in satire here that is not only individual and literary, with reference to personae, but social, with reference to institutions and to their scientific study.

Such generic identity is a problem that concerns not the origin and development of literary forms as such, but rather their mutant occurrence. Mandeville's *Fable of the Bees*, for example, has always forced its readers to grapple awkwardly with guesses about what Mandeville is satirizing, partly because it is not always apparent that it is satire he has written. Within the *Fable* itself is the short satire in Hudibrastic verse to which he wrote a lengthy exegesis. In it, human society is shown to be a beehive, imaginatively described as prosperous and beautiful only as long as pride, selfishness, corruption, hypocrisy, fraud, and injustices are freely and widely practiced; ". . . fools only strive/ To make a great and honest hive. . . . Without great vices, is a vain/ Eutopia seated in the brain. . . . Bare virtue can't make nations live/ In splendor." When Mandeville's ingenuous description of society as a hive full of sweetness and light is not taken seriously, what you get is, as Basil Willey says, a misanthrope and austere Christian moralist. Similarly, what is to be made of Defoe's *Robinson Crusoe*? This fable is often read as unintentionally funny in its exaltation of middle-class busyness, which is perhaps innocent and whimsical in isolation, as on

an island—the locale of numerous utopian fantasies—but also is destructive and grotesque in the competitive forms it assumes in real society. Ian Watt says Crusoe's island is "the utopia of the Protestant ethic," where Crusoe's adventurous spirit is tenuously reconciled to his practical interests; and, Watt asks, "can we be sure that [Defoe's] irony is not accidental?" Martin Price, who claims to perceive both a formalism as clear as it is ironic in *Fable of the Bees* and an unmitigated purpose in Crusoe, seems hard-pressed. Speaking of the "primary" method of Mandeville's satire, or of the "fundamental" ambiguity of his "rational artifice," as Price does, leaves a lot out of consideration. Is not Crusoe an inept symbol of the Christian seeking his salvation in this imperfect world? Not intending to argue the case either way here, I simply maintain that Mandeville does not always intend satire, and Defoe perhaps even less frequently.[18]

Though religious satire and religious sociology are "Neare twins" with numerous complementarities, we can see that they are not identical. It is only when, as Donne might say, we turn them upside down that "our Mistresse faire Religion" looks like a strumpet, a wench, or a whore; yet their generic similarities seem to suggest other genealogy than a strictly literary one. The fictional form of the body of religious satire is inseparable from the facts of its existence. How it behaves is not necessarily and merely a function of what it looks like. Heredity, environment, and free will are involved; surely, it is an obvious and wrong simplification to think that the nature of any literary genre, like the aesthetics of any woman's appearance, is a function of any one thing.

How satire attempts to act "correctly" can be understood if not appreciated; how satire particularly distinguishes between religion and its socialized abuses can be suggested in a contrast of Swift with Priestley. Swift's *Argument Against Abolishing Christianity* and *Tale of a Tub* are familiar and, if not in all particulars, easily understood as religious satire. Written on the eve of the French Revolution, Priestley's *History of the Corruptions of Christianity* is a defense of religion which involves not satire on the abuses of traditional Christianity but rather an exorcism of virtually everything in it. His prose has the ring of Swift's, and it is hard to remember that what he wrote was intended as a social prophylactic and not as hyperbolic satire. With an eye to the eventual purification of religious vestiges, Priestley considered the liturgy of the Mass, for example, to be the most "extraordinary" accretion of abuses; though he explicitly approved of its social or public function among "primitive christians," he deplored the fact that from its very inception it was regarded as a sacramental act of faith. The whole Protestant Reformation, too, was for him baffling where it was

not inept: "It is remarkable that with respect to most of the reformers from popery in the sixteenth century, the article of the eucharist was the last in which they gained any clear light." For himself, this superstitious "article" had only the social value "to communicate":

> I would only advise the deferring of communion till the children be of proper age to be brought to attend other parts of public worship, and till they can be made to join in the celebration with decency, so as to give no offence to others. This being a part of public worship, there cannot, I think, be any reason for making them communicate at an earlier age; . . . their attendance . . . is the object to be aimed at. . . . I flatter myself, however, that in due time, we shall think rationally on this, as well as on other subjects relating to christianity, and that our practice will correspond to our sentiments.

I quote Priestley here to illustrate literary rather than religious problems: Just exactly where is there a satiric intention? *Is* there one? For the Anglican Dean Swift, religion and science were frequently grotesque; whereas Priestley, a scientist as well as a clergyman, saw utopian progress in both. Priestley has claims to fame both honorable and unassailable: he was the discoverer of oxygen, the author of a history of electricity, a psychologist and a theologian, a social reformer and a political revolutionary, and an emigrant to Pennsylvania. Priestley's writings have an amazing range; they number in all 509 items, with many editions and translations, given Polonius-like classifications in his bibliography: theological and religious, political and social, educational and psychological, philosophical and metaphysical, historical, and finally, scientific. His leading biographer in the twentieth century labels him "Adventurer in Science and Champion of Truth." Whatever else he was, Priestley was no poet, at least not intentionally, though obviously he did have interlocking interests of other varieties. Any reader is made to ponder in at least two directions: how Priestley's accomplishments are related to his disavowal of what he called all the "other subjects related to christianity," from baptism to last rites, and, how such disavowal is related to the vast dystopian English literary tradition of the last two centuries.[19]

Raymond Williams suggests that "what were seen at the end of the nineteenth century as disparate interests, between which a man must . . . declare himself poet or sociologist, were, normally, at the beginning of the century, seen as interlocking interests." Auguste Comte, only two generations removed from Montesquieu and immediately following Priestley, is generally acknowledged as the founder of sociology, giving that modern and "soft" discipline its name and elevating it to the scientific prominence of its "hard" and ancient siblings, such as mathematics, astronomy, physics, chemistry, and biology. Priestley was rep-

resentative of the social formulation of new religion; Comte was its most effectual and unabashed spokesman, it can be said, though some others, like Jean Marie Guyau might also qualify for this particular honor, arguing as he did that the salvational basis for all religions lies in "mythic or mystic sociology." Still, Comte, born into a Catholic and monarchist family, was the most influential prophet of an extensively amalgamated socio-religion; he describes, in a style of unrelieved prolixity and ingenuous approbation, what many readers regard as a virtual parody of Roman Catholicism. Even Raymond Aron, one of Comte's most sympathetic readers, ends his summation with qualified praise, saying that "of all the sociological religions, Comte's sociocracy seems to me philosophically the best," but that it is also "politically the weakest"; Aron poses the apologetic question whether Comte's "religion of human unity" really could be surpassed in its attempted solution of temporal, if not also transcendent, problems.[20]

Whatever spiritual values are contained in Comte's subject matter, it is possible to say of the literary form he gave them that the "excessive length and prolixity and the clumsy style of his mature works" can be explained autobiographically as well as sociologically. Comte is like Priestley on two counts; he was straight-faced and earnest in his utopian expectations, and he seems to have been not a bit sardonic about them. Religion of Humanity services might be regarded as a parody of Christian liturgy, but they were intended and attended in dedicated seriousness by English advocates for more than three decades. In what Comte calls the "transitional modern period" since the Reformation, the destruction of Catholic and Protestant disciplines alike, their hierarchies, and in fact all Christian dogma, he regarded as inevitable and good. Though Comte deserves his reputation as the founder of sociology, his great historical influence was as the founder of a religion; "Comte is a reformer before he is a scientist, and it is small wonder that, sharing the preoccupations of his age, he should have ended as an archbishop."[21]

Like Priestley, Comte was a scientific clergyman, certainly, not a religious satirist, and stylistically he too is confounding. He sees humanity as its own object of worship, its own divinity, and possible only *now*: "Towards Humanity, who is for us the only true Great Being, we, the conscious elements of whom she is composed, shall henceforth direct every aspect of our life, individual or collective. Our thoughts will be devoted to the knowledge of Humanity, our affections to her love, our actions to her service. . . . The conception of Humanity as the basis for a new synthesis was impossible until the crisis of the French Revolution."[22] A social reformer yields objectivity to imagination, becoming religious in ways which transcend subject matter, when, gram-

matically, the objective present tense is intermingled with utopian future, and the indicative mood gives way to the subjunctive. Thus, Comte's "Sociolatry" both is and will become society's worship of itself: "In our static festivals social Order and the feeling of Solidarity will be illustrated; the dynamic festivals will explain social Progress, and inspire the sense of historical Continuity." Nine "social sacraments" surpass by two the number of analogous but obsolescent Christian ones, and the Positivist Calendar matches, where it does not surpass, the numerous intricacies of older liturgy. Worshippers come to identify themselves with the Being they adore; the voice of the people is the voice of God, for the principles of "systematic morality" are "identical with those of spontaneous morality, a result which renders Positive doctrine equally accessible to all." The populist Trinity— Love, Order, Progress—is a secular mystery, immediately real but ineffable. The very conception of Humanity "is a condensation of the whole mental and social history of man."

Writing contemporaneously, Comte's countryman DeTocqueville made similar, but different, prophetic observations upon visiting what was for him the brave new world of America. Noting that in the Middle Ages religion imbued all of Europe with the same civilization, DeTocqueville argued that sociological changes in religious institutions seemed to tend toward the same end, namely, that "among almost all Christian nations of our days, Catholic as well as Protestant, religion is in danger of falling into the hands of the government," and that rulers of individual states "divert to their own use the influence of the priesthood, they make them their own ministers—often their own servants— and by this alliance with religion they reach the inner depths of the soul of man."[23] Joachim Wach, who refers to DeTocqueville as the "modern Montesquieu" (his quotation marks), shows how "the analyst of New World society traces the indirect influences which religion continues to exert upon the 'manners' and intelligence of the Americans in several concisely and circumspectly worded paragraphs, scattered through the two volumes of his book."[24] Although these paragraphs are concise and scattered, they are also sharply descriptive. Comte and DeTocqueville may have in common a subject matter, but the former anticipates with enthusiasm for the future what the latter foresees with a sardonic and almost cryptic melancholy. Whether one regards humanism, in its several definable varieties since the Renaissance, as the greatest good in this imperfect world is not the point here. Comte is laudatory while DeTocqueville clearly is disparaging; both are imaginative and objective in their descriptions of humanism in its quasi-religious forms, though that might not be their intention as sociologists.

The scope of the socialization of religion vitiates an attempt to describe it whole, except perhaps in imaginative terms that transcend geographic location and the synchronic particularities of objective sociology.[25] It is not just that there were "conversions" among the English, such as Harriet Martineau and Frederick Harrison, who became and continued to be articulate and influential disciples into the twentieth century. Harrison's *Apologia*,[26] an autobiographic testimony of widespread conversion and synopsis of New Religion, is no more curiously devoid of humor and self-criticism than many hundreds of other inspirational books in America, as Schneider and Dornbusch have shown.[27] Indeed, New Religion continues to have its impassioned spokesmen. The point stressed here is that one is scarcely able to distinguish between the religious fantasies of social prophecy and the satires of authors who, despite their very different religious and social allegiances, can argue that the socialization of religion warrants a stylistic ridicule. They both adopt a literary past tense and a future perfect viewpoint. This grammatical convention of ingenuousness, typical of much sociological prophecy and modern religious satire alike, is to confound the present in relation to the past and the future.

Jacques Barzun speaks in religious terms about Comte's "sudden conversion" and his "mysticism," not as representative in all men surely but "in enough of them to make Comte . . . represent mankind." It occurs to him that "the points of similarity between Comte's second Utopia—which Mill called 'the regime of a blockaded town'—and totalitarianism need no enumeration," though he notes that "the country where theory and practice have gone farthest in the direction of Comte's later proposal is also that where the organization of positive science reached a degree of perfection that was but recently the admiration of the world." Which country that is today is a moot question. What J.L. Talmon calls "the modern secular religion of totalitarian democracy" has had an unbroken continuity as a "sociological force" for over 150 years, and has actually shaped both the French and the Bolshevik revolutions. It constitutes an apocalyptic crisis not in the history of ideas but rather in the "climate of ideas, a frame of mind, we may say faith."[28] Identifiable in real, historic time, though not so succinctly as in fictional, satiric time, it is yet not seen in a particular nation or people, or even in an entire culture.

Beyond the sphere of modern democracies, totalitarian and other, it is the main thesis of Zevedei Barbu that an international "psychological condition" has settled to a great extent the fate of Nazism and Communism. Jules Monnerot tries to show how both Communism and Islam are the same kind of "secular religions" in our time seeking to become a world state; he admonishes that if such religions are to be fought they

must be criticized, but also that criticism is not enough. "If the faithful of these religions are not *comic*," Monnerot says, "it is solely because they are strong."[29]

If the genre of religious satire can be said to exist in its subject matter, it can also be identified as sometimes unintentional. A theoretical category of unintentional satire is seemingly a valid one, even according to strictly formalist methodology, in the sense that Wellek and Warren find literary theory possible only on the basis of concrete works and not *in vacuo*. Structuralism and poststructuralism certainly leave out much too much. I would not go so far as to argue, as Kenneth Burke does, for an entire "sociological criticism of literature" with a pattern of classifications applying to all works of art and social situations outside of art. However, I do not see that one can or should reject such a sociological criticism, particularly where its cultural values are relative to the age in which they are dominant. Wellek and Warren's cognitive literary theory posits a difference between "pure" and satirical poetry; is wary of any studies of literature as social document (or vice versa); and makes only incidental, passing references to satire. But satire at least, of all the traditional genres, clearly requires both "intrinsic" and "extrinsic" reading. Alvin Kernan's insistence that satire *is* a literary genre seems to me cogent, despite its inclusion of a complex and disparate mass of poetry, prose, and drama. Kernan contends that "satire is not a form of biography or social history but an artistic construct." Accepting his idea of satiric genre (as definable in the "strictly" literary terms of scene, satirist, and plot), I would yet enjoin that it is not always possible to make a distinction between the "form" of biography or history, and artistic "construct." Perhaps all literary study must be comparative in this sense; Harry Levin, for example, consistently generalizes about the problem of the relation of literature and life (which he regards as the "first and primordial" point of his critical focus) in terms of a reconciliation of the autonomy of literary forms with the responsive counterclaims of society: "Literature is not only the effect of social causes; it is also the cause of social effects."[30]

It is not a sociologist's responsibility to go beyond the facts that are his responsibility to record, of course, but the point is that by and large he does not intend to. Religious socialization is a real phenomenon, not an imaginary one, yet it is not wholly suited to empirical description. Insofar as it cannot be "seen" within political, geographic, economic, and other socially stratified or simply objective limits, satire tends to be the more inclusive mode for describing it. Though the phenomenon of religious socialization is ultimately modern, coterminous with technological civilization perhaps, if not equivalent to it, the generic marks of the literature describing it are very much older. Describing the

phenomenon whole involves the use of imagination as well as reason, art as well as science. The imaginative implications are what lead to statements of value and to the grotesquery in literary satire and even in sociological studies. The scientific intention of a sociologist is to be as objectively removed from his work as he possibly can be; a satirist, by contrast, attacks in others those weaknesses and temptations that he can "see" within himself, and in this sense even a scientist may be a satirist. Even if his delineations are regarded as psychological rather than sociological, he nonetheless goes beyond careful subjectivity. He frequently uses the first-person grammatical form or the rhetorical "we," a strategy which, even if "only" fanciful or fictive, and sometimes a literary puzzle for biographers and critics alike, is a constant reminder of the person behind the persona. A satirist counts himself in the world, a world thereby more whole than if he presumed to leave himself out.

"Is there, in fact, a difference in kind between the literary imagination at work on a society and the social scientific mind 'making sense of' its material?" Richard Hoggart asks. "Are not the imaginations of the two at their best close to each other?"[31] My answer to both questions is affirmative. His own sociology of literature is as ironic, in an imaginative sense, as it is scientific. A theoretical category of *unintentional* satire is a valid one, even according to formalist methodology, in the sense that literary theory is possible only on the basis of concrete works. Roy Harvey Pearce begins his defense of historicism with an analogy to an early excursus in Georg Simmel's *Sociology:* "How is Society Possible?" becomes "How is it possible that literature should be what it is?" Pearce argues that no forms of historical study are irrelevant to formalist criticism. Northrop Frye maintains that "there can be no such thing as, for instance, a sociological 'approach' to literature," that there is "no obligation to sociological values" in literary criticism.[32] This may be so, some of the time, with reference to all literary genres, even satire. However, I cannot agree that sociological values and theological standards make for nonsense in a theory and criticism of religious satire. I do not think they can or should be avoided. Although the near twins of religious satire and the sociology of religion are look-alikes, having some family resemblances, indeed even perhaps the same parentage, their individuality as they have grown older and more modern is unmistakable. I say this even though the uses of ridicule seem not always conscious, and its parenthood seems not always planned.

# 6

# Magic and Religion in "Chesterbelloc"

One special question about satire is the extent to which it is shaped by its subject matter: when satire, preeminently among all literary genres, contains so many referents to the real world, how precisely can it be regarded as fiction? This question can be stated more easily than can speculations about satirists' private intentions or about audiences' reactions, but generic confusion abounds when satire's subject matter has its own bafflements. Consequently, religious satirists suffer misunderstanding not only in their satires but also in their argumentative and devotional writing.

Even in their social character or public roles, religious satirists might be definable in strictly generic terms, as distinct from their near twins, mere ridiculers or devotional exegetes. Still, to what extent can it be said—as Shaw implied in his "Chesterbelloc" nametag for them—that Chesterton and Belloc were themselves not merely near twins but literary Siamese? The question is primarily literary and generic, and secondarily theological or anthropological, considering how magic and religion in the writings of "Chesterbelloc" are deliberately—not to say exclusively—literary concerns. I have no interest in the anthropological quarrel over religion and magic: whether public customary actions and private motivations of religion are directly connected, or whether it is possible to classify cultural rituals of magic according to their psychological uses. However, Keith Thomas's *Religion and the Decline of Magic* grapples with a conception of "magic" as set off from "religion," and he works in a context I find congenial to the literary focus of this chapter. His definition of religion covers beliefs and practices that are comprehensive and organized, and are concerned with providing in-

clusive symbols for the meaning of life; this is set against a definition of magic as a label for beliefs and practices that are specific and incoherent, and are intended (though ineffectively) to provide practical solutions. Thomas notes that though today many scientists and theologians agree in using the term "magic" negatively and pejoratively, "ineffectiveness" is not part of his definition of it.[1] Consideration of whether or how magic and religion occur in a literary context necessarily involves an "extrinsic" approach to literature, satiric or otherwise. This chapter focuses on magic and religion in G.K. Chesterton and Hilaire Belloc's mode of perception, with some unavoidably complicated references to its intentions and effects.

Though ridicule may be the halfway house of satire, the world of ridicule is the real world, the here and now, populated by persons with the names found in polemics, in political cartoons, in controversy generally, whether literary or not. It is by common definition the deliberate fictionality of satire that is literary; however, it is the deliberate ambivalences of that fiction—primitive and modern, fantastic and real, past and future, real and abstract, physical and spiritual—which make it satiric. "Magical art," according to H.D. Duncan, must have a greatly desired end or purpose in view before it can begin to work; and, far from making the subject of magical art "otherworldly"—in Duncan's sense of that word, linking it with religion or aestheticism—it is rather an attempt to "glamorize," to make attractive for practical reasons, but not to spiritualize or analyze. Robert C. Elliott and others have shown that in the history of satiric literature, the "primitive" belief that satire kills, persists even today in obscure ways. Arguing that art is a sublimation of magic revealed in a shift from ritualistic efficacy to aesthetic value, Elliott shows how, in the uses of ridicule, we are all "primitive," whatever the level of our deepest selves.[2]

However different Chesterton and Belloc are as men and as artists—and they *are* different in their persons and as we see them in their satiric personae—the similitude of their social and political ideas accounts for the adhesive validity of Shaw's legendary "Chesterbelloc." Indeed, what is remarkable, Robert Speaight says, is that two men whose temperaments were so diverse should have thought alike on all important questions. If *The Servile State* and *The Restoration of Property* are set beside Chesterton's *What's Wrong with the World* and *The Outline of Sanity*, Maisie Ward says, "the Chesterbelloc sociology stands complete."[3]

If religious satire is focused on its subject matter, how can generic confusion about it persist anyway? As I have tried to show, the sociology of literature and the literature of sociology—of religion as a social institution—are mutually impinging, with real Siamese-like connec-

tions; the subject matter of religious satirists is therefore duplicitous. Beyond that, these satirists' intentions and effects are replete with ambivalences that are not always intentional. Duplicitous subject matter and unintentional ambivalences are not easily summarized, yet they can be generically described, to the extent that religion is not magic. In *Popular Religion: Inspirational Books in America,* for example, Schneider and Dornbusch examine forty-six best sellers published from 1875 to 1955. Because inspirational books are such a voluminous portion of mass culture, these sociological authors select a limiting set of four criteria to comprise a working definition. In addition to the best seller requirement, these criteria for the genre are actually statements about a kind of author who (1) must assume the general validity of the Judeo-Christian tradition, (2) inspire the hope of salvation on some terms, (3) offer the reader some "techniques," and (4) address the "everyday people." Employed according to a kind of "arithmetic of the spirit," such criteria are sufficiently broad and abstract so that devotional literature *en bloc* might be encompassed, including such "classical religious documents" as Augustine's *Confessions* or Thomas À Kempis's *Imitation of Christ.* Still, the writers taken up in *Popular Religion*—including Harry Emerson Fosdick, Emmet Fox, Mary Pickford, Joshua Liebman, Thomas Merton, Daphne Du Maurier, and Norman Vincent Peale—cannot, without a wild stretch of imagination, be called religious satirists.

The most damning conclusion reached in *Popular Religion* is that inspirational best sellers are not, in effect or intention, religious literature at all. Perhaps because these books are designed to have the widest possible appeal, their authors shy away from the avowal of specific denominational commitments. Thus, Schneider and Dornbusch say, indication of what is or is not acceptable from the Judeo-Christian tradition is extremely rare, and the subject of the genre seems not to be religion but magic. Concerning the hope of salvation and the "techniques" for achieving it, "an initial and evidently necessary distinction may be made between the themes of salvation in the next life and salvation in this. . . . The view that happiness can be expected in this world proves to be a dominant one, almost to the point of exclusion of such alternative views as that it cannot be expected or cannot be expected by most men." If there is an "otherworldly" strain in inspirational books, it appears only in the sense that this world does not really exist (but only exists, as Emmet Fox has put it, as "the out-picturing of our own minds"). Schneider and Dornbusch repeatedly quote the simplistic insinuations of the authors of inspirational books that the most complex social problems are reducible—by inspiration—to the terms of a personal and infallible morality. In short, religion will give life mean-

ing *now*, make a better world *here*, give our nation and our cause victory (adaptable in Frank Buchman's doctrine of Moral Rearmament to an international encompassing of conflicting causes), and promote optimism, peace of mind, good health, and financial and business success.

*Popular Religion* nowhere mentions Chesterton and Belloc, but its theoretical perspective includes three sympathetic or even kindly qualifications about some Catholic writers of inspirational books: (1) they are concerned more than Protestants with "last things," (2) "on the hope of happiness in this world . . . are more inclined to pessimism," and (3) place their emphasis on the theme that suffering has divine significance. Nonetheless, the "few outstanding features of the literature as a whole" are the exact opposite of devotional: "It sets out a religion that is in many respects this-worldly. It stresses 'power to live by' as a boon that religion will give. It is concerned with 'happiness in this world.' . . ." Considering the relentless stress on "use of God and religion for the purpose of man, it is not surprising that there should appear a . . . spiritual technology: . . . an instrumental attitude toward religion, an accordant emphasis on technique or 'science,' and a magicalization of spiritual notions or principles." This is not to imply that "classical religious faith" was never manifested by an interest in practical "results"; rather, such a manifestation differs from the "strong element of magic" in inspirational books. Schneider and Dornbusch suggest that such publications result from a modern sociological and cultural transition in which possible consequences of religion have been converted into deliberately sought ends: "The lines blur at times, but the distinction is clear in principle: It is the distinction between inadequate rendering and rendering of the inadequate." The authors conclude that inspirational literature may be seen to contain uniquely modern elements, but also elements that trace well back into the history of man. Their book, even more than Riesman's *Lonely Crowd*, transcends uniquely American phenomena: "The market for magic still appears to be very much alive, as it presumably was in far antiquity."[4]

Very nearly everybody in the journalistic world, Chesterton says, took it for granted that his *Orthodoxy* was not an expression of his faith in the Christian creed but rather was a pose of paradox, a stunt or a joke. It was not until long afterwards, he observes, when he formally entered the church, "that the full horror of the truth burst upon them; the disgraceful truth that I really thought the thing was true." This was also true with his friend; Chesterton noted that even "before reading what Belloc wrote, the critics started to criticise what Belloc would probably write. They said he threatened us with a horrible nightmare called the Servile State. As a fact, it was his whole point that it was not a night-

mare, but something that we were almost as habituated to accepting as to accepting the daylight." Far from reading *The Servile State* as a controversial, politico-religious treatise, "many supposed that it was a sort of satiric description of a Socialist State; something between Laputa and Brave New World."[5] Fact is perceived as fiction by his readers. And what is intended as fiction is perceived as fact. This is the chief significance of magic and religion in the satires of Chesterton and Belloc.

W.H. Auden implies a relation between two different generic problems for all readers of Chesterton, apart from subject matter and an author's intention: regarding controversial writing, "once it has won its battle, its interest to the average reader is apt to decline"; and regarding personal tastes in readership, and what Chesterton called "The Ethics of Fairyland," there are "persons to whom [the fairy stories of] Grimm and Anderson mean little or nothing: Chesterton will not be for them."[6] The intended effects of all satire have never been very clearly definable, and this necessarily impedes the particular definition of religious satire: Is it magic? ritual? art?

Perhaps one can say that the notion of magic has to do with the literary perception of an author, rather than with its real effects. Christopher Hollis suggests that magic is at once the "peculiar sin" which Chesterton accused himself of and which accounts for the mixed appreciation of his first play, *Magic*, "no doubt because of its subject, which was that of its title." Hollis argues that though "many theatre-goers were put off *Magic* by its appeal to magic, and dismissed it therefore as silly and unreal," nonetheless Chesterton "was writing about magic— writing about an evil of which, as he believed, he had had personal experience. . . . *Magic* was not an exercise in whimsy-whamsy. It was an entirely real study of an experience which Chesterton thought entirely true."[7]

Numerous literary artists on both sides of the Atlantic—Joyce and Yeats, O'Neill and Fitzgerald, O'Hara and Mary McCarthy—have "broken" with the Catholic church; others, like Chesterton, who did not break from their religious heritage, have recorded bitter personal reflections about religious abuses. They did so, however, within the experience of a lifetime allegiance to the church, or a conversion to it. For them, the importance—if not the immutability—of religious life is unmistakable. Still, G.K. Chesterton's seventy or more publications might seem, understandably, too bulky an oeuvre in considering precisely how modern literature is amenable to a generic classification according to an author's subject matter or his religious predispositions through a lifetime. We might therefore limit our attention to Chesterton's output

from five to eighteen years before his conversion to Catholicism in 1922. Both because of practical consideration of voluminousness and because in this short time he wrote some of his best known books, I think generic illustrations and differences can be drawn without forcing them. I do not want to suggest that there is an intellectual parable in the metamorphosis of Chesterton's religious thoughts, from liberalism through humanism to the theism of his later years; however, it might be pointed out that many of his readers were surprised, upon hearing of his conversion, that he had not been a member of the church for the preceding twenty years. Also, his four earliest satiric fantasies—*The Napoleon of Notting Hill, The Man Who Was Thursday, The Ball and the Cross,* and *The Flying Inn*—are considered his best. The politico-religious treatises, or controversial expositions of this period in his life, are *Heretics, What's Wrong with the World,* and *Utopia of Usurers.* His *Orthodoxy,* published in 1908, was the first of a long line of expressly devotional works, the best being *The Everlasting Man.* The nature of Chesterton's spiritual life, his conversion, and other religious experiences are not the point here.[8] Rather, my purpose is to distinguish between his three generic species—satiric, argumentative, and devotional—and to try to account for the variety of disesteem into which they have fallen.

Chesterton's four large satiric fantasies superbly represent their own form and content in great detail, in relation to religion and magic. Chesterton is a religious satirist whose argumentative and devotional nonfictions are certainly similar to his satiric fantasies, but they are just as certainly not the same.

*Notting Hill,* written in the prophetic past and set in the year 1984, at once medieval and futuristic, is a story of a war between London suburbs. It contains, his biographers say, "the most picturesque account of Chesterton's social philosophy"; it is also the book which Chesterton himself "always considered his basic statement of political belief," namely, that it would be better for men to die *as* men rather than function as machines, to disregard a promised millennium, and to reject efficiency-and-uniformity.[9] *Notting Hill* intentionally parodies H.G. Wells's scientific fantasies, and nowhere demonstrates any "quasi-religious belief in the miraculous power of unlimited evolutionary progress."[10] Quite within the long tradition of Menippean satire,[11] the narrator-persona "I" writes from a viewpoint *sub specie aeternitatis,* after and "above" the false prophets represented in the narrative. Nowhere in the book does Chesterton suggest that this imperfect world can ever become some finer other world. He keeps his worlds apart while pointing to their correspondences. The hero, Auberon Quin, is an

aesthete who makes a joke out of being a prophet-king, but he also sees
the social and political ridiculousness of his joke, his imaginative jux-
taposition of real London with a better if also less "real" place.

Notting Hill is "The Hill of Humour" (the title of the concluding
chapter of Book One). Auberon sees the social reformation in laughter,
the purgative and individual value of jokes "received in silence, like a
benediction." For him, "true humour is mysterious, . . . the one sanctity
remaining to mankind." He regards his function as social and political
leader to be "funny in public, and solemn in private," to "play the fool"
in this "Paradise of Fools."[12] Notting Hill as a place-name (persona-
Chesterton says parenthetically) may be derived from Nutting Hill, an
allusion to the rich woods which no longer cover it, or may be a corrup-
tion of Nothing-Ill, referring to its reputation among the ancients as an
earthly paradise. Adam Wayne, the other major-domo in *Notting Hill*,
is "the new Adam," whom Quin regards at first as the only other sane
man, even though he sees deification as ludicrous: " 'Yes,' he cried, in a
voice of exultation, 'the whole world is mad but Adam Wayne and
me. . . . All men are mad, but the humorist.' " According to Adam:
"Crucifixion is comic. It is exquisitely diverting. . . . Peter was crucified,
and crucified head downwards. What could be funnier than the idea of
a respectable old Apostle upside down? What could be more in the
style of your modern humour? But what was the good of it?" The
difference between Auberon and Adam is not a social and political
issue. The level of that issue is not that "real" in the sense of being
externalized. "Two Voices," the last chapter, suggests that the issue is
perhaps physical but metaphysical, too, and cerebral:

> You and I, Auberon Quin, have both of us throughout our lives been
> again and again called mad. And we are mad. We are mad because we are
> not two men but one man . . . because we are two lobes of the same brain,
> and that brain has been cloven in two. . . . When dark and dreary days
> come, you and I are necessary, the pure fanatic, the pure satirist. We
> have between us remedied a great wrong. We have lifted the modern
> cities into that poetry which every one who knows mankind knows to be
> immeasurably more common than the commonplace. . . . We are but the
> two lobes in the brain of a ploughman.

Adam's last duality connects the "blasphemous grotesques" of
medieval cathedrals with the laughter and love of modern people.

The issue most troublesome to readers of *The Man Who Was Thurs-
day*—Chesterton himself called it "a very formless form of a piece of
fiction"—reveals itself in the character of the "real anarchist" called
Sunday, who, "in one sense not untruly, . . . was meant for a blasphem-
ous version of the Creator."[13] When *Thursday* was adapted for the stage
almost twenty years after its publication, fifteen years after *Magic*,

## SATIRE NEWS LETTER

Volume I • Number I

Fall • 1963

### THE ETERNAL TWINS

Taking fun
  as simply fun
and earnestness
  in earnest
shows how thoroughly
  thou none
of the two
  discernest.

## SATIRE NEWSLETTER

Number 19
Volume X : : Number 2
Spring : : 1973

Chesterton offered this clarification: "There is a phrase used at the end, spoken by Sunday: 'Can ye drink from the cup that I drink of?' which seems to mean that Sunday is God. That is the only serious note in the book, the face of Sunday changes, you tear off the mask of Nature and you find God."[14] One possible explanation why many reviewers have called the story irreverent is that it is about Nature and God, indeterminately real and unreal, natural and supernatural, this-worldly and otherworldly at once. It is scarcely identifiable as orthodox or apostate, intrinsically. It is neither devotional (what is the object of veneration?), nor politico-religious (what is the argument or controversy, exactly?). The ideas in *Thursday* are no more obscure than those in the *Orthodoxy* published in the same year. Nor is it particularly a question of the book's fictional form being an "extraneous decoration only, a distracting and unnecessary element"; it is, perhaps, the book's apparent formlessness and indeterminate material that make Ronald Knox describe it as rather something like the *Pilgrim's Progress* in the style of the *Pickwick Papers*.[15] The lack of critical agreement may be due not to what it is but rather to what effect it has on the individual reader.

*Thursday*'s subtitle, *A Nightmare*, is something of a generic commonplace, though, so far as I know, comparisons of this fantasy with others of its kind are rare and very fleeting.[16] Nonetheless it is, for example, like Bertrand Russell's *Nightmares of Eminent Persons*, a gallery of caricature-portraits. Seven anarchists, "really" detectives in disguise, are led by the foreboding Sunday, who, as chief of the anarchists, is indeterminately a vision of destructive *and* benevolent forces, even perhaps of God Himself. The narrator "I" tells of paired-off poets who engage in a flyting-match at Saffron Park, a suburb with a "social atmosphere" like "written comedy." Lucian-Gregory, the satirist-anarchist, "seemed like a walking blasphemy, a blend of the angel and the ape."[17] Gabriel Syme, the story's hero and a kind of archangel, is pitted against him: Lucian is on the side of lawlessness in art and art in lawlessness; Gabriel, a poet of law and order, argues that Chaos is dull and that man can make Victoria into a New Jerusalem. For them both order and anarchy come to be the same thing.

Two things are essential to satire, Northrop Frye says in his theory of myths: "one is wit or humor founded on fantasy or a sense of the grotesque or absurd, the other is an object of attack." As Chesterton himself has said, "The ordinary orthodox person is he to whom the heresies can appear as fantasies."[18] A reader who finds the myth of *Orthodoxy* unacceptable or muddled may also regard *Thursday* as confused in its sense of grotesquery or irreverent in its object of attack. However, in neither case would such an effect in the reader necessarily mean that the book lacks clarity.

In satire, violent dislocations in the logic of narrative should not be an imposing difficulty. By definition, Menippean satire particularly concerns abstract ideas and theories rather than facts, and is "stylized" rather than naturalistic. It deals less with people "as such" than with mental attitudes, yet it does deal with both. When the mental attitudes are offensive—in both senses of that word—the people "as such" or the personae may seem to be obscure. Yet, the fact that all the characters in *Thursday* speak like Chesterton testifies to a harmony of author's intention and—in the terms of Northrop Frye's definition of the genre—to a functionally consistent use of symbols within a framework of myth.

In *The Ball and the Cross*, as in *Notting Hill* and *Thursday*, the paired protagonists cannot be definitely differentiated in their character or their conflict of interest, even though it is apparent that Evan MacIan is a simple Catholic lad from the Scottish Highlands, and James Turnbull a sincere atheist. Like Auberon and Adam in *Notting Hill*, they are "two voices," in effect not two men but one man, "two lobes of the same brain."[19]

*Ball and Cross* begins with a discussion between Professor Lucifer and a holy man, a monk "one of whose names was Michael." As typical introductory protagonists, they are as differentiated, as functional in the framework of the myth as the title's symbols. Swooping down over fog-enshrouded London in a flying ship, Lucifer and Michael barely miss smashing the ball and cross atop St. Paul's Cathedral. It is Lucifer who, arguing his case against Christian humbug, points to them:

> "What could possibly express your philosophy and my philosophy better than the shape of that cross and the shape of this ball? This globe is reasonable; that cross is unreasonable. It is a four-legged animal with one leg longer than the others. The globe is inevitable. The cross is arbitrary. Above all the globe is at unity with itself; the cross is primarily and above all things at enmity with itself. The cross is the conflict of two hostile lines, of irreconcilable direction. That silent thing up there is essentially a collision, a crash, a struggle in stone. Pah! That sacred symbol of yours has actually given its name to a description of desperation and muddle. When we speak of men at once ignorant of each other and frustrated by each other, we say they are at cross-purposes. Away with the thing! The very shape of the thing is a contradiction in terms."
>
> "What you say is perfectly true," said Michael with serenity.[20]

The symbolism is clear despite its inherent complexity: the world and the other world, the natural and the supernatural, Nature and God, the objects of rational analysis and of acceptance by faith. MacIan and Turnbull are a second pair of protagonists, more "real" or down-to-earth than either Lucifer or Michael; these two are more indeterminate, if not more complex, perhaps necessarily. It is at any rate *their* story

that forms the bulk of the fantasy. Chesterton's literary strategy is an identification of his complex mental attitudes with these people in order to depict an extensive absurdity, the socialization of religion, and to provoke attack on it and not on him.

Plainly opposed to one another with a categorical, chiasmic enthusiasm which allows no compromise, MacIan and Turnbull see no alternative but to fight out their differences in a duel to the death. And yet in the end they are reconciled. MacIan is the only man to regard Turnbull's secularist newspaper with serious respect. It seems to Turnbull that as year after year of his life has gone by, the Death of God in his Ludgate shop is less and less important. The two men quarrel when young MacIan smashes Turnbull's shop window upon seeing an atheistic insult to Our Lady. Turnbull is overjoyed. They are hauled before a magistrate, who scarcely begins to understand their quarrel because his religion is one of "law and order," quite divorced from either of their interests. A shopkeeper of swords near Turnbull's shop is greatly amused about their miasmic differences on Mariology: " 'Well, this is a funny game,' he said. 'So you want to commit murder on behalf of religion. Well, well my religion is a little respect for humanity.' " The pornographic bookseller from next-door concurs; and, despite Turnbull's grating contempt, all of London is on the side of the bookseller and the journalists, who, far and wide, play up the curious disagreement for its outlandish novelty. MacIan and Turnbull are misunderstood by everyone, everywhere. Badgered by all the resources of civilization, they try to find a place to fight their duel in secret. When found out, they try, without success, to explain themselves, but are interrupted at every turn by simplistic men who, even when they lend a sympathetic ear, cannot hear.

The dilemma of the clash between them is not—except perhaps in a Miltonic sense—the clash between good and evil. As in Lucifer and Michael's appraisal of two worlds, MacIan and Turnbull represent a dilemma of principles opposed and perhaps contradictory, but both of them true. They end up in the garden of a lunatic asylum near Margate. "Turnbull, this garden is not a dream, but an apocalyptic fulfillment. This garden is the world gone made. . . . The world has gone mad," said MacIan, "and it has gone made about Us."

Though Chesterton's *Flying Inn* might be called generically Menippean in its deliberate, functional use of both verse and prose, it too has little other than a loose, episodic structure. Its most famous parts are the drinking songs, which contribute to the overall effect of a "completely frameless utopian novel."[21] However, I identify—partly on the basis of its improbable subject matter, but more specifically on two ambivalent characteristics of narrative *form*—the generic nature of the

ancient Arabic-Hebrew maqāma: a narrative interlaced with short metrical poems, derived from the word for "place."

> The classical maqāma was created when a talented and quick-witted fellow, skillful at mockery and jest, appeared at the "place" flaunting his erudition, particularly in language and literature, and delighted listeners (and ultimately readers) with humorous remarks and stories. At the "place" he frequently encountered an acquaintance of similar abilities. . . .[22]

Insofar as there is a basic theme, it appears in the suggestion that some inns in Pebbleswick-on-Sea are actually named after the symbols of long-healthy, national, religious superstititon, namely, the cross of Christianity and the crescent of Islam. The story itself is an extended dispute between Patrick Dalroy and Lord Ivywood. Preaching a lukewarm gospel of toleration, Ivywood is not so illiberal as to deny "to the ancient customs of Islam what I would extend to the ancient customs of Christianity." He advocates an international denominationalism as a way to the salvation of the world: "Ours is an age when men come more and more to see that the creeds hold treasures for each other, that each religion has a secret for its neighbor, that faith unto faith uttereth speech and church unto church showeth knowledge." Unfortunately, he is unable to practice what he preaches, becoming "quite a Methody parson who pulls down beershops right and left." This prohibition is the emergent occasion of Patrick's Flying Inn, a furtive, "floating" pub that tends to the "spiritual" needs of all persecuted Englishmen. "All roads lead to Rum," says Lord Ivywood at his Church Congress. However, Patrick, who believes that "even a rascal sometimes has to fight the world in the same way as a saint," is ultimately successful in his missionary work.[23] Rolling his round cheese and keg of rum through the countryside, reestablishing the glory of "good jokes and good stories and good songs and good friendships," Patrick brings tidings of comfort and joy.

Such are the immediate and yet abstract terms in which Chesterton envisions, and derides, secular religion and twentieth-century "Islam," attempting especially to strip the disguise of orthodoxy from a body of heresy. By restricting the scope of his vision to Pebbleswick-on-Sea, to that "real" place and the "real" people in it, he tries to show how the pretensions of "Chrislam" are as ridiculous as they are unseen, as comic as they are powerful. In *Esto Perpetua* Belloc set out to write a historical and geographic book about North Africa, especially the contact of Islam with the "genius of Europe" on that continent. Like Chesterton, he examines the alleged mystery and militancy of Islam, taking up the subject of Islam, as both Christian heresy and cultural invasion,

in the socialization of religion. But in *The Flying Inn* Chesterton writes
with the intention of reforming, as a utopian satirist, rather than in-
forming, as would a historian or a sociologist. Here too the "two lobes
of the same brain," and the "conflict of two hostile lines, of irreconcil-
able direction," are replicated in the places of Chesterton's narratives,
but especially, I think, in the personae: in Dalroy and Ivywood, as in
Auberon Quin and Adam Wayne, Lucian-Gregory and Gabriel Syme,
Evan MacIan and James Turnbull. Ultimately, this duality was collec-
tively represented by the two-headed grotesquery Shaw christened
"Chesterbelloc."

Chesterton's nonfictional *Heretics*—like *What's Wrong with the
World* and *Utopia of Usurers* in the same period—aroused much
animosity in a way that his satiric fantasies *sui generis* did not. In these
controversial books he does not create personifications of his own
thoughts and feelings about abstract matters that defy any other but
fictional shapes. Rather, he is concerned with *real* matters of dispute
with *real* people; and he seems content to state his case without persua-
sion or indirection, as though he believed (to paraphrase Patrick Dal-
roy) that even a saint sometimes has to fight the world in the same way
as a rascal. "Blasphemy is an artistic effect," which, Chesterton asserts,
"depends upon belief, and is fading with it";[24] his quarrel is with those
other literary artists who seem to him because of their doctrinal unbe-
lief incapable of communicating such an effect. He is concerned to
define and deplore such unbelief insofar as it has particular and practi-
cal consequences in this world. After his fashion, not quite like Bel-
loc's, Chesterton attempts to sustain a levity. Thus, Kipling he called "a
Heretic—that is to say, a man whose view of things has the hardihood
to differ from mine," while he described Shaw as "a Heretic—that is to
say, a man whose philosophy is quite solid, quite coherent, and quite
wrong." Chesterton allows that it is perhaps because of his own "Nega-
tive Spirit" that he opposes the popular phrases of "liberty" and "prog-
ress" as H.G. Wells uses them. Although his levity may alleviate his
feelings of anger, it does not keep him from his task; and Kipling, Shaw,
and Wells, among others, receive hard knocks: Kipling for his imperial
worship of the ideal of discipline spread over the whole world; Shaw
for his delusive discovery of a new god in the unimaginable future; and
Wells for the fault of personal hypocrisy, even as he categorically
charged the religions of the past with that fault. Excoriating all "unde-
nominational religions" and decrying "the absence from modern life of
both the higher and lower forms of faith," Chesterton singles out Com-
tism and the Salvation Army as particular examples of heretical—that
is, partial—good derived from "fantastic proposals for pontiffs and
ceremonials" and from ritualistic "crash of brass bands."

His literary confession is that his own way out is "Divine Frivolity," that is, "giving people a sane grasp of social problems by literary sleight-of-hand"—despite his critics' fears about "the danger arising from fantastic and paradoxical writers." He defends the function of satire written by "men who can laugh at something without losing their souls"; the opportunity for divine frivolity is immense for both literary heretics and ordinary readers, whose daily lives are "one continual and compressed catalogue of mystical mummery and flummery." Most men "may think, and quite seriously think, that men give too much incense and ceremonial to their adoration of this world."

Chesterton intended *Orthodoxy* "to be a companion to 'Heretics,' and to put the positive side in addition to the negative." That is, he disallows controversial argument and acknowledges personal vulnerability, having written "not an ecclesiastical treatise but a sort of slovenly autobiography." *Heretics* is a literary attack in which the defense of Christianity is incidental; *Orthodoxy* nowhere suggests that Christianity is an impersonal disposition or a scientific hypothesis: "No one can think my case more ludicrous than I think it myself: no reader can accuse me here of trying to make a fool of him; I am the fool in this story." Chesterton's definition of Christianity is not the answer to all men's arguments, but to his own dilemma and needs.

To be sure, many of Chesterton's utterances in *Orthodoxy* carry with them not only incidental levity but also large-scale vituperation: "The modern world is full of the old Christian virtues gone mad." "Satire may be mad and anarchic, but it presupposes an admitted superiority in certain things over others; it presupposes a standard. . . . And the curious disappearance of satire from our literature is an instance of the fierce things fading for want of any principle to be fierce about." Still, there is frequent reiteration of personal and devotional rather than argumentative and societal intention: "I do not propose to turn this book into one of ordinary Christian apologetics; I should be glad to meet at any other time the enemies of Christianity in that more obvious arena. Here I am only giving an account of my own growth in spiritual certainty." In a chapter titled "The Ethics of Elfland," Chesterton tackles the credibility of "the things called fairytales," especially insofar as they are magical explanations of the laws of nature: "When we are asked why eggs turn to birds or fruits fall in autumn, we must answer exactly as the fairy godmother would answer if Cinderella asked why mice turned to horses or her clothes fell from her at twelve o'clock. We must answer that it is *magic*. . . . A tree grows fruit because it is a *magic* tree." Magic, or elfland, by which term he refers to *imaginative rather than calculable perceptions*, might not be true, but for him these perceptions are superior to natural explanations. Imaginative as well as

calculable perceptions define the naturalists' eternal evolution, as
Chesterton knows. But, for himself, the chief merit of religious or-
thodoxy is that it is the source of what he calls, in another chapter
heading, "The Eternal Revolution," the source of eternal reform: "In the
upper world hell once rebelled against heaven. But in this world
heaven is rebelling against hell. For the orthodox there can always be a
revolution; for a revolution is a restoration."

In the language of Schiller, Chesterton's mode of perception can be
said to identify possible species that are magical; for Chesterton, con-
ventional literary genres tentatively explain religious mysteries in
mundane existence: "We are perhaps permitted tragedy as a sort of
merciful comedy: because the frantic energy of divine things would
knock us down like a drunken farce. . . . There was some one thing that
was too great for God to show us when He walked upon our earth; and I
have sometimes fancied that it was His mirth."[25]

Despite their shared interest in fairylands and the nature of truth,
Belloc is scarcely the same kind of writer as Chesterton. There can be
no doubt that Belloc was much more explicitly disputatious and even
more conspicuously devotional than Chesterton. As a Christian apolo-
gist he was much more disputatious than confessional or satiric. The
size of Belloc's satire, whether of form or content, and the strength or
extent of his ridicule, are no match for Chesterton's. Unlike Chesterton,
he was not a "personal" writer. The Cruise of the 'Nona' was as close as
he came to autobiography; he scarcely ever argued against his contem-
poraries as such. When he did argue, which was often, his efforts to
refrain from mere quarreling can be seen in his infrequent mentioning
of personal names, Wells and Kipling being the obvious exceptions for
him as for Chesterton. Except for a few nonsense verses and metrical
jokes, like "John Grubby" and "The Donkey," Chesterton, unlike Bel-
loc, wrote very little satiric verse. One big difference between the two
writers, their light verse aside, is that Chesterton, who was given to
literary flights of imagination, is more the satirist, page-for-page and
proportionately writing more satire, and Belloc is more the historian.
Chesterton is given over to paradoxical complexities, Belloc to
verifiable simplifications. Still, there can be made for them both a work-
ing generic differentiation, between those predominantly devotional
works that attempt to achieve insight without argument, their satires,
and the controversial texts. Especially as a religious writer who is
sometimes a satirist, Belloc reveals interests or commitments which,
like Chesterton's, are in different works identifiably this-worldly,
otherworldly, or both, dependent not so much on those interests or
commitments as on a recognition of the forms they have taken.

There can be little question that Belloc is—along with Chesterton,

Shaw, and Wells—among the Big Four of Edwardian letters, or that he is Britain's foremost Catholic apologist in the twentieth century. His reputation notwithstanding, even before the singleness of purpose in his later years—when, no doubt, the chief aim of his writing was to proclaim the church as the font of all civilization insofar as it has survived in Europe—there has been no careful attempt to distinguish among Belloc's apologetic kinds. His books have continued to be regarded indeterminately as merely polemic and propagandist and didactic, like Chesterton's, logically and even perversely *parti pris*. It is probably because of assumptions about his rhetorical intentions and his writings that whenever literary categories are mentioned in reference to Belloc, they are overbrimming and interleaking.

Belloc's ideal of the good social order is not a utopia. He does argue that an ideal society might be approximated, and he rejects a parochialism of vision that fails to extend beyond the last century in Europe or beyond the Reformation in England. His argument has a number of parallels in contemporary social theory; the Chesterbelloc is the embodiment of such a parallel, as Shaw was able to see it. Parochialism within the orthodox church—as well as outside it—is the object of attack in a long line of such texts as Belloc's *Servile State*, or T.S. Eliot's *Idea of a Christian Society*, wherein society is conceived of as fundamentally traditional or "organic." Both see society in concrete terms, familial and private, or pluralistic and public. Belloc's ideal of modern British society is not like Eliot's, which is aristocratic, post-Reformation, and Anglo-Saxon. However, the "Distributive State," as Belloc calls it, is neither abstractive nor perfect. Its focus on *real* consequences, despite its inexactnesses or inaccuracies, makes it a remarkable prophecy of several economic varieties of totalitarianism in the past sixty years, even as it sums up those biases that Chesterton came to share: an esteem for peasants and monarch; an emphasis on ancient Rome as the civilizing force in Western culture; and an appraisal of the major task of modern society as essentially negative—namely, to check wherever possible the accelerating process of dehumanization spawned by the industrial revolution, and to assuage the effects of what has come to be called future shock.

Few readers fail to see Belloc's biases, but sometimes these biases are at once literary and religious in their referents. In *The Contrast* Belloc defines the ambivalent form his biases take, even in his section and chapter headings: "the Physical Contrast which underlies the whole"; "the Social Contrast—the contrast in those daily human relations which are the small external symbols of deep-seated spiritual motives producing them"; "the Political Contrast: the contrast in the conception of government"; and so on. His title refers to the old and the new, in

Europe and America, and the implications of his referents transcend
national or political boundaries. What Belloc calls America's "social
spirit" and "spirit of common action" correspond to Riesman's notion
of "other-direction" and Schneider and Dornbusch's "popular reli-
gion":

> This spirit of common action takes the form also of creating enormous
> markets even for the things of the soul. [For example] the "Best Seller":
> the book which spreads like fire through dry grass, not because it makes
> any special appeal to individual minds but because a crowd takes it
> up. . . . This spirit . . . shows itself much more importantly in the realm of
> ideas, from which all material manifestations spring. Social Doctrines
> are in America universal. . . . Again, the value, sacredness and efficacy of
> the vote. . . . The conception that a majority has a divine right to decide
> in any matter is universal in America, not as a conclusion of reason but
> as an accepted dogma.[26]

That the religion of the Servile State must have no dogmas or
definitions, Chesterton had argued in *Utopia of Usurers*;[27] but that State
is itself definable in literary as well as religious terms.

  *The Path to Rome*, for example, has many of the characteristics of
*The Four Men*, which Belloc subtitled *A Farrago*. Perhaps a "polemic
in disguise," as George Shuster has called it,[28] it is in any case a *literary*
and religious pilgrimage as well as an actual travel record. The Catholic
church, though geographically centered in Rome, is for Belloc the ob-
ject of a kind of loyalty which transcends considerations of time and
place. The path to Rome, like the walk through Sussex, has a literary
significance that defies geographic and chronological identification.
That is, the ambivalent devices of fantasy and morality, and the con-
ventions of autobiographic confession, suggest that they both are a kind
of fiction called Menippean. The name of the literary form applies also
to an attitude of mind.

  *The Path to Rome* is in effect a sustained devotion, like the Corpus
Christi processional or the Stations of the Cross. This does not deny the
abundant humor in the book. Though not an account of a sentimental
journey, it is full of Shandian tricks: a foolish Preface; word puns;
ellipses, brackets, italics, and other peculiarities of puncutation; illus-
trations; nonsensical and irrelevant breaks ("So to make a long story
short, as the publisher said when he published the popular edition of
'Pamela' . . ."); cataloging and dialoging. Belloc offers an explanation—
by way of humorous anecdote—of "why a pilgrimage, an adventure so
naturally full of great, wonderful, far-off and holy things should breed
such fantastic nonsense as all this."[29]

  Above all, the book is a first-person account of Belloc's "enchanted
pilgrimage" or "great march" to a Church Triumphant rather than in

behalf of a Church Militant. Description of the mountainous passages is more visionary than visual—what Frye calls free play of intellectual fancy, a vision of the world in terms of a single intellectual pattern. Belloc writes:

> When I call up for myself this great march I see it all mapped out in landscapes, each of which I caught from some mountain, and each of which joins on to that before and to that after it, till I can piece together the whole road. The view here from the Hill of Archettes, the view from Ballon d'Alsace, from Glovelier Hill, from the Weissenstein, . . . and at last . . . the Via Cassia, whence one suddenly perceives the City. They unroll themselves all in their order till I can see Europe, and Rome shining at the end.

The Hill of Archettes, or Weissenstein, is like Chesterton's Notting Hill, a special place, a "Hill of Humour." During the pilgrimage, two inner voices, not people but rather attitudinal personae, like Chesterton's "two lobes of the same brain," constantly interrupt in order to clarify what Belloc has to say for himself to the reader:

> I am still wondering. Giromagny is no place for relics or for a pilgrimage, it cures no one, and has nothing of a holy look about it, and all these priests——
>
> LECTOR. Pray dwell less on your religion, and——
>
> AUCTOR. Pray take books as you find them, and treat travel as travel. For you, when you go to a foreign country, see nothing but what you expect to see. But I am astonished at a thousand accidents, and always find things twenty-fold as great as I supposed they would be, and far more curious; the whole covered by a strange light of adventure. And that is the peculiar value of this book. Now, if you can explain these priests——

Belloc throughout, in a kind of internal colloquy, entertains "a puzzling thought, very proper to a pilgrimage, which was: 'What do men mean by the desire to be dissolved and to enjoy the spirit free and without attachments?' " The vision of the Alps drew from Belloc an expression as much allegorical and religous as factual and descriptive:

> So little are we, we men: so much are we immersed in our muddy and immediate interests that we think, by numbers and recitals, to comprehend distance or time, or any of our limited affinities. . . . Let me put it thus: that from the height of Weissenstein I saw, as it were, my religion. I mean, humility, the fear of death, the terror of height and of distance, the glory of God, the infinite potentiality of reception whence springs that divine thirst of the soul; my aspiration also toward completion, and my confidence in the dual destiny. For I know that we laughers have a gross cousinship with the most high, and it is this contrast and

perpetual quarrel which feeds a spring of merriment in the soul of a sane man.

Belloc's *Four Men: A Farrago* is the satire its subtitle indicates; on appearances it is also similar enough to *The Path to Rome* to invite comparison as a devotional kind. A eulogy in praise of his native Sussex, the book was ordered by an American publisher but was refused because of its "religious tone"[30]—a fact which I interpret as a symptom of its ambivalent nature. Like *The Path to Rome*, it is a kind of pilgrimage, but even more full of "such fantastic nonsense," more sustained in its formal awareness or literary depiction of "dual destiny," more demonstrative of how "laughers have a gross cousinship with the most high" in prolonged "contrast and perpetual quarrel." The narrator "I" or "Myself" is less Belloc himself than is the narrator in *The Path to Rome*; "Myself" is less confessional in the autobiographic sense of personal revelation. He is less "real" as a person; he *is* indeed the other three personae: the Poet, the Sailor, and Grizzlebeard the philosopher. The book he writes is, to use Frye's definition of a confession, a sustained revelation of character and incident by a stream-of-consciousness technique. In *The Path to Rome* Belloc is three men: I, Lector, and Auctor, the first only occasionally interrupted by the other two. In *The Four Men* he is Myself, Poet, Sailor, and Grizzlebeard, in sustained colloquy. The plot and scene as well as the narrator are subordinate to the purpose to which they are directed, and are obliquely identified with that purpose. The book is a travel fantasy: the personae represent no individuals, no "real" persons; the locale, though "real" enough, is completely transformed in a dream sequence. This transformation is apparent from the beginning of the book: the frontispiece, for example, is a straightforward landscape painting of Sussex, while the first illustration (there are many, as in *The Path to Rome*) following the preface depicts a fanciful, utopian "Regni Regnorum cui vulgo Sussex nomen est." The time is "nine years ago" from October 29 to November 2, 1902—that is, Halloween, Feast of All Saints, and the Day of the Dead.

On a pilgrimage to "the land they know" (which is "really" Sussex in the dream of Myself), the four men (who are all "really" Belloc) sing Varronian songs on various heresies and religious abuses. Satire derives from the visual as well as verbal structure of the songs, which are randomly illustrated, whimsically over-punctuated, with and without musical scores, choruses and semi-choruses, italics, brackets, parentheses, large and small caps, blocked stanzas of arbitrary shape, dialogue interjected, with and without indentations and redundant quotation marks; they are a proofreader's or typesetter's nightmare, but

a satirist's dream. Solo and as a quartet, the four men sing in the company of a Sussex crowd of indeterminate size, a fantastic song, for example, about the heretic Pelagius and Saint Germanus of Auxerre, who were real and important antagonists in church history. Stripped of almost all of their naive, playful trappings (as they are here), the verses retain the expository and historical precision required for their explicit purpose, "the very robust outthrusting of doubtful doctrine and the uncertain intellectual":

> Pelagius lived in Kardanoel,
>   And taught a doctrine there,
> How whether you went to Heaven or Hell,
>   It was your own affair.
> How, whether you found eternal joy
>   Or sank forever to burn,
> It had nothing to do with the Church, my boy,
>   But was your own concern.
> Oh he didn't believe
> In Adam and Eve,
>     He put no faith therein!
> His doubts began
> With the fall of man,
>     And he laughed at original sin!
> With my row-ti-tow, ti-oodly-ow,
>     He laughed at original sin!
> Whereat the Bishop of old Auxerre,
>   (Germanus was his name),
> He tore great handfuls out of his hair,
>   And he called Pelagius Shame:
> And then with his stout Episopal staff
>   so thoroughly thwacked and banged
> The heretics all, both short and tall,
>   They rather had been hanged.
> Oh, he thwacked them hard, and he banged them long,
>   Upon each and all occasions,
> Till they bellowed in chorus, loud and strong,
>   Their orthodox persuasions!
> With my row-ti-tow, ti-oodly-ow,
>     Their orthodox persu-a-a-sions! . . .

And there is more. The Sailor tells the crowd listening that "every word of what we have just delivered to you is Government business."[31] Nonsense, of course. So too the symbolism "when the Poet threw beer at a philosopher to baptise him and wake him into a new world." And the Man in the Chair at the Inn of Steyning, the "Hideous Being" (H.B.?), gives them a calling card bearing the fantastic name "Mr. Deusip-

senotavit." All this certainly has a "religious tone," as the wary Ameri-
can publisher did fear. The Varronian songs and symbolic playfulness
are generically religious, forcing a consideration of the differences be-
tween this world and an other world by way of an imaginative and
necessarily nonsensical identification or confusion of them. This far-
rago has the effect of satire to the extent that the values of a real and an
imaginary world—the world of government, say, and a new world—are
perceived as mixed or scrambled and, therefore, as ridiculous.

Arguing the case for Belloc's "integrated Christian humanism," Fred-
erick Wilhelmsen has asserted that "to grasp the essence of Belloc's
integrated humanism is to possess the key to understanding his posi-
tion as a satirist and controversialist."[32] He views Belloc as no alienated
man insofar as he neither "situates his destiny in this world" nor,
despising the limits of the horizons, solely "contemplates the world
beyond." Wilhelmsen calls The Four Men "the most articulate and
symbolic statement of the natural humanism underlying Belloc's mili-
tant Catholicism." If Belloc is almost incomprehensible to the postwar
intellectual (even the postwar Catholic intellectual), he says, the lack of
understanding can be traced to the amazing personal integration of the
man, and to the lack of comparable integration on the part of those most
representative of the modern spirit. This may be pressing the case for
Belloc too far. He is not much read; Belloc's name, despite its promi-
nent place in literary history, does not occur in general studies of satire
and scarcely ever appears through decades of MLA bibliography.

When authors like Belloc and Chesterton are not commonly read or
examined, it may be beside the point to insist that they are incompre-
hensible. Nonetheless, the notion of an integrated Christian humanism
does point to the kind of interest in two worlds that is unmistakable in
religious satire: otherworldly commitment in constant interplay with
this-worldly fact. The satire depends on or exists because of this jux-
taposition. Also, the notion of Christian humanism points willy-nilly to
the relative nature of any definition of satire and the precariousness of
"success" of any such satire. In a literary context of questionable practi-
cality and appeal, the integration of two kinds of value will be an
attempt rather than an achievement. Regarded as an attitude of mind as
well as a literary form, religious satire will always be difficult to define
or to find an audience for. Among literary historians, from Douglas
Bush on Milton to Wilhelmsen on Belloc, the humanist-Christian anti-
thesis is one of the most persistent and slippery commonplaces. In
addition, as Robert C. Elliott has demonstrated, both a satirist's work
and his status with respect to society are necessarily problematic; the
power of satire is a mysterious and magical thing.[33]

Both irony and satire are included in Frye's "Mythos of Winter," the

chief distinction being that irony is a "lesser satire" and satire a more militant irony. In terms of Frye's theory, and considering the setting and time of *The Four Men*, I would say that Belloc's satire is autumnal rather than wintery, ironic rather than satiric. In his literary work the most "militant irony" is to be found in his political and economic satires: *Emmanuel Burden, Mr. Clutterbuck's Election*, or *A Change in the Cabinet*. His militant religious defenses usually took the form of history, which is what Belloc wrote the most of (or, as his detractors would say, tried to write). His religious satire is both less frequent and less militantly ironic. As a series of literary skits, *Caliban's Guide to Letters*, for example, does not produce the artistic effect Chesterton approbatively called blasphemy. It has nothing of the tragedy or tragic irony leading to the large visions of evil in the form of personae, as they are created by many other religious satirists: Chesterton's Lord Ivywood in *The Flying Inn*, Benson's Julian Felsenburgh in *Lord of the World*, Firbank's eccentric and epicene Cardinal Pirelli, Huxley's Mustapha Mond in *Brave New World*, C.S. Lewis's disembodied Devil in *That Hideous Strength*, or Bertrand Russell's incarnate Inca in *Zahatapolk*. Belloc's Thomas Caliban, Doctor of Divinity and practicing journalist, solemnly asserts that "Whosoever works for Humanity works, whether he knows it or not, for himself as well."[34] As a Comtean caricature, Caliban is effective enough, but surely not vicious. The "I" of the *Guide* is Caliban's literary executor, a punning word in the context; however, his portrait of Caliban is, despite either of the nametags, pathetic rather than cruel. *Lambkin's Remains* is more biting, but again, for a work by a prolific apologist, remarkably gentle as religious satire. The butt of the joke, Lambkin is a clerical don, but his portrait is, as Robert Speaight says, immortal in a minor way because of the infusion of satire with affection.[35] Lambkin (a diminutive Lamb of God?) is no ogre; in his portrait we scarcely begin to see the gentlemanly Prince of Darkness bottom-side up. Here is the harshest passage:

> Lambkin was essentially a modern, yet he was as essentially a wise and moderate man; cautious in action and preferring judgment to violence he would often say, "*transformer* please, not *reformer*," when his friends twitted him over the port with his innovations.
> Religion, then, which must be a matter of grave import to all, was not neglected by such a mind.
> He saw that all was not lost when dogma failed, but that the great ethical side of the system could be developed in the room left by the decay of its formal character. Just as a man who has lost his fingers will sometimes grow thumbs in their place, so Lambkin foresaw that in the place of what was an atrophied function, vigorous examples of an older type might shoot up, and the organism would gain in breadth what it lost

in definition. "I look forward" (he would cry) "when the devotional hand
of man shall be all thumbs."[36]

Even if irony is "lesser satire," its purpose is still grand; though its
tone is light, its intention is weighty. In one of his dedications Belloc
equates his verse with the "foolish, painted and misshapen toys" of
mere boyhood, suggesting nonetheless that those of his readers who
have "the child's diviner part" might, through these "imperfect toys, . . .
attain the form of perfect things." In another dedication, addressed to
the presumed readership of "A Child's Book of Imaginary Tales," he
concludes that his readers "pray for men that lose their fairylands."[37] In
his essay "On Irony," Belloc says that irony is a sword which must be
used as a sword, but which "like some faery sword . . . cannot be used
with any propriety save in God's purpose." It may be treated angrily
where men love ease, he says, and be merely ignored when men have
lost a sense of justice. To many—the young, the pure, the ingenuous—
irony must always "appear to have in it a quality of something evil, and
so it has, for . . . it is a sword to wound." The intention of irony, no less
than satire, is to wound, and in the wounding to effect "the curing and
preserving of morals." In Belloc's view "irony is in touch with the
divine and is a minister to truth"; and in the perception as well as in the
literary creation of irony, "there is nothing less than the power by
which truth is of such effect among men. No man possessed of irony
and using it has lived happily, nor has any man possessing it and using
it died without having done great good to his fellows and secured a
singular advantage to his own soul."[38] It is a faery sword that the liter-
ary executor uses on Caliban. For the readers who would accept this
viewpoint, the mutual assumption is that even if irony is "lesser sa-
tire," its effect is yet pain rather than pleasure, the intention of writer
and reader alike being a kind of religious purgation. One might con-
clude that the satires of both Belloc and Chesterton are only distantly
related to ridicule or inspirational books. In nonetheless magical ways,
their satires belong to a devotional rather than an argumentative genre.

Religion and magic are forces in the extrinsic real world of society
and politics as well as in the intrinsic world of letters, whether or not
people go to church or read books. To say that the religious satires of
"Chesterbelloc" belong in magical ways to a devotional rather than to
an argumentative genre is not to say that religion and magic are the
same thing. Satire enjoys a questionable practicality and appeal either
way. It is not necessarily literary, that is, verbal and artistic; but it is
shaped by its this-worldly subject matter. Satire is a distant verbal
relative of mere ridicule, and of inspirational books too, which them-
selves have primordial connections with religion and magic.

# 7

## A Priestly Art?
## The Literary and Other Intentions
## of Benson and Knox

As we have seen in our detailed reading of Chesterton and Belloc, whether literary satire is intentional or not in its religious subject matter, its effects are nonetheless duplicitous and equivocal. Religious literature always presents problems, not only in satire. Its problems have never lacked identification and discussion through millennia, perhaps even more in scientific than in artistic arenas. Roger Bacon's two modes of knowing, argument and experience, are not just armchair metaphysics from the thirteenth century. Rather, these two modes of perception are the province of our two half-brains, and it can be said that two astonishingly different persons inhabit our heads. William Blake's literary dialectics—Innocence and Experience, Two Contrary States of the Human Soul, Fearful Symmetry, Marriage of Heaven and Hell—have modern analogues in popularly received neurological theories and in recent syntheses outside the academic industry of literary criticism.

One of the humanistic uses of religious imagery is explanation of scientific esoterica, for example, in Fritjof Capra's *The Tao of Physics*: "the similarity between a spiritual insight and the understanding of a joke" in relation to rational and intuitive consciousness; the nonsense riddles of Zen koans, and haiku verses, as "insight into the very nature of life"; dust particles floating within the dome of St. Peter's Cathedral in Rome, as a way to "picture the nucleus and electrons of an atom"; Heraclitus' and Lao Tzu's discovery in the sixth century B.C. that "all opposites are polar and thus united"; the fanciful name of "quarks" in Joyce's *Finnegans Wake* to identify the symmetries of subatomic particles; Blake's famous lines on a world in a grain of sand and eternity in

an hour. The *T'ai-chi* symbol of Yin and Yang that Capra adapts as the Logos for his book is the motif Niels Bohr chose for his coat-of-arms, when he was knighted for his interpretation of quantum theory. It is from Bohr that Robert Elliott developed his last formulations regarding Swift's real and literary selves. Capra on science and religion and Elliott on science and satire validate Bohr's conviction that the principle of complementarity is applicable in a number of areas of knowledge and learning.[1]

In *The Dragons of Eden: Speculations on the Evolution of Human Intelligence*, Carl Sagan contends that "the most significant creative activities of our or any other culture—legal and ethical systems, art and music, science and technology—were made possible only through the collaborative work of the left and right cerebral hemispheres." Appropriately, Sagan has chosen epigraphs for this book from the literary works of Aristotle, Plato, Shakespeare, Milton, Dryden, and Blake. This same polymathic scientist begins his overview of "bamboozles galore in contemporary society," in *Broca's Brain: Reflections on the Romance of Science*, with Lucian's religious satire from the second century A.D. on "Alexander the Oracle-Monger." In Jacob Bronowski's *The Ascent of Man*, the concluding essay is a neurological history framed with Leonardo's *Madonna of the Rocks* and Blake's frontispiece to *Songs of Experience*, and contains sequential commentary on the works of Hippocrates, More's *Utopia*, Erasmus' *Praise of Folly*, and the computer mathematics of John von Neumann.[2] Commenting on the mystery of neurological dynamics, the psychologists Corballis and Beale remark, "If the evolution of symmetry can be understood in terms of the conservation of parity in the strong interactions and observable laws of nature, is there a common thread underlying the emergence of consistent asymmetry? . . . We have no idea."[3]

These analogues and syntheses cannot be ignored in reading "Chesterbelloc" or reading about any satiric personae as "two lobes of the same brain." When and if they are ignored, what results is most certainly part of the subject matter of religious satire throughout its history. Ignorance of them permits, if it does not cause, not only an overabundance of inconsequential literary criticism, but also satire's duplicitous and equivocal effects. This paradox—the ignorance of subject matter being subject matter—is difficult to resolve in the literary criticism of religious satire as well as in religious satire itself, whether its contexts are theological, psychological, or aesthetic, or all three. There may never be an end to invincible ignorance or partial knowledge.

Jacques Maritain posits "two fundamentally different ways of interpreting the word Existentialism," represented in the contrasting

philosophies of Aquinas and Sartre, which are historically irreconcilable, the one "authentic," the other "apocryphal," within a framework expressly verbal and perceived. Even so, William F. Lynch, S.J., has shown how complex and numerous are the theological implications of literary imagination. He argues the case for "literature in its relation with the human and the real," against warring theories which "give literature a basically strange character" in its exclusively verbal perceptions; he also rejects "baleful" theories that find in literature "a treasure house of philosophy or theology or politics or sociology."[4] Father Lynch is opposed to theoretical contrasts between time and eternity, tragedy and comedy, all the while pressing himself to the penultimate question: "does the literary imagination have a theological dimension?" His advocacy of meaningful ambivalence, for both Christ and Apollo, suggests that there are correspondences in the genres of tragedy and comedy, and in "the problem of the comic and theology" insofar as it is related to the "permanent debate of our time . . . between two forms of intellectualism." I think the reputations of Jerome and Erasmus identify this theoretical ambivalence as "permanent debate." It reflects a suspicion that the literary imagination is, as Father Lynch puts it, "compact with theology, that is to say, with some theology or another," or that, conversely, "if we cannot keep theology out of things anywhere, . . . then we ourselves are Manicheans and are discarding the very substance of the achievement of contemporary civilization." Thus, the contradiction in the reputations of priests as satirists—from Jerome and Erasmus to Benson and Knox—is "built into" contexts that cannot be defined as simply verbal or exclusively literary.

What happens when a religious writer attempts to be at once "serious" and "popular," as both priest and satirist? A clergyman, after all, cares for his flock, and purportedly affirms the goodness and worth of Everyman. The priest-satirist, on the other hand, finds himself pointing his finger at, even being accused of attacking, the selfsame institutions for which he is a living symbol and the very people he is pledged to serve. A priest sitting down to write satire is like a circle sitting down to draw a square. In his dual role he may have two aesthetic difficulties: getting himself to write satire in the first place and, after that, managing to be at once coherent and still "legitimate"—that is, understandable to preliterate masses, accepted by theologians, and appreciated in the literary world. This is a tough if not a holy order.

Historically considered, Jerome and Erasmus challenge the easy assertion that a man of the cloth need not be a man of letters. Still, a "priestly art" may also be a contradiction in modern garb; it is a point I want to consider now with reference to Monsignors Benson and Knox. In any era, of course, one way out of the contradiction is to recognize

that a priest as a performing artist—administering the sacraments and acting out his liturgical duties—need not be a professional theologian as well. It can even be charged by high church officials that scripture is no longer, alas, the main concern of theologians, that theologians seem to read mainly each other's books, even that "theologians and pastors of souls have largely ceased to speak the same language." It is as though, like Milton on the subject of utopian writers, modern theologians can have two different claims made for them, that they can be admirable or ineffectual. Some theologians, certainly, argue that the gospel stories of Christ are no more history than that Genesis is science. One result is that "clergy—and especially bishops—hesitate to challenge professional theologians because they are almost certain to be accused of being anti-intellectual."[5]

But to stress these obvious facts is not necessarily to ignore others, that priests are indeed sometimes humanists, that clergymen can be theologians too. Professional theology succeeds no more (or less) than other humane and academic disciplines in its striving for the highest spiritual clarities. Sometimes, if not often, theologians become lost in verbal geography while they are preparing the maps of essence and existence, transcendence and immanence, being and nonbeing, not only for one another but also for their pastoral congregations and homiletic audiences. No doubt the antinomies of metaphysics and history challenge the competence of a wide readership. Defined as a "crisis in theology" and a "crisis of identity in the ministry," and even a "double crisis of theology and liturgy," the problem is bewilderment not about the subject matter but about its mode of expression, to wit, the "theological method in general." "Not so much *what* as how theology is being done today" compromises its possible values, as renowned theologians are, of course, themselves aware.[6] The simplicities of "popular" apologetics, in their attempt to avoid the bafflement of abstraction, cloy for the reason of too quick topicality. Syndicated columns in daily newspapers and feature stories in diocesan presses define themselves as "relevant," but generically they suffer the same simplistic fragmentation as secular radio and televised newscasts, or are as intellectually guilty of unverifiable documentation as yellow journalism is. Popular theology is inevitably vest-pocket wisdom.

If popular literature is vest-pocket delight too, and popular literary criticism is not much informed, it is possible that a connection exists between them. "The decline of critical standards can be dated no more precisely than the fall of man or the dissociation of sensibility," Eugene Goodheart says, and I admire his "effort to enlarge the territory of discussion." Goodheart argues that "the ethos of modern artistic crea-

tion resembles the ethos of industry and technology"—inherently and superficially it has planned obsolescence built into it. He also thinks that modern literature and modern literary criticism is "a dialectic between the Protestant-inspired, largely English tradition from Carlyle to Lawrence and the Catholic-inspired literary modernism of Flaubert, Joyce, and Eliot"; and he argues that it is specifically Protestant inspiration that has lost out. I do not share his belief that literary criticism "inspired by the long Protestant experience in England" has exclusive moral and curative powers to change the world. Nor can I agree with his suggestion that Christian humanism *is* literary criticism in relation to the other arts and to social philosophy and in direct and explicit contrast to other learning.[7] Modern literature—certainly much religious satire—is Christian without being denominationally dialectic.

I propose that Protestant theology does not stand alone in forcing a consideration of metaphor as fact, in elevating correspondence above its corollary opposition, in asserting that natural objects always hold sacral meaning. This "mode of perceiving the relationship of natural life and religious meaning" is not a unique characteristic of seventeenth-century English poets and of twentieth-century Protestant theology. Paul Tillich's sense of "the power and meaning of natural objects" is not exclusively relevant to the deepest interest of Protestant literature; nor, conversely, is it that literature alone that celebrates an earthly and secular joyfulness quite separately identifiable from, but nonetheless connected with, religious meanings. Thus, for example, Ronald Berman argues persuasively, first, on "the dual meaning of the sensate human relationship" in the writings of Augustine, Thomas Aquinas, Martin Luther, Paul Tillich, and Reinhold Niebuhr; and, second, on the relevance of that nondenominational and nonsectarian meaning to an understanding of Herrick's poetry or Herrick's obsession with "dual meaning," which "is not pagan, and is of course not wholly secular, but an ardent and orthodox way of reaching the reality behind sensate appearances."[8]

Even religious literature, prepossessing as well as popular, may suffer the generic flaws that all verbal life is heir to. Fictional versions of the life of Christ seem always open to adverse criticism of two corresponding kinds: they replicate too closely the already understood gospel message, biblical fundamentalism being the watermark of all narratives on the model of *The King of Kings, The Robe,* and *The Silver Chalice.* Or they can be said to experiment too freely with historical fact and truth, as in D.H. Lawrence's *The Man Who Died,* Faulkner's *A Fable,* and Monty Python's *The Life of Brian (of Nazareth).* Eccentric blasphemy is commonplace, and surely endangers the faith of mul-

titudes even as it incurs the wrath of legions of decency. Though the
Passion of Jesus Christ has been wonderfully rendered in music and
painting and sculpture through centuries, it has enjoyed much less
success in modern novels and motion pictures, even when their artistic
impetus is neither mere surprise nor gross irreverence. In light of such
entertainments as *Godspell* and *Jesus Christ, Superstar*, audience de-
mands for meaning in the Incarnation seem to be met without much
bothering with the aesthetics of suffering and death. Perhaps it can be
said further that much "serious" as well as merely "popular" literature
risks undeserved aesthetic neglect as well as "orthodox" (in the sense
of vested) rejection, slow to receive professional acclaim or ecclesiastic
imprimatur. This is the twofold fate suffered by such otherwise diverse
texts as Teilhard de Chardin's *Phenomenon of Man* and Nikos Kazant-
zakis' *Last Temptation of Christ*. Notwithstanding the authors' quite
divergent primary vocations and religious beliefs, their reputations
have been similar. Teilhard was professionally chastened for his "spiri-
tual anthropology" and Kazantzakis was criticized adversely for his
fictional rendering of a "truly human Christ."[9] In the case of Teilhard,
holy orders did not confer or imply special intellectual privileges. His
lectures on original sin and its relation to evolution were regarded as
unorthodox by his Jesuit superiors. He was forbidden to continue
teaching in France, and he never succeeded in obtaining permission to
publish any of his major works.[10] As for Kazantzakis, theological sanc-
tion and approval were not a prior condition to his strong popular
reception. Paperback editions of several of his novels, two films made
from them, *He Who Must Die* and *Zorba the Greek*, and the Broadway
musical version of the latter, are widely known in the English-speaking
world, despite their cultural topicality. However, a posteriori literary
criticism of *The Last Temptation* is implicit in the fact that the Greek
Orthodox Archbishop of Athens refused to allow Kazantzakis' burial in
his native province.[11] Of course, Kazantzakis was not only a layman but
an unorthodox one. "Perhaps God is simply the search for God," he
exclaims, through his hero Saint Francis.[12] Kazantzakis' unorthodoxy is
not just that he is incessantly preoccupied with the mysteries of the
conflict between action and contemplation, flesh and spirit, restating
the *bellum intestinum* of Christian allegory; but rather, as translator
Peter Bien says, it is that Kazantzakis became a "priest of the imagina-
tion," primarily by way of his literary employment of demotic lan-
guage: plain, concrete, popular speech.[13] I think the value of
Kazantzakis' "priestly art" is not only that, as Bien has said, "beneath
the laughter and satire of his books we sense his inconsolable suffering
and his anguished attempt to direct all his denials into a triumphant
affirmation"; it is also that "insofar as he has had influence it is pre-

cisely because he too transforms abstract thoughts into feeling and passion."[14]

In structuralist terms, one might say that the divergent literary strategies implicit in such binary opposition are irreconcilable, that, whether a writer adopts a theocentric "orientation toward the speaker" or a humanistic "orientation toward the hearer," his effort will be self-defeating.[15] But then, perhaps, one might not say so. Roger Lloyd, an Anglican canon, praises "amateur theologians" who have been at work since the very beginning of Christianity. It might be accurate to say, as he does, that such popular religious teachers as G.K. Chesterton, Dorothy L. Sayers, and C.S. Lewis do inhabit a "country of the mind" outside time and place, somewhere between Christian theology and English literature. It is not a fictional country, exactly, as many supposed Belloc's Servile State to be, Chesterton said, "something between Laputa and Brave New World."[16] Rather, it is a country which actually exists even though its boundaries are vague and conjectural, Roger Lloyd says, "like such fabled lands of human imagination as Lilliput or Utopia."[17] In his view, there have always been inhabitants of this Borderland who, interpreting the thoughts of professional theologians, attempt to communicate such thoughts to a vaster audience than would otherwise be reached: "Creeds have to be compressed into poems and doctrines into novels before most moderns will heed them." His special concern then is with twentieth-century apologists, beginning with Chesterton, "chief among the Borderland's permanent residents," whose *Heretics* in 1905, Lloyd says, marks the beginning of Christianity's modern recovery of intellectual prestige and the modern concession to its claims to be taken seriously. In short, Borderland is Das Schlaraffenland with eggheads, and Das Narrenschiff sails from it to all seven seas.

Canon Lloyd may be saying too much for Chesterton's influence in a long line of theological progenitors, and for Christianity's "intellectual prestige" generally.[18] Still, Lloyd's dates are probably right, and his main thesis, insofar as it draws attention not so much to a writer's presumptive intention as to what is written, is grounded in the definable terms of literary genres. Even so, admirers of Borderland's inhabitants concede the generic, if not the theological, validity of novelist Kathleen Nott's *The Emperor's Clothes* which, the jacket-banner proclaims, is "an attack on the dogmatic orthodoxy of T.S. Eliot, Graham Greene, Dorothy Sayers, C.S. Lewis, and others."[19] Perhaps any churchman as proselyte will employ the genres of apologia and propaganda, merely to be intelligible, and not necessarily out of missionary zeal. There is intellectual danger in setting up orthodoxy as a literary standard. The perennial question of author psychology must not be

lightly regarded, nor as in the case of Milton's invocations to the Heav'nly Muse, it is to be answered merely by textual explication. One surely ought not presume on the literary intentions of the Holy Ghost.

The problem of divergent and disparate religious commitment, of apostate and orthodox satire, is not the point here (as it is in my concluding chapter). Nor am I concerned here with the fact that Christian polemists are frequently satirists. What I am concerned with is that the satirists also sometimes happen to be theologians.[20] Robert Hugh Benson and Ronald Knox are in this century the two best-known (though not most widely read) of these specially identifiable men of letters; they are both converts to Catholicism, both priests, both prodigious apologists as well as spokesmen for their faith. Their uniqueness, in this context, is not that their books defend or even represent "amateur theology" of either a devotional or controversial variety, but rather than their satires are identifiable as a particular literary genre similar to but different from these. The literary interest in these two monsignors—or more particularly, in Benson's *Lord of the World* and Knox's *Memories of the Future*—is not that they were apologists and priests, autobiographically controversial or suprapersonally devotional, but rather that such titles are satiric, in ways which neither contradict nor transcend such definable but apparently exclusive vocations. Pastoral functions can be literary. Even when religious satirists are orthodox in their beliefs and articulate in their theologies, what they write and what they write about can seem neither religious nor satiric, sometimes, as in the case of Robert Hugh Benson and Ronald Knox.

Benson, though a priest, is comparable to such laymen as Chesterton and Belloc in the qualities of his devotional literary effort. Benson is different from them too—as different as Chesterton and Belloc are from each other—in the quantities of that effort, for example. Benson's *Confessions of a Convert* is not especially priestly. Like Chesterton's *Orthodoxy* or Belloc's *Path to Rome*, it is merely representative of devotional literature. Such a book may pick real arguments by naming names, or perhaps even display occasional earmarks of satiric fantasy; but its primary intention is to state a personal commitment which is neither explicitly autobiographic nor continuously fantastic, though it may seem sometimes to be both. The "main problem" of *Orthodoxy* seems to me representative in its dual intention; Chesterton's defense of his faith is to show how it answers the "double spiritual need," for "the familiar and the unfamiliar," not to show that his faith is "true from every standpoint," but rather that the believers' real world is at once a "queer cosmic town" and "our own town."[21] Benson, in his prefatory apologia for his faith, insists not only on the similarity but also on the difference in the comparison of "the sensations of a convert

from Anglicanism to those of a man in a fairy story, who, after wandering all night in a city of enchantment, . . . finds to his astonishment that the buildings are no longer there." The man who is a convert is not an imaginary man but a real one; his intention is not to be quarrelsome with those real friends and acquaintances with whom he does *ipso facto* differ: "he is conscious of no bitterness at all." Nor is he himself "really" as important as the "story" he has to tell. Benson writes, in the third person, that "he is conscious of the appalling egotism of such pages as these; yet he has still to learn how an autobiography can be written without it."[22] Thus, a religious genre which is normally autobiographic can be defined as devotional insofar as an author does not consider himself as important as his "story." Chesterton says, in his preface to *Orthodoxy*, that his book is "unavoidably autobiographical," not an ecclesiastic treatise but a "slovenly autobiography." Though it may look like a "fairy story" it is not imaginary; though he may seem to be quarrelsome, his weapon is not a rhetorical bludgeon, nor does he make ironic thrusts with what Belloc called a "faery sword." Northrop Frye says that autobiography can be distinguished from imaginative literature, even though it may merge with "creative" or fictional forms by a series of "insensible gradations." And Frye's definition of the confession, as a genre, does not take into account value judgments outside the work itself; to do so is taboo in his literary theory. A confession, Frye says, is autobiography regarded as a form of prose fiction, or prose fiction cast in the form of autobiography. The religious value judgments made by the work certainly are not to be ignored, though, according to Frye, criticism ought not meet them with value judgments of its own.[23] Yet, the intention of Benson's *Confessions* seems to be to avoid not only fiction but also some of the vagaries of autobiography; it would seem hardly possible to limit the generic designation of the confession to exclude its categorically religious value judgments.

It is especially characteristic of Benson that his entire body of published work tends to be devotional. Though his brother and biographer, E.G. Benson, was a prolific and popular social satirist, Benson himself was not like his brother much concerned with the social reforms that moved many others, Shaw, Chesterton, and Belloc, for example, to various and copious literary expression. Also, despite his wide acquaintance in clerical circles—his father was a broad churchman and an Archbishop of Canterbury—he did not enter into religious disputes. He seems to have become a Catholic quite apart or aloof from the intellectual currents around him; his vested interest in religious orthodoxy was a personal rather than a public one, despite his frequent publication. Thus, Evelyn Waugh can say of Benson's biographical *Richard Raynal, Solitary*—the "true story" of a hermit who, happy in

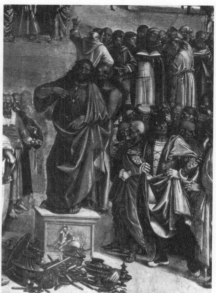

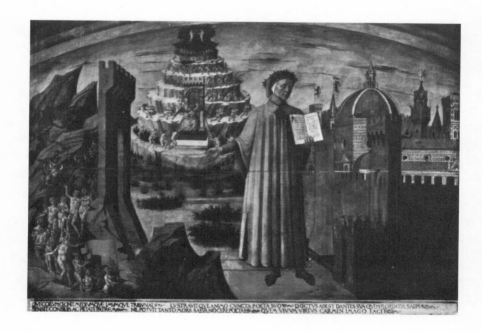

QVI COORVM DOCVIT MEDIVM QVE LAMENQVE TRIBVNAL         LVSTRAVIT QVE ANIMO CVNCTA POETA SVO         DOCTVS ADEST DANTES SVA QVEM FLORENTIA SAEPE
SENSIT CONSILIIS AC PIETATE PATREM         NIL POTVIT TANTO MORS SAEVA NOCERE POETAE         QVEM VIVVM VIRTVS CARMEN IMAGO TACITT

his solitude, is yet called to deliver a message to the world—that the book is "an expression of Benson's earliest dream." Yet, Waugh's further assertion is that except for *Raynal* all Benson's books are "direct propaganda."[24] George N. Shuster says of Benson that "being concerned largely with spiritual cases, he never wrote without a religious purpose, and his books have some of the atmosphere of a 'tract.'"[25]

Benson's *Lord of the World*,[26] as religious satire, is not in these terms antinomic; though it may be direct propaganda, yet it is written by a man whose inclination was to be solitary; it is concerned largely with spiritual cases *and* has some of the atmosphere of a tract. Its theme is the apparent triumph of evil at the turn of the next century, the Christian faithful near spiritual extinction, Anti-Christ reigning; but though the theme is in this sense predominantly otherworldly, the narrative form is not. Benson's account of the end of the world is made more comprehensible, or life-size, by containing his self-portrait; his book is a verbal equivalent to Signorelli's Orvieto frescoes of the Last Judgment and to Bosch's Garden of Delights, both of which give Anti-Christ prominence along with the artists' countenances. Anticipating contemporary atomic malaise, it is indistinguishable from the vast library of secular apocalypse and typical dystopia. But, first published in 1907, it is largely an "original" effort of its kind. Benson's narrative is global, and might have rambled into formless theorizing; but he controls the "action" of the story, such as it is, to just two places, London and Nazareth, and the time span is something under two years. The number of speaking personae is about a half-dozen, and it is through them that the mode of action is developed: internal monologues or soliloquies, the complexities and implications of fictional Armageddon "seen" from different viewpoints. Simple dialogue or colloquies—just two or three speakers at a time—show how that doom works itself out. A preface and prologue precede three separate books of four, eight, and six chapters respectively, the books corresponding to dramatic acts and the chapters to individual scenes. In short, it has many of the formal characteristics of Menippean satire. Templeton, Father Percy Franklin, and Father Francis are the most frequent interlocutors; Templeton is an intermittent but important *choragos*, the two priests rather conventional protagonists of the genre, not two men but one man, two lobes of the same brain, opposed as they are to one another, like a dilemma of principles, opposed and perhaps contradictory, but both of them true. Percy is ultimately elected Supreme Pontificate because no other priest in the world survives corruption or persecution. Francis becomes minister to the mysterious Julian Felsenburgh who himself is, first, President of Europe, and then, Lord of the World.

The effect of these hierarchic cataclysms on ordinary humanity is

clarified in the personae of Oliver Brand, a minor government official
(as in most modern fantasies, everyone works for the government), and
his wife Mabel, who are "humanly speaking" the embodiment of Tem-
pleton's thesis, that there is a New Religion: God is Man. Oliver is a
little troubled by the fact that his wife was brought up as a Christian for
a few years, and it seems to him, sometimes, as if her rearing has left a
taint. For his own part, Christianity is both wild and dull, wild because
it is so utterly apart from the exhilarating main stream of Human Life.
Mabel is sometimes troubled by imponderables, especially when they
manifest themselves in outward signs; when a "volor" (a kind of rocket-
jet that hovers like a helicopter) crashes in the station square at Brigh-
ton, killing and maiming hundreds, she is somewhat distraught, but her
spirit is mollified and her heart leaps in relief when she sees Ministers
of Euthanasia rushing to the scene. The fundamental form of the fiction
as a satire is otherworldly commitment constantly suggested as inter-
play with this-worldly "fact." The satire, the grotesquery, depends on
or exists because of this juxtaposition.

Sometimes Percy as the voice (not one of several voices) of Benson is
too obtrusive, seeming only a faint disguise for Benson himself, and the
satire breaks down into religious polemic or devotional tract.
Nonetheless, there is a lot of literary indirection. The news clippings
from the daily *New People* and the frequent epistolary exchanges help
to keep Benson at a distance from the story he has to tell. Julian Felsen-
burgh, Benson's most complex persona, is impressively unbelievable
not only in himself but in his "biography," a kind of ghosted *Mein
Kampf* written in Newspeak, full of curious aphorisms: "No man for-
gives, he only understands." "It needs a supreme faith to renounce a
transcendent God." "A man who believes in himself is almost capable
of believing in his neighbour." "To forgive a wrong is to condone a
crime." The literary validity of Felsenburgh is sustained by his never
saying anything in person in the narrative. His parables are "quoted"
from parabolic object lessons in his biographical scripture, and in news
reports about him, and his Secretaries deliver His Word. This literary
portrait is perhaps necessarily indirect, something comparable to the
problem of making Christ "true to life." Or, Julian may be, like the
Wizard of Oz, a revealed fake, or "really" the Lord of the World. Ben-
son's literary achievement is that Julian is one or the other or both, and
not anything else.

Ronald Knox, in comparison with Benson as religious satirist, was
quantitatively more a theorist than a practitioner. If Benson as a reli-
gious satirist is comparable to Chesterton, then Knox is more like Bel-
loc. As devotional and apologetic writers, Benson and Knox are prolific
and in that sense have much in common. But it is also true that as

religious satirists, they seem to be different breeds. In *A Spiritual Aeneid*, the account of his conversion, which he says is a religious autobiography not intended as a tract, Knox claims that he was first drawn to the church by reading Benson.[27] Though he met Benson only once, he "always looked on him as the guide who had led me to Catholic truth." Evelyn Waugh, who was appointed by Knox as his sole literary executor and who knew Knox "primarily as a man of letters rather than as a priest," recalls that "Ronald always felt an affinity for R.H. Benson; perhaps because there was a physical resemblance between them and because both were the sons of Anglican bishops and both Etonians. To the observer [Waugh himself] their differences of temperament and of accomplishment seem enormously wider than their similarities." Yet it may be supposed there are differences between them as satirists, accounting for the differences between their utopian satires.

Knox's vested interests seldom take obtrusive shapes. His renowned translation of the Old and New Testaments, his *Pastoral Sermons*, and his other devotional labors in translating, revising, and editing, all indicate the vast bulk of a literary production which, if apologetic, can scarcely be called controversial. Many of his contemporaries deplored the waste of his genius, his general passivity to more immediate interests of the church. Belloc had written to Knox that to remake Europe was their "intense and urgent call." But, in Waugh's view, Belloc was one of many who did not understand "the diffidence which held him back from controversy, and his constitutional dependence on [his sacramental and vocational] orders." Knox's inherent patience and courtesy—indicating a strength of temperament, if diffidence and dependence suggest weakness—kept him clear of politics, as well as most religious quarreling. "It was repugnant to Ronald to make any political judgment," Waugh says, "and only once, during his chaplaincy at Oxford, did he preach a political sermon."[28] If such was Knox's temperament, it is well suited to his satires as well.

His single utopian fantasy, and longest satire, is *Memories of the Future: Being Memoirs of the Years 1915–1972 Written in the Year of Grace 1988 by Opal, Lady Porstock*; as a record of conversations, epistolary exchanges, news clippings, sermons and speeches, it closely resembles Benson's *Lord of the World*. But it scarcely evokes the same effect, clearly having a different intention. Anticipating a kind of grotesquery and horror, the reader is surprised with gentleness, or perhaps disappointed by it. The literary machinery seems to grind for too small a purpose, or much of the time fails to grind at all. The reader is obliged to feel that the generic structure is too heavy to support just an easy intention to poke fun at contemporary autobiographies of ladies of

fashion, and that even this small intention is unfocused. Is Opal, Lady Porstock, a joke, or isn't she? For several pages at a time, as when she turns to the church, Lady Porstock loses her satiric identity altogether. Though she is left with a "permanent legacy" from early childhood, a "horror of spiders and the Pope," the book she writes is, as prophetic fantasy, as memories of the future, astonishingly uncomplicated by that horror. The comic embodiments of church and state in Opal's *Memoirs*—Canon Amphibolus Dives, Rev. Didymus Rowland and his wife, Rev. Agape Rowland, Prime Minister Holroyd, Lord Brede—are not foreboding or frightening but merely ineffectual. The Westernizing of the High Churchmen (that is, the making of the clergy into a political party), the Royal Commission on Ecclesiastical Discipline, the vision and the revision of The Book of Modern Prayer, the legalization of Marriage and the Social Improvement of other sacraments, the rituali-zation of the modern instinct of Home Life, the Great War (of 1972), all these are seen, in literary retrospect, to be short-lived follies of the recent past rather than persistent vices extending into the present. The joke is let out, and it loses its force. The reader discovers in the context of the *Memoirs* that there is not and cannot be any progress of an ideal kind in human society; and there will not be any loss. Society will continue to amuse itself, human folly will remain the same; as things were, so they will continue, with the grace of God silently working on individual souls. Lady Porstock is not ingenuous, nor sardonic; though the world is not "really" any better than it has ever been, it is not worse either. For Lady Porstock and, evidently, for Knox, 1988 *is* a Year of Grace. The book is optimistic as a forecast, even as it demonstrates that the idea of utopian history is an illusion. The central problem it poses is important, but imaginary rather than abstract or opaque. In a long letter to her niece Opal, Miss Linthorpe is adamant rather than vituperative about it:

> The lie you will find people telling all around you . . . is that the great movements of the human mind, whether in the arts or in politics or in morals or in religion, are similarly [as in science] part of an irresistible progress. . . .
> I wish I knew what it all meant. But I think this: I think it is the result of man being born immortal, and thinking (like an ass) that he has only this world to satisfy his immortal instincts with. Despairing of immortal-ity in this world, and forgetting it in the next, he makes the human race the immortal unit, and so endows it with life. And because he has been told that life means growth, he cannot be happy until he believes that the world in which he lives is growing, from something to something else. That is humanity's favourite dogma, and there is no atom of proof for it. Everything we know about history and natural history shows that there

is a kind of progress in the world . . . from the less to the more complicated, from the less to the more organized: nothing suggests, except to our vanity, there is a progress from the worse to the better. . . . Sweating away on the treadmill, humanity fancies that it is mountaineering, and that the dawn is just going to show above the next slope.[29]

The explanation is facile, or rather, it is as though no explanation is necessary. Humanity's dilemma of fitting ideal, utopian values to a real, imperfect world is illusory rather than problematic.

*Barchester Pilgrimage*, Knox's most ambitious work of the 1930s, is an effective imitation of Trollope's style; and, as Waugh says, "it is a dry, gentle satire on the social, political, and religious changes of the twentieth century," which "gave some plausibility to the ever-ready criticism that the Church of Rome had not fostered his genius."[30] In the secularized cathedral town of Barchester, it is not necessary for a clergyman to have his beliefs, only "moral tastes" and a manner of reading lessons; he can occupy the pulpit for three-quarters of an hour without making a single allusion to Christianity; and he need not wear collars that go around the wrong way, or otherwise distinguish himself from the laity by any peculiarities of appearance or behavior. Knox explodes on target, but the pattern of shot spreads so widely as to make no kill. All incur slight injuries, but all survive: the Catholic priests, Shoehorn, Smith, and Flanagan, of Saint Philomena's parish; the High Churchmen, Bishop Johnny Bold, prebendary Theophylact Crawley-Grantley, almost-seminarian Marmaduke Thorne (torn between the Anglican and Catholic folds, but ultimately a promoter of unsuccessful theatrical ventures in America); the Low Churchmen, Dr. Catacomb, Rev. Easyman, and Rev. Obadiah Slope. As a literary imitation *Barchester* is more polished than *Memories of the Future*, but, as a satire, even less ominous, or foreboding, or even nasty.

Knox might have in his controversial tracts, *Caliban in Grub Street*, say, or *Broadcast Minds*, written at about the same time, obviously set out after famous symposiasts and scientific publicists; but his large-scale satires are, in any comparison with them, remarkably subdued. One sees a self-reflecting ambivalence in Knox's commentary on Belloc's verse:

> What is the fellow about? Is he to be taken seriously or with a grain of salt? Is he to be classed with Rabelais, or with George Herbert? Criticism does not love the unpredictable.
>
> Actually, it may be doubted whether Belloc was not too much of a humorist to be a straight satirist, and *vice versa*. The satirist, for the sake of contrast, ought to take himself seriously; in Belloc, there was a streak of humility which let down the average—he could laugh at himself. . . .
> You cannot divide up Belloc's poetry . . . into Serious and Comic; the

two qualifications overlap and interlock; in letters, as in life, the severity of his lips is pulled downwards, all of a sudden, into a smile.

Knox did not live to write the introduction for *Literary Distractions*, the compilation of lectures in which this commentary appears. The title is Knox's; Waugh in a review remarks on its significance:

> There is a sense in which it can be said that all his intellectual life was a distraction from the spiritual. He was both priest, scholar and artist, and where the claims of his vocations were in conflict his priesthood came first. But many of the duties of a priest's life are themselves distractions from the spiritual.[31]

Yet, though Knox's satires are like Belloc's either gentle or modest in their design, and though they might be explained away as mere literary exercises, Knox himself testifies to the fact that the literary circumstances and emergent occasions of his satires have provided a definite and real purpose for them. The purpose may be strikingly conventional; his autobiographic apologies for them may be unsurprising; but they are significant in their clarification of his intention as a satirist and of the effect of his satires. In my first chapter, I have written about how the vested interest which Knox shared with other satirists is fully stated in his *Essays in Satire*, which was written several years before his Catholic conversion in 1917. Knox's introductory essay "On Humour and Satire" is a theoretical and historical statement regarding audience for satire and not regarding satire's subject matter. Literature before the nineteenth century, he says, has no conscious humor apart from satire; since the French Revolution, satire is dying out though humor flourishes. Satire, unlike humor, in his view, "provokes laughter that has an intensely remedial effect; it purifies the spiritual system of man as nothing else can do." Satire is unique in being at once malicious and remedial. If Knox is right, then ridicule—like satire, but unlike humor—is denunciatory and derisive. In Knox's terms, one can say that ridicule, like humor, is its own end rather than an eventual remedy, and that the concern of satire, religious satire at any rate, is both. Yet, its purpose is perhaps practical or remedial in a this-worldly sense; satire might also be otherworldly in a religious and aesthetic sense. Ridicule, unlike satire, tends to be cryptic rather than sustained, as much vituperative as innocuous, especially definable in its intentions and effects—qualities that can be called Catholic, surely, as well as Protestant.

One might be tempted to say that Knox's discussions of his satiric intentions are more personal—perhaps more Protestant—in his autobiography, no doubt a more confessional genre, but in the literary rather than theological sense. It seems to me an important point. "Ever

since I can remember, or at least since the age of seven," he confesses, "I have been possessed with the devil of lampooning." The idea for *Absolute and Abitofhell* he carried around in his head at first simply as a parody of Dryden's poem; only after several months "it hammered itself out into solid form." It begins, as he says, with a sketch of the modernizing tendency in the Church of England. Then it takes up questions he disputed with several Anglican theologians, friends of his whose names were "hidden under Biblical or quasi-Biblical aliases, just as in Dryden"—but clearly identified in footnotes in the anthologized reprint. Knox wrote that "there was not a line that I had not weighed and turned over scrupulously; it was as faithful as I could make it to Dryden both in spirit and style." This seems to have been Knox's intention, from his viewpoint, an innocent if also deliberate one. But "a stray literary venture" is the way he describes his little parody, on the basis of its effect. "It was not," he says, "in a personally unkind spirit that the satire was meant." The curiosity here is that Knox was able to regard the spirit of Dryden as something divorced from the style of Dryden, evidently thinking that the style is not the man.

Knox insists that whereas *Absolute and Abitofhell* was the work of months, *Reunion All Round*, two years later, in 1914, was completed in four days. Devoting his full-time labors to a sequence of sermons, Knox says he incidentally renewed his acquaintance with "the admirable satirical vein of Dean Swift," and the idea occurred to him of "utilizing his manner for the conveyance of an ecclesiastical message." Although it was possible, he says, to regard *Reunion All Round* as merely a graceful *jeu d'esprit*, he meant it for much more than this. Centering on an Anglican tendency to ignore doctrinal differences with other sects or churches in the interests of Christian good fellowship, the argument is a *reductio ad absurdum*: "the spirit of satire carried me away, and I suggested with every appearance of misgiving that perhaps after all, given proper precautions, charity should demand of us that we should accept the submission of the Pope." Knox found that the secular press was more kind to him than the ecclesiastical, a discovery other modern satirists have come to make. Pleased that Chesterton, whom he calls "my earliest master and model," reviewed the piece with enthusiasm, Knox is baffled by the curious nature of the wide popularity of the piece; and he makes a reader wonder, in turn, about the curious and necessary qualifications which must be made concerning the notion of "success" in satire, or its intended effect:

> If reports were true, it was read by a community of Catholic nuns, who supposed the suggestions to be quite serious; it was read in refectory at the English College, under the impression that I was a Catholic, and

caused great doubts of my salvation when it proved that I was not; it was read to the Prime Minister as he sat in bathing costume on the riverbank in that hottest of summers. I was even told that it gained the hearts of the episcopate.

Knox's intention in *Absolute and Abitofhell* was to be noncombative, he says; yet he acknowledges that he wrote it like a devil possessed, suffering something of a literary seizure during which "it hammered itself out." In spite of himself, and though the "objects" of the satire did not regard it as "personally unkindly," he says, the satire was seen as a pamphlet serving an aggressive purpose. On the other hand, *Reunion All Round*, a more immediately composed piece, was not supposed to be merely a literary exercise, a graceful *jeu d'esprit*; having avoided a vein of good-tempered exaggeration, he says, he expected the precise, even mathematical treatise to be abundantly clear. Yet, where it enjoyed wide popularity it was misconstrued.[32] If modern literature is largely made up of deliberate and somewhat ornate pamphleteering, a part of it is pamphleteering which is not deliberate. *Absolute and Abitofhell*, intended more or less simply as a literary exercise, was regarded as an expression of combative orthodoxy (even before Knox's first steps toward conversion). Ironically, when some pamphleteering is deliberate, it is not recognized as such or as otherwise "effective"— witness *Reunion All Round*.

It may be that when Knox's inclination as a satirist ran against the devotional grain of his nature, he was unable to be as "deliberate" as Benson was. Or, when and if he was purposeful and intended to lash out in an impulsive way uncharacteristic of him, the result tended to be either baldly controversial or ineffectually satiric. Knox's Utopia is utopian, Benson's is not. Knox did not want to reform the world, or believe it could be reformed, or apparently think that it should be. For Knox, the world was not a perfect place, but good enough perhaps to serve whatever greater purposes for which it was created. He could take it in his stride; "Ronald was no economist," Waugh says, and he caught only a "slight and transient infection of Socialism."[33] Whatever his professional aversion to lukewarm gospels of toleration, or to international devotionality as a means toward the salvation of the world, Knox the satirist took aim at them without killing them off.

Knox identified in Saint Paul characteristics which, if he would not claim for himself, he certainly admired, indeterminately ancient or modern, Catholic or Protestant. There are three things, Knox says, that especially contribute to the impression that Paul's Epistles are authentic and unselfconscious. Regarding Paul's character, Knox says Paul was "no saint of the stained-glass window," but rather "he is, like the

rest of us, a mass of apparent contradictions." His writing style is full of "utterances so *decousus*," but draws on "rich supplies of Old Testament erudition," and is "best of all when his theology overflows into the affairs of daily life; when the mere associations of a word, or the inner significance of some moral situation, touch a spring that lets loose a whole flood of mystical speculation." Paul, despite his divine vocation, "does not waste his blows on the air; there is always a situation to be grappled with [which is] so concrete."[34] I think it can be said that Benson and Knox are members of a brotherhood which is Pauline, in the sense of being both literary and clerical, concerned with "situations" perceived as at once moral and concrete. And I think that their intention as satirists seems to be the same, even when the literary effects of their religious orthodoxy are disparate. It may be possible to say, and Knox seems to suggest this at great length, that what all religious satirists have in common—whether their personal beliefs or alternative vocations are Catholic or Protestant—are their literary circumstances and emergent occasions. Benson and Knox—though their devotional and polemic efforts are qualitatively no more alike than their satires—can be said to have matching pastoral and artistic intentions.

# 8

# Waiting for Gödel: Beckett and Eliot

As all poets fear and frequently lament, songs and sonnets may fade away or survive in an afterlife, in greeting cards marketed in drug stores. There is also the possibility that the novel too will die, insofar as even now "while the survival of the novel is not in doubt, it does seem that reading contemporary novels has become a much less important matter for people of intellectual and artistic interests than it once was." There is less likelihood that drama will suffer the same fate. Drama commemorates secular holidays and religious holy days, celebrates birth and death, much like greeting cards. Even when dramatic comedy seems culturally related to Donald McGill's pictorial seasides, or when tragedy degenerates into mere science fiction and demonology, it can seem to depict large significances, to suggest supernal mysteries in the simplest language suitable for mass audiences. There is some technical complexity in contemporary drama; however, it also has qualities of durability and simplicity which can be traced back to medieval mimes and pageants, and which can be seen to derive from modern thought as well. In like manner, numerous mathematical conjectures can be stated in language as simple and unambiguous as Esperanto, for everyone to understand, even when those conjectures represent secular mysteries defying easy explanation. Algorithms—methods of mathematical analysis—are complex and precise sets of instructions that define mere "computer literacy." Their complex causes and effects are apparent in the simple cultural appeal of pinball machines, electronic games, and software programs for shopkeepers and homemakers. *Time* magazine's Man of the Year for 1982, "the greatest influence for good or evil," was not one man but all computers.[1] No one would try to persuade urbane

theater audiences that Pac-Man and Hamlet are equally important dramatis personae, no more than one can say that gamesters in amusement arcades know the algorithmic languages that articulate their electronic war games. However, there are technically defined high-level and low-level languages in mathematics that have their audible equivalents in modern drama; and there is a deus ex machina revealed in mathematics.

In the eighteenth century, Goldbach's Conjecture, a still unproved theorem, defined prime numbers by the simple fact that none of them can be made up by multiplying any two smaller numbers together; schoolboys can understand the arithmetic mystery no one can explain: that every even number is the simple sum of two prime numbers, that every integer greater than 2 can be written as the sum of two prime numbers. And Möbius over a hundred years ago posed the Four-Color-Map Theorem, which can be stated as a simple yet baffling puzzle: it is possible to color every country on any flat map with one of four colors without having the same color in bordering countries, whatever their size or shape or number. In our time, however, computer scientists suggest that mathematical theory and practice, though resolutely antithetical by their own definition, can be reconciled: "Some kinds of computational problems require for their solution a computer as large as the universe running for at least as long as the universe. They are nonetheless solvable in principle."[2] This is to say that it is possible in mathematics, no less than in religious drama, to imagine and depict problems which have solutions beyond methodology, problems that allow for faith and hope, in the secular sense that the Map Theorem put forward in 1852 was actually solved in 1976.

The smallest logical puzzles and brain teasers are also very sophisticated verbal playpens; modern drama can appear to be more articulate than cerebral, or vice versa. Raymond Smullyan renders mathematical logic in the language of Lewis Carroll and Kafka, and writes mini-dramas that read like Beckett and Pinter. In *Gödel, Escher, Bach: An Eternal Golden Braid*, Douglas R. Hofstadter plays a single dramatic theme in the quite different keys of music and art.[3] In this book, which he calls "a statement of my religion," Hofstadter illustrates Gödel's Incompleteness Theorem: "In short, Gödel showed that provability is a weaker notion than truth no matter what axiomatic system is involved." He concerns himself with something much more opaque than Goldbach's Conjecture, and he alternates his discursive chapters in what he calls a "counterpoint" with twenty-one dialogues that violate any conventional sense of time and place.

"Little Harmonic Labyrinth," for example, is one of three rather lengthy dramatic colloquies that read like Theater of the Absurd. Hof-

stadter takes this title from an organ piece by Johann Sebastian Bach. His text throughout contains Shandian tricks which have meticulous scientific detail built into them; this particular drama is interspersed with three illustrations. Two of them are lithographs by M.C. Escher, "Convex and Concave" and "Reptiles," both typical of Escher's perception of an internally consistent but completely inconsistent composite modern world. The third illustration is an early Florentine engraving no less consistently inconsistent than Escher's; Hofstadter's selected "Cretan Labyrinth" is also, of course, typical of numerous other Renaissance depictions that sacrifice chronology for compression; its various narrative incidents are seen simultaneously: Theseus courting Ariadne, and girded for battle with the Minotaur; Ariadne abandoned on Naxos, and floundered in the Aegean waves; Aegeus and Icarus both plunging into the sea; Daedalus successful in flight.[4] Hofstadter's verbal play creates a similar and deliberate isomorphic confusion; the one famous line of the Cretan poet Epimenides, "all Cretans are liars," translates into numerous deconstructive analogies, such as "this sentence is false." His own small cast of mythological dramatis personae includes Achilles and the Tortoise, from Zeno's paradoxes; but their conversations are quite modern, like those of Tom Stoppard's professors in *Jumpers,* or Beckett's tramps in *Waiting for Godot.* They isomorphically make light of metaphysics that impedes as well as defines the possibilities of truth, religious or otherwise, in human thought:

> *Tortoise:* Do you really believe all this stuff about GOD, Achilles?
> *Achilles:* Why certainly, I do. Are you atheistic, Mr. T? Or are you agnostic?
> *Tortoise:* I don't think I'm agnostic. Maybe I'm meta-agnostic.
> *Achilles:* Whaaat? I don't follow you at all.

The common *humanitas* and the enduring *vanitas* here are a kind of verbal mime, an eternal braid of dramatic implications, ordinary characters in conflict, having built into them what computer scientists call "inherent complexities of decision problems." The imaginative loopholes of language and the "strange loops" of mathematics combine here in a kind of waiting for Gödel.

Can it not be said that great dramas in the arts or in the sciences require not great audiences, but rather merely literate ones? Drama does, of course, have connections with many other arts. Like pulpit oratory or grand opera or classical ballet, for example, it often combines its aesthetic limitations with a self-reflecting sense of its own importance; it is in the nature of performing arts to have grandeur written all over them. Just as satire often seems to settle for being merely satiric, so too drama is sometimes merely dramatic. Just as Greek dramas endured

along with saturnalias, and Elizabethan drama competed with bearbaiting and public executions for audience appeal, "dramatic" expressions today are not necessarily art but rather may be mere sporting contests, whatever their size or hoopla, or what Aristotle's *Poetics* calls spectacle. In the modern idiom of kinesics, drama is as much body language as verbal language, and the "things seen" in body motions on stage correspond to the visual qualities of satire in nonverbal art. But modern drama is no more *intentionally* simplistic than pulpit oratory or grand opera or classical ballet, whether from the viewpoint of highly talented performers or their attentive audiences. Verbal, musical, and athletic artists want to appear effortless even as their admiring and attentive audiences want to be knowledgeable. I am referring to that expertise, however limited, to which popular culture or the general public sometimes clearly aspires. Still, to the extent that literary criticism is itself one of the performing arts, it comes to share that unaesthetic brashness which is commonplace among them, nowhere clearer than in drama criticism.

Some of drama's simple though important ambiguities have a large appeal because they are as available as they are confounding, as significant as they are comprehensible, independent of *scientia et doctrina*. This intentional simplicity was Robert Gitting's concern in his Son et Lumière production at Canterbury cathedral in 1970, the 800th anniversary of Becket's death: "The whole script must be intelligible to a mass audience at first hearing, and yet carry overtones that accord with its impressive and timeless setting. It should have some quality of an argument overheard: as if the audience were eavesdropping on the unending quarrel of Church and State, in the persons of Becket and Henry, and recognizing that the terms used apply to their own lives too."[5]

There is a connection between diachrony and synchrony in the study of literature that is subtle and difficult, requiring an awareness and practice often uncultivated, and not only by mass audiences. "The two modes correspond to two ineradicable needs of human nature and will always persist," Frederick A. Pottle has said, even in literate culture, that is, among undergraduate and graduate students, antiquarians and New Critics, English professors and climbers of Mount Everest:

> Granting this, it might still be the case that the two modes have eternally to be party affairs, Republicans and Democrats, ins and outs. Perhaps we have always to live in a polemical atmosphere, saying things about our opponents and their platforms that we only half believe because an election is always coming up. Perhaps literature by its very nature is so passionate a thing that one cannot be reasonable about it. If I thought that were true, I should long since have chucked the whole

childish business and looked about for a more grown-up way of making a living. . . . The choices of synchrony are conditioned or limited by diachrony, but there are choices enough.[6]

I want to compare rather than contrast two playwrights independent of their respective premises and commitments. I think Samuel Beckett and T. S. Eliot are international because of what I would call "interplays" in more a generic than a geographic sense. They both have an appeal—as dramatists, specifically—that is as uncomplicated as their "message," which itself is independent of considerations of orthodox commitment or apostasy, or of diverse philosophical premises. I do not question that it is important to make a choice between them, Eliot, for example, on the basis of a preference for the aesthetic appeal of religious faith and "experience of the ineffable," or Beckett, for the possible delights in literary nihilism and "secularization of a religious vision."[7] What I am stressing is that Beckett and Eliot can be described as religious satirists, sometimes, whose generic mix of tragedy and comedy is an intentional combination of relatively simple thought and dramatically powerful feeling. Their dramas today, no less than the great dramas of Greek and Elizabethan culture, derive from their literary circumstances and emergent occasions. Beckett and Eliot show how religious satirists and their art function as "interplays." Like "tragisatires," their dramas are substantively constructed and derived, having shared generic qualities, quite independent of their authors' presumed doctrinal beliefs or personal spirituality.

Surely dramatists are not their dramatis personae any more than Beckett is Becket. I have no intention of blurring lines carefully drawn or spoken. But I do think there are generic interplays. As Ellen Douglas Leyburn has suggested, "in modern drama comedy has so far invaded tragedy—and tragedy comedy—that the terms have lost their old distinctiveness," and she says that dramatists of the absurd especially are aware of this "interpenetration of tragedy and comedy," that this "poses for contemporary critics an awkward problem of terminology." Thus, Martin Esslin writes about the plays of Beckett, Adamov, and Ionesco being "wildly extravagant tragic farces and farcical tragedies."[8] Some paradoxes of literary art are unresolvable and copious stock in trade. Is there anyone today, reader or writer, who would argue that thought and feeling are discrete human experiences, or that tragedy and comedy are, either in life or art? The answer is yes, even though, as James D. Hart tries to explain, "each age has its special texts," and even if "belief does not remain static and taste is ever fluid."[9]

I remember from the numerous Saturday matinees of my childhood very few featured films—*Wizard of Oz*, of course, *Frankenstein, Adven-*

*tures of Robin Hood, Snow White*—and only for their climactic moments and not their story-lines. What I do remember very clearly are the half-hour serials—*Flash Gordon, Tim Tyler's Luck, The Green Hornet,* and *The Lone Ranger*—those powerfully visual embodiments of some of the little radio dramas which impregnated my spiritual ear during the week. The radio dramas were more numerous, including also *Renfrew of the Royal Mounted, Tom Mix, Jack Armstrong, Pretty Kitty Kelly,* and *Little Orphan Annie;* but they were less captivating than their cinematic equivalents, what with their following one another in random fifteen-minute sequences, with messages to be decoded, box-tops to be sent in, and super-prizes to be anticipated by mail. The movie serials had the simplistic but profound appeal of medieval moralities: succeeding pageants of circumscribed and repetitious actions, in *fitts* and starts, heroic or terrifying or comic in proportions which I could understand and which yet would surprise; the prologue script unfurled like a piano roll, each week, into the horizon, a symbolic representation of past episodes, its verbal importances intensified by the accompanying theme from a Beethoven symphony or an overture by Rossini. It all seemed worth much more than the ten-cent price of admission.

Then on my way to Confession—about as regular as my movie attendance and almost always immediately following—my mind would be filled with characters of virtue and vice confronting one another on the precipices of oblivion. I am sometimes astonished how I remember too the so-called Merrie Melodies—or was it Looney Tunes?—a kind of juvenile Theater of the Absurd, Porky Pig its pontificating *choragos,* stuttering "That's All, Folks!" through closing curtains which I used to imagine were transparent but which actually enveloped mysteries that still baffle me. None of that was grand in any aesthetic sense, of course; but I own up to the lasting impact. My retrospective explanation of that impact posits the continuing existence of mystery plays, not only in the medieval sense with reference to subject matter more or less religious, but also in the psychological sense with reference to the audiences' range of critical responses.

Beckett's beliefs and spirituality are not so verifiable as the configurations and representations to be found in his dramatic art; but then they are not so relevant to an understanding of it either. As a student of Beckett's plays rather than as a "true believer" I am struck by the satisfaction many of Beckett's readers take in his apparent triviality of content and his obsessive attention to a "formless form" or "flawed flawlessness." Both the satisfaction and obsession have a velocity and vegetable growth of their own, and as much as Beckett's content and form they suggest that there is more rather than less than meets the eye

in them. The awesome bulk of Beckettian criticism has not so much solved as buried Beckett's mysteries. First, one might say that the continuing quandary about *form* (even in *Waiting for Godot*, which bears a specifically generic subtitle, "a tragicomedy in two acts") results from the predisposition that there is so little content; the dramas, as much as the poetry or novels, it is said, are steeped in a nihilistic vacuum of suffering and boredom. The implication seems always that since Beckett believes in so little, there is not much extrapolative—only some derivative, allusionary, and compendious—content. Secondly, the intrinsic religious significance of the plays is further mollified in an extrinsic comparison Beckett's biographers always make: like Joyce, he had in his youth lost even the vestiges of a practicing Christian faith. But Beckett's dramatic triviality is to me a ritual playfulness, approximately as irreligious as medieval allegory, or as absurd as simple, finite, objective description of modern life. Managing to avoid catechismal finality of several varieties, it has both a Christian and a psychological validity. It may not all be beautiful, but it is good.

C. S. Lewis has argued, as I have remarked in two earlier contexts, that allegory begins with Christian religion and its awareness of the divided will, that "to fight 'Temptation' is also to explore the inner world," the *bellum intestinum* being the primal action of the age of Augustine, whose "obvious parallel is modern psychoanalysis and its shadowy personages such as the 'censor'." Why *did* Augustine rob the pear tree? Why *does* tragedy please? Quoting from the *Confessions*, Lewis says Augustine "worries such problems as a dog worries a bone," and depicts "experiences strangely analogous to those of a beginner in modern psychology."[10] Certainly, Beckett is no such beginner, having "tolle'd and legge'd" a long distance according to his Augustinian pun in *Whoroscope*. But his own anatomizing confessions—in the satiric if not the autobiographic sense—provide no answers more apparent than Augustine's to the questions he poses. His questions are Augustine's, as are his generically allegorical-psychological ways of communicating them. The *flyting* match of Body and Soul is the elemental, Christian, and persistent irony. By elemental I mean the simple depiction, as in a Tom & Jerry movie cartoon, the modern beast fable of a cat asleep, on a kitchen floor, being tempted by his devilish self, at midnight, whispering in one ear for him to feast on the turkey carcass in the refrigerator, all the while being unsuccessfully restrained by the voice of his angelic self, who stands on his opposite shoulder. Tom Cat's turkey is Augustine's pear tree.

This is the basic condition of Christian consciousness, also a literary commonplace in the twentieth century. It seems to me that Trilling's notion of the modern writer as an Opposing Self can be identified as a

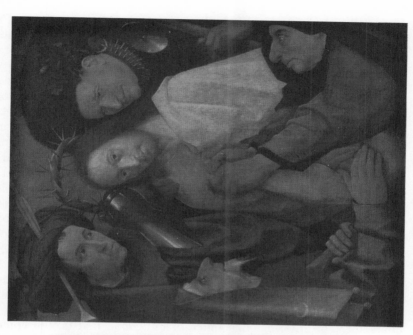

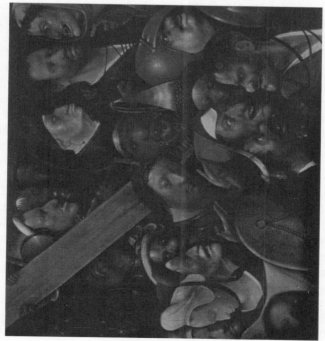

literary secularization of the *bellum intestinum*. In his essay on Freud and the Crisis of our Culture, Trilling is careful to delineate psychoanalytic rather than Christian orthodoxies; but they do not cancel each other out, at least not in a literary context, established with aesthetic sophistication. Such a context and sophistication *both* define the Crisis, what Trilling calls "the misapprehension of the nature of the self, and of the right relation of the self to the culture."[11] In short, the *humors* of the self and society can be defined in medieval quadruples or modern ones; there is a rational and emotional correspondence— between hot and cold, wet and dry, or the ego and superego, id and libido—in the literary depiction of the psyche at war with itself and with other psyches. In virtually all of Beckett's plays and novels, as everyone knows, pairs of contrasting but inseparable characters are the basic structural device. The Christian orthodoxy of these, as *debat* or *flyting*, extends in English literature from Everyman in his dialogues with his conscience, a precursor which G. S. Fraser was among the first to point out, to *Murder in the Cathedral*, with Thomas and his Four Tempters, and then, in the second part of the play, the Four Knights. Few would question that, in *Godot*, similarly, the voices heard on stage, Vladimir and Estragon, Pozzo and Lucky, represent two sides of a character. The interior conscience of *Endgame*, that is, the voices of Hamm and Clov, Nell and Nagg, in the French production was depicted as a monodrama within the interior of a skull, Clov's two high, small windows representing its eye sockets.

This staging may seem modern, but even as a structural device it extends back through three centuries and more, the convention of "inner voices" occuring in, say, George Herbert's "The Collar," as well as in Eliot's Prufrock poem, and heard among Wallace Stevens' Three Blackbirds. If Beckett's quadruple personae represent types rather than individuals, they have been a psychological and artistic conventionality too, in all Menippean satire, Theophrastan characters, Burton's *Anatomy of Melancholy*, and Jonson's comedy of humours. Their analogic number occurs in the Four Ages myth, the Biblical exegeses of Origen, Saint Thomas Aquinas' four-fold symbolism and all its modern derivatives, the *trompe l'oeuil* renditions of the seasons and elements by Arcimboldo, Francis Bacon's Idols, and Belloc's Four Men.

As with Beckett so with Eliot. Whatever their personal beliefs or unfathomable spirituality, these two religious satirists reveal similarities in their dramatic art that are more striking than their contrasts. The moot question with which criticism of Eliot's Canterbury play seems inevitably to grapple is whether in the light of its Christian and historical context it can be called a tragedy, and be valued as such. In comparing the play with Tennyson's *Becket*, John Peter for example

puts a higher value on *Murder in the Cathedral*; but if *Becket* succeeds only in trying to be a kind of Shakespearean tragedy, yet Eliot's play would seem to suffer in comparison with it on one point: the idea of Thomas suffering a "tragic" death just does not come off. Making the same comparison, Grover Smith suggests that even though "remission of guilt, as well as retribution, comes within the scope of tragedy, one would still be nearly right in designating *Murder in the Cathedral* a comedy." If the play is not clearly tragedy or comedy, then it is, according to critical commonplace, something of both, modeled after Greek ritual and medieval morality. A perennial part of the debate seems to be pleasure in it, delight being taken in the perception that Becket is "a character of ambiguous motives," or that the play as a whole is "a new integration of secular and religious drama," "human and divine realities," "liturgy and tragedy."[12]

The incidental humor, in Thomas's dialogue with the Tempters and the Knights, has frequently been remarked upon by critics. But no one to my knowledge has yet suggested that these dialogues constitute an expressly satiric theme and a satiric structure. I do not propose to make a generic identification once and for all. Theorizing about satire, like criticism of Eliot's play, is a matter of debate and legitimating claims, predilections for "pure" literary structure vying with interests in author's intention and in deciphering ideology. I would have to concede that satire is a "mixed animal" anyway. Nor do I want to simplify the large implications of the play's central theme, though an extended identification of it outside the structure of the play seems to me unnecessary to a literary argument about it. The issue of the genre of the whole play cannot be attended to by a consideration of only some of its parts. Nonetheless, I do say that Thomas's quadruple dialogues with the Tempters and the Knights are crucial to an understanding of the central theme and the structure of the play; they can be identified as an imaginative mode which Northrop Frye calls Menippean satire, the historical contest written in a contemporary context which makes it possible.

Of course, the dramatic action hinges on the prospect of whether and how Thomas, on behalf of the authority of the Church, is going to suffer martyrdom at the hands of the State. The Cathedral setting is, as Francis Fergusson says, "neither Canterbury in 1935 nor Canterbury in 1170 but a scheme referring to both, and also to a social order like that which Sophoclean tragedy reflects."[13] The conflict of religious and social values in literary contexts has a history which goes back to pre-Christian eras. Antigone, in transgressing the laws of Creon's society, has committed an act at once holy and criminal. Creon chastises her on social grounds in that she "dared defy the law." But, on her side, Anti-

gone's crime was one of piety, obeying the "immortal unrecorded laws of God." Creon, for his part, despite admonitions from Antigone, Haimon, the Chorus, and Teiresias, learns too late that "the laws of the gods are mighty, and a man must serve them/ To the last day of his life." The dilemma in the ancient *Antigone* of Sophocles and the modern *Antigone* of Anouilh is the same, though the dramatic resolution varies in particulars. Such conflict, if regarded as inevitable and revealing of man's imperfection, necessarily and always has aroused pity and fear. But to the extent that such conflict has become impossible or unlikely, or, as the likelihood of such conflict wanes, it has also provoked laughter. The perennial dilemma of maintaining and spanning a distance between Church and State has produced both tragedy and comedy. The posture of straddling can be both painful and funny.

In *Murder in the Cathedral* as in Anouilh's *Becket*, the Chancellor who becomes Archbishop defends the supranational authority of the Church against the proposed canonical innovations of the King, including the unreserved obedience of the bishops to the English throne. The fundamental conflict of values is cast in different form in these plays, with a corresponding difference in dramatic effect; in Eliot's, Henry II does not even appear as a dramatis persona, and Anouilh's play is not a Christian one. Still, whatever the estimate of the cause for which Thomas died, that he was a martyr is indisputable in both of these plays. In both, Thomas personifies at one point in history the inevitable clash of social and religious values; and, in Eliot's play at least, the murder of Thomas in the cathedral is a reiteration of "an eternal action, an eternal patience/ To which all must consent that it may be willed/ And which all must suffer that they may will it." Historically considered, the dilemma can be seen to transcend factions of political ideology and national boundaries. The extraliterary implications continue to be long-lived, numerous, and complex; the literary question is how these implications apply to a generic identification. Specifically, is the historical subject of Eliot's play causally relevant to its modern literary form? Does the play's subject provide its synchrony and diachrony?

Like Antigone, Thomas Becket is a persona who repesents the paradox of martyrdom—the pious violation of the social order, the sacrifice of real earthly pleasure for anticipated heavenly bliss—he is an actor in an action both piteous and joyful. In Part I, the Tempters are allegorical or, in a religious sense, otherworldly; but paradoxically their proferred rewards are all social or this-worldly. The First Tempter offers Thomas pleasure: "Now that the King and you are in amity,/ Clergy and laity may return to gaiety." But the King and the Archbishop are not in amity; the conflict of values is unresolved, obviously, as the

Tempter with "humble levity" takes his leave: "If you remember me, my Lord, at your prayers,/ I'll remember you at kissing-time below the stairs." The Second Tempter, also rebuffed, offers Thomas social power at the price of religious concessions:

> King commands. Chancellor richly rules.
> This is a sentence not taught in the schools. . . .
> Real power
> Is purchased at a price of a certain submission.
> Your spiritual power is earthly perdition.
> Power is present for him who will wield.

But in the metaphor of the play that "certain submission" is a lesser mission in its lesser obedience. It is a "sentence" pronounced in a lower court. It is the yielding to as well as the wielding of temporal power, lesser if also more certain. The Third Tempter offers a "happy coalition of intelligent interests," in a revolt against the King. Thomas will not have that either: "If the Archbishop cannot trust the Throne,/ He has good cause to trust none but God alone." The Fourth Tempter ostensibly shows Thomas that his acceptance of martyrdom is itself motivated by unreligious reasons, however religious a martyr's act may be. He charges—and praises—Thomas for his strength of pride rather than for his grace in love, for aiming at "general grasp of spiritual power" rather than at spirituality itself. Thomas concedes this possibility but regards it as part of the inevitability and suffering in the irresolution of opposing values:

> The last temptation is the greatest treason:
> To do the right deed for the wrong reason. . . .
> Servant of God has chance of greater sin
> And sorrow, than the man who serves a king.
> For those who serve the greater cause may make
>        the cause serve them,
> Still doing right: and striving with political men
> May make that cause political, not by what they do
> But by what they are.

In these discourses in the first part of Eliot's play, there is no mistaking the unresolved conflict of values. If politics can be regarded as the technology of social power, yet man—revealing his nature in the social pattern he forms, and in the manner in which social power is distributed and exercised—cannot have his destiny articulated in overtly political terms.

The Tempters, like their discourses, are in an obvious way not historical but imaginary, fictitious rather than factual, stylized rather than naturalistic; they depict not people but mental attitudes, and as a com-

bination of fantasy and morality they suggest that evil and folly are not
social diseases of the body politic. Precisely on all of these points,
Northrop Frye identifies satire as a literary genre as well as an attitude
of mind.

In Part II of the play, the Four Knights replace the Tempters and as a
group correspond to them in what I am suggesting is its satiric struc-
ture. Accused by them as "the Archbishop in revolt against the King; in
rebellion to the King and the law of the land," Thomas repeatedly
enjoins and rebukes them:

> Both before and after I received the ring
> I have been a loyal vassal to the King.
>
> . . . . . . . . . . . . . . . . . . . . . . .
>
> It is not I who insult the King,
> And there is higher than I or the King.
>
> . . . . . . . . . . . . . . . . . . . . . . .
>
> Petty politicians in your endless adventure!
> Rome alone can absolve those who break Christ's
> indenture.
>
> . . . . . . . . . . . . . . . . . . . . . . .
>
> I give my life
> To the Law of God above the Law of Man.

The Knights are "real" or, in a social sense, this-worldly, not only in the
values they represent ironically, but in their dramatic identity. That is,
having completed the murder, they advance to the front of the stage and
at considerable length address the audience on their own behalf, in
"almost ideal" or utopian terms:

> We are not getting anything out of this. We have much more to lose than
> to gain. We are four plain Englishmen who put our country first. . . .
> When you come to the point, it does go against the grain to kill an
> Archbishop, especially when you have been brought up in good Church
> traditions. . . . King Henry—God bless him—will have to say, for reasons
> of state, that he never meant this to happen. . . . Had Becket concurred
> with the King's wishes, we should have had an almost ideal state: a
> union of spiritual and temporal administration, under the central gov-
> ernment. . . . And at a later time still, even such temperate measures as
> these would become unnecessary. But if you have now arrived at a just
> subordination of the pretensions of the Church to the welfare of the
> State, remember that it is we who took the first step.

The ambivalence of their implicit motive and their explicit intention
re-identifies the perennial dilemma as a satiric theme. The ancient idea
of the separation of church and state and, more specifically, the inevita-
bility of a conflict in the values they represent have modern practical
consequences in arguments about economic or political expediency.

Yet the idea can scarcely be defined, or the conflict resolved, in terms of such consequences. In their collectivity, acting as "We" on stage, and having an italicized textual identification, Eliot's Knights seem to me to signal the kind of "resemblance" which defines the satiric category, even though the generic identification of Zamiatin's *WE* novel, in the long tradition of utopian literature, is as problematic as the identification of Eliot's poetic drama. "Comedy deals with *man in society*," Kenneth Burke says, "tragedy with the *cosmic man*," and the church in society has historically "gravitated towards the 'comic'." In the reiterated, collective pronoun "We" there is an ambiguous identification of interest; such an identification is, I think, an example of what Burke calls "corporate we's" and the "function of sociality."[14] One large-scale implication of Zamiatin's novel and Eliot's play alike is that in a modern United State, no matter where its temporal and geographic location, there is no difference between a society which only reluctantly complicates its goals with the "'law' of ancient religion," as D-503 mockingly refers to it, and a society which pursues its goals without religious considerations.

The Four Knights who murdered Saint Thomas of Canterbury are, in the play if not in history, comic rather than tragic archetypes, though their function in the structure of the play is not merely to duplicate the kind of humorous fun which finds its place in the less formal structure of medieval morality plays. If Eliot's play is no tragedy, it is not a morality play either. The Knights' apologia has been variously identified as a dramatically unsatisfactory "form of diversion to hold our interest," or "light relief," which if not exactly an excrescence yet has only a thematic importance without being a generic part of the play.[15] They are not dramatis personae like some of Eliot's others, in *The Cocktail Party* for example, revealing "high moral seriousness and 'light' comedy in the Noel Coward idiom"; but I do think that they are equally part of Eliot's "two-eyed vision which brings laughter which brings salvation from the prison of self."[16]

In historical time the conflict of opposing values was perhaps both inevitable and unresolved. Conflict presupposes virtual equals; for if values, like forces, are unequal, a resolution or decision is never in doubt. But in the play the conflict—from the viewpoint of the Knights at least—is perpetrated and resolvable. The "pretensions" of the Church are unequal to the "welfare" of the State. In the imaginative mode of Eliot's play, "We" have taken the first step on the stairway to paradise. The shift from Part I to Part II in the play, represented by the Tempters and the Knights, intensifies the satiric implications of a clash between Church and State. Both the Tempters and the Knights represent ways in which the conflict of opposing values can be terminated.

The Tempters try to persuade Thomas that a resolution, on their terms, will not violate his pious responsibilities; the Knights attempt to persuade the audience that their act was no crime.

The crucial theme of *Murder in the Cathedral* is developed in a satiric way: the formal symmetry of the two parts of the play, virtually equal in length, is substantively appropriate to that theme; and the dramatis personae, the Four Tempters and the Four Knights, whose dialogue with Thomas contributes most to sustain that structural balance, are satiric. Most of Part I is a dialogue between Thomas and the Four Tempters, who are not people but attitudinal personae in Menippean roles. In Part II, the Knights are certainly more imaginative as dramatic types than they are "real" as historical representations; and, to the extent that they are literary conventions more sophisticated than those in a morality play, they are ridiculous past the point of comic relief.

This sense of metaphysical anguish at the absurdity of the human condition—communicated in numerous dramas in every age—is not definable as *either* synchronic *or* diachronic, though perhaps it is describable under the successive heads of Climate of Opinion, Sensibility, and Idiom which Pottle suggests as clarifications in writing history of literature. But absurdity is not necessarily profound, not so much as a theological complexity, but rather as a simple revelation of the art of sinking in drama. It is not only Ionesco who says he is unable to understand the difference that is made between the comic and the tragic. A synchronic perspective, especially one that is not exclusively literary, can be intricate and in its own way bifocal, that is, diachronic too.

Beckett no less than Eliot, as a religious satirist and in his art, represents a *kind* of orthodoxy and simplicity found in much drama. Ruby Cohn suggests in a concluding chapter that the old wedding jingle— *Something old, something new,/ Something borrowed, something blue*—can "symbolize and summarize" all of Beckett's work.[17] I like the suggestion for the emphasis this epigraph-as-paradigm puts on Beckett's traditional *orthodoxies,* and for aesthetic *simplicity.* This is not to say that these violate either the *newness* or the *complexity* in Beckett's modern perspective. Science, for example, has for centuries been more than the simple manipulation of exact measurements; the arithmetic of nature has been replaced by its geometry. The humanities, suffering a kind of cultural lag in this respect, observable in much Beckettian criticism, are caught up in the Naming of Parts—who is Godot? and so on—which may be not only a pointless pastime, but an absurd one. I am saying that Beckett's little voices, like Eliot's Tempters and Knights, have their analogy too in the discovery of form in mathematics.

Beckett's incidental correlations of slapstick and theology—the ir-

reverent twist of Jesus' actual words to Saul: "*it is* hard for thee to kick against the pricks," the Trinitarian last lines of Mr. Knott, the discourse of the neo-John-Thomist Mr. Spiro, Moran's list of theological questions—all traverse the "comic gamut," as Cohn calls it, of cosmological possibilities. But it seems to me inaccurate to imagine them as either trivial or despairing, though of course they fall short of "grand style," and they certainly can be melancholy, and invite adverse attention. Even the first Great Cham of popular culture sometimes has to be defended for his platitudes, and not for his aesthetic sophistication; Johnson remarked, as an apologia for commencing *The Rambler*, that "men more frequently require to be reminded than informed." Platitudes in life or art are not boring to people who frame them in an attempt to make samplers and simple sense of their experiences, or to invest them with a significance that is uncertain.

The later and slighter plays by Beckett, especially the radio plays, are extraordinarily bare dialogues. In *Words and Music*, Joe or Words and Bob or Music represent, as I read them, the quadruped mentality of a persona named Croak. In *Cascando* the story-teller is only two component voices, the Opener and Voice, but with the Opener himself (?) having two "doors," one for Voice and one for Music. I suspect their intended effect might be deliberately simple, simpler even than Son et Lumière, like the juvenile moralities and comic shows popular before the advent of television. Some of Fred Allen's radio dialogues are like Beckett's in their aesthetic rather than moral duplicity, that is, for their simplicities geared to audience level and attention span. And Allen says, in his autobiographical *Treadmill to Oblivion*, that his personal pessimism was relieved by the small, topical satires he forced to be pleasant, to sound like merely light banter. The four personae who inhabited Allen's Alley—he lists them twice—Senator Claghorn, Titus Moody, Mrs. Nussbaum, Ajax Cassidy—are at once comic and grotesque. The radio plays he chose as representative of his career have Beckettian themes, personae, and language.[18]

Popular genres often have legitimate if also ill-defined value as art, and one might say it is too easy a way out to criticize them for conspicuous shortcomings even when, like most theater pieces, they are short-lived or spasmodic. Michael Flanders and Donald Swann, for example, in performances deprecatingly titled *At the Drop of A Hat*, are certainly articulate on stage and screen, and only apparently frivolous; virtually immobile, one sitting at his piano, the other in his wheelchair, they are seldom only trivial or mildly amusing. In contrast to them, on television, Hee Haw's *choragos*, lamenting "gloom, despair, and misery on me," are not cultural analysts, but they are clowns who suggest the weight of living. What many such personae simply and with duplicity

have in common is an uneasy balance between portentous subject mat-
ter and effervescent tone, a forced humor perhaps made innocuous by
the very goal of popular receptivity. Donald Swann's *The Space Be-
tween the Bars* is, like Fred Allen's *Treadmill*, a vocational autobiog-
raphy which belongs to both genres of Inspirational Literature and
Popular Book; in a whimsical blurb on it his partner Flanders says,
"The book reminds me of the *Confessions of St. Augustine*. But not
much."[19]

At his best or his worst, similarly, Beckett creates dramas which are
like a Tom & Jerry cartoon, or a Laurel and Hardy or Marx Brothers film.
It is probably inaccurate to say that they are only simple-minded, on
the one hand, or that they are especially sophisticated, just as one can
be skeptical of the aesthetic claims made for Charlie Chaplin, Buster
Keaton, and W.C. Fields, whose great implications of meaning are said
to thrive on their verbal simplicity reduced to silence. The Sound of
Silence is a recurring popular theme in song too, and in Jules Feiffer's
cartoons: two personae meeting, their faces curiously resembling the
countenances of "real" persons, talking at one another, with animosity
and misunderstanding, in a dialogue during which no thoughts or feel-
ings get shared. The theme and intended effect occur in *Krapp's Last
Tape*, in the dialogue, such as it is, of Krapp with his own recorded
voice, or in *Happy Days*, in the dialogue of Winnie (who in at least two
senses is not quite "all there") and Willie (who is on stage for only the
briefest time). There is not much bulk to these dialogues, but then,
there is not supposed to be. It is because they are slight that they are
vehicles for Beckett's popular acclaim, and his notoriety. This holds
true for his two longest and best dramas too. As Ronald Hayman says,
"In a curious way, *Happy Days* is an extension of *Endgame*, just as
*Endgame* was of *Waiting for Godot*—a reincarnation of the less interest-
ing of the two pairs of characters."[20]

Matthew Hodgart's claim that Beckett is representative of contempo-
rary dramatists in his "moving away from the traditional forms, such as
satirical comedy and tragi-comedy" and into "new realms" seems to me
to be inaccurate; rather I think his plays do fit into Hodgart's ordinary
and generic category of "the popular theatre," that is, the form of mim-
ing, song and dance, the vehicle for the simplest forms of satire in
vaudeville, burlesque, revue, or the "more naive and sentimental art of
the music-hall."[21] Here "naive and sentimental" seem to me to have
Schiller's meaning. Beckett himself describes *Waiting for Godot* as a
tragicomedy, after all. The most accurate statements in the vast library
of sometimes contradictory claims for Beckett, first, point to his ge-
nerically traditional and popularly "simple" forms, and second, sug-
gest a religious orthodoxy that is not so much uncomplicated as simply

devoid of sectarian definition. As William Saroyan says in his essay printed on the phonograph slipcase for the recording of the American *Godot* production, the "theatrical manner of Bert Lahr would appear to be ideal for Gogo," suggesting that the international appeal of vaudevillian clowns transcends whatever is "something unique in each person in the world," that the performance of Bert Lahr as Gogo is like his performance of the Cowardly Lion in *Wizard of Oz*. What Saroyan claims for the play as "a chapter in the contemporary Bible, . . . the gospel so to say according to Samuel Beckett,"[22] has its generic equivalent in the French language editions of The Gospel According to Peanuts, and in the institutional sanction and zealous appeal of Pierrot, the circus, and marionette theaters in many European cities. Beckett's mysterious Unnamable, Hugh Kenner suggests, is merely like Emmett Kelly, "a sort of 4 a.m. Pagliacci," and "the central Beckett situations are outrageously simple,"[23] even in the comparatively sophisticated and intricate novels.

So, to ponder the unquestionable artistry of Beckett's *Godot* is ultimately to consider the absolute appeal of trivia. The silly but secure profession of various stand-up comics, whether academic, journalistic, or priestly is not limited to the varieties of *borscht* circuit in the Adirondacks, Atlantic City, Las Vegas, and Miami. Their unintentional humors include the melancholy that is part and parcel of attempts to create significance out of ordinary Human Interest or, conversely, to see entertainment value in what used to be called merely Current Events: the cosmo-techno-theology of space rockets; the miracle of temporary salvation by kidney machine or heart transplant; the philanthropic balls, parties, and other conspicuous almsgiving in High Society; the automotive massacre of highschool sweethearts at graduation; GI's killed during military service in "peacetime" or their willy-nilly deaths from legally contested causes after their return to civilian life; moments of joy and sorrow preserved "forever" by candid cameramen; the everlasting and therefore immemorial sequence of baseball scores and championship contests; the whole panoply of human acts called *serioludere* in the medieval moralities, and today called Comics and Funnies.

The cinematographic days of March of Time, Movietone News, and Passing Parade have themselves now passed. But in the fullness of time we are sequentially blessed with TV's Big News and Wide World of Sports; we continue to have the eternal and ritualized depictions of that subject matter one electronic *choragos* calls, in a litany I suspect every schoolboy today knows, "the thrill of victory and the agony of defeat." The agony of defeat for Unamuno, in *The Agony of Christianity*, is that "hopeless and frustrating (because non-resolvable) dialectic of faith

versus reason"; but it is not the defeat of faith or of reason as one of Unamuno's translators claims, but rather, I think, of the dialectic. This very point may account for the popular reception of Beckett's two big plays, despite their grandeur written all over and conversely some critical enjoinders to the effect that they have been "overpraised." Of *Endgame*, Hayman says, you have to see more than Beckett put there. Christian and psychological validity in art, after all, is not restricted to "impressive" artistic forms or "significant" subject matter.

In "Why does Stephen Dedalus pick his nose?"[24] Richard Ellmann draws autobiographical connections in James Joyce's personae, as when Stephen quotes Aristotle with approval: "The soul is in a manner all that is: the soul is the form of forms." Ellmann makes many claims for Joyce, the author most frequently compared to Beckett, which have a larger validity, especially regarding Joyce's attraction to Giordano Bruno's simplistic and universal theory of the coincidence of contraries: "Hot is opposite to cold, but they are both aspects of a single principle of heat, and their kinship can be seen in the fact that they are both united at their minima, the least hot being also the least cold. The deepest night is the beginning of dawn." Ellmann says that "Bruno's coinciding contraries may in retrospect be seen to give form to each episode of *Ulysses*, as though each had been generated out of some pair of seeming opposites which might be shown to join." And Ellmann claims that the ultimate unstated proposition that declares itself is that "the obverse of God's descent into matter is matter's ascent towards at least provisional divinity." Ellmann's mode of perception spans the centuries between Bruno and Joyce, at once medieval and modern, humorous and thermodynamic, thus suggesting what Pottle makes explicit, that in the study of literature, diachrony and synchrony are two ineradicable needs of human nature and will always persist, that they are connected in theory, but also that they require practice not always cultivated.

Such literary spirituality may or may not be defined in secular terms, but its identification *in* and *as* religious satire seems to be inescapable. Of course, Ellmann and Pottle are themselves literary rather than religious in their perception. I contend that something like the Christian consciousness and the medieval *flyting* is to be found not only in Bruno's coinciding contraries, or Milton's Satan's hateful ones, but also in Joyce's episodic pairs of seeming opposites which might be shown to join, or in Beckett's and Eliot's "interplays." Something like it is "built into" writers and readers alike if not equally. For all persons and dramatis personae, it might be part of what Teilhard calls the phenomenon of man, what Teilhard's adverse critics—some of them quite religious—dismiss as "spiritual anthropology."

As a performing artist, Jacob Bronowski is best known for his topsy-turvy didacticism. Achieving distinction in mathematics, the sciences, and literary study, his last great work was *The Ascent of Man*, the TV series and picture book for the mass audiences he esteemed. Not exactly a pulpit orator, he never dissuaded anyone from religion, but he has won converts to science, celebrating the arts and the sciences without denigrating religion, whether in Blake and Yeats or Einstein and Heisenberg. In *The Origins of Knowledge and Imagination*, five times in the first chapter, Bronowski refers to man's "modes of perception." It is Bronowski's phrase, not Schiller's, identifying the stereoptic vision of humans that connects the visual to the visionary, the experience of the world with the images of the mind. Bronowski nowhere argues that man as animal contradicts man as spirit. Like Marvell, he seems to argue for the dialogue of body and soul. Indeed he takes to task such divergent persons as Bishop Wilberforce and Konrad Lorenz, separated as they are by more than time and place, for arguing the case in absolutely opposite directions. Bronowski reads Yeats's poem "For Anne Gregory" as though Anne Gregory were one of the Hesperides and as if the poem were written by Herrick, because its theme, like Herrick's, is his theme: in his love for woman or God, a man gets his experience which is not directly physical through physical means. For Bronowski, even Einstein was no less a delightful person for "his special capacity of sometimes treating God as if God were his uncle, and of sometimes treating God as if he were God's uncle."[25]

Unamuno insists that his own agony of Christianity is not an existential voice crying in the wilderness but a spiritual plurality, despite the fact that for him the dialectic of faith versus reason was hopeless and frustrating: "Maybe a better term would be mono-dialogues. . . . The person who takes part in a dialogue, who converses with himself by dividing himself into two or three or more persons, or even into an entire people, does not soliloquize. . . . Job was a man of inner contradictions; so were Paul and Augustine and Pascal; and so I believe am I." Unamuno argued that "mystical agony . . . proceeds by way of antitheses, paradoxes and even tragic plays upon words."[26] The identification of such persons and personae can be made by any man whatever his capacity for thought, passion, or holiness. It is not only in saints or in tramps that a character of ambiguous motives can be found, but in that greater part of humanity that falls between them.

# 9

## The Fiction of Apostate and Orthodox Satire

Profane disagreement if not sacral mismanagement occurs within all religious institutions. Even Papal Infallibility has its "genuine" difficulties continuously in print, within its own aegis. The social encyclicals of Pius XI, on the Church and the Reconstruction of the Modern World, even after a half-century provoke among the faithful an unabated opposition ranging from indifference to hostility. The personhood of Pius XII—like his persona in Hochhuth's *The Deputy*—endures indifferent defense and vigorous attack. John XXIII's *Mater et Magistra* achieves notoriety among diocesan factions even while it is largely unread. Electronic journalism feasts on the bones of Vatican II. In the New and Third Worlds "progressive" and "traditional" divisions wage a conflict of interpretation of the faith, pastoral peace or even ceasefires eluding Papal intercession. Priests are shot and churches bombed and The Holocaust is appraised as benign neglect. Professed and even professional Christians play politics with aggrieved taxpayers, and sometimes they play with themselves, agreeing that social evils left, right, and center are all once or one at a time the work of the Devil. Life does not imitate the art of satire so much as the fiction of satire is fact.

Profane mismanagement looks like sacral disagreement within all social institutions. The uses of religion are replicated by satirists inside and outside organized religion. Eugene Zamiatin's denigrating references to the United State, for example, were not Soviet propaganda directed against an enemy on the American continent. D-503 asserts that " 'We' is from God, 'I' from the devil," and insists, parenthetically, "it goes without saying that we are not taught the 'law' of ancient religion but the law of the United State." Zamiatin is able to show an

essential and existential schism in the early twentieth century by de-
picting imaginatively in the future, the merger of two institutions
within which both ancients and moderns have their identity. "How
many things, of which the ancients had only dreams, are materialized
in our life!" D-503 expostulates. "The ancients . . . preferred to believe
that they saw *heaven*, even though it was a toy made of clay, rather than
confess to themselves that it was only a blue nothing. We, on the other
hand (glory to the Well-Doer!), we are adults, and we have no need of
toys."[1] The "We" of Zamiatin's great novel is a fictional pronoun accu-
rately used as a title but too large for a personal grammatic antecedent;
it is a plural kind of conglomerate, depicting the merger of Church and
State, a supranational United State complete with solemn liturgies and
devotional calendar, Guardian Angels, New Jehovah, and Well-Doer.
"We" in this sense has no historical antecedents either. Though this
fictitious "thing" of the Russian novelist exists in future time, a generic
mark of the vast library of Miltonic or anti-utopian satire, the point of it
is that in present time society does function without religion as it has
existed in the past. Karel Čapek's *War with the Newts* characterizes the
special new religious system as "composed" for insurgent newts by the
"popular" philosopher Georg Sequenz, but understood and honored by
adherents among human beings everywhere: the ritualistic Newt Litany
and the amphibious, orgiastic Newt Dance becoming widespread in the
modern world.[2] Such themes, occupying the interest of numerous mod-
ern satirists, are as much factual as fictitious, sociological as well as
literary, objectively delineated whatever the subjective intentions em-
bedded in them. In short, modern satiric personae are often social
rather than personal creatures in two senses: they depict institutional
rather than individual follies, and they transcend the different religious
allegiances or political commitments of individual satirists. Religious
satire is an imaginative mode written within a factual context that
makes it possible.

Satirists, whatever their individual values, are appalled by the fact
that religious excitement may exist without religious knowledge and
foster goals which vitiate religion's past values.[3] It is precisely the pur-
gative or cathartic revelation of this large fact which constitutes the
value of their satire as a literary genre, or at least helps to define it
independent of the "size" of the satire itself. No one would say, for
example, that C.S. Lewis and Bertrand Russell are fellow parishioners,
or fellow travelers. But as satirists they sometimes have an identical
focus, as in Lewis's *The Screwtape Letters* or *Screwtape Proposes a
Toast*, and Russell's *Satan in the Suburbs* or his *Nightmares of Eminent
Persons*. *The Screwtape Letters* is more completely epistolary than *Sa-
tan in the Suburbs* (which also begins with a piece of correspondence

and contains a long letter, almost all of section III). They are both marked by incipient debunking with extraterritorial, mythic scope beyond merely national boundaries. In *Screwtape*, His Infernal Majesty advises his nephew Wormwood on the pivotal event in the life of a hellish "convert": "Once you have made the world an end, and faith a means, you have almost won your man, and it makes very little difference what kind of worldly end he is pursuing. Provided that meetings, pamphlets, policies, movements, causes, and crusades, matter to him more than prayers and sacraments and charity, he is ours—and the more 'religious' (on those terms) the more securely ours."[4] To find this argument-by-indirection in Lewis does not surprise, but the fact is that it occurs in Russell's satires too. In *Satan in the Suburbs*, Beauchamp writes to Yolande about his *"ill-omened visit to that malignant incarnation of Satan,"* Dr. Mallako, who admired him for his *"devotion to noble causes,"* including the distribution of Bibles in many languages and many lands: *"I told him how conscious I was that if I were going to win you I must have more to offer, more in worldly goods, but not in worldly goods only—more also in richness of character and conversational variety. . . .'My friend,' said he. . . . 'A little freedom, a little daylight, a little fresh air, even on the subjects from which you have sought to avert your thoughts (vainly, I am afraid) can do nothing but good, and is indeed to be commended by the example of the Holy Book.' "*[5]

"Zahatopolk," one of Russell's nightmares, clarifies the modern effects and historical evolution of religious socialization, along with its primitive manifestations. It is, like other and larger efforts of both apostate and orthodox religious satirists, larger-than-life for being in the future, referring to the past and critical about the present. The time of "Zahatopolk" is some astonishing forty centuries from now. Professor Driuzdustades, head of the College of Indoctrination at Cuzco (the Peruvian city actually occupied by pre-Incan tribes), relates that during the Greco-Judean era some men publicly and without shame ate peas, but did not, when the number of their children exceeded three, eat the excess to the glory of the State. And, more ridiculous than this shame and reluctance, they believed that a state could be stable in spite of fundamental divergences in the religious beliefs of its citizens. Driuzdustades lauds the holy religion of the divine Founder Zahatopolk for effecting the "monumental stability of traditional orthodoxy," and he is baffled when Diotima, a beautiful and gifted student (namesake too of Socrates' reputed teacher of philosophy), refuses to sacrifice herself to the incarnate Inca. "Come, come," says her father, "you don't suppose, do you, that sensible men believe all that palaver about . . . what is called Holy Night; but . . . we know that these beliefs, however ground-

less they may be, are useful to the State. They cause the government to
be revered, and enable us to preserve order at home and empire
abroad. . . . Rash girl! You refuse to be a sacrifice to the Inca, but you
have not thought that the true sacrifice is to law and order and social
stability, not to a gross prince." And, "Come, come," says the Professor,
"Do you not know that the truth of a doctrine lies in its social utility
and spiritual depth, . . . that since the true is socially useful, the doc-
trines of our holy religion are true."⁶ But alas, the skeptical heroine is
unpersuaded and burned at the stake for her socio-religious heresies.

Theological precision is elusive in literary contexts, but to the extent
that theology is a science as well as a subject matter of art, the fiction of
apostate and orthodox satire can be said to be a common literary enter-
prise. The varieties of satiric experience notwithstanding, I think it is
possible to regard the voices of orthodoxy as clearer or at least more
explicit than apostasy's. Chesterton, referring to the Religion of Hu-
manity since Comte, that is, the worship of "corporate mankind as a
Supreme Being," says that "the modern world is madder than any
satires on it," and that "it is the real rival to the Church of Christ."⁷ One
of T. S. Eliot's recurring themes is that "there is an aspect in which we
can see a religion as the *whole way of life* of a people," and he deplores
the inferiority of actual societies in which their religion and their cul-
ture become fused and identical.⁸ Chesterton's "corporate mankind"
like William James's "corporate dominion" or like Kenneth Burke's
"corporate we"—or Zamiatin's, Eliot's, or Waugh's—is multifarious
and no mere fiction. In Emergent Collectivism, what Burke sees as Act
V in his dramatic Curve of History, secular prayer and the gospel of
service are important to no one vested interest: "In 'secular prayer'
there is *character-building*, the shaping of one's individual character
and role with respect to a theory of collective, historical purpose. . . . By
the 'gospel of service' one refers to *social service*. It is a *collective
attribute*."⁹ Such secular prayer and gospel of service have no finite
boundaries any more than they can be expressed as an orthodox and
(therefore) vested interest. Oceans do not cut it up. Nancy Mitford says,
"A friend of mine voiced this attitude during the war: 'Well, you know,
I don't do firewatching or Home Guard and I feel one must do some-
thing to help the war, so I always go to Church on Sunday.' I am sure he
did not imagine that his prayers would drive back the German hordes;
he went as a gesture of social solidarity."¹⁰ Burke says, "We [in
America] are still far behind England in the extent to which the 'sociali-
zation of losses' has been democratized."¹¹ Santayana says that ". . . it is
astonishing how much even religion in America (can it be so in En-
gland?) is a matter of meetings, building funds, schools, charities,

clubs, and picnics."[12] Wyndham Lewis, whom Burke calls "the compleat satirist of our day," argues that the United States is a "grotesque advance copy of a future world order," "something more than a nationality," "what amounts to a religion, 'a way of life'."[13]

Orthodoxy and apostasy, dogma and heresy, have no one prescribed shape, at least not for literary religious satirists, in their church affiliations or denominational allegiances or the strength of them. Some satirists are converts to the Episcopal and Catholic Churches, others life-long opponents of organized religion with any recognizable dogma or sectarian bent. My point is that apostasy or orthodoxy do not count for much in satire. Theologians distinguish among apostasy, heresy, and schism, but for literary purposes—wherein interest may or may not focus more on definition than on salvation—it is possible that the referents coincide. Heresy, for example, can be regarded as a metaphor in explicitly a secular context. Lord Percy of Newcastle, in *The Heresy of Democracy*, writes that "in the desperate insecurity of the modern world, what is at issue is not one more mistake in the technique of government, where every generation has multiplied its mistakes since the first syllable of recorded time, but a culminating error of belief which can accurately be described only in the language of religion."[14] I do not think that the "culminating error of belief" in *vox populi vox Dei* is one thing or identifiable in one word, but I do think Lord Percy makes clear sense in arguing that any political system *as* a religion is wholly incompatible with Christianity, or with its tradition of dualism, *Regnum et Sacrum*. A religious satirist putting his finger on secular developments in this context could not accurately be called apostate, heretical, or schismatic. Voltaire and others, in attacking the claims of orthodox religious ethics, may speak of the church as a deliberate plot against society. Others like Rousseau claim that a man cannot be a citizen and a Christian at the same time. And Helvetius argued that it is from the legislature alone that a beneficent religion could originate. "The distinctive appeal of political Messianism," Talmon writes, "lies no more in its promise of social security, but in its having become a religion which answers deep-seated spiritual needs."[15] Talmon's study, like Durkheim's, implies and infers that modern men, whatever their political allegiances, seek in politics what can be supplied only in religion. There is nothing unique in the arguments of Percy and Talmon (as it was almost 150 years ago, in DeTocqueville) that revolution culminates in tyranny with the sanction of popular consent. My point is that political Messianism as a "sociological force," as Talmon calls it, and as an historical fact, considered synchronically and diachronically, provides a kind of counter-sanction for debunking which can substan-

tively and generically be called religious. Its universality allows modern satirists to attack it independently of their political convictions, national origins, or religious belief.

Satiric fantasy is near kin to numerous other verbally articulated kinds, including what I have called unintentional satire, which is not deliberately literary or artistic, with configurations that seem merely existent rather than crafted or constructed and a reality that may be religious in only a nominal way. The question may be asked, whether such political Messianism or social salvationism has revealed itself in the church throughout history. Norman Cohn in *The Pursuit of the Millennium* indeed points out that the more carefully one compares the revolutionary Messianism in medieval and Reformation Europe with twentieth-century totalitarian movements the more remarkable the similarities appear. However, Cohn makes some very careful conclusions. Thus, Messianism is not fanaticism only (for historically it has sometimes been religious) but rather revolutionary fanaticism in particular. And it is not the sum total of medieval heresy (for the varities of religious dissent that have appeared and flourished have been many, like the varieties of religious experience and the varieties of religious satire), but rather *eschatological fantasy*. It is a revolutionary movement as "quasi-religious salvationism" whose promises are terrestrial and collective, not spiritual and individual, that is, a "secularized version of a phantasy that is many centuries old."[16] Cohn suggests that his history can be regarded as a "prologue" to the upheavals of the present century by the ideologies of both Communism and Nazism. But the fanaticism he delineates through past centuries he regards as an historical and psychological fact, not a religious one. If such fantasy is not definable within the traditional church, then it is probably not to be attributed to bona fide Protestant denominations either. Ernst Troeltsch insists, for example, in *Protestantism and Progress*, that the early Protestant Reformers were "at one with Catholicism" in their recognition of church and state, and that "the indications of the continuance of an essential homogeneity between the world of the Reformers and the modern world are . . . mere straws." A chief problem for Troeltsch— and, I would argue, for many satirists as well—is that "Modern Protestantism, since the end of the seventeenth century, . . . has forgotten . . . the identity of the *Lex Dei* and *Lex Naturae*; so completely forgotten it as to have lost all understanding of it."[17]

The subject allows and invites attack; it is large and easy to hit, and satire can be a convenient weapon at hand. Santayana concludes that "if we do not know our environment, we shall mistake our dreams for a part of it, and so spoil our science by making it fantastic, and our dreams by making them obligatory. The art and religion of the past, as

we see conspicuously in Dante, have fallen into this error. To correct it would be to establish a new religion and a new art, based on moral liberty and on moral courage."[18] But satirists would seem to say that if we do not know our dreams, we shall mistake our environment for a part of them, and so spoil our fantasies by making them scientific, and our obligations by making them dreamlike. The value of satire as a mode of knowledge is that it forces an awareness of these differences, even in what one might call little apostate satire, or silhouettes.[19]

In both "Zahatopolk" and "Faith and Mountains," the two longer short stories in Bertrand Russell's *Nightmares of Eminent Persons*, Russell is certainly not a spokesman for "religion of the past," but rather he seems particularly inclined to put the screws to conservative politics and dogmatic religious beliefs. In the prefatory note to *Satan in the Suburbs*, Russell explicitly had declared that his intention was not to "point a moral or illustrate a doctrine" but simply to be "either interesting or amusing." But *Nightmares*, two years later, he warned in its short preface, has the opposite intention, to have a moral rather than to amuse. Some of his nightmares are "purely fantastic" but "Zahatopolk" is meant to be "completely serious" and "Faith and Mountains" will appear fantastic only to readers who "have led sheltered lives." This is a frequent and aggressive admonition about religious satirists and their art, comparable, for example, to the admonition Auden has made on Chesterton's behalf. "Faith and Mountains" depicts the struggle between two new rival and phony "spiritual" religious leaders, and like "Zahatopolk" takes the reader, however briefly, into a world as terrifying as Huxley's or Orwell's.

One may question Russell's capacity as writer of fiction, while admiring his achievement as a philosopher. His stories are crude demonstrations of traditional story-telling methods; his two slim volumes are uneven as imaginative efforts, being, as Russell admits, "a new departure at the age of eighty." Though he has no metaphysical propensities in over a hundred other books and essays, Russell concerns himself with the analysis of moral judgments and religious beliefs and of their historical consequences. One might say that if Russell, like Samuel Butler and other apostates, rejects metaphysical theses it is because they are not supported by anything he can regard as adequate evidence. But the fact that theology does not bear rational examination shocks him less than the fact that its ministers have so often abused their power; it is in its social and political configurations, not its theological ones, that Russell was hostile to religion. To a critic of *The Principles of Social Reconstruction*, for example, he says he did not write "as a 'philosopher'" but rather "as a human being who suffered from the state of the world, wished to find some way of improving it, and was

anxious to speak in plain terms to others who had similar feelings."[20]
The book is derisive in temper and reflects Russell's distrust of both
social and political institutions. But, one speculates, it is not merely his
tone of voice which accounts for the unhappy reception of his ideas for
the reconstruction of the modern world.

The little apostate satires of Bertrand Russell have a subject matter
and a scope that have little if anything to do with his religious beliefs.
He wrote a lot of religious satire long before he intentionally sat down
to write fiction, as an octogenarian. *Bertrand Russell's Best: Silhouettes
in Satire*,[21] is an anthology collated from twenty-four sources through a
half century, with only one extract from each of his two volumes of
fiction. All of these silhouettes are brief excerpts arranged by subject
matter in six categories, including religion, witty combinations of
humor and seriousness, more than ridicule and other than polemic,
manifestations of Russell's spirit even as they are a random sequence of
bits and pieces, like Butler's *Notebooks* or *Shaw on Religion*. I think
they all suggest how satire occurs piecemeal in novels and plays yet
controls their mode of perception throughout. In an often quoted essay
of 1903, "A Free Man's Worship," Russell's religious views were early
stated and they changed very little in his lifetime, because it seemed to
him, there was no new evidence for belief in orthodox religions. Yet,
despite the brevity and clarity of his religious views, to the effect that
what men need is not dogma but rather an attitude of "Christian love
and compassion," his frequent statements have been misconstrued in-
ternationally by many of his readers. Popes of the Church—never deri-
sive in temper and, surely, not distrustful of social and religious
institutions—have shared Russell's literary fate, in the clash of their
personal intention and public effect.[22] Brevity may be the soul of wit,
and *copia* the body of religious wisdom, but neither can guarantee
salvation, or even comprehension.

E.M. Forster, like Russell certainly no orthodox churchman, unlike
Russell certainly an accomplished writer of prose fiction, shares Rus-
sell's mode of perception. Silhouettes occur often in his novels, as
when in *Howards End* his materially prospering and social-climbing
heroine, Mrs. Margaret Schlegel Wilcox, contemplates the significance
of religious observances: "A funeral is not death, any more than bap-
tism is birth or marriage union," she thinks. "All three are the clumsy
devices, coming now too late, now too early, by which Society would
register the quick motions of man." Concerning the first Mrs. Wilcox's
death (and at that time she had not yet married the widower Mr. Wil-
cox), "Don't brood too much," she advises her sister, "on the superior-
ity of the unseen to the seen. It's true, but to brood on it is medieval.
Our business is not to contrast the two but to reconcile them."[23] But it is

not necessarily in the novel as sustained prose narrative that the con-
tention of the "unseen" to the "seen" is strongest or most deliberately
sustained. Yet it *is* this contention more than the length or size of the
narrative which is the generic mark of apostate satire. One of Forster's
several short fantasies, "The Machine Stops," expressing a dystopian
concern with the evil effects, now and in the future, of machinery on
humanity, shows how machinery warps men's minds in religious
ways. The technological "refinement" of Forster's underground world
are horrifying in themselves certainly, and the official religion of "un-
denominational Mechanism" contributes to that horror. But in its
manifestations—perceived as curious on all sides—the modern merger
of religion and society suggests much that is primitive as well as an-
cient, uncivilized as well as simply old.[24] It violates religious predis-
positions for or against the merger of church and state, and transcends
secular or antinomial differentiation between them. Such a modern
merger of religion and society is a large subject matter, and satire is one
way of cutting it down to size. Social and religious denominations
alone cannot.

"From what sort of self does satire issue?" Asking herself this open-
ing rhetorical question, Patricia Meyer Spacks singles out aggression—
inborn misanthropy all around over against an elevated *humanitas*—as
one of the components rarely stressed in satire, on the satirists' part or
in an equivalent readers' "permission for verbal destructiveness."
Spacks is unenthusiastic about the commonplace literary "movement
toward considering satire a way of feeling rather than a genre," and she
admonishes literary criticism created out of contradictory single-
mindedness and oversimplification, dependent on the dubious anti-
thesis of personal creativity over against external events. My third
chapter's explication of Ian Jack and Konrad Lorenz shows my concur-
rence on her point that aggression is one of satire's components. More
especially in this chapter, I think that the misidentity of persons and
personae counts among what Spacks neatly calls "satire's peculiarly
troublesome demands on its readers, its insistent generation of uncer-
tainties."[25] Defining such uncertainties was Gödel's vocational glory,
and their existence defines the age in which we live.

Even in religious satires which seem to be partisan, apostate or or-
thodox, the tone of objectivity can be found, but it is not easy; it is not
easy to keep in mind that the "real" narrators, authors or authors' per-
sonae, are, in their own "way of feeling" commonly called dramatic
irony, "really" serious and not trying to be funny. Such satires are
fictions with ambivalent and not singleminded solemnity, even when
they are conspicuously ludicrous and obviously brief. Dorothy L. Say-
ers' "Cosmic Synthesis" or "Pantheon Papers"[26] in *Punch*, for example,

Calendar of Unholy & Dead-letter Days

Beautification of St Kenna
St Lukewarm of Laodicea, the Tolerator
Apotheosis of the C.M. Commonly
called Lowbrow Sunday
St Marx the Evangelist
All Fools' Day
Venerable Bernard Shaw, G.O.M.
Sacred name of Science

Fiery Loins of St Lawrence
Smothering Sunday
St Sigmund (Freud) Sub-Limine
Theophany of the Spirit of Progress,
commonly called Petrol Sunday
Gratification of St Gorge
Blessed Lytton Strachey,
The Debunker

was a series of fragmented but clearly focused orthodox silhouettes, many of them straightforward and topical rather than imaginative, even when they are allusive. "Cosmic Synthesis" has a form and substance similar to those of Knox's small satires, and to C. S. Lewis's *Screwtape Letters* and *Screwtape Proposes a Toast* (which first appeared serially in *The Guardian* and *Saturday Evening Post*, respectively), a short chapter from Firbank's *Valmouth* (first published periodically with the title of "Fantasia in A Sharp Minor"), or Russell's satires (which also first appeared in various periodicals). "Edited" by Dorothy Sayers, the Papers are offered as a scholarly find of large proportions, with photo-gravure and plates not to be found in the British Museum or the Bod-leian, but nonetheless as fine as many other things of their kind which aspire to more deliberatively literary ends, sometimes by virtue only of their page length: Hagiological Notes on such saints as Lukewarm of Laodicea, the believer in all cults, and Supercilia, the patroness of pedants, and the Creed of St. Euthanasia. The Calendar of Unholy and Dead-letter Days includes: the Apotheosis of the Common Man, com-monly called Lowbrow Sunday; the Beautification of St. Henna; and the Feast of Blessed Lytton Strachey, the Debunker; the Fiery Loins of St. Lawrence; the Non-committal of St. Dubius, St. Cloud the Obscure, and St. Statisticus. The Cacaphonous Discordants—or Polarites—celebrate Wishmas, mostly an exchange of cards bearing wishes for Recipients' prosperity and adorned with ice, snow, holly, and other Polar symbols. These are small jokes, certainly, but their delineation of cacaphonous polarities makes them large as life.

Satirists such as Dorothy Sayers, whose orthodoxies are well-known traditional articulations, can of course be said to defend an interest as vested as it is apparent. Nonetheless, though they have an intention that would seem to be relatively uncomplicated, orthodox no less than apostate fictions suffer the fate of being misread. Thus, in the so-called "short novels" of Ronald Firbank, the world-view is not directly or obviously factual. They are expressions of large and ominous reality, yet not "Catholic" or otherwise personal regarding Firbank's satiric self. That Firbank was a "true believer" is no more relevant to his satire than that he was a fop. The "personal" comparison of Firbank with, say, Forster and Saki comes easy, though it is certain that they did not share anything like religious orthodoxy. As a matter of practical literary criti-cism or of literary theory, Firbank's personae, or Forster's or Saki's, even perhaps Waugh's, are often an exotic and epicene breed. And their satires despite modest size have vast and abstruse contexts.

That Firbank's novels are not a conflagration of moral passion is clear enough. But satire as a kind of aggressive indignation consumes—or purifies?—where it smolders even as much as where it flames. Fir-

bank's Duquesa is indeed like Forster's Mrs. Wilcox, or like Saki's Duchess and his Lady Caroline. When Reginald charges that the Duchess is irreligious, she counters: "Oh, by no means. The fashion just now is a Roman Catholic frame of mind with an Agnostic conscience: you get the medieval picturesqueness of the one with the modern conveniences of the other."[27] Reginald himself advocates "Christian fortitude" to her over against the Duchess's inclination to appraise fame and fate as at best whimsical and at worst disappointing: "It's not always safe to depend on the commemorative tendencies of those who come after us. There may have been disillusionments in the lives of the medieval saints, but they would scarcely have been better pleased if they could have foreseen that their names would be associated nowadays chiefly with race-horses and the cheaper clarets." When the Reverend Poltimore Vardon argues that the Christian church's best self-interest is for it to become "rather more exclusive than the Lawns at Ascot," Lady Caroline objects:

> That is the great delusion of you would-be advanced satirists; you imagine that you can sit down for a couple of decades saying daring and startling things about the age you live in, which, whatever other defect it may have, is certainly not standing still. The whole of the Sherard Blaw school of discursive drama suggests, to my mind, Early Victorian furniture in a traveling circus.

Whether Saki's disposition is misogynist or otherwise "personal" seems certainly less definite than that in the satire it is Reginald who is the fop and Reverend Poltimore who is the would-be advanced satirist who "had once seen a resemblance in himself to Voltaire, and had lived alongside the comparison ever since." Lady Caroline's "Sherard Blaw" is no more a derision than Shaw's "Chesterbelloc," and it is Saki himself as narrator who says Reverend Poltimore is no Voltaire.

Apostasy as distinct from orthodoxy in religious satire is an elusive dichotomy, one of its persistent, generic uncertainties. Firbank's *Eccentricities of Cardinal Pirelli* would not seem to have an immediacy, for it is so utterly fantastic; there is nothing actual in it; yet one may say that the personae inhabiting it—attitudinal personae in satirical roles—are not so much unbelievable as amoral. If they are unbelievable, then so too are the personae of Waugh's *The Loved One*, though his subtitle "An Anglo-American Tragedy," is a generic identification, only moderately puzzling, of the true-to-life in fantasy. Firbank's Madrid and Waugh's Los Angeles are at once real and fictitious. The epicene Cardinal, utterly vacant Duquesa of DunEden (dystopia?), stupid Monsignor Silex, and indeed everyone else in Firbank's curious diocese, are not so much unreal as repulsive. In a flurry of excitement and festivity, the

Duquesa brings her dog to be baptized at the Cathedral font. This function of sociality—the administration of the first sacrament by the Cardinal, like the burial of housepets in the Happy Hunting Grounds or the preservation of corpses in Whispering Glades—reveals sentimentality which seeks by absurd social means to straddle the gulf separating human life from lower life, and the living from the dead.

Sophisticated though it may be, and obscure and impalpable its ways of affecting writer and reader alike, Robert Elliott argues, satire still retains an enigmatic connection with its primitive past. That the connection seems sometimes to be severed is as much a commentary on the satirist's audience as on his art. The primitive past is depicted in the present. His Weariness the Prince in Firbank's *The Flower Beneath the Foot* is not a *Blaue Blume* but a festering primeval weed. Firbank's *Prancing Nigger*, at once noble and savage, lives in a world at once fantastic and corrupt; he is more exotic than Huxley's Savage in *Brave New World*, but is like him nonetheless. Cuna-Cuna is a little city of lies and peril, its harsh realities mollified in faerie dusk; its mere size and primitive blue blur suggest nothing of the technological validity of Orwell's Oceania. But its primitive simplicities are themselves not unbelievable, nor merely reportorial; the fact that Firbank actually made a stay in the Negro republic of Haiti is no more relevant to the story he tells than the fact that Orwell did not actually live in the year 1984 or on Notting Hill. Like Saki's Reverend Poltimore or Russell's Zahatopolk, such personae as Firbank's Cardinal Doppio-Mignoni in *Valmouth* are caricatures precisely because they are depicted as real and not merely sectarian; the climactic Marriage-Baptism in *Valmouth's* last chapter, like the union of Margot and Paul Pennyfeather in Waugh's *Decline and Fall*, is a sacramental parody implicating the reader in a religious insouciance and social fervor defying doctrinal specificity. The Cardinal's habitat—a Comtean basilica in the parish of St. Veronica, with its tapestries depicting Birth of Tact and showing Taste supine on a flower-decked couch amid ultra-classic surroundings, the esoteric altarpiece of the School of Sodoma, the mystic windows revealing the astonishing life of St. Automona Meris—is a silhouette world no more detailed than the macrocosms in *WE*, *Brave New World*, and *1984*, but as real as Reginald's London.

Such religious uncertainties reveal themselves as finite social realities in orthodox as well as apostate satires. They are often sophisticated, *and* obscure and impalpable, in the satirists' mode of perception, not their own personal mysticism so much as a depicted social attitude. Such an attitude—"slovenly sentimentality" Chad Walsh calls it—also permeates all the actions of Waugh's personae in *Love Among the Ruins*.[28] A small orthodox satire, scarcely more than fifty pages, it

like many other silhouettes first saw publication in weekly journal-
ism.[29] Yet, however limited in physical size, it too has a large, macro-
cosmic perspective: the Ultimate Good at Satellite City and Mountjoy is
Full Family Life and euthanasia; in their expletives, "Great State,"
"State help me," "State be with you," Waugh's personae reveal that the
State has made them, and made them into its own image (the name of
the "hero" is Miles Plastic); the fourth chapter is set in Santa-Claus-
Tide, during which only children sing old ditties about peace, good-
will, and the tidings of comfort and joy (like the metamorphoses of
Halloween and St. Valentine's Day). The point is not, as the popular
idiom puts it, that Christmas is for children; Christmas *is* children.
Subtitled a "romance of the near future," Waugh's satire has a central
limiting action: the courtship of Miles and Clara, and Miles's socio-
sacramental marriage to Miss Flower. But what the action is about is
the limitless sentimentality which robs all men and women of their
identity; it is even impossible to distinguish between them. There can
be little question of Waugh's social and religious "conservatism,"
something quite different from the "liberalism" of Christian orthodoxy
in the person of John XXIII or John Paul II. Yet there is plenty of room
for clarification about the forms that "conservatism" has taken in
Waugh's art. There is, heaven knows, little critical agreement about it.[30]
But the generic problem is not, I think, insurmountable. Though the
purpose of *a* Utopia may be, as Walsh and Gerber say, man's earthly
welfare, it is not true of *all* Utopias. Waugh's referents are not concrete
nor his personae directly identifiable, at least not all of them. *Love
Among the Ruins* is not a ridiculing polemic but a satire. The purpose
of a satire may be practical or remedial or this-worldly in the sense of
"earthly welfare." But it is also otherworldly and impersonal, religious
and aesthetic, as far from explicit ridicule as it is from devotionalism or
socio-political tract.

The fictional employment of religious orthodoxies in fantasies larger
than these by Firbank and Waugh may be even more encompassing.
*Orphan Island,* an early novel by Rose Macaulay, for example, has the
earmarks commonly ascribed to that multiform genre: character differ-
entiation and development within a circumstance chronologically or-
dered and realistically depicted. It is fantastic to the extent that it is
unlikely a society would exist much less develop through seventy years
after a shipful of children foundered on an unknown Pacific island; but
this circumstance is set in a brief and surprisingly uncomplicated
opening chapter. Miss Charlotte Smith, in the beginning simply a gov-
erness, a "kind-hearted lady of thirty or so," undergoes a metamor-
phosis by the time the Thinkwells arrive three generations later. No
longer a human being but a socio-religious deity, she represents an

identification of Church and State which survives trade in the island and the missionary efforts of a Jesuit priest. Throughout most of the novel, Thinkwell, a Cambridge sociologist, presses for an understanding of Charlotte Smith as socio-religious deity. The Old Testament of the Smith-Religion, he finds, is based on a small volume entitled *Mixing in Society, or Everybody's Book of Correct Conduct*. The Smithy priest carves on trees totemistic slogans adapted from Bunyan's *Holy War* but formed in the aphoristic Newspeak of a Felsenburgh or a Big Brother. Miss Smith's Journal constitutes the longest sustained joke, and with the ostensible subject of a "kind of satiric history of Smith Island"[31] by Hindley Smith-Rimski, provides its main substantive focus.

Macaulay's last book, *The Towers of Trebizond*, she refers to as being "a great nostalgia for the Church," in her posthumously published *Letters to A Friend*.[32] The narrator "Laurie" is in some of the facts of her life identifiably Rose Macaulay. The structure of her story is unexceptionable, rooted in present time, and, despite the obvious fictionality, it is a chronicle concerned with some real people in real places, with extended discourses on the Cold War with Russia, the BBC and the general culture of England, the missionary efforts of Billy Graham and Seventh-Day Adventists, Israel, tourism in Jerusalem, and so on. It is no Utopia, not as surely as it was a "popular novel." But it is also a compendium of religious speculations, like Belloc's *Path to Rome* a kind of sustained devotion, a sentimental journey which though "true to life" has a kind of significance which is not geographical and chronological. It too is a pilgrimage to a Holy Land more than a travel record.

Orthodoxy is sometimes even more "far out," and resembles mere science fiction. In C.S. Lewis's *Out of the Silent Planet*, the "hnau" are transposed to a different State of Being, by Oyarsa, the spiritual overlord of the planet called Malacandra; and this lengthy narrative is only one of his three sequential "interplanetary novels." But, again, the satiric genre is identified in the inclusive attitude of sociological fantasy rather than in its physical size or narrative scope. Perhaps the most comprehensive satire Lewis has written, though the subtitle identifies it merely as a fairytale, *That Hideous Strength*, the last of the trilogy, shows the Omnipotent Devil coming to inhabit the earth. His fictive existence, as a disembodied head—the face of Big Brother more or less in the flesh—supplied with blood and saline solutions through rubber tubes, demonstrates the Triumph of Scientific Knowledge; and his National Institute of Coordinated Experiments virtually gains control of England and the world in the Name of Science, Progress, and Society, the neo-trinity. The "hero" of the tale is a muddled and ingenuous Fellow in Sociology, Mark Studdock, whom the N.I.C.E. alternately

flatters and terrorizes into joining the Cause, in much the manner that
the Party acts on Winston Smith in 1984, or that Pryer advocates in his
plans for a College of Spiritual Pathology in *Way of All Flesh*. Stud-
dock's lengthy indoctrination is in the hands of Professor Frost, a kind
of spoiled priest or black John the Baptist, their relationship like that of
Brother O'Brien and Smith in 1984 or that of Mustapha Mond and John
Savage in *Brave New World*, or Professor Driuzdustades and Diotima in
Bertrand Russell's "Zahatopolk." The earthly brotherhood, Frost and
Mad Parson Straik among them, reflexively and reflectively respond to
the promptings of demonic spirits. Though "interplanetary" and fan-
tastic, *That Hideous Strength* is earthy stuff. Though its scope is vast
and sublime, its intended effect is immediate and ridiculous.

These contentions are artistic incongruities. As "uncertainties of sa-
tire," they are immune to the expository rigors of Christian apologetics,
vexing within and without "orthodox persuasion" and vulnerable to
the aesthetic pitfalls of mere demonology and science fiction even as
they contribute to befuddled appreciation of great literary art. Shaw for
example has written so much, so many ways, in so many different
directions, that his religious beliefs seem smoke-screened, no doubt
there but with imprecise configurations. Thus, Warren Sylvester Smith
says that his anthology, *Shaw on Religion*, is both an historical curios-
ity and an entry into current religious dialogue. Smith calls his anthol-
ogy a book depicting the Essential Religious Shaw, not to explain
Shaw's "own peculiar mysticism" but to provide topical reading for
non-theologians, not for Shaw's answers (which are parenthetically
dismissable as "no longer surprisingly different from those of many
liberal theologians") but rather for Shaw's "*manner* of looking at the
problems." Smith does not say that his selections are silhouettes, or
even little apostate satires. But he does seem to suggest that they are a
mode of perception; and Smith rightly numbers Shaw with Bertrand
Russell as someone who did not need a church "though he sometimes
appreciated the empty buildings." *Shaw on Religion* is an interesting
anthology, but an uncertain one too, intended to be read as Christian
apologetics or disputation, as religious explicitly but only implicitly
satiric, not theological exactly but not fiction either. The uncertainty, it
seems to me, is neither Shaw's nor Smith's but rather built into the state
of the art. This is not an adverse criticism but a descriptive one insofar
as silhouettes by generic definition are not details.

"After all," Shaw has said, "the salvation of the world depends on the
men who will not take evil good-humoredly, and whose laughter de-
stroys the fool instead of encouraging him."[33] It is from this viewpoint
that, to take a single Shavian instance, one listens sympathetically to
the formulation of the utopian state of mankind coming from the mouth

of a mad priest, in *John Bull's Other Island*. The English civil engineer Broadbent envisions the social and economic development of Ireland, and a growing rapport between the two countries. But Shaw's Irish personae smile at such illusions. For Father Keegan, the unfrocked priest, "there are but two countries: heaven and hell; but two conditions of men: salvation and damnation." Smith says Keegan represents "Shaw's own existential pain," and Broadbent a "comedic fatuousness."[34] There can be no reconciliation between these two personae, the civil engineer and the priest; not only their plans but also their fantasies simply do not square:

> BROADBENT [reflectively]. Once, when I was a small kid, I dreamt I was in heaven. . . . I didn't enjoy it, you know. What was it like in your dreams?
> KEEGAN. In my dreams it is a country where the State is the Church and the Church the people: three in one and one in three. It is a commonwealth in which work is play and play is life: three in one and one in three. It is a temple in which the priest is the worshipper and the worshipper the worshipped: three in one and one in three. It is a godhead in which all life is human and all humanity divine: three in one and one in three. It is, in short, the dream of a madman.

Shaw's Keegan is mad, like Lewis's Parson Straik, Broadbent as ingenuous as Studdock; and John Bull's Other Island is, in a shared Swiftian perspective, as dystopian as England itself. In fictive terms Utopia *is* John Bull's Other Island, or perhaps, as the duality of the predicate nominative allows, the other way round.

In his Preface to *Back to Methuselah: A Metabiological Pentateuch,* Shaw offers physiological-homeopathic-mithraditic solutions to "problems" in religious education and concerning the nature of would-be religious educators:

> In truth, mankind cannot be saved from without, by schoolmasters or any other sort of masters: it can only be lamed and enslaved by them. . . . Voltaire was a pupil of the Jesuits; Samuel Butler was the pupil of a hopelessly conventional and erroneous country parson. But then Voltaire was Voltaire, and Butler was Butler: that is, their minds were so abnormally strong that they could throw off the doses of poison that paralyse ordinary minds.[35]

Shaw and Voltaire and Butler are religious satirists, sometimes. One problem here is that in his prefatory exposition, Shaw begins to sound not only like one of his dramatis personae but like Saki's Reverend Poltimore. Are not Shaw and Butler equally would-be Voltaires? If so, then it is not always apparent whether they are being scientific or religious, factually accurate or even trying to be. The tentative nature of

satirists' self-description is one of the most durable traditions built into
their genre and among its vexing uncertainties.

Religious satirists build into their art the tentative delineating nature
of their literary tradition. *Back to Methuselah* itself, after the expository
Preface, begins in the prehistory of Genesis "In the Beginning: B.C.
4004 (In the Garden of Eden)" and then proceeds in the multimillennial
direction of futurology "As Far As Thought Can Reach: A.D. 31,920."
Shaw's play is an intentional utopian fantasy, a satiric kind to be read
rather than a drama of manageable size that lends itself to theatrical
production. Not all silhouettes are small even as they are unwieldy,
incomplete, uncertain. By definition they are indefinite, incomplete,
always insufficiently detailed. Ever a theorist as well as practitioner of
his art, Bernard Shaw, in the lecture "Modern Religion,"[36] discusses the
institutional form that he anticipates religion will take in the twentieth
century, and, in passing, he delineates his own interpretation of the
facts of Christian history, speaking seriously and optimistically of the
formulation of a great modern religion which will not be the Roman
Catholic Church, the Church of England, or the Calvinist Church he
was brought up in or, for that matter, any church at all. In Chesterton's
view the differences between himself and Shaw "on almost every sub-
ject in the world" are acute, complete, and overall religious.[37] Yet per-
haps one can agree that though Shaw is most surely not orthodox, the
facts of his life do indicate that his "interest in religion was profound
and never declined," and that he was "as nearly Christian as it is possi-
ble for a man who repudiates the greater part of Christian doctrine, to
be."[38] I suggest that the distance between the *literary* spirit of a Shaw
and a Chesterton, as of a Russell and a Lewis, whose worth's unknown
although his height be taken, may not be so vast. Many a Shavian play
is satiric colloquy more than *dromenon*, or thing done. Also, Shaw may
have forsaken the novel early in his career, but as a literary socialist—
bent on social if not religious reform—he is in fact just as well read as
acted, what with all his prefaces, postscripts and epilogues, meticulous
bagatelle and concern for language.

Uncertainty in satire is not the same as imprecision in satirists
though uncertainty and imprecision equally guarantee that satirists and
their art will not always be appreciated. Whether the value of *any* art
exists independent of advocacy of social reform or acceptance of reli-
gious belief remains as it has always been a moot question. Like Shaw,
Samuel Butler can be valued for his intricately religious and scientific
thought, in one way, by largely ignoring the fact that what Butler writes
is largely fiction, not to say specifically religious satire.[39] Butler
nonetheless suffers the more common fate of religious satirists, namely
that the body of his work is picked apart for biographical specimens

and autobiographical self incrimination, as in Edmund Wilson's essay on Butler as a satirist who had "begun as a boy of pious family" and "ended as a kind of crank."[40] Such a judgment is a typecast not only of religious satirists but of biographers of religious satirists. I think that it makes good literary sense to identify Butler as an apostate satirist on textual evidence, who constructs art forms that do not reveal special dogmatic propensities, and for whom orthodoxy is not anathema nor heresy a crutch. Certainly no traditionalist, Butler satirizes not orthodoxy but "Irreligion of Orthodoxy," not the religion of Christians but the observable *want* of religion in Christian society,[41] not orthodox Christians but "certain ultra-orthodox Christians, who imagined that they could detect an analogy between the English Church and the Erewhonian Musical Banks."[42]

Butler was critical of the values of the society in which he was raised, though he did not try to absolve himself from them. Like Benson and Knox he was destined for an ecclesiastic life; like them he had a father who was Canon in the Church. Yet, early on, Butler disbelieved in the Resurrection and to the end of his life he poked fun at the conventional God of the religious. As is frequently said of Chesterton, like Butler a layman, Butler "loved a paradox above most things,"[43] and his major literary works are satires which identify and wrestle with paradoxes. His copious *Note-Books* are full of them, and though they are not always clearly satiric—perhaps because they are so brief, as silhouettes too shadowy—they are at once real and unreal, symbolic and topical, abstract and immediate:

> Time is the only true purgatory.

> God does not intend people, and does not like people, to be too good. He likes them neither too good nor too bad, but a little too bad is more venial with him than a little too good.

> Heaven is the work of the best and kindest men and women. Hell is the work of prigs, pedants and professional truth-tellers. The world is an attempt to make the best of both.[44]

Even his milder reflections of a generalized and abstractive nature square with his persistent, derisive attitudes toward actual clergymen in the Church, whom he observed with a careful and jaundiced eye.[45] And it is no surprise that *The Fair Haven* evidently did Butler grave harm in the literary world too.[46] But he included himself in his satire. *The Way of All Flesh* testifies throughout to a strength of sympathetic feeling about personae Canon Pontifex and his son Ernest, the latter modelled of course after Butler himself and hardly a flattering portrait. Butler's mouthpiece and Ernest's friend, Overton—the omniscient nar-

rator "I"—makes it clear that Ernest is a fool, as when, in his passion for regenerating the Church of England, and through this the universe, Ernest subscribes to Pryer's plans for a College of Spiritual Pathology; this College would not have to do with supernatural graces but with efficacy, "approaching both Rome on the one hand and science on the other—Rome as giving the priesthood more skill, and therefore as paving the way for their obtaining greater power, and science, by recognizing that even free thought has a certain kind of value in spiritual enquiries."[47]

Though Edmund Wilson insists that Butler's person and persona are identical—ranging from impious to cranky—he reads *Erewhon* as the uncharacteristic and attractive work of a young man full of freshness and bravado, but not a great work, not comparable with *Candide* or *Gulliver's Travels*, not a satire or even satiric, "not a definite expression of a satirical point of view based on mature experience," having neither Voltaire's focus nor Swift's logic. But *Erewhon* and *Erewhon Revisited* head Richard Gerber's chronological list of 250 modern Utopias, Miltonic and other. What Gerber calls the "role of religion" is exceedingly important in them. *Erewhon, or, Over the Range* is no doubt a kind of "symbolic journey," as Gerber says,[48] both allegorical and utopian, both "dreamlike in a certain vagueness" and also "hard matter-of-fact," a bridge between the two worlds of psychological perception and social complexity. It is to "this unknown world" that Higgs says he journeys.[49] In this generic sense—qualitative considerations aside—the book is like C.S. Lewis' *The Pilgrim's Regress*, and Bruce Marshall's *Father Malachy's Miracle: A Heavenly Story with an Earthly Meaning.* Or, considering that Chesterton's *The Man Who Was Thursday* is something like *Pilgrim's Progress*, as Ronald Knox has said, so too are the Erewhon Books. Like *Thursday*, or *Flying Inn*, the Erewhon Books have a structural looseness, but they also have a discernible subject matter in focus. Like Knox's *Barchester Pilgrimage* or Belloc's *Path to Rome*, *Erewhon* does not strictly speaking have a plot. But it does have an explicitly religious central theme, established in the very beginning and sustained to the very end. It is persona Higgs's two-fold intimation that he imagines himself to have made a discovery and to have chosen a course of action of an extraordinary and prophetic kind, "as has not been attained by more than some fifteen or sixteen persons, since the creation of the universe." The discovery is that the Erewhonians are the Ten Lost Tribes of Israel, a matter of historical fact which in its legendary aspects impels the reader to an imaginative consideration both Biblical and contemporary, real and unreal. (For the Ten Tribes really were lost, but still are not lost in the sense of Anglo-Israelite theory which identifies the Ten Tribes with the English.) Higgs's growing and

reiterated intention to convert the Erewhonians presses the curious implication, in the precise ways that give the satire its bite, that England-as-Erewhon is not really a Christian nation. Higgs seems to perceive "the everlasting Is-and-Is-Not of nature," which operates in the world and all it contains, including man. When man had grown, Higgs says, to the perception "that the world . . . is at the same time both seen and unseen, he felt the need of two rules in life." For him this is an abstractive, internal dilemma measured off against real, external circumstances. Like Mrs. Wilcox in *Howards End*, he chooses not to brood on the superiority of one to the other, if also with less apparent success; his way out, like hers, is not to contrast the two but to reconcile them. The "dual commercial system" of the Musical Banks is a social institution of "mercantile transactions," and Higgs describes it in detail. "The saving feature of the Erewhonian Musical Bank system (as distinct from the quasi-idolatrous views which coexist with it . . .) was that while it bore witness to the existence of a kingdom that is not of this world, it made no attempt to pierce the veil that hides it from human eyes." Traditional Christianity is of course a composite of just such "quasi-idolatrous views." Butler's point is that, if one takes away their validity, their historic roots, then those socialized forms of religious activity which exemplify the Church Militant in this world are precisely the details of the Musical Bank in "this unknown world" of Higgs's records. In the worship of Ydgrun, Higgs sees not only a correspondence to the religion of his native land but to his own beliefs as well. Ydgrunism is social conventionality in its religious manifestations.

The reader finds, in the end, that the conversion Higgs has in mind for Chowbok and the Erewhonians is not a religious conversion; Higgs's purpose in writing of his adventures is not a religious purpose. His subjects scarcely exemplify the Pauline Character and Conversion as John Owen explores them, and Higgs is surely not the embodiment of the Christ-Ideal. A fundamental contrariety or ambivalence is Higgs himself. It is Higgs and not Chowbok who, as Higgs says of him in the beginning, "exceeded all conceivable limits of the hideous," and it is Higgs who shows the reader, unwittingly, that "the ridiculous and the sublime are near." If ultimately there is no "real" explanation for a Pauline Character or Conversion, similarly there is no resolution to the problems posed by the character of Higgs and of Chowbok. Reflecting Ydgrun belief, Higgs confesses that "the example of a real gentleman is, if I may say so without profanity, the best of all gospels." Then, observing that the Erewhonians "had no sense of a hereafter, and their only religion was that of self-respect and consideration for other people," Higgs asserts that he knows his own religious convictions "were the only ones which could make them really good and happy, either here

or hereafter." The reader is not sure whether Higgs is being in any way consistent, or more exactly, whether Butler's characterization of him is a meaningful complication of an apparent ingenuousness, or a lack of artistic control of materials which defy manipulation. The complexity in understanding Butler's viewpoint in Higgs's discussion of Erewhonians is precisely like understanding Swift's intention in depicting Gulliver's appreciation of the Houyhnhnms.

Though the idea of the separation of church and state undoubtedly has practical consequences, Butler's point is that it cannot be defined in terms of such consequences. In *Erewhon Revisited* Butler's satiric point of view is developed in a way even more personally involved than one expects in the genre; I say more personally involved insofar as Butler was partly serious about his notions of "vicarious immortality" or "vicarious life" and insofar as the story is cast as a fictitious transcription, by Higgs's son, of a record of Higgs's comments by the Erewhonian Dr. Gargoyle which Higgs's son says his father says he never made. The confusion of person and persona, here, may be insuperable; I would say that it is also deliberate and effective. Lewis Mumford concludes that "if Butler does not always seem to fight on the side of the angels, it is perhaps because the angels have a horrid way of getting into bad company."[50] If what Butler has done is to make for himself a private religion, perhaps part of the price he has had to pay for it is a certain incomprehensibility. Yet, clearly, the thrust of much of Butler's satire, like that of orthodox satirists, is that the modern social uses of religion have evolved without the church as it has developed from the past.

For other apostate satirists too, these uses and abuses of religion are a dismal fact, even when what they argue and advocate may seem obscure alternatives. I have not much discussed H.G. Wells among the Big Four of Edwardian letters, for example, only because he is numbered among those I call "other utopians" and as such his dispositions are well-enough recounted by Hillegas' *The Future As Nightmare*. But the cultural significance of Wells is problematic. Even Carl Sagan, one of our age's most esteemed celebrators of science fiction and an opponent of demonology, is cautionary in his literary criticism, comparing Wells to Jules Verne as suitable to that part of himself that is still ten years old. Still, Sagan, like lesser extraterrestrial enthusiasts and other science fiction buffs, leans on Wells in his attempt to explain the Cosmos to twentieth-century's Everyman.[51]

Wells envisions the society in *A Modern Utopia* not as a "permanent state" but rather as a "hopeful stage, leading to a long ascent of stages."[52] Exploring the myriad problems of "Man versus the State," he shows how religion, especially for his "poietic" and imaginative Samurai, has unlimited value. His approbative presentation of such ideas is directly

and repeatedly identified with the name of Comte, who himself comes in for little praise, however. Wells no doubt is unorthodox, "heretical" about "speculative and metaphysical elements," as he says in his prefatory note. For Wells, mankind is basically good and getting better in this world, and Wells's religious participation in Man the Undying precludes his consideration of the world of Here and Now as the handiwork of God. The topography of his narrative—dream vision, philosophic polemic, religious tract—is set in two different worlds: Utopia, an entirely imaginary planet, and a second world of Here and Now. Wells's ambivalence or indefiniteness is, I think, built right into this fictive duality, and one questions to what extent the purpose or the consequences of the Samurai are honorific or satiric. Their Greater and Lesser Rule is a prescription of Spiritual Exercises, not the exact equivalent of the book by Our Ford, Huxley's neo-New Testament, nor *the* book forbidden the lesser mortals in Orwell's Oceania. Wells seems pleased to think of the transcendental results of the seven-day annual retreats of the Samurai, "of the steadfast yearly pilgrimage of solitude, and how near men might come to the high distances of God." In the utopian visions of Huxley and Orwell, similarly, the untranscendental purpose of maintaining the State is partly satisfied by Solidarity Services, or the Two-Minute Hate and Hate Week.

Huxley has referred to Butler's *Erewhon* as an expression of skepticism about collective pride, or social hubris, that religion of Inevitable Progress which is a violation of the Perennial Philosophy he regarded as the true religious faith existing within and without—but mostly without—the organized churches.[53] This expression of skepticism is, identifiably, the steel glass of his own apostate satire. Just as Russell had spent many years engaged in verbal warfare against *all* kinds of orthodoxy, social and religious, so too Huxley chastized the "formulators of metaphysical doctrines and the believers in such doctrines" for their "meaningless pseudoknowledge," the results of which throughout history have always been, he says, the "kind of mess that makes angels weep and the satirists laugh aloud." The traditional churches, or "organized religion (and organized religion, let us never forget, has done about as much harm as it has done good)," were for Huxley a real if also here a parenthetical bugaboo.[54] That he should receive criticism for this, however, is no more puzzling than that organized religion should sometimes have tried to separate a black sheep like Waugh from the rest of the fold in objection to his Black Mischief. Waugh, staunch believer in the Agnus Dei, was himself hounded by a variety of watch-dogs. These included not only Rose Macaulay, Kathleen Nott, and Edmund Wilson, themselves partisans who felt that his "Catholic dogmatism" limited the artistic success of his satire; on the

basis of his satire, Waugh was also censured by clerical shepherds and the laity (most harshly in diocesan newspapers) for not being a really "good" or "proper" Catholic. There is apparently no distinguishing between Huxley and Waugh on the grounds of apostasy and orthodoxy.

A man of letters does not always have to be a satirist any more than that a man of the cloth always has to be priestly. Always and never are much less probable than sometimes. Still, a generic line can be drawn between apostasy and orthodoxy when what we are talking about is satire.

Aldous Huxley, for example, may have gone to his grave as an "other utopian" but much of his literary lifetime was given over to apostate satire. In the New World of Huxley's anti-utopia, individuals are bred by Predestinators; only the state, and science, can be said to have an existence. The World State's motto is COMMUNITY, IDENTITY, STA-BILITY, its neo-trinitarian meaning learned during bi-weekly Solidarity Services in the Fordson Community Singery, the President-as-Priest making the sign of the T, the choir of electronic instruments emitting solemn synthetic music, the consuming of the dedicated soma tablets and the drinking of strawberry ice-cream soma serving as a kind of eucharist. "Better a dramme than a damn." The yearning stanzas of the Solidarity Hymns—"Orgy-porgy, Ford and fun"—and the socio-religious "ecstasy" are the consummation of the Greater Being. During the seasonal worship of Belial too, in Huxley's *Ape and Essence*, the lives of the nuclear monsters—modern Yahoos—are indistinguishable from the social lives of technological splendor in the New World; their lives are ruled by the Arch-Vicar of Belial, under the Sign of the Horns:

> Church and State,
> Greed and Hate:—
> Two baboon-persons
> In one Supreme Gorilla. . . .

Huxley's "one Supreme Gorilla" is like Waugh's "Loved One," a "corporate we," or an image of "corporate dominion," in a context at once fictive and real.

The New World six hundred years from now is not yet "achieved" in the Oceania of Orwell's 1984. Orwell's Emmanuel Goldstein the prophet is "really" an Enemy of the People, more like Benson's Julian Felsenburgh than like Mustapha Mond. Emmanuel (meaning "God is with us"), the reader is told, has the "face of a sheep, and the voice, too, had a sheeplike quality." He is in effect the *Agnus Dei qui tollis peccata mundi* of earlier civilizations. Winston Smith's first meeting with O'Brien (my temptation is to call him Father O'Brien) is a travesty of Confession and a kind of Black Mass, with sorrow for past sins and

promise of redemption, O'Brien ritualistically offering Smith wine and a "flat white tablet," something half-way between the eucharist and a soma dosage. This travesty functions generically in the fantasy; that is, O'Brien is not "really" a disciple of Emmanuel, as he pretends to Smith, though even in the betrayal, "He had the air of a doctor, a teacher, even a priest, anxious to explain and persuade rather than punish." The penultimate point is that Smith is "converted" to the new faith of Big Brother. But equally, in Huxley's *Brave New World* and in the society of *1984*, individual men cannot sin as individuals but only commit social or political crimes.

*Poeta nascitur, orator fit.* Religious fervor has never saved people from verbal blindness, and four centuries ago Sir Philip Sidney's eloquent *Defence* ends with a curse. Popular culture often reveals what some ecclesiastic authorities assert, that this century is a bona fide post-Christian age. Whatever their vantage, modern satirists see through eyes given vision by a Christian past, whatever their religious commitments. Though their literary efforts are vulnerable or imperfect as satire, they are a way of coping with reality not always reducible to traditional terms. If it is true that the humanities are concerned with problems that cannot be solved but only lived with, then satire can be numbered among them, that is, among those arts that some call "misbehavioral sciences." Satire is a strategy, for readers and writers alike, that is at least available if not always satisfactory for coping with incompleteness and uncertainty. It is not strictly rhetorical or purely academic. When the imagination finds no satisfaction in existing reality, Karl Mannheim has said, it constructs fantasies. Religious satires are then like other genres "expressions of that which was lacking in actual life."[55]

Nicolas Berdyaev, whose words provide the epigraph to Huxley's *Brave New World*, concluded the autobiography he wrote in exile shortly before his death with the assertion that modern Christianity is most sorrowfully blind to what is happening in the world:

> There is a craving for belief in modern man, similar to that which inspired the Russians throughout the nineteenth and twentieth centuries. Faced with the futility of existence the modern European finds himself stranded high and dry. The trouble is not, of course, political in the narrow sense. . . . Christians, therefore, . . . will have to show a power to move men *in extremis*, without looking to the right or to the left, coupled with a genuine sensitiveness to the issues of our time. For my part, I can see no solution to the betrayal of Christianity by the world until history is ended. Only beyond history is there victory for the spirit of God and of man.[56]

If there is such a craving for belief in modern man, perhaps the function

of satire is to alleviate the craving and amend the futility and feeling of
being stranded. If the devotional means of Christianity are not avail-
able, one possible way out is to be literarily *outré*. If the trouble is not
political in the narrow sense, yet satire is a power available to move
and be moved *in extremis*, not politically either to the right or left, nor
devotionally to orthodoxy or apostasy. In this view, the craving for
belief, rather than the abnegation of it or an aesthetic indifference to it,
would be at the bottom of the literary form of malefaction called reli-
gious satire. And it is "coupled with a genuine sensitiveness to the
issues of our time."

In *Emperor of the Earth: Modes of Eccentric Vision*, a collection of
essays on Slavic literature, Czeslaw Milosz focuses on his culture's
concern with man's destiny and its obsession with the riddle of evil in
history. "Science Fiction and the Coming of Antichrist" is given over to
a careful reading of Vladimir Solovyov's *Three Conversations*, which
concerns the three divisions of Christians and which certainly seems to
belong to the same genre as Zamiatin's *WE* and Čapek's *War with the
Newts*. The authors Milosz singles out for comparison to Solovyov,
with great accuracy to my way of thinking, are Swift, Wells, Huxley,
and Orwell. Milosz's book title derives from this essay, in which he
remarks that we need a term to identify literary mutations occurring
since the sixteenth century on, "from simple tales of adventure to
utopias and philosophical satire," from antiquarian Christian folklore
to complex philosophic reflections spawned from science and technol-
ogy.[57] His conclusions derive from Signorelli's sixteenth-century fres-
coes in Orvieto Cathedral, which he saw in his youth:

> Man wants to be good, but he is not good; he wants to be happy, but he is
> not happy; he wants to live, but he knows he must die. This awareness,
> distinguishing him from all other living creatures, is a sad joke if it
> cannot save him from the fate of the animals. . . . We are unable to reduce
> the present, so full of contradictions, to one common denominator be-
> cause we live in it and it lives in us. But perhaps its most unexpected
> trait is a willful blindness, a rejection of historical experience, as if man
> had learned about his own demonic drives and could no longer bear
> it. . . . The emperor of the nations of the earth may remain forever in the
> sphere of a writer's fantasy.

Perhaps not only in the sphere of a writer's fantasy. Craving for
belief, whether or not its sensitiveness is "genuine," is what Robert
Elliott calls the power of satire. It may certainly be true, as many
thoughtful men have said, that all power corrupts in mysterious ways,
destructive or self-defeating of the very ends it would serve, even while
it presumes a rationality and control and strives for ends which can
scarcely be envisioned. But abnegation, in *Murder in the Cathedral*,

was the counsel of the Tempters to Thomas Becket; and, in Russell's "Zahatopolk," indifference was the cause of anxiety for Diotima's counsellors. If only beyond history can there be victory for the spirit of God and of man, there must yet be a means in which this spirit can find expression. Perhaps not until history is ended is there a solution to the inevitable conflict between the two worlds, as Berdyaev claims, the "betrayal" of each of the worlds he refers to in the title of his last book and in its last paragraph. Satire then, orthodox or apostate, is at least an attempt to cope with a problem or trouble beyond history, to "see" the issues of our time beyond our time, and to explore those worlds in which Christians live and Christianity has its being, without betraying either of them. The particular craving and sense of futility, though modern, is amenable to and amended by a kind of symbolic activity which is itself very old.

In reading these satirists then, and numerous others whose apostasies and orthodoxies are equally well-known articulations, one need not infer that a literary criticism of their works is perforce religious. There is no necessity or obligation to "accept" dogma catholic in scope and High Church in variety; this is not necessary, or even possible, since the satiric brotherhood is so diverse as to include writers who share no such obligation: Butler, Forster, Huxley, Orwell, Russell, Saki, Shaw, Wells. Orthodoxy is clearly not the only vested interest in religious satire; satirists as such, in their satire, are equally literary malefactors, but they are not primarily, let alone exclusively, interested in any one social or religious doctrine. The relevance of social and religious values is to the literary forms which those values take, not as abstractions of indefinite size and shape, but as generic elements. An appreciation of the satiric genre is a recognition, not an "acceptance," of the variety of forms which apostasy and orthodoxy may take. Such appreciation is part of the psychology of consciousness, neurological certainly and spiritual perhaps. I am not sure what "consciousness raising" is or whether it is possible, in the same way that I doubt whether the appreciation of satire can be taught. If Heisenberg's principle of indeterminacy applies not only to elusive particles of matter and energy, if the act of seeing always interferes with what is being seen, then consciousness in the reading as well as in the writing of literary texts is always problematical. Limits always defy circumvention, certainly for satire, the literary mode of perception most given to depict the physical universe. How can spirituality reveal itself in nature, without compromise, without debasement? Is it possible for *any* church to do its work in the world without itself becoming worldly? In the perennial clash between God and Caesar, why are religious ideals regarding a good social order so conspicuously incompatible with utopian goals?

Such questions transcend sectarian bias, and their answers cannot be purchased even though they might be promised by church membership. The questions occur, even where the answers do not, among the varieties of satiric experience.

# Notes

## INTRODUCTION

1. Stanley Weintraub and Philip Young, eds. *Directions in Literary Criticism* (University Park: Pennsylvania State Univ. Press, 1973), p. vii. Other theorists specifically and consecutively cited in my preface:

*Miscellaneous Prose of Sir Philip Sidney*, ed. Katherine Duncan-Jones and Jan Van Dorsten (Oxford: Clarendon, 1973), pp. 111–12.

J. Dover Wilson, *The Fortunes of Falstaff* (1943; rpt. Cambridge Univ. Press, 1953), p. 128.

*Sir Thomas Browne: Selected Writings*, ed. Geoffrey Keynes (London: Faber, 1968), pp. [3], 14.

George Santayana, *Soliloquies in England and Later Soliloquies* (1922; rpt. Ann Arbor: Univ. of Michigan Press, 1967), pp. 139–40.

F. W. Bateson, "The Novel's Original Sin," in *Directions in Literary Criticism*, pp. 112–20.

Schiller, *Naive and Sentimental Poetry and On the Sublime*, trans. Julius A. Elias (New York: Ungar, 1966), pp. 116–17. Schiller's subsequent references to modes of perception are in two long footnotes, pp. 125–26, 145–47. On Schiller's defining and delimiting literary genres, see Ernest L. Stahl, "Literary Genres: Some Idiosyncratic Concepts," in *Theories of Literary Genre*, ed. Joseph P. Strelka (University Park: Pennsylvania State Univ. Press, 1978), pp. 80–92.

John Reichert, "More than Kin and Less than Kind; The Limits of Literary Theory," in *Theories of Literary Genre*, p. 65.

Hugh Kenner, *A Homemade World: The American Modernist Writers* (New York: Knopf, 1975), pp. xi–xvii, 220–21; *Joyce's Voices* (Berkeley: Univ. of California Press, 1978), pp. ix, 16, 31, 62–63, 99; *Bucky: A Guided Tour of Buckminster Fuller* (New York: Morrow, 1973), esp. pp. 9, 17, 64, 81–85, 95–101, 218–22.

Walter J. Ong, S. J., *The Barbarian Within* (New York: Macmillan, 1962), pp. 9–11, 26–29; *In the Human Grain* (New York: Macmillan, 1967), pp. 131, 175; *Interfaces of the Word: Studies in the Evolution of Consciousness and Culture* (Ithaca: Cornell Univ. Press, 1977), pp. 10, 44.

Murray Krieger, *The Play and Place of Criticism* (Baltimore: Johns Hopkins Univ. Press, 1967), pp. 106, 119–23; *Theory of Criticism* (Baltimore: Johns Hopkins Univ. Press, 1976), esp. pp. 128, 179; *Poetic Presence and Illusion: Essays in Critical History and Theory* (Baltimore: Johns Hopkins Univ. Press, 1979), esp. pp. [iv], xv.

Paul Hernadi, *Beyond Genre: New Directions in Literary Classification* (Ithaca: Cornell Univ. Press, 1972), pp. 160, 166, 188, 193; "Order without Borders: Recent Genre Theory in the English-Speaking Countries," in *Theories of Literary Genre*, pp. 202–7.

W. B. Carnochan, *Confinement and Flight: An Essay on English Literature of the Eighteenth Century* (Berkeley: Univ. of California Press, 1977), esp. 117–19, 157–60.

2. Julius A. Elias, "Introduction," in Schiller, *Naive and Sentimental Poetry*, p. 47. Schiller cited in this paragraph, pp. 116–20.

3. Graham Reynolds, *The Raphael Cartoons* (London: Victoria and Albert Museum, 1974), p. 3.

4. Konrad Schaum, "Introduction," in *Plautus in the Convent* [and] *The Monk's Marriage* (New York: Ungar, 1965), pp. xi–xiv.

5. Toynbee, *A Study of History*, new ed., rev. and abridged with Jane Caplan (New York: American Heritage and Oxford Univ. Presses, 1972), pp. 89, 135.

6. Cf. Fredson Bowers, "Adam, Eve, and The Fall in *Paradise Lost*," *PMLA*, 84 (1969), 264; Don Parry Norford, "The Separation of the World Parents in *Paradise Lost*"; Douglas A. Northrop, "The Double Structure of *Paradise Lost*"; and Helen Damico, "Duality in Dramatic Vision: A Structural Analysis of *Samson Agonistes*," in *Milton Studies XII*, ed. James D. Simmonds (Pittsburgh: Univ. of Pittsburgh Press, 1979), pp. 3–24, 75–116, Maynard Mack, Jr., "The Second Shepherd's Play: A Reconsideration," *PMLA*, 93 (1978): 78–85, and Francis L. Lawrence, "Dom Juan and the Manifest God: Moliere's Antitragic Hero," same issue, 86–94.

See also: Robert Grudin, *Mighty Opposites: Shakespeare and Renaissance Contrariety* (Berkeley: Univ. of California Press, 1979), pp. 1–11; Joyce Carol Oates, *Contraries: Essays* (New York: Oxford Univ. Press, 1981), p. vii; John Kendrew, *The Thread of Life: An Introduction to Molecular Biology* (Cambridge: Harvard Univ. Press, 1966), p. 12.

7. Leo Rosten, "Harold Lasswell: A Memoir," and Heinz Eulau, "The Maddening Methods of Harold D. Lasswell," the first two festschrift essays in *Politics, Personality, and Social Science in the Twentieth Century*, ed. Arnold A. Rogow (Chicago: Univ. of Chicago Press, 1969), pp. 10–12, 18–30.

8. Chargaff, *Heraclitean Fire: Sketches from a Life before Nature* (New York: Rockefeller Univ. Press, 1978), pp. 65, 77–78, 86, 93, 100–103; cf. Watson, *The Double Helix*, Norton Critical Edition (New York: Norton, 1980), esp. pp. 75–79, and editor Gunther S. Stent's "Review of the Reviews," pp. 168–72.

9. Ehrenfeld, *The Arrogance of Humanism* (New York: Oxford Univ. Press, 1978), pp. 3–22. Eiseley, *The Star Thrower*, intro. W. H. Auden (New York: Harcourt, 1978), pp. 186, 201, 268.

10. Dyson, "Dreams of Earth and Sky," in *Disturbing the Universe* (New York: Harper, 1979), pp. 254–61.

11. See Cowan, "Science, History, and the Evidence of Things Not Seen," in *From Parnassus: Essays in Honor of Jacques Barzun*, ed. Dora B. Weiner and William R. Kaylor (New York: Harper, 1976), pp. 313–24.

12. Jean A. Perkins, "Presidential Address 1979: E Pluribus Unum," *PMLA*, 95 (1980), 316–17, and Walter J. Ong, "Presidential Address 1978: The Human Nature of Professionalism," *PMLA*, 94 (1979), 392–93.

13. Bruns, "Allegory and Satire: A Rhetorical Meditation," *New Literary History*, 12 (1979), pp. 121–31; Bloom and Bloom, *Satire's Persuasive Voice* (Ithaca: Cornell Univ. Press, 1979), pp. 15–30.

14. Putnam, "Literature, Science, and Reflection," *New Literary History*, 7 (1976), 486; Eiseley, *Star Thrower*, p. 279.

# CHAPTER 1

1. Elias, "Introduction," in *Naive and Sentimental Poetry*, p. 66.

2. Fr. Ong makes this point regarding Yugoslavian peasant lyrics *In the Human Grain*, pp. 24–27; cf. *Naive Art in Yugoslavia*, ed. Smithsonian Traveling Exhibition Service (Zagreb: Galerija primitive umjetnosti, [1977]), a catalogue with notes on 97 paintings and sculptures dating from 1935–1975.

E. H. Gombrich's lifelong fascination with the art of ornament began with his mother's collection of Slovak peasant embroideries, prior to but connected with his sophisticated interest in the problems of representation in art. See *The Sense of Order: A Study in the Psychology of Decorative Art* (Ithaca: Cornell Univ. Press, 1979), pp. vii, 73, 159, and Col. Plate I.

3. Cf. Karl-Heinz Ohlig, "Comics und religiöse Mythen. Oder: Was Religion und Unterhaltungsliteratur *nicht* gemeinsam haben," in *Comics und Religion*, ed.Jutta Wermke (Munich: Wilhelm Fink, 1976), pp. 121–36, and, for a practicing illustrator's overview rather than a theoretical analysis, John Geipel, *The Cartoon: A Short History of Graphic Comedy and Satire* (Cranbury, N.J.: A. S. Barnes, 1972).

The deliberate combination of literature and low art can function as parodic themes. See the Chas. Addams cartoon of the Minotaur and Daedalus' labyrinth, both frontispiece and culminating motif in George deForest Lord, *Heroic Mockery: Variations on Epic Themes from Homer to Joyce* (Cranbury, N.J.: Univ. of Delaware Press, Associated Univ. Presses, 1977), pp. 2, 109–11.

4. Quotations in this paragraph and the fifth paragraph in my Ch.5 are from the first edition of James, *The Varieties of Religious Experience* (New York: Longmans, Green, 1902), pp. v–vi, 7, 18, 36–38, 101–10, 145–49, 326, 360f.

5. Knox, *Essays in Satire* (1928; rpt. London: Sheed and Ward, 1954) pp. 11–31. For humor theory in popular culture: "Baffle-Gab Thesaurus," 13 Sept. 1968, p. 22; "American Humor: Hardly a Laughing Matter," 4 March 1966, p. 46; "The Humor of Hostility," 17 Jan. 1969, p. 43; "The Mystery of Laughter," 9 Feb. 1970, p. 60. In *New York Review of Books:* Charles Rycroft, "What's So Funny?" 10 April 1969, p. 24f. In the *New York Times Magazine:* Alice Shabecoff, "What's so funny?" 15 Sept. 1968, p. 114f.; Jim Hassett and Gary E. Schwartz, "Why can't people take humor seriously?" 6 Feb. 1977, p. 103. Syndicated columnists: James Reston, "Washington: Why Not Try Laughter?" *New York Times* 12 March 1967, p. 12E; Norman Vincent Peale, "Can't People Learn to Laugh Again?" *Philadelphia Inquirer*, 30 May 1971, p. 9; Louis Cassels, "When is a religion a put-on?" *Philadelphia Evening Bulletin*, 31 March 1973, p. 7; Tom Webb, "Divine comedy: How religious jokes manage to abide," *Philadelphia Inquirer*, 17 April 1983, pp. 1–I, 11–I.

6. Kenner, *The Counterfeiters: An Historical Comedy* (Bloomington: Indiana Univ. Press, 1968), p. 158.

7. See Morton W. Bloomfield, "The Gloomy Chaucer," in *Veins of Humor*, ed. Harry Levin (Cambridge: Harvard Univ. Press, 1972), p. 68; Elliott, "Swift's 'I'," *Yale Review*, 62 (1973), 372–91, reappears as ch. 6 in *The Literary Persona* (Chicago: Univ. of Chicago Press, 1982), pp. 107–23; see also Elliott's discussion of quantum "complementarity" as it concerns the "schizoid notion of two Chaucers" and Swift's selves, pp. 99–103, 166.

8. See e.g. *Gulliver's Travels*, illus. Arthur Rackham, Children's Illustrated Classics (1952; rpt. London: J. M. Dent, 1975); *Gulliverove cesty*. 3. vyd. (Bratislava: Mladé Letá, 1967), a translation of Lilliput and Brobdingnag selections, by Viera Szathmaryova-Vlčkova; *Gulliver's Reisen in fremde Welttheile. Nach Jonathan Swift. Für die reifere Jugend bearbeitet von Eduard Wagner. Mit sechs Bildern in Farbendruck nach Original-Aquarellen von Heinrich Leutemann* (Leipzig: Alfred Oehmigke's Verlag, n.d.).

9. See *Bizarreries and Fantasies of Grandville*, ed. Stanley Applebaum (New York: Dover, 1974), rev. by Michael Olmert; "J. J. Grandville's phantasmagoric view of humanity," *Smithsonian* 9, No. 6 (1978), pp. 133–40.

10. See esp. Chukovsky, "The Sense of Nonsense Verse," in *From Two to Five*, trans. and ed. Miriam Morton (Berkeley: Univ. of California Press, 1968), pp. 89–113. Cf. Elizabeth Sewell on "Sense and Nonsense" and "The Right Words," in *The Field of Nonsense* (London: Chatto and Windus, 1952), pp. 1–6, 17–26; and Iona and Peter Opie's categories of "Half-belief" and "Children's Calendar," in *The Lore and Language of Schoolchildren* (Oxford: Clarendon, 1959), pp. 206–92. Esp. on Busch's "domiciled profundities," "grave opposites," and incidental blasphemy, see Erich Heller, "Creatures of Circumstance," *TLS*, 7 Oct. 1977, pp. 124–26.

11. See "Wit and its poor relations," *TLS*, 18 Dec. 1969, p. 1452; D. Keith Mano, "Christianity as Fairy Tale," *New York Times Book Review*, 21 Feb. 1971, p. 20; "Whistling in the dark," *TLS*, 14 June 1974, p. 633; Robert Lee Wolff, "The preacher in fairy-

land," *TLS*, 15 Nov. 1974, p. 1282; Edwin Morgan, "The dark side of fairyland," *TLS*, 6 Dec. 1974, p. 1371; Anthony Quinton, "Humpty-Dumpty for eggheads," *TLS* 20 Dec. 1974, p. 1436; Anya Bostock, "The poetry of frustration," *TLS*, 25 April 1975, p. 465; Eric Partridge, "In common parlance," *TLS*, 28 Nov. 1975, p. 1414; and numerous reviews of Bruno Bettelheim's *The Uses of Enchantment* (New York: Knopf, 1976), incl. John Updike, *New York Times Book Review*, 23 May 1976, pp. 1–2, and Richard Todd, *Atlantic Monthly*, June 1976, pp. 103–105.

Cf. Robert Detweiler, "The Jesus Jokes: Religious Humor in the Age of Excess," *Cross Currents*, 24 (1974), 55–74. Cf. George Mikes, *Humour in Memoriam* (London: Routledge and Kegan Paul, 1970), esp. Pt. 2, "The joke as minor art," pp. 61–115.

12. In an interview, "Friedrich Dürrenmatt at Temple University," *Journal of Modern Literature*, 1 (1970), 89–94; cf. *The Physicists*, trans. James Kirkup (New York: Grove, 1964), esp. pp. 12, 95–96.

13. Cf. Giovanni Battista Montini, *Man's Religious Sense* (Westminster, Md.: Newman, 1961), pp. 9–14, and, on "oceanic feeling" in all men, Sigmund Freud, *Civilization and Its Discontents* (1930; rpt. Garden City: Anchor, 1958), pp. 1–12.

14. See, *Jest Upon Jest*, ed. John Wardroper (London: Routledge & Kegan Paul, 1970), rev. in "Good for a laugh," *TLS*, 10 Sept. 1970, p. 1160. There are numerous similar anthologies of individual periods, e.g. *Humour, Wit & Satire of the Seventeenth Century*, ed. John Ashton (1883; rpt. New York: Dover, 1968).

See also the first *Satire Newsletter* symposium, "Norms, Moral or Other, in Satire," 2, No. 1 (1964), pp. 2–25, esp. Leyburn's statement, pp. 18–20, and the second symposium, which focuses on it, "Modern Satire: A Mini-Symposium," *Satire Newsletter*, 6, No. 2 (1969), 1–18.

15. The collected poems of Randle Manwaring, London: Mitre Press, 1960.

16. See Gerd Heinz-Mohr, *Das vergnügte Kirchenjahr: Heitere Geschichten und schmunzelnde Wahrheiten* (Düsseldorf: Diederichs, 1974), and Georg Bungter & Günter Frorath, *Limerick teutsch* (München: Piper, 1969).

17. See e.g. the Eagle's Prologue to "Neueröfnetes Puppenspiel," in Goethe's *Satiren, Farcen und Hanswurstiaden* (Stuttgart: Reclam, 1968), pp. 88–90. Martin Stern's "Nachwort," esp. pp. 210–14, draws heavily on Schiller's sense of dualistic perspective but does not go so far as to claim that Goethe's satires constitute a genre.

18. *Playboy*, December 1974, pp. 141–46, 318.

19. See e.g. Mark Twain & Jean Effel, *Tagebuch von Adam und Eva* (Zürich: Sanssouci, 1953).

20. Cf. Rüdiger Ahrens, *Englische Parodien* (Heidelberg: Quelle & Meyer, 1972), esp. pp. 9–26, 239–51, and John Wells, "Sehr funny, ja?" *TLS*, 2 May 1980, p. 492, rev. of John Eccleston, *Jest a Moment/Englische Witze*.

21. Priestley, *English Humour* (New York: Stein and Day, 1976), esp. pp. 8–12, 161f.

22. See Blyth, *Oriental Humour* (Tokyo: Hokuseido, 1968), p. 565, and *Senryu: Japanese Satirical Verses* (Tokyo: Hokuseido, 1949), pp. 1–57, Cf. Norman R. Holland on senryu and haiku, in *The Dynamics of Literary Response* (New York: Oxford Univ. Press, 1968), pp. 287–99.

23. Cf. Toshihiko Izutsu and Toyu Izutsu, "Far Eastern Existentialism: *Haiku* and the Man of *Wabi*," in *The Personality of the Critic*, ed. Joseph P. Strelka (University Park: Pennsylvania State Univ. Press, 1973), pp. 40–69.

24. See *The Satirist's Art*, ed. H. James Jensen & Malvin R. Zirker, Jr. (Bloomington: Indiana Univ. Press, 1972), p. 88.

25. Cf. Gilman, "The Witness as Rational Amphibian," in *The Curious Perspective: Literary and Pictorial Wit in the Seventeenth Century* (New Haven: Yale Univ. Press, 1978), pp. 232–38.

26. Colie, *The Resources of Kind: Genre-Theory in the Renaissance* (Berkeley: Univ. of California Press, 1973), p. 114.

27. Elkin, *The Augustan Defence of Satire* (Oxford: Clarendon, 1973), p. 201. Elkins's own chapters—on satire's Origin and History, criticism's Attack and Defence, satirists' Motives and Character, Limitations and Restrictions in satire's subject matter—are themselves antithetical.

28. Cf. respectively Martin, "Wit and Humour," ch. 3 in *The Triumph of Wit: A Study*

*of Victorian Comic Theory* (Oxford: Clarendon, 1974), pp. 25–46, and Barolsky, *Infinite Jest: Wit and Humor in Italian Renaissance Art* (Columbia: Univ. of Missouri Press, 1978), esp. pp. 1–17.

29. Wellek and Warren, *Theory of Literature*, 3rd ed. (New York: Harcourt, 1956), p. 192.

30. Wimsatt and Brooks, "Epilogue," in *Literary Criticism: A Short History* (New York: Knopf, 1957), p. 746.

31. Thomson, *Classical Influence on English Poetry* (1951; rpt. New York: Collier, 1962), pp. 90, 183; *Classical Influences on English Prose* (1956; rpt. New York: Collier, 1962), p. 193.

32. Hodgart, *Satire* (London: World Univ. Library, 1969), p. 10.

33. Misericords are, like the cathedrals, internationally if also quite incidentally, visual forms of religious satire. See Dorothy and Henry Kraus, "Naughty notions in holy places," *Smithsonian*, 7, No. 1 (1976), 94–102, and *The Hidden World of Misericords* (New York: Braziller, 1975), largely a photoalbum of misericords in France. See also *Das Chorgestühl im Ulmer Münster*, Text von Hans Seifert, Aufnahmen von Erich Müller-Cassel (Freiburg: Langwiesche, n.d.), and Mary Frances White, *Fifteenth Century Misericords in the Collegiate Church of Holy Trinity, Stratford-upon-Avon* (Stratford-upon-Avon: Philip Bennett, 1974).

34. Paul Goldberger, "A Triumph of Style: Sir John Soane's Home and Collection," *Smithsonian* 8, No. 1 (1977), 100–107; Thomas B. Hess, "Introduction," in *Souls in Stone: European Graveyard Sculpture*, photographed by Anne de Brunhoff (New York: Knopf, 1978), p. vii.

35. Quoted in Barbara Rose, *Claes Oldenberg* (New York: Museum of Modern Art, 1970), pp. 10–11, 139–143.

36. See John David Farmer, "James Ensor and the Art of His Time," in *Ensor* (New York: Braziller, 1976), pp. 14–33; Robert Hughes, "Ensor: Much Possessed by Death," *Time*, 7 March 1977, p. 51; Victoria Donohoe, "Unique images of Ensor," *Philadelphia Inquirer*, 27 March 1977, p. 11-G; and Stephen Spender, "Armature and alchemy," rev. of *Interviews with Francis Bacon*, by David Sylvester, *TLS*, 21 March 1975, pp. 290–91.

37. Hein with Jens Arup, *Grooks* (Cambridge, Mass.: MIT Press, 1966), frontispiece, last four end papers, and p. 3; also in *Runaway Runes: Short Grooks I* (Copenhagen: Borgen, 1968), p. 1.

38. Fowler, *Modern English Usage* (1926; rpt. Oxford: Clarendon, 1950), p. 241, and Nicholson, *American-English Usage* (New York: Signet, 1958), p. 244. This objection I have to Fowler and Nicholson's "tabular statement" applies equally to Holland's 25-unit table, in *Literary Response*, pp. 290–91.

39. Lewis, *The Problem of Pain* (1940; rpt. Glasgow: Collin, 1977), pp. 54, 77, 83–87.

Chad Walsh defines the shape of C. S. Lewis's own dual sensibility in *The Literary Legacy of C. S. Lewis* (New York: Harcourt, 1979), p. 59: "One half of Lewis's mind functions easily within the rational framework of exposition and argument. The other half turns to highly imaginative ways of saying things indirectly. The two halves present the same ultimate intuition of reality, but the strategies by which they storm the reader's guard are very different."

40. See Edwards's "Preface," "Introduction," and "Notes on *Jest*," *Jest, Satire, Irony and Deeper Significance* (New York: Ungar, 1966), pp. v–xxxv.

41. Calder-Marshall, *Wish You Were Here: The Art of Donald McGill* (London: Hutchinson, 1966), pp. 9–78. Calder-Marshall makes a similar argument about Cruikshank's illustrations, in *Lewd, Blasphemous and Obscene* (London: Hutchinson, 1972), pp. 62–68.

42. Orwell, "The Art of Donald McGill" (1941), in *A Collection of Essays* (Garden City: Anchor, 1954), pp. 111–23.

## CHAPTER 2

1. See Gerald of Wales, *The Jewel of the Church*, intro. and trans. John J. Hagen, O.S.A., Davis Medieval Texts and Studies, Univ. of California, Davis, Vol. 2 (Leiden: E. J. Brill, 1979), esp. II.21–34, pp. 205–76. George Gascoigne's *Steele Glas* (1576) is with some

justification called the first English blank-verse satire; "The Preface of the Author" in Swift's *Battle of the Books* (1704) is the best-known reference to satire as "a sort of glass." See also *Hamlet,* III.ii and Pope's *First Satire of the Second Book of Horace Imitated,* ll. 55–62.

2. See Clarence H. Miller, "Some Medieval Elements and Structural Unity in Erasmus' *The Praise of Folly,*" *Renaissance Quarterly,* 27 (1974), 499–511; C. A. L. Jarrott, "Erasmus' Biblical Humanism," *Studies in the Renaissance,* 17 (1970), 119–52; Bruce E. Mansfield, "Erasmus in the Nineteenth Century: The Liberal Tradition," *Studies in the Renaissance,* 15 (1968), 193–219; cf. Sister Geraldine Thompson, *Under Pretext of Praise: Satiric Mode in Erasmus' Fiction* (Toronto: Univ. of Toronto Press, 1973); see also Richard Sylvester, "The Problem of Unity in *The Praise of Folly,*" *English Literary Renaissance,* 6 (1976), 125–39; and Harry S. May, "Erasmus and the Jews—A Psychohistoric Reevaluation," *Sixth World Congress of Jewish Studies Abstracts* (Jerusalem: The Hebrew University, 1973), B-34.

3. Thompson, "Introduction" to *The Colloquies of Erasmus* (Chicago: Univ. of Chicago Press, 1965), p. xx. Cf. "Introduction: Erasmus and Reform," John C. Olin, ed., *Christian Humanism and the Reformation: Desiderius Erasmus* (New York: Harper Torchbook, 1965), pp. 1–21.

4. Michael Olmert, "Scholars celebrate 1,500 years of Benedictine vision," *Smithsonian,* 11, No. 3 (1980), pp. 81, 86; *The Rule of Saint Benedict,* trans. Cardinal Gasquet (New York: Cooper Square Publishers, The Medieval Library, 1966), p. 26.

5. Leclercq, *The Love of Learning and the Desire for God: A Study of Monastic Culture,* trans. Catherine Misrahi, 2nd rev. ed. (New York: Fordham Univ. Press, 1974), pp. 8–9, 27–28, 59, 140, 173, 316, 319, 327–28. Leclercq's note identifies the humorous mirror as Kierkegaard's.

6. Consecutively, Grierson, *Cross-Currents in 17th Century Literature* (1929; rpt. New York: Harper, 1958), esp. pp. 338–40; Kermode, "Dissociation of Sensibility," *Kenyon Review,* 19 (1957), 169–94, and "Carnal and Spiritual Senses," ch. 1 in *The Genesis of Secrecy: On the Interpretation of Narrative* (Cambridge: Harvard Univ. Press, 1979), pp. 1–21; Ong, *The Barbarian Within,* pp. 260–85; van Kaam, "A Psychology of the Catholic Intellectual," *Insight,* I, No. 4 (1963), 9–23.

7. Panofsky, *Studies in Iconology: Humanistic Themes in the Art of the Renaissance* (1939: rpt. New York: Harper, 1962), pp. 99–109, 153–56, 210; Green, chs. 1 and 2 in "Medieval Tradition: *Sic et Non*" and "Medieval Laughter: *The Book of Good Love,*" in *Spain and the Western Tradition* (Madison: Univ. of Wisconsin Press, 1963) I, 3–71, and on the "abstract and literary character of much Renaissance satire," see "Satire: castigat ridendo mores," III, 428–432; van der Leeuw, *Sacred and Profane Beauty: The Holy in Art* (New York: Holt, Rinehart, 1963), pp. xi, 333.

8. Cf. Cecil Gould, *The Sixteenth-Century Italian Schools (excluding the Venetian)* (London: National Gallery, 1962), p. 131, and National Gallery Trafalgar Square *Catalogue,* 86th ed. (1929; rpt. London: National Gallery, 1946), "Index of Religious Subjects, Saints, &c.," p. 427.

9. Department of Prints and Drawings: BM 1875. 7. 10. 6942, BM 1871. 12. 9. 680, and BM 1863. 5. 9. 922, respectively. I am grateful to the British Museum staff for kind assistance.

10. BM 1868. 8. 22. 185; cf. BM 1895. 1. 22. 692, and BM 1912. 1. 12. 12. *St. Jerome in His Study* is reproduced with some, though not all, the engravings I describe here, in *The Complete Engravings, Etchings and Drypoints of Albrecht Dürer,* ed. Walter L. Strauss (New York: Dover, 1972), reproduced mostly from the collection in the New York Metropolitan Art Museum. See also Dürer's woodcuts and engravings in Mary von S. Jarrell's edition of Randall Jarrell's *Jerome* (New York: Grossman, 1971).

11. Clark, *Civilization: A Personal View* (New York: Harper, 1969), p. 155.

BM 1863. 8. 22. 185, E. 4. 11, and BM 1951. 12. 13. 149. The three Dürers discussed in this paragraph are Nos. 8, 56, and 77 in Strauss's *Complete Engravings.*

12. Panofsky, *The Life and Art of Albrecht Dürer,* 4th ed. (Princeton: Princeton Univ. Press, 1955) pp. 239–40.

Cf. Dürer's "Ss. Nicholas, Ulrich, and Erasmus," BM 1895. 1. 22. 700 (not in the

*Complete Engravings).* Some of its satirical implications are discussed in comparison with "Ss. Stephen, Sixtus and Laurence," in *Catalogue of Early German and Flemish Woodcuts. . .* , ed. Campbell Dogson (London: British Museum, 1903), I, 287. Cf. Larry Silver, "Prayer and laughter: Erasmian elements in two late Metsys panels," *Erasmus in English,* Newsletter 9 (Toronto: Univ. of Toronto Press, 1978), pp. 17–23.

13. Two of the oil portraits, with six others very similar, are reproduced in *The Paintings of Hans Holbein,* ed. Paul Ganz (London: Phaidon, 1950), Plates 64, 65, 66 and Figures 13, 14, 15, 16, 17.

BM 1864. 7. 14. 79. (figure facing left), and BM 1895. 1. 22. 844. The pen-and-ink drawing, in Basle's Öffentliche Kunstsammlung Print Room, and the latter (right-facing) woodcut appear as illustrations in Johan Huizinga, *Erasmus and the Age of Reformation* (New York: Harper, 1957), Frontispiece and opposite p. 247.

14. See Maria Monteiro trans., José de Sigüenza's *The Life of Saint Jerome* (1595) (London: Sands and Co., 1907), pp. 470–88; Sister M. Jamesetta Kelly, *Life and Times as Revealed in the Writings of St. Jerome Exclusive of His Letters* (Washington, D.C.: Catholic Univ. Press, 1944), pp. 60–73; and Edwin A. Quain, S. J., "St. Jerome as a Humanist," in *A Monument to Saint Jerome,* ed. Francis X. Murphy (New York: Sheed & Ward, 1952), pp. 203–32.

15. See Ong, *The Presence of the Word* (New York: Simon and Schuster, 1970), pp. 95–96; and "Satire and Sanctity," rev. of *St. Jerome as a Satirist,* by David S. Wiesen, *TLS,* 12 Aug. 1965, p. 700.

16. Suidas quoted this way, though unnamed, in *Lucian: Satirical Sketches,* trans. Paul Turner (London: Penguin, 1961), p. 8. Cf. Dryden's similar historical documentation, "Life of Lucian" in *The Works of Lucian Translated from the Greek, by Several Eminent Hands* (London: Briscoe, 1711), I, 13–14.

17. *Lucian,* trans. A. M. Harmon (Cambridge, Mass.: Loeb Classics, 1953), V, 15, 19.

18. Dryden, *Eminent Hands,* I, "Epistle Dedicatory," and *Eminent Hands,* I, 34. Dryden's "Discourse concerning the Original and Progress of Satire" (1693) was published with his translations from Juvenal and Persius. The First Satires of both Juvenal and Persius, and several of Horace's, themselves are sustained definitions of the genre.

19. See Thompson's *Colloquies,* pp. xxx–xxxi.

20. Steinmann, *Saint Jerome,* trans. Ronald Matthews (London: Chapman, 1959), pp. 13, 17, 57; cf. J. N. D. Kelly, *Jerome: His Life, Writings, and Controversies* (London: Duckworth, 1975), esp. pp. 104–15; Wiesen, *St. Jerome as a Satirist: A Study in Christian Latin Thought and Letters* (Ithaca: Cornell Univ. Press, 1964).

21. Letter to Alfonso Valdes, Basle, 1 August 1528, in Huizinga, *Age of Reformation,* pp. 246–49.

22. Aubrey, "Desiderius Erasmus," in *Aubrey's Brief Lives,* ed. Oliver Lawson Dick (Ann Arbor: Univ. of Michigan Press, 1957), p. 103.

23. Huizinga, *Age of Reformation,* p. 39.

24. See Sister Geraldine Thompson's epigraph [p. v] in *Under Pretext of Praise,* and pp. 75–76.

25. Erasmus, *Enchiridion,*trans. Miles Coverdale (1545), ed. George Pearson, *Parker Society Publications,* XIII (Cambridge: Univ. Press, 1844), pp. 492–493. New translation by John P. Nolan in *The Essential Erasmus* (New York: Mentor-Omega, 1964), pp. 28–93.

26. Erasmus, *Enchiridion,* ch. 5, p. 502.

27. Huizinga, *Age of Reformation,* p. 52.

28. Erasmus, *Twenty Select Colloquies of Erasmus,* trans. Roger L'Estrange (1680) (Boston: Abbey Classics, 1923). See also *The Earliest English Translations of Erasmus' COLLOQUIA: 1536–1566,* ed. Henry de Vocht, *Humanistica Lovaniensia,* II (Louvain: Librairie Universitaire, 1928).

29. Erasmus, *The Colloquies of Erasmus,* trans. Craig R. Thompson, p. 292.

30. Cf. John K. Yost, "Tavener's Use of Erasmus and the Protestantization of English Humanism," *Renaissance Quarterly,* 23 (1970), 266–76, and Richard L. Demolen, "Erasmus' Commitment to the Canons Regular of St. Augustine," *Renaissance Quarterly,* 26 (1973), 437–43.

31. Frye, *Anatomy of Criticism* (Princeton: Princeton Univ. Press, 1957), p. 310. For a

representative range of theoretical differences see Kathleen Williams, ed., *Twentieth Century Interpretations of The Praise of Folly* (Englewood Cliffs: Prentice-Hall, 1969).

32. Erasmus, *The Praise of Folly*, trans. John Wilson (1688) (Ann Arbor: Univ. of Michigan Press, 1958), p. 83.

33. Ibid., pp. 136–39.

34. Huizinga, "Erasmus's Character," ch. xiv, pp. 117–129, summarized here. See Robert C. Elliott, "The Satirist and Society," in *The Power of Satire* (Princeton: Princeton Univ. Press, 1960), pp. 257–75.

35. Wellek and Warren, *Theory of Literature*, p. 226.

36. Leon Cristiani, *Heresies and Heretics*, trans. Roderick Bright (New York: Hawthorn, 1959), p. 1; vol. 136 of *The Twentieth Century Encyclopedia of Catholicism*.

37. For a Thomistic analysis, see W.F. Cobb, "Abuse, Abusive Language," in *Encyclopedia of Religion and Ethics*, ed. James Hastings (New York: Scribner's, 1951), pp. 52–53.

# CHAPTER 3

1. The neatest discussions of what is "seen" in literary theory and practice are Patricia Meyer Spacks' ch. 1, "Vision and Meaning: An Introduction to the Problem," in *The Poetry of Vision: Five Eighteenth-Century Poets* (Cambridge: Harvard Univ. Press, 1967), pp. 1–12, and her ch. 3, "Word and Vision: Donne's *Anniversarie* Poems and *An Essay on Man*," in *An Argument of Images: The Poetry of Alexander Pope* (Cambridge: Harvard Univ. Press, 1971), pp. 41–83.

2. "The Two Cognitive Dimensions of the Humanities," in *In Search of Literary Theory*, ed. Morton W. Bloomfield (Ithaca: Cornell Univ. Press, 1972), pp. 73–89. In *The Personality of the Critic*, see Strelka on "two basic modes of approaching and comprehending a literary work," John Fizer on Ingarden and "insoluble dichotomy" in many theories and criticism, and Hans H. Rudnick on Kant's "two heterogeneous faculties," pp. xi, 24–25, 152–54.

3. Ellis, *The Theory of Literary Criticism: A Logical Analysis* (Berkeley: Univ. of California Press, 1974), pp. 188, 233, 240; Fuller, "Professors and Gods," *TLS*, 9 March 1973, pp. 273–75.

4. Grierson, *Cross-Currents*, p. 306; Bush, *English Literature of the Earlier Seventeenth Century* (1945; rpt. New York: Oxford Univ. Press, 1952), p. 360; Lewis, *The Allegory of Love: A Study in Medieval Tradition* (1936; rpt. London: Oxford Univ. Press, 1953), pp. 60–68; Stern, "Scientific Knowledge and Poetic Knowledge," ch. 3 in *The Flight from Woman* (New York: Farrar, Strauss, and Giroux, 1965), pp. 41–57.

In literary history, the most extensive conflicting values derive from Arthur O. Lovejoy's *The Great Chain of Being* (1936; rpt. Cambridge: Harvard Univ. Press, 1954), ch. 2, "The Genesis of the Idea in Greek Philosophy: The Three Principles," p. 24: "The cleavage to which I refer is that between what I shall call otherworldliness and this-worldliness." See also "The Parallel of Deism and Classicism" (orig. publ. 1932) in *Essays in the History of Ideas* (1948; rpt. New York: Braziller, 1955), pp. 78–98.

5. See Miner, "Wit: Definition and Dialectic," and "Themes: Satire and Song," in *The Metaphysical Mode from Donne to Cowley* (Princeton: Princeton Univ. Press, 1969), esp. pp. 120–21, 159–60.

6. Sacks, *Fiction and the Shape of Belief* (Berkeley: Univ. of California Press, 1964), pp. 1–31, 266. Cf. John Reichert in *Theories of Literary Genres*, pp. 62–64, and Patricia Meyer Spacks, *Argument of Images*, pp. 14–16, 197–209.

Bloom and Bloom, *Satire's Persuasive Voice*, pp. 23–25, 160–201; see Carnochan, "Satire, Sublimity, and Sentiment: Theory and Practice in Post-Augustan Satire," and Carnochan's subsequent "Forum" exchange with William Kupersmith, *PMLA*, 85 (1970), 508–11, 1125–1126.

7. Jensen and Zirker, "*The Satirist's Art*, pp. ix, 94. Cf. Ronald Paulson, *The Fictions of Satire* (Baltimore: John Hopkins Univ. Press, 1967), pp. 3–73.

8. See Fussell, *The Rhetorical World of Augustan Humanism: Ethics and Imagery from Swift to Burke* (Oxford: Clarendon, 1965), esp. pp. 76–77, 112–15, 141, 276–77, and

Fussell, *The Great War and Modern Memory* (New York: Oxford Univ. Press, 1975), esp. pp. 79–82.

9. Krieger, *Poetic Presence and Illusion*, pp. xv, 266–69.

10. Ong, *Rhetoric, Romance, and Technology* (Ithaca: Cornell Univ. Press, 1971), pp. 190–212, 304–36.

11. *Prose of Sir Philip Sidney*, pp. 114–16, 120–21.

12. See Patricia Meyer Spacks, "From Satire to Description," *Yale Review*, 58 (1969), 232–48. With an eye on "the cataclysmic realignment of philosophic assumptions in the last two centuries," Spacks makes a sustained comparison of Johnson's poem with Robert Lowell's "meticulous translation" of Juvenal's Tenth Satire.

13. Barber, "The Alliance of Seriousness and Levity in *As You Like It*," ch. 9 in *Shakespeare's Festive Comedy* (1959; rpt. Princeton: Princeton Univ. Press, 1972), pp. 222–39; Bush, *Mythology and the Renaissance Tradition in English Poetry* (1932; rpt. New York: Norton, 1963), p. 132. Cf. Willard Farnham, *The Medieval Heritage of Elizabethan Tragedy* (1936; rpt. Oxford: Blackwell, 1956), pp. 432–37; Morton W. Bloomfield, "The Man of Law's Tale: A Tragedy of Victimization and a Christian Comedy," *PMLA*, 87 (1972), 384–89.

14. Sutherland, *English Satire* (Cambridge: Cambridge Univ. Press, 1958), p. 68.

15. Kernan, *The Cankered Muse: Satire of the English Renaissance* (New Haven: Yale Univ. Press, 1959), p. 21; Babbington, "Soliloquy?" *TLS*, 20 March 1969, p. 289; Wellek and Warren, *Theory of Literature*, p. 25.

16. Kermode, "Dissociation of Sensibility," p. 190; Grierson, *Cross-Currents*, p. 100, emphasis added; Farnham, *Medieval Heritage*, p. 30; Sutherland, *English Satire*, pp. 81–82; Paulson, *Fiction of Satire*, p. 8.

17. Highet, *The Anatomy of Satire* (Princeton: Princeton Univ. Press, 1962), p. 151; Lewis, *English Literature in the Sixteenth Century* (Oxford: Clarendon, 1954), pp. 165–71. The debate over More's generic ambivalence never ends. See e.g.: Robin S. Johnson, *More's Utopia: Ideal and Illusion* (New Haven: Yale Univ. Press, 1969); Alan F. Nafel, "Lies and the Limitable Inane: Contradiction in More's *Utopia*," *Renaissance Quarterly*, 26 (1973), 173–80; Martin N. Raitiere, "More's *Utopia* and *The City of God*," *Studies in the Renaissance*, 20 (1973), 144–168.

Trevor-Roper, "The Intellectual World of Sir Thomas More," *American Scholar*, 48 (1978), 19–32. On the interplay of religion, good and bad, on More's character, good and bad, there is a similar industry. See e.g.: "The Good Counsellor," *TLS*, 14 Sept. 1956, p. 540; "More and More," *TLS*, 29 July, 1965, p. 656; H. Schulte Herbrüggen, "A Prayer-Book of Sir Thomas More," and ". . . And a Facsimile," *TLS*, 15 Jan. 1970, p. 64; George Will, "Thomas More: The center held," *Philadelphia Inquirer*, 22 June, 1978, p. 17-A; G. R. Elton, "The Myth of More." Review of *Thomas More: History and Providence*, by Alistair Fox. *New York Review of Books*, 3 Feb. 1983, pp. 3–5.

Gerber, *Utopian Fantasy* (London: Routledge & Kegan Paul, 1955), pp. 57–60.

18. Bush, *Earlier Seventeenth Century*, pp. 39–56, 294–96. Cf. Richard Hoggart, *The Uses of Literacy: Aspects of working-class life, with special reference to publications and entertainments* (London: Chatto & Windus, 1957), esp. on "The Hulton Readership Survey" and "The Derby Survey," pp. 283–84.

19. Mack, "The Muse of Satire," *Yale Review*, 41 (1951–52), 80–92. Cf. Mack, p. 85 and the Blooms, *Satire's Persuasive Voice*, p. 197.

20. Peter L. Berger, "Christian Faith and the Social Comedy," in *Holy Laughter: Essays on Religion in the Comic Perspective*, ed. M. Conrad Hyers (New York: Seabury, 1969), p. 125. Cf. Robert Nisbet, *Sociology as an Art Form* (New York: Oxford Univ. Press, 1976), p. 12.

21. See Jack, *Augustan Satire: Intention & Idiom in English Poetry 1660–1750* (1952; rpt. Oxford: Clarendon, 1966), esp. pp. 18 and 108.

22. See Kernan, *The Plot of Satire* (New Haven: Yale Univ. Press, 1965), esp. pp. 3–18, 199–222.

23. See Sewall, *The Vision of Tragedy* (New Haven: Yale Univ. Press, 1959), pp. 1–8; Grotjahn, *Beyond Laughter* (New York: McGraw-Hill, 1957), pp. 255–64; Frye, *Anatomy of Criticism*, pp. 206–23; Steiner, *The Death of Tragedy* (1961; rpt. New York: Hill &

Wang, 1969), pp. 31, 192, 331, 353; Laing, *The Politics of the Family and Other Essays* (New York: Vintage, 1972), p. 11; Duncan, *Symbols in Society* (New York: Oxford Univ. Press, 1968), pp. 25, 106, 175, 225.

24. Brown, *Closing Time* (New York: Random House, 1973), pp. 50, 57, 59.

25. See Kermode, "Carnal and Spiritual Senses," p. 16, and n. 4, p. 147. Cf. E. H. Gombrich, Julian Hochberg, and Max Block, *art, perception, and reality* (Baltimore: Johns Hopkins Univ. Press, 1972), esp. Gombrich, pp. 1–46, and Hochberg, pp. 73–91.

Lorenz, *On Aggression*, trans. Marjorie Kerr Wilson (New York: Bantam, 1967), pp. 201–202, following quotations from pp. 4, 6, 47, 67, 213, 228, 265, 269, 283–90; Kernan, "Aggression and Satire: Art Considered as a Form of Biological Adaptation," in *Literary Theory and Structure: Essays in Honor of William K. Wimsatt*, ed. Frank Brady, John Palmer, and Martin Price (New Haven: Yale Univ. Press, 1953), pp. 115–29.

26. Kris, *Psychoanalytic Explorations in Art* (1952; rpt. New York: Schocken, 1967), p. 188. Cf. Harry Levin, *Contexts of Criticism* (New York: Atheneum, 1963), p. 25.

27. See esp. Basil Willey, *The Seventeenth Century Background* (1934; rpt. New York: Anchor, 1953); and Frank Livingstone Huntley, *Sir Thomas Browne* (Ann Arbor: Univ. of Michigan Press, 1968).

28. Jack, *Augustan Satire*, pp. 52, 76, 135.

29. Pearce, *Historicism Once More* (Princeton: Princeton Univ. Press, 1969), p. 9; Burke, *The Philosophy of Literary Form*, rev. ed. (New York: Vintage, 1957), esp. pp. 3–117, 253–62.

30. Chad Walsh, *From Utopia to Nightmare* (New York: Harper, 1962), pp. 135, 143.

## CHAPTER 4

1. See respectively: "An Apology, &c." in *Works*, ed. Frank Allen Patterson (New York: Columbia Univ. Press, 1931), Vol. 3, pt. 1, pp. 294–95, 329; "Means to Remove Hirelings," Vol. 6, pp. 44–45; "Areopagitica," Vol. 4, p. 318.

2. There is an extensive entry on satire, none on Utopia, in *A Milton Encyclopedia*, William B. Hunter, Jr. et al., eds. (Lewisburg: Bucknell Univ. Press, 1979), Vol. 7, pp. 169–72. On Milton's "grim laughter" in relation to its historical circumstances, largely excluding contemporary theories of genre, see Raymond A. Anselment, *'Betwixt Jest and Earnest': Marprelate, Milton, Marvell, Swift & The Decorum of Religious Ridicule* (Toronto: Univ. of Toronto Press, 1979), esp. pp. 3–7, 62–69.

Utopian scholarship thrives, for the most part without Milton, as in *Studies in the Literary Imagination*, 6, No. 2 (1973), special issue on "Aspects of Utopian Fiction." Milton's name appears once on an old point; see David Ketterer, "Utopian Fantasy as Millennial Motive and Science-Fiction Motif," p. 94, in relation to "the problem . . . which stumped Milton in *Paradise Lost*, seeming to make him, unconsciously, of the devil's party."

3. John T. Shawcross, ed., *Milton: The Critical Heritage* (New York: Barnes & Noble, 1970): "During the period 1700–31, in addition to a tacit objection to Milton's politics, there was fault finding with the ideas and character, literary devices, language, and prosody of *Paradise Lost*" (Intro., p. 25). It is possible that Dryden marks the origins in 1685: "It is as much commendation as a man can bear, to own him excellent; all beyond it is idolatry" (p. 94). In *Milton 1732–1801: The Critical Heritage* (London: Routledge & Kegan Paul, 1972), Shawcross again anthologizes both the "positive" and "negative" criticism, the latter apparently more extensive and various: "It is easy to see why Sir Walter Raleigh called *Paradise Lost* a monument to dead ideas, and that deathly hue elongated its shadows over Milton's other works" (Intro., p. 3).

4. "Milton" and "Gray," in *Lives of the English Poets* (London: Everyman's, 1925), Vol. 1, p. 108, and Vol. 2, p. 392.

5. See Richard D. Altick, *The English Common Reader: A Social History of the Mass Reading Public, 1800–1900* (Chicago: Univ. of Chicago Press, 1957), pp. 180n., 253, 256; James D. Hart, *The Popular Book: A History of America's Literary Taste* (Berkeley: Univ. of California Press, 1963), p. 27. On Milton's literary as distinct from popular influence

through the centuries, in America and England, see the *Milton Encyclopedia*, Vol. 4, pp. 103–46.

6. Saillens, *John Milton: Man, Poet, Polemist* (Oxford: Blackwell, 1964), p. 346.

7. Jarrell, *Poetry and the Age* (New York: Vintage, 1953), p. 3.

8. Hughes, *John Milton: Complete Poems and Major Prose* (New York: Odyssey, 1957), f.n., p. 381; Wimsatt, *Hateful Contraries: Studies in Literature and Criticism* (Lexington: Univ. of Kentucky Press, 1965), esp. pp. 6 and 26.

9. Steiner, *Language and Silence: Essays on Language, Literature, and the Inhuman* (New York: Atheneum, 1970), p. 25; Price, "Poem Doctrinal and Exemplary to a Nation," in *Things Themselves: Essays & Scenes* (New York: Atheneum, 1972), pp. 214–59.

10. Hoggart, *The Uses of Literacy*, p. 153; on "Primary Religion" in "the 'real' world of people," and on "Candy-Floss World," see also, pp. 93–99, 171–201; also, *Speaking to Each Other, Vol. II: About Literature* (London: Chatto and Windus, 1970), pp. 26, 30.

11. Letter No. 8, to Benedetto Buonmattei, in *Works*, Vol 12, p. 3.

12. See Douglas Bush, "Polluting Our Language," *American Scholar*, 41 (1972), 238–47; cf. above, ch. 1, n. 5.

13. Frye, "Varieties of Literary Utopias," in *The Stubborn Structure* (Ithaca: Cornell Univ. Press, 1970), pp. 109, 113, 116, and 126.

14. Rabkin, *The Fantastic in Literature* (Princeton: Princeton Univ. Press, 1976), pp. 146–50, 227.

15. R. M. Frye, *Milton's Imagery and the Visual Arts* (Princeton: Princeton Univ. Press, 1978), p. 16. Italics textual.

16. This and following citations from Morton, *The English Utopia* (1952; rpt. London: Lawrence and Wishart, 1969), pp. 11–45, 55, 88–90, 261–76.

17. Steadman, "Milton's Rhetoric: Satan and the 'Unjust Discourse'," in *Milton Studies I* (Pittsburgh: Univ. of Pittsburgh Press, 1969), p. 68, 69; Rosenberg, "Parody of Style in Milton's Polemics," in *Milton Studies II* (Pittsburgh: Univ. of Pittsburgh Press, 1970), pp. 114, 118. See also the essay on parodies of Milton's poems themselves, in the *Milton Encyclopedia*, Vol. 6, pp. 109–19.

18. See Burke, *The Philosophy of Literary Form: Studies in Symbolic Action*, rev. ed., abr. (New York: Vintage, 1957), p. 3, and *The Rhetoric of Religion: Studies in Logology* (Berkeley: Univ. of California Press, 1970), pp. 101, 273–316.

19. Ernst, *Utopia 1976* (1955; rpt. New York: Greenwood, 1969), pp. 7, 188–200, 301, 305, and *The Best Is Yet . . .* (New York: Harper, 1945), pp. 26–27, 41, 99, 114, 205.

20. Andrew M. Greeley, *Religion in the Year 2000* (New York: Sheed and Ward, 1969), pp. 3, 167; Herbert J. Muller, *Uses of the Future* (Bloomington: Univ. of Indiana Press, 1974), pp. 3–5; Miriam Strauss Weiss, *A Lively Corpse* (Cranbury, N.J.: A.S. Barnes, 1969), pp. 152, 154, 221, 237–38, 267, 320.

21. Toffler, *Future Shock* (1970; rpt. New York: Bantam, 1972), pp. 1–4, 127–51, 446–87. Toffler's *Eco-Spasm Report* (New York: Bantam, 1975), though a mere one-fifth the length of *Future Shock*, is nonetheless intended as its companion piece. Utopia occurs also in essays edited by Toffler, *Learning for Tomorrow: The Role of the Future in Education* (New York: Random House, 1974), esp. Dennis Livingston's "Science Fiction as an Educational Tool," pp. 234–56. On Toffler's stylistic exaggeration, see Hugh Stephenson, "Trends and speculations," *TLS*, 8 Aug. 1975, p. 894. *Future Shock* is listed among a sub-species of "Non-Fictional Speculations" in the Bibliography of *Utopia/ Dystopia?* ed. Peyton E. Richter (Cambridge, Mass.: Schenkman, 1975), p. 150.

22. See e.g. Elliott, "Anti-Anti-Utopia," in *The Shape of Utopia* (Chicago: Univ. of Chicago Press, 1970), p. 134, and Melvin M. Schuster, "Skinner and the Morality of Melioration," in *Utopia/Dystopia?*, p. 102.
Cf. Tibor R. Machan, "Skinner's utopianism" and "Skinner's God's-eye view," in *The Pseudo-Science of B. F. Skinner* (New Rochelle: Arlington, 1974), pp. 40–45; R. Puligandla, *Fact and Fiction in B. F. Skinner's Science & Utopia* (St. Louis: Warren H. Green, 1974); Joseph Wood Krutch, "Ignoble Utopias," in *The Measure of Man* (New York: Grosset & Dunlap, 1954), pp. 55–76. Cf. the interview in *B. F. Skinner: The Man and His Ideas*, ed. Richard I. Evans (New York: Dutton, 1968), pp. 46–55. Skinner's main

reply to Krutch is his discussion of "cultural designs to be found in utopian literature," in *Beyond Freedom and Dignity* (New York: Knopf, 1971), pp. 153–183; Skinner here makes a brief reference to, or a distinction between, "satiric" and "serious" versions of Utopia.

23. Skinner, *Walden Two* (1948, rpt. New York: Macmillan, 1972), pp. 45–47, 87, 101–15, 198–99, 203, 216, 249–53, 261, 288–303, 308, 320.

24. But Skinner does cite Milton twice in *Verbal Behavior* (New York: Appleton, 1957), pp. 158, 392.

25. Vahanian, *God and Utopia: The Church in a Technological Civilization* (New York: Seabury, 1977), pp. xxiii, 9, 25, 49, 71–72, 101, 105, 111, 133.

Cf. Hugh Kenner's *Bucky*, pp. 9, 64, 95, 124, 128, 171. In Kenner's mostly unhesitant appreciation of Buckminster Fuller, Kenner obviously enjoys Fuller's mastery of vector forces and his satiric skills. But Fuller's *Utopia or Oblivion* is the text, or context, in which Kenner's affection for Fuller splits most clearly from his admiration. See esp. "Dialogue with a Skeptic," pp. 263–89.

26. Rajan, *Milton Studies VII* (Pittsburgh: Univ. of Pittsburgh Press, 1975), pp. 29–48.

27. Cf. Jason P. Rosenblatt, on "the precedent in Pauline Christian tradition for Milton's use of moral opposites as a structural device in his poetry," in "'Audacious Neighborhood': Idolatry in *Paradise Lost*, Book I," *PQ*, 54 (1975), 553–68.

28. Lewis, *The Allegory of Love*, esp. chs. 1 and 2.

29. Poirier, *The Performing Self* (New York: Oxford Univ. Press, 1971), pp. 27–44; Hodgart, *Satire*, pp. 20–32; Mannheim, *Ideology and Utopia*, Trans. Louis and Edward Shils (1936; rpt. New York: Harcourt, 1960), p. 205.

# CHAPTER 5

1. Cornford, "Comedy and Tragedy," Part III in *The Origin of Attic Comedy*, ed. Theodor H. Gaster (1914; rpt. Garden City: Anchor, 1961), pp. 165–91. Gaster persuasively suggests that "the reference to 'the change from the satyric' does not mean that Tragedy developed out of a form like the Satyric drama known to us, a century later, from Sophocles' *Ichneutae* and Euripedes' *Cyclops*—a form which appears, on the contrary to be modelled on Tragedy—but simply that Tragedy changed from a satyric to a dignified tone."

2. "Cross Purposes," *TLS*, 28 Sept. 1967, p. 851; "Sociology and Literature," *TLS*, 4 April 1968, p. 345; Sallie TeSelle, "What Is 'Religion' in Literature?" *America*, 14 Dec. 1968, p. 616; Laurenson and Swingewood, *The Sociology of Literature* (New York: Schocken, 1972), p. 7. Cf. J. Robert Barth, "A Newer Criticism in America: The Religious Dimension," *Uses of Literature*, ed. Monroe Engel (Cambridge: Harvard Univ. Press, 1973), pp. 67–82; Leo Lowenthal, "Literature and Sociology," and J. Hillis Miller, "Literature and Religion," in *Relations of Literary Study*, ed. James Thorpe (New York: Modern Language Association, 1967), pp. 89–110, 111–26.

3. See Gaster, in *Origin of Attic Comedy*, p. 269, f.n. 27. Cf. Hans Eysenck and Glenn Wilson, "Sense of Humour," in *Know Your Own Personality* (Baltimore: Penguin, 1976), pp. 115–151; and Arthur Koestler's triptych, "satire, social analysis, allegory," in *The Act of Creation* (New York: Macmillan, 1964), frontispiece and pp. 70–74.

4. Three notable instances of ridicule functioning in sociology: Colin Campbell, *Toward a Sociology of Irreligion* (New York: Macmillan, 1971); John Rex, *Sociology and the Demystification of the Modern World* (London: Routledge and Kegan Paul, 1974); and M. J. Jackson, *The Sociology of Religion* (London: Batsford, 1974). See respective review articles: "To measure godlessness," *TLS*, 28 April 1972, p. 471; "Sectarian warfare," *TLS*, 23 Aug. 1974, p. 903; and "Eternal truths and their effects," *TLS*, 6 June 1975, p. 628. A symposium collection, is as much constrained as eminent on a topic which invites vituperation. See esp. Robert Bellah, "Between Religion and Social Science" in Rocco Caporale and Antonio Grumelli, eds. *The Culture of Unbelief* (Berkeley: Univ. of California Press, 1971). Cf. Benjamin Nelson, "Is the Sociology of Religion Possible?: A Reply to Robert Bellah," *Journal of the Scientific Study of Religion*, 9 (1970), 107–11.

5. See above, ch. 1, n. 4.

6. Freud, *Totem and Taboo*, (1913; rpt. New York: Random House, 1946), pp. 133–40; Freud, *Civilization and Its Discontents* (Garden City: Anchor, 1958), pp. 100–104; Maritain, "Freudianism and Psychoanalysis: A Thomist View," in *Freud and the 20th Century*, ed. Benjamin Nelson (New York: Meridian, 1958), p. 253. See also A. L. Kroeber, "Totem and Taboo: An Ethnologic Psychoanalysis," in *The Nature of Culture* (Chicago: Univ. of Chicago, 1952), pp. 301–05, and Kenneth Burke, Postscript (n) in *The Rhetoric of Religion*, pp. 257–65.

7. Durkheim, *The Elementary Forms of Religious Life: A Study in Religious Sociology*, trans. Joseph Ward Swain (London: George Allen & Unwin, n.d.), p. 206; Malinowski, *Magic, Science and Religion* (Garden City: Anchor, 1954), p. 36; cf. Durkheim, *Elementary Forms*, pp. 37–42.

8. Stark, *The Sociology of Religion* (New York: Fordham Univ. Press, 1970), IV, 158; Wach, *Sociology of Religion* (Chicago: Univ. of Chicago Press, 1944), pp. 11–13, 374 f.; O'Dea, *The Sociology of Religion* (Englewood Cliffs: Prentice 1966), pp. 114–117; Stark, IV, 187; Elizabeth K. Nottingham, *Religion and Society* (New York: Random House, 1954), p. 58.

9. Riesman, with Nathan Glazer and Reuel Denney, *The Lonely Crowd: A Study of the Changing American Character*, abridged (Garden City: Anchor, 1954), esp. chs. 1 and 12.

10. David Lyon, *Christians and Sociology* (London: Inter-Varsity, 1975), pp. 8 and 71. Such schizophrenia is not, of course, specifically identifiable with any one Christian denomination. See above, Fr. Adrien van Kaam, my ch. 2, n. 7.

11. Richard Hofstadter, *Anti-Intellectualism in American Life* (New York: Vintage, 1966), p. 431. Cf. George Falle, "Divinity and Wit: Swift's Attempted Reconciliation," *Univ. of Toronto Quarterly*, 46 (1976), 14–30. Falle defines a correlation of Christianity and satire in Swift's temperament and literary intentions, even though "it is generally admitted that in the formal sense Swift had little theology and less metaphysics."

12. Veblen, "Devout Observances," in *The Theory of the Leisure Class* (New York: Modern Library, 1934), pp. 293–331.

13. Herberg, *Protestant—Catholic—Jew* (Garden City: Anchor, 1960), pp. 75, 78, 79; Schneider and Dornbusch, *Popular Religion: Inspirational Books in America* (Chicago: Univ. of Chicago Press, 1958), p. 43.

14. Cox, *Feast of Fools* (Cambridge: Harvard Univ. Press, 1970), esp. his appended note, "The Challenge of Sociology," pp. 171–73; on Target, Allegro, Wilson, and on Cox, e.g., see respectively: "Selling God like soap," *TLS*, 4 July 1968, p. 708; "Spermatozoa spreading from the East," *TLS*, 28 May 1970, p. 591; "The cultic fringe," *TLS*, 27 Aug. 1971, p. 1034; "Returning to source," *TLS*, 20 Sept. 1974, p. 1024; see also Christopher Ricks, "Social and personal," rev. of Jennifer Platt, *Realities of Social Research*, *TLS*, 20 Feb. 1976, pp. 195–96.

15. Schneider, *Sociological Approach to Religion* (New York: John Wiley 1970), p. 135; Swingewood, *The Sociology of Literature*, p. 25.

16. Stephen, *English Literature and Society in the Eighteenth Century* (1904; rpt. New York: Barnes & Noble, 1962), pp. 70, 110–11; Willey, *The Eighteenth Century Background* (1940; rpt. New York: Beacon, 1961), pp. 12, 34–39, 100–101, 137, 157.

17. Montesquieu, Nos. XLVI and LXXXV, *Persian Letters*, trans. J. Robert Loy (New York: Meridian, 1961), pp. 105, 168.

Emile Durkheim claims that rather than Comte "it is Montesquieu who first laid down the fundamental principles of social science." See Durkheim, *Montesquieu and Rousseau: Forerunners of Sociology* (Ann Arbor: Univ. of Michigan Press, 1960), p. 61 and p. 141, n. 18.

18. Cf. *Eighteenth Century Background*, pp. 95–100; Ian Watt, "*Robinson Crusoe* as a Myth," in *Eighteenth-Century English Literature: Modern Essays in Criticism*, ed. James L. Clifford (New York: Oxford Univ. Press, 1959), p. 170, and *The Rise of the Novel* (Berkeley: Univ. of California Press, 1959), p. 119; Martin Price, *To the Palace of Wisdom* (Garden City: Anchor, 1965), pp. 114–129; and Maximillian E. Novak, "Defoe's Use of Irony," in *Stuart and Georgian Moments*, ed. Earl Miner (Berkeley: Univ. of California Press, 1972), pp. 189–220.

19. Priestley, *History of the Corruptions of Christianity*, vol. 2 (Birmingham: Piercy

and Jones, 1782), pp. 58–59, 64–65; F. W. Gibbs, *Joseph Priestley* (London: Nelson, 1965); *A Bibliography of Joseph Priestley, 1733–1804*, ed. Ronald E. Crook (London: Library Association, 1966).

20. Williams, *Culture and Society 1780–1950* (Edinburgh: Penguin, 1961), p. 48; see Nahum N. Glatzer's essay in Guyau's *The Non-Religion of the Future: A Sociological Study* (1887; rpt. of English trans. 1897, New York: Schocken, 1962); Aron, *Main Currents in Sociological Thought, Volume I*, trans. Richard Howard and Helen Weaver (Garden City: Anchor, 1968), pp. 123–24; cf. Basil Willey, *Nineteenth Century Studies* (London: Chatto & Windus, 1955), pp. 187–203.

21. "Auguste Comte: a messiah for the age of positivism," *TLS*, 4 Jan. 1974, pp. 1–2; Comte, *The Positive Philosophy of Auguste Comte*, trans. Harriet Martineau (New York: Calvin Blanchard, 1858), p. 653; D. G. Charlton, *Positivist Thought in France: 1852–1870* (Oxford: Clarendon, 1959), p. 50.

22. Comte, *A General View of Positivism*, trans. J. H. Bridges (1848; rpt. Stanford: Academic Reprints, n.d.), p. 365. All references in this paragraph are to ch. 6, "The Religion of Humanity," in *General View*, pp. 355–444.

23. DeTocqueville, *Democracy in America*, ed. Henry Steele Commager (London: World's Classics, Oxford Univ. Press, 1953), Part II, chs. xxvi and xxxiv, pp. 396–7, 566.

24. Wach, *Types of Religious Experience: Christian and Non-Christian* (Chicago: Univ. of Chicago Press, 1951), p. 186.

25. But see Werner Stark's remarkable and ambitious *The Sociology of Religion*, who attempts in five volumes to establish what he calls a "macrosociology of religion."

26. Harrison, *The Creed of a Layman: Apologia Pro Fide Mea* (New York: Macmillan, 1907).

27. See esp. the first and last chs. in Schneider and Dornbusch's *Popular Religion*, on the criteria which define the genre, and on the "strong element of magic" which constitutes its market value.

28. Barzun, *Darwin, Marx, Wagner: Critique of a Heritage (1789–1914)*, rev. 2nd edn. (Garden City: Anchor, 1958), p. 356; Talmon, "The Secular Religion," in *The Origins of Totalitarian Democracy* (London: Mercury, 1961), pp. 21–24; Talmon, *Political Messianism: The Romantic Phase* (London: Secker & Warburg, 1960), p. 17. This second volume of Talmon's three-volume study traces the complex development of the revolutionary credo up to the Revolution of 1848 and its aftermath. Cf. Aron's "The Sociologists and the Revolution of 1848" in *Main Currents*, pp. 303–40.

29. Barbu, *Democracy and Dictatorship: Their Psychology and Patterns of Life* (New York: Grove, 1959); Monnerot, *Sociology and Psychology of Communism*, trans. Jane Degras and Richard Rees (Boston: Beacon, 1960), f.n., p. 163. Italics and emphasis are textual.

30. Burke, *Philosophy of Literary Form*, pp. 253–62; Wellek and Warren, *Theory of Literature*, pp. 23, 25, 102, 104, 181, 228, 231, 234; Kernan, *The Cankered Muse*, p. 250; Levin, "Literature as an Institution," in *Literary Opinion in America*, ed. Morton Dauwen Zabel (New York: Harper, 1951), p. 660.

31. Hoggart, "The Literary Imagination and the Sociological Imagination," *Speaking to Each Other*, Vol. 2, p. 265. Cf. Paul Ramsey, "Literary Criticism and Sociology," in *Literary Criticism and Sociology*, ed. Joseph P. Strelka (University Park: Pennsylvania State Univ. Press, 1973), p. 27: "Good sociologists should be humanists, *as* sociologists."

32. Pearce, *Historicism Once More*, p. 3; Frye, *Anatomy of Criticism*, p. 19.

# CHAPTER 6

1. Cf. Hildred Geertz, "An Anthropology of Religion and Magic, I," and Keith Thomas, "An Anthropology of Religion and Magic, II," *Journal of Interdisciplinary History*, 6 (1975), 72–89, 91–109.

2. Duncan, *Language and Literature in Society* (Chicago: Univ. of Chicago Press, 1953), p. 28; Elliott, "The Uses of Ridicule," in *Power of Satire*, pp. 66–87.

3. Speaight, *The Life of Hilaire Belloc* (London: Hollis & Carter, 1957), p. 149; Ward,

*Gilbert Keith Chesterton* (1944; rpt. London: Penguin, 1958), p. 217; see also Christopher Hollis, "The Chesterbelloc," in *The Mind of Chesterton* (London: Hollis & Carter, 1970), pp. 100–131.

4. Schneider and Dornbusch, *Popular Religion*, pp. 25, 27, 29, 45, 60, 136, 144.

5. Chesterton,*The Autobiography of G. K. Chesterton* (New York: Sheed & Ward, 1936), pp. 180, 306, 307.

6. Auden, "Foreword," in *G. K. Chesterton: A Selection of His Non-Fictional Prose* (London: Faber, 1970), pp. 16, 18. Cf. Auden's "The Gift of Wonder," in *G. K. Chesterton: A Centenary Appraisal*, ed. John Sullivan (London: Elek, 1974), pp. 73–80; and Robert Hamilton, "The Rationalist from Fairyland," *Quarterly Review*, 305 (1969), 444–54.

7. Hollis, "Magic and the Slade," in *Mind of Chesterton*, pp. 22–30. Cf. William B. Furlong, "Shaw and Chesterton: The Link Was Magic," *Shaw Review*, 10 (1968), 100–107; Furlong's subsequent *Shaw and Chesterton: The Metaphysical Jesters* (University Park: Pennsylvania State Univ. Press, 1970) is an extended description of "the interaction of the minds of the two artists, one upon the other."

8. See Lawrence S. Cunningham, "Chesterton as Mystic," *American Benedictine Review*, 26 (1975), 16–24.

9. Ward, *Gilbert Keith Chesterton*, p. 126, and Garry Wills, *Chesterton: Man and Mask* (New York: Sheed & Ward, 1961), p. 105. Hollis calls *Notting Hill* an "amusing extravaganza," *The Mind of Chesterton*, p. 107.

10. Richard Gerber characterizes this belief as essential to the genre; see *Utopian Fantasy*, pp. xii, 3–14.

11. For a discussion and definition of Menippean satire, see *Anatomy of Criticism*, pp. 308–12.

12. Chesterton, *The Napoleon of Notting Hill*, in *A G.K. Chesterton Omnibus* (London: Methuen, 1958), pp. 31–33, 42–44; next quotations from pp. 75–76, 197–199. Page refs. to *Thursday* and *Flying Inn* are also to this *Omnibus* comprising these three respective fantasies.

13. *Autobiography*, p. 98.

14. In Ward, *Chesterton*, p. 136.

15. See Wells, *Man and Mask*, pp. 45–51, and Hollis, *Mind of Chesterton*, pp. 56–60.

16. See e.g. Chad Walsh, *From Utopia to Nightmare*, and Mark R. Hillegas, *The Future as Nightmare: H. G. Wells and the Anti-Utopians*.

17.Chesterton, *Omnibus*, p. 207.

18. Frye, *Anatomy of Criticism*, p. 224; Chesterton, *Fancies Versus Fads* (New York: Dodd, Mead, 1923), p. vi.

19. Cf. Robert E. Ornstein, "Two Sides of the Brain," ch. 2 in *The Psychology of Consciousness* (San Francisco: W. H. Freeman, 1972), pp. 49–73, and "Two for One," *New York Times*, 9 Aug. 1973, p. 35; also Maya Pines, "We are left-brained or right-brained," *New York Times Magazine*, 9 Sept. 1973, p. 32f., reprinted as ch. 7 in *The Brain Changers* (New York: Harcourt, 1973), pp. 138–59; Michael C. Corballis and Ivan L. Beale, *The Psychology of Left and Right* (Hillsdale, N.J.: Lawrence Erlbaum, 1976); and, William Sargant, *Battle for the Mind: A Physiology of Conversion and Brain-Washing* (1957; rpt. Baltimore: Penguin, 1961), esp. pp. 237–41.

20. Chesterton, *The Ball and the Cross* (New York: John Lane, 1906), p. 10; quotations also from pp. 53, 380–81.

21. Gerber, *Utopian Fantasy*, p. 116.

22. See "MAQĀMA (pl. maqāmāt)," *Encyclopaedia Judaica* (New York and Jerusalem: Macmillan, 1971), IX, 936–38. This generic term is defined as "topsy-turvy didacticism in an autobiographical framework" in Otis H. Green, "Medieval Laughter," ch. 2 in *Spain and the Western Tradition*. "Topsy-turvy didacticism" defines the intentional satire in both Chesterton's large fantasies and Belloc's small "Child's Book of Imaginary Verses."

See above, ch. 1, n. 10. Chukovsky, translator of Chesterton and, like Belloc, a writer of children's verses, argues that "topsy-turvies" and "doodles" *(pereviortishi and zakaliaka)* have much educational value even as they have misguided and stubborn enemies. Intrinsic didacticism and extrinsic animosity are international qualities of satire.

23. Chesterton, *Omnibus*, pp. 429, 467.

24. Chesterton, *Heretics* (New York: John Lane, 1905), p. 20; next quotations from pp. 22, 216–33, 249.

25. Chesterton, *Orthodoxy* (1908; rpt. Garden City: Image), pp. 6, 9–13, 42, 52–53, 110, 142, 160.

26. Belloc, *The Contrast* (London: Arrowsmith, 1923), pp. 68–70.

27. Chesterton, *Utopia for Usurers* (New York: Boni and Liveright, 1917), pp. 36–37.

28. Shuster, *The Catholic Spirit in Modern British Literature* (New York: Macmillan, 1925), p. 258.

29. Belloc, *The Path to Rome* (1902; rpt. Garden City: Image, 1956), pp. 52, 71–72, 110, 113–14.

30. Speaight, *Life of Hilaire Belloc*, p. 325.

31. Belloc, *The Four Men: A Farrago* (Edinburgh: Nelson, 1912), pp. 92–96, 146, 154, 266f.

32. Wilhelmsen, *Hilaire Belloc: No Alienated Man* (New York: Sheed and Ward, 1953), p. 78.

33. See esp. Elliott, "The Satirist and Society," in *The Power of Satire*, pp. 257–75.

34. Belloc, *Caliban's Guide to Letters*, and *Lambkin's Remains* (London: Duckworth, 1920), p. 45.

35. Speaight, *Life of Hilaire Belloc*, p. 123.

36. Belloc, *Lambkin's Remains*, p. 248.

37. Belloc, *Sonnets & Verse by H. Belloc*, intro. Reginald Jebb (London: Duckworth, 1954), pp. vi, 82.

38. Belloc, *Hilaire Belloc: Selected Essays*, ed. J. B. Morton (Baltimore: Penguin, 1958), pp. 124–27; rpt. from *On Anything* (London: Constable, 1920).

# CHAPTER 7

1. Capra, *The Tao of Physics: An Exploration of the Parallels Between Modern Physics and Eastern Mysticism* (1975; rpt. New York: Bantam, 1980), pp. 24, 30, 35, 54, 104, 242–43, 288; cf. Capra, pp. 145–46, and Elliott, *Literary Persona*, pp. 99–103.

2. Sagan's books were first published, respectively, in 1977 and 1974; Bronowski's in 1973.

3. Corballis and Beale, *Psychology of Left and Right*, p. 197.

4. Maritain, *Existence and the Existent*, trans. Lewis Galantiere and Gerald B. Phelan (New York: Doubleday, 1956), p. 13; Lynch, *Christ and Apollo* (New York: Mentor-Omega, 1963), pp. xi–xii, 113, 119, 134, 161–63.

5. Cardinal Heenan, "Modern theology and the care of souls," *TLS*, 22 Dec. 1972, pp. 1551–1552.

6. These quoted phrases identify typical problems in theology. See, e.g., essays by Eulalio R. Baltazar, James M. Gustafson, Leonard Swidler, George H. Tavard, Alexander Schmemann, and Carl J. Peter, respectively, in *Transcendence and Immanence: The Papin Festschrift*, Vol. 1, ed. Joseph Armenti (St. Meinrad, Indiana: Abbey Press, 1972).

7. See Goodheart, *The Failure of Criticism* (Cambridge: Harvard Univ. Press, 1978), pp. 1–7, 10–12, 27–29.

8. See Berman, "Herrick's Secular Poetry," *English Studies*, 52 (1971), 20–29.

9. Adverse "Catholic" criticism is not necessarily unappreciative of Kazantzakis' "Protestant" fiction. See Lynch, *Christ and Apollo*, pp. 177–180. On the Incarnation, see Wimsatt and Brooks, above, ch. 1, n. 30.

10. Sir Julian Huxley, "Intro.," in *The Phenomenon of Man* (London: Fontana, 1965), pp. 24–25.

11. See Morton P. Levitt, "The Cretan Glance: The World and Art of Nikos Kazantzakis," *Journal of Modern Literature*, 2 (1971–72), 163–164.

12. Kazantzakis, *Saint Francis*, trans. P. A. Bien (New York: Simon and Schuster, 1962), p. 37.

13. Bien, "A Note on the Author and His Use of Language," in *The Last Temptation of Christ* (New York: Bantam, 1968), p. 491f.

14. Bien, "Kazantzakis' Nietzschianism," *Journal of Modern Literature*, 2 (1971–72), pp. 252, 266. Cf. Father Lynch on Nietzschian "contrariety," *Christ and Apollo*, p. xiv. Carl Skrade refers to Kazantzakis' Zorba approbatively as representative of a twentieth-century "call beyond reason." See "Non-Rationalistic Theology," in *God and the Grotesque* (Philadelphia: Westminster, 1974), pp. 63–73; Skrade defines a theology which "must take as its principal data the disclosure of reality which is made manifest in man as he is, now concretely" (p. 71), and argues the case that "theology may again become poetry" (p. 145).

15. Ewa M. Thompson, "Russian Structuralist Theory," *Books Abroad*, 49 (1975), 236.

16. Chesterton, *Autobiography*, p. 307.

17. Lloyd, *The Borderland* (New York: Macmillan, 1960), pp. 15, 28, 53.

18. See the review of Canon Lloyd's book, "On the Frontier" (editorial), *TLS*, 29 July 1960, p. 481, or "Ill Writ" (editorial), *TLS*, 9 March 1962, p. 163. Also see *TLS*, 17 Feb. 1961, p. i, largely a lament on the historical fact that, necessarily, "the task of telling it out among the heathen has passed . . . to the laymen: G. K. Chesterton, Professor C. S. Lewis, Dorothy Sayers, Charles Williams and others."

19. Nott, *The Emperor's Clothes* (Bloomington: Indiana Univ. Press, 1958). The Canon nowhere mentions this book, which is an attack on the kind of amateur theology and theologians he particularly praises, including, among the "others" alluded to in the jacket banner, Jacques Maritain, Basil Willey, and Evelyn Waugh. For a reluctant appreciation of Nott's polemics see John W. Simons, "An Attack on the New Orthodoxy of Literature," *Commonweal*, 22 April 1955, pp. 83–84, and Martin Turnell, "Belief and the Writer," *Commonweal*, 13 May 1955, pp. 143–46.

20. I think that Sheldon Sacks's *Fiction and the Shape of Belief* on "the relation between ethical belief and literary form," and in his generic definitions of Satire, Apologue, and Action, is immensely interesting and useful. I certainly concur with his assertions concerning the "constant and necessary relationship between the ethical beliefs of novelists, whatever the content of those beliefs, and novels." What I would question, mainly, is the categorical exclusivity of the three literary types as he defines them.

21. Chesterton, *Orthodoxy*, p. 15.

22. Benson, *Confessions of a Convert* (London: Longmans, 1915), pp. viii–ix.

23. Frye, *Anatomy of Criticism*, pp. 307–308, 312–14.

24. Benson, *Richard Raynal, Solitary* (Chicago: Regnery, 1956), p. xiii.

25. Shuster, *Catholic Spirit in Modern British Literature*, p. 217.

26. Benson, *Lord of the World* (1907; rpt. New York: Dodd, Mead, 1950).

27. References to Knox, *A Spiritual Aeneid* (London: Longmans, 1919), p. 35f., p. 183.

28. References to Waugh, *The Life of Ronald Knox* (London: Chapman, 1959), pp. 14, 146, 200–201, 227–29.

29. Knox, *Memories of the Future* (New York: George H. Doran, [1923]), pp. 69–71.

30. Waugh, *Knox*, p. 241.

31. Knox, *Literary Distractions* (New York: Sheed & Ward, 1958), pp. 206–7; Waugh, "Posthumous Miscellany," *The Spectator*, 17 Oct. 1958, p. 523.

32. Knox, *Spiritual Aeneid*, pp. 112–115, and 165–69.

33. Waugh, *Knox*, p. 91.

34. Knox, "A Man and His Work: An Impression of St. Paul from the Epistles" in *The Bible . . . Described by Christian Scholars and Published by The Times*, June 1954, pp. 21–22.

## CHAPTER 8

1. See "Who Reads Novels? A Symposium," *American Scholar*, 48 (1979), 165–190, and "Machine of the Year: The Computer Moves In," *Time*, 3 Jan. 1983, p. 16.

2. Larry J. Stockmeyer and Ashok K. Chandra, "Intrinsically Difficult Problems," *Scientific American*, 240, No. 5 (1979), 140–59.

3. Smullyan includes six Beckettian mini-dramas on religious topics in *The Tao Is Silent* (New York: Harper, 1977); see esp. "Whichever the Way," "Taoism Versus Morality," and "Is God a Taoist?" pp. 61–67, 70–85, 86–110. For Hofstadter's commentary on three literary pieces by Smullyan, see *The Mind's I: Fantasies and Reflections on Self and Soul*, composed and arranged by Douglas R. Hofstadter and Daniel C. Dennett (New York: Basic Books, 1981), pp. 340–43, 384–88, 427–29. My citations from *Gödel, Escher, Bach* (New York: Vintage, 1980), pp. xxi, 17–19, 27, 103–26.

4. See W. H. Matthews, *Mazes and Labyrinths: Their History and Development* (1922; rpt. New York: Dover, 1970), pp. 17–22, and Janet Bord, *Mazes and Labyrinths of the World* (New York: Dutton, 1976), pp. 35–45.

5. Gitting, *Conflict at Canterbury* (London: Heinemann, 1970), p. xi.

6. Pottle, "Synchrony and Diachrony: A Plea for the Use in Literary Studies of Saussure's Concepts and Terminology," in *Literary Theory and Structure*, p. 14.

7. See Harold L. Weatherby, "Eliot and Mystical Wisdom," ch. v in *The Keen Delight: The Christian Poet in the Modern World* (Athens: Univ. of Georgia Press, 1975), pp. 99–122, and Eugene Webb, "The Ambiguities of Secularization: Modern Transformations of the Kingdom in Nietzsche, Ibsen, Beckett, and Stevens," ch. 3 in *The Dark Dove: The Sacred and Secular in Modern Literature* (Seattle: Univ. of Washington, 1975), pp. 34–87.

8. Leyburn's "Comedy and Tragedy Transposed" and Esslin's "The Theatre of the Absurd" are consecutively republished in *Perspectives on Drama*, James L. Calderwood and Harold E. Toliver, eds. (New York: Oxford Univ. Press, 1968), pp. 177–201.

9. Hart, *The Popular Book*, p. 280.

10. Lewis, *Allegory of Love*. See my ch. 3, fn. 4, and ch. 4, fn. 28.

11. Trilling, *Freud and the Crisis of Our Culture* (Boston: Beacon, 1955), p. 33, and "Freud: Within and Beyond Culture," in *Beyond Culture* (New York: Viking, 1968), p. 103.

12. Peter, "Murder in the Cathedral," *Sewanee Review*, 61 (1953), 362–83; Smith, *T. S. Eliot's Poetry and Plays* (Chicago: Univ. of Chicago Press, 1956), p. 184.

David E. Jones says "Eliot's indebtedness to the *form* of medieval English drama is not great. . . . For the form he is mainly indebted to Greek tragedy." *The Plays of T. S. Eliot* (London: Routledge & Kegan Paul, 1960), p. 51. Carol H. Smith says that "the events in *Murder in the Cathedral* are presented as neither tragic nor comic, but Christian, for Thomas goes to glory although he suffers martyrdom. In Eliot's conception of drama, neither laughter nor tears is the desired response, but rather peace which passeth understanding." *T. S. Eliot's Dramatic Theory and Practice* (Princeton: Princeton Univ. Press, 1963), p. 102.

See John P. Cutts, "Evidence for Ambivalence of Motives in *Murder in the Cathedral*," *Comparative Drama*, 8 (1974), 199–210, and Edith Pankow, "The 'Eternal Design' of *Murder in the Cathedral*," *Papers on Language & Literature*, 9 (1973), 35–47.

13. Fergusson, *The Idea of a Theater* (Garden City: Doubleday, 1953), p. 225.

14. See Burke's analytic debunking of "corporate we's" and "secular prayer" in *Attitudes toward History*, rev. 2nd ed. (Boston: Beacon, 1961), pp. 42, 264–68.

Such "corporate we's" are fingered, by textual italics, in dialogue of other religious satires whose generic definition is open to speculation. In Evelyn Waugh's *The Loved One* (subtitled an Anglo-American tragedy) for example, the central action of the story is the death and burial of an English expatriate, Sir Francis Hinsley. His erstwhile colleagues *use* the loss of their Loved One in ways which are social, and political perhaps, but certainly not religious:

"This is an occasion when we've all got to show the flag. We may have to put our hands in our pockets—I can't suppose old Frank has left much—but it will be money well spent if it puts the British colony right in the eyes of the industry. I called Washington and asked them to send the Ambassador to the funeral, but it doesn't seem they can manage it. I'll try again. It would make a lot of difference. In any case I don't think the studio will keep away if they know *we* are solid . . ." *The Loved One* (New York: Random House, 1948), p. 36.

15. In addition to Peter, pp. 377, 379, Grover Smith, pp. 194–195, Jones, p. 61–62, and

Carol H. Smith, p. 102, see also Stevie Smith, "History or Poetic Drama?" in *T. S. Eliot: A Symposium for His Seventieth Birthday*, ed. Neville Braybrooke (New York: Farrar, Straus, & Cudahy, 1958), p. 173, and Gerald Weales, *Religion in Modern English Drama* (Philadelphia: Univ. of Pennsylvania Press, 1961), pp. 191–192. Allen Guttmann calls the assassination scene Eliot's best, for dramatic intensity and thematic point (the matter of structure aside); the Knights' anachronistic apologia "shocks the spectator into the realization that the whole meaning of the play is as relevant to the present as the completely contemporary language"; see "From Brownson to Eliot: The Conservative Theory of Church and State," *American Quarterly*, 17 (1965), 498.

16. Gary T. Davenport, "Eliot's *The Cocktail Party*: Comic Perspective as Salvation," *Modern Drama*, 17 (1974), 301, 306.

17. Cohn, "A Comic Complex and a Complex Comic" in *Samuel Beckett: The Comic Gamut* (New Brunswick: Rutgers Univ. Press, 1962), pp. 283–299. Cf. her *Back to Beckett* (Princeton: Princeton Univ. Press, 1973), p. 5: "I cringe today at the systematized structure of my first book on Beckett, but I would still hold to one of its basic insights: 'Our world, "so various, so beautiful, so new," so stingily admitted to Beckett's work, is nevertheless the essential background for appreciation of that work.' Like us all, Beckett has lived in the world."

18. Allen, "The Summer Theater," "The March of Trivia," "Belles Lettres With George Jessel," "Falstaff Openshaw, the Bowery Bard," and "Rockwell Hillbilly Skit" in *Treadmill to Oblivion* (Boston: Little, Brown, 1954), pp. 36–38, 91–99, 111–21, 151–54, and 169–79. See also Allen's "old Lithuanian fable . . . about two Siamese twins who were going through life as though they had just stepped out of Noah's ark. One twin was always complaining. . . ." (pp. 163–164) Allen's twins have family resemblances with those of James Joyce and Piet Hein, which I discussed in my third chapter on tragisatire.

19. Swann, *The Space between the Bars: A Book of Reflections* (New York: Simon and Schuster, 1969). Swann's first chapter "Interstices" amplifies the theme implicit in the book title: the invisible connections which define paradox and meaning in music, daily life, and religion.

20. Hayman, *Samuel Beckett* (London: Heinemann, 1968), p. 57.

21. Hodgart, *Satire*, pp. 202, 207.

22. Columbia Records 02L-238 (OL5015-5016) 1956. Edition recorded: New York, Grove Press.

23. Kenner, *Samuel Beckett: A Critical Study* (Berkeley: Univ. of California Press, 1968), pp. 13, 14.

24. The first T. S. Eliot lecture for 1971, given at the University of Kent, Canterbury, on May 11, in *TLS*, 21 May 1971, pp. 591–93.

25. Bronowski, *The Origins of Knowledge and Imagination* (New Haven: Yale Univ. Press, 1978) pp. 3–18, 99–100.

26. Unamuno, *The Agony of Christianity*, trans. by Kurt F. Reinhardt (New York: Ungar, 1960), pp. 13, 25.

# CHAPTER 9

1. Zamiatin, *WE*, trans. Gregory Zilboorg (1924; rpt. New York: Dutton, 1952), pp. 39–40, 63, 109, 121.

2. Čapek, *War with the Newts*, trans. M. & R. Weatherall (1936; rpt. New York: Bantam, 1959), pp. 155–57.

3. William Sargant's *Battle for the Mind: A Physiology of Conversion and Brainwashing* examines the socio-political uses of religious excitement, and refers to the interest such satirists as Ronald Knox, Huxley, and Orwell have had in the subject.

In examining *Mein Kampf*, Kenneth Burke repeatedly refers to Hitler's "astounding caricature of religious thought," and generalizing from it suggests that "it is the corruptors of religion who are a major menace to the world today, in giving the profound patterns of religious thought a crude and sinister distortion." *Philosophy of Literary Form*, p. 188.

4. Lewis, *The Screwtape Letters* (New York: Macmillan, 1943), pp. 42–43.

5. Russell, *Satan in the Suburbs, and Other Stories* (1953; rpt. Harmondsworth: Penguin, 1961), pp. 27–28.

6. In Russell, *Nightmares of Eminent Persons* (New York: Simon and Shuster, 1955), pp. 110–11, 115–16.

7. Chesterton, *The Everlasting Man* (1925; rpt. Garden City: Image, 1955), pp. 81–83.

8. Eliot, *Notes towards the Definition of Culture* (London: Faber, 1948), p. 31. Cf. "Religion and Literature," in *Selected Essays* (New York: Harcourt, Brace, 1950), pp. 343–54.

9. Burke, *Attitudes toward History*, pp. 159, 162.

10. Mitford, *Noblesse Oblige* (New York: Harper, 1958), pp. 47–48.

11. Burke, *Attitudes*, p. 98.

12. Santayana, *Character & Opinion in the United States* (New York: Braziller, 1955), p. 106.

13. Lewis, *America and Cosmic Man* (Garden City: Doubleday, 1949), pp. 30–34.

14. Percy, *The Heresy of Democracy* (Chicago: Henry Regnery, 1955), p. 11.

15. Talmon, *The Origins of Totalitarian Democracy*, p. 254.

16. Cohn, *The Pursuit of the Millenium*, 2nd ed. (New York: Harper, 1961), pp. 307–19.

17. Troeltsch, *Protestantism and Progress* (1912; rpt. Boston: Beacon, 1958), pp. 29 f.n., 45–46.

18. Santayana, *Three Philosophical Poets* (Garden City: Anchor, 1953), p. 190.

19. My definition for little apostate satire derives in *practice* from Bertrand Russell's *Silhouettes in Satire*. For a complete statement in *theory*, see Horst S. Daemmrich, "The Aesthetic Function of Detail and Silhouette in Literary Genres," in *Theories of Literary Genre*, pp. 112–22. Daemmrich employs what I have called an aeronautical mode of perception, defining silhouettes as they occur in all poetry and prose fiction, arguing that the internal dynamics of all literary texts have two poles, marking off a rhythm between extended perspective and concrete circumstances. *Detail* is concrete elements, concentrated attention, while *silhouette* is universal significance and limitless expansion: "They acquire a new dimension which is characterized by a kinetic structure, familiar to us from such natural phenomena as the V-formation of flying geese or the changing shapes of windswept dunes. . . . The presentation of the eternal rhythm of life almost necessitates a focus on the small world."

20. *The Philosophy of Bertrand Russell*, ed. Paul Arthur Schilpp, 3rd ed. (New York: Tudor, 1951), pp. 730–31.

21. *Bertrand Russell's Best*, Robert E. Egner, ed. (London: George Allen & Unwin, 1958).

22. See e.g. "Pacem in Terris . . . Possible Misunderstandings," *America*, 20 April 1963, p. 518, and the introductory essay in *The Church and the Reconstruction of the Modern World: The Social Encyclicals of Pius XI*, ed. Terence P. McLaughlin, C.S.B. (Garden City: Image, 1957), p. 20: "In one of his letters Pius XI, quoting Tertullian, says: 'This alone truth sometimes craves, that it be not condemned unheard.'"

23. Forster, *Howards End* (1921; rpt. New York: Vintage, 1954), pp. 102–04.

24. In Forster's *Collected Short Stories* (London: Sidgwick and Jackson, 1948), pp. 115–58. Cf. "Forster and Religion: From Clapham to Bloomsbury," in Frederick C. Crews, *E. M. Forster: The Perils of Humanism* (Princeton: Princeton Univ. Press, 1962), pp. 7–18.

25. Spacks, "Uncertainties of Satire," *Modern Language Quarterly*, 40 (1979), 403–11.

26. In four issues, 2 Nov. 1953, and 6, 13, and 20 Jan. 1954. Cf. "The Road to 1984," which ran for eleven issues in *Punch*, 26 Aug. to 11 Nov. 1959, on such diverse subjects as Church and State, Beatniks, the Kremlin, modern Germany, and Chicago, in no particular order. See esp. Tom Driberg, "The Road to 1984—Church and State," 2 Sept. 1959, pp. 96–98.

27. See "Reginald at the Theatre," "Reginald at the Carlton," and "The Unbearable Bassington," ch. 10, in *The Complete Works of Saki: H. H. Munro*, intro by Noel Coward (Garden City: Doubleday, 1976), pp. 12–14, 22–25, 632–39.

28. Walsh, *From Utopia to Nightmare*, p. 79. Cf. James F. Carens, *The Satiric Art of Evelyn Waugh* (Seattle: Univ. of Washington Press, 1966), pp. 20–22, 151–56. My appraisal of these two satires by Waugh is closer to Walsh's. "Slovenly sentimentality" in satiric personae is comparable to what "slovenly autobiography" is in satirists. See Chesterton above, my ch. 6, fn. 28.

29. Waugh in *Commonweal*, 31 July 1953, pp. 410–22.

30. Waugh summarized his opposition to major social and religious changes in "The Same Again Please: A Layman's Hopes of the Vatican Council," *National Review*, 4 Dec. 1962, pp. 429–32. See Frederick J. Stopp, *Evelyn Waugh: Portrait of an Artist* (London: Chapman & Hall, 1958), pp. 31, 42–49, 56–59. Censorious judgment of Waugh on all sides is summarized by Paul A. Doyle, "The Persecution of Evelyn Waugh," *America* 3 May 1958, pp. 165–69, and by Leo Hines, "Waugh and His Critics," *Commonweal*, 13 April 1962, pp. 60–63.

31. Macaulay, *Orphan's Island* (New York: Boni and Liveright, 1925), esp. pp. 174, 180, 247–48.

32. The second volume of them, *Last Letters To A Friend: 1952–1958*, Constance Babington-Smith, ed. (New York: Atheneum, 1963), p. 225. These letters to the Anglican priest, Father Johnson, disclose not only Macaulay's grace and wit but also some of the intricacies of her un-organizational catholicity. The letters of 1956–1957 record her intention in *Towers of Trebizond*, commenting on the curious misunderstandings (among professional reviewers and best-seller readers alike) of the "blend of satire and fantasy."

33. Shaw, *The Quintessence of Ibsenism*, 1913 ed. (New York: Brentano, 1915), pp. 106–07.

34. Smith, *Shaw on Religion* (London: Constable, 1967), pp. 34–35. Smith includes this passage from *John Bull's Other Island*, but throughout his anthology his commentary is on Shaw's religion apart from satiric cause and effect.

35. Shaw, *Back to Methuselah* (1921; rpt. Baltimore: Penguin, 1961), p. 11.

36. Shaw in *Platform and Pulpit*, ed. Dan H. Laurence (New York: Hill and Wang, 1961), pp. 110–30.

37. Chesterton, *The Autobiography*, pp. 231–32.

38. St. John Ervine, *Bernard Shaw: His Life, Work and Friends* (New York: Morrow, 1956), pp. 51, 92.

39. See Thomas L. Jeffers, *Samuel Butler Revalued* (University Park: Pennsylvania State Univ. Press, 1981). "Except for purposes of catching certain ironies," Jeffers is rightly cautious about describing Butler's expressly polemic works over against "the elusive satires." Jeffers' purpose is theological and moral rather than literary, but he neatly identifies the emergent occasions of Butler's satire and parody, commenting briefly on the genres' vexing nature, extensively on Butler's complicated temperament.

40. Wilson, "The Satire of Samuel Butler," in *The Shores of Light* (New York: Farrar, 1952), pp. 557–65.

41. See "The Irreligion of Orthodoxy" and "Society and Christianity" in *The Note-Books of Samuel Butler*, Henry Festing Jones, ed. (London: Fifield, 1918), p. 360.

42. Butler, "Preface" to *The Fair Haven*, 2nd ed. (London: Fifield, 1913), p. xv.

43. G. D. H. Cole, *Samuel Butler* (London: Longmans, Green, 1952), p. 21.

44. Butler, *Note-Books*, pp. 23, 28, 35.

45. See e.g.: Butler's "Clergymen and Chickens," p. 56; "Snapshotting a Bishop," p. 254; "The Sacro Monte at Varese," p. 260; "The Bishop of Chichester at Faido," p. 271; and "Siena and S. Gimignano," p. 274.

46. See R. A. Streatfield's "Introduction" to *Fair Haven*, p. x, and "Satire and Irony" in John F. Harris, *Samuel Butler, Author of Erewhon* (London: Grant Richards, 1916), pp. 117–28.

47. Butler, *The Way of All Flesh*, 2nd ed. (London: Fifield, 1908), p. 243.

48. Gerber, *Utopian Fantasy*, pp. 57–60, 108. Cf. Elliott, *The Shape of Utopia*, pp. 112–13.

49. References are to Butler, *Erewhon*, rev. ed. (1901), and *Erewhon Revisited*, "Introduction" by Lewis Mumford (New York: Modern Library, 1955).

50. Mumford in *Erewhon*, p. xxvii.

51. Sagan, "Science Fiction—A Personal View," ch. 9 in *Broca's Brain*, pp. 162–72, and *Cosmos* (New York: Random House, 1980), esp. pp. 317–18, 339.

52. References to Wells, *A Modern Utopia* (London: Chapman & Hall, 1905); this first edition is reproduced with an introduction by Mark R. Hillegas but, alas, without the seven full-page illustrations, (Lincoln: Univ. of Nebraska Press, 1967).

53. Huxley, *The Perennial Philosophy* (London: Fontana, 1961), pp. 88–91, 102–03.

54. Huxley, "Knowledge and Understanding," in *Collected Essays* (New York: Harper, (1960), pp. 379–80, and in *Tomorrow and Tomorrow and Tomorrow* (New York: Harper, 1956), pp. 35–37.

55. Mannheim, *Ideology and Utopia*, p. 205. Cf. Levin's first section in "Art as Knowledge," *Contexts of Criticism*, pp. 15–22.

56. Berdyaev, *Dream and Reality: An Essay in Autobiography* (London: Geoffrey Bles, 1950), p. 326.

57. Milosz, *Emperor of the Earth: Modes of Eccentric Vision* (Berkeley: Univ. of California Press, 1977), pp. 15–31.

# Index